THE ARCHAEOLOGY OF WESTERN SAHARA

edited by
Joanne Clarke and Nick Brooks

With contributions by
Salvatore Garfi, Anne Pirie, Sue J McLaren, Yves Gauthier, Helena White,
Marijke van der Veen, Tony Gouldwell, Maria Guagnin,
Alexander Wasse, Vicki Winton

OXBOW | books
Oxford & Philadelphia

Published in the United Kingdom in 2018 by
OXBOW BOOKS
The Old Music Hall, 106–108 Cowley Road, Oxford OX4 1JE

and in the United States by
OXBOW BOOKS
1950 Lawrence Road, Havertown, PA 19083

© Oxbow Books and the individual contributors 2018

Hardback Edition: ISBN 978-1-78297-172-6
Digital Edition: ISBN 978-1-78297-175-7 (epub)

A CIP record for this book is available from the British Library

Library of Congress Cataloging-in-Publication Data

Names: Clarke, Joanne, 1953- editor. | Brooks, Nick (Researcher on Climate
 Change), editor. | Garfi, Salvatore, contributor.
Title: The archaeology of Western Sahara / edited by Joanne Clarke and Nick
 Brooks ; with contributions by Salvatore Garfi, Anne Pirie, Sue J.
 McLaren, Yves Gauthier, Helena White, Marijke van der Veen, Tony
 Gouldwell, Maria Guagnin, Vicki Winton.
Description: Philadelphia : Oxbow Books, 2018.
Identifiers: LCCN 2017051851 (print) | LCCN 2017053488 (ebook) | ISBN
 9781782971757 (epub) | ISBN 9781782971764 (mobi) | ISBN 9781782971771
 (pdf) | ISBN 9781782971726 (hb)
Subjects: LCSH: Western Sahara--Antiquities. | Excavations
 (Archaeology)--Western Sahara. | Land settlement patterns,
 Prehistoric--Western Sahara.
Classification: LCC DT335 (ebook) | LCC DT335 .A73 2018 (print) | DDC
 964.80109009--dc23
LC record available at https://lccn.loc.gov/2017051851

All rights reserved. No part of this book may be reproduced or transmitted in any form or by any means, electronic or mechanical including photocopying, recording or by any information storage and retrieval system, without permission from the publisher in writing.

For a complete list of Oxbow titles, please contact:

UNITED KINGDOM
Oxbow Books
Telephone (01865) 241249, Fax (01865) 794449
Email: oxbow@oxbowbooks.com
www.oxbowbooks.com

UNITED STATES OF AMERICA
Oxbow Books
Telephone (800) 791-9354, Fax (610) 853-9146
Email: queries@casemateacademic.com
www.casemateacademic.com/oxbow

Oxbow Books is part of the Casemate Group

Cover image: An assemblage of standing stones (feature TF0-34), west of the TF1 intensive survey area Study Area.

For the people of Western Sahara

Contents

Acknowledgements ... ix
List of Figures ... xi
List of Tables .. xv
List of Plates .. xvii

Chapter 1: The Archaeology of Western Sahara in Context
Joanne Clarke and Nick Brooks ... 1

 Introduction ... 1
 Aims and approach of this volume .. 3
 Geopolitical context .. 3
 The Western Sahara Project: history, context and aims .. 4
 Previous archaeological and environmental research in Western Sahara 5
 The archaeology of Western Sahara in regional context ... 7

Chapter 2: The Environmental Survey
Sue J. McLaren, Nick Brooks, Helena White, Marijke van der Veen, Tony Gouldwell and Maria Guagnin 10

 Introduction ... 10
 Geology and topography .. 10
 Overview ... 10
 Northern Sector ... 11
 Southern Sector ... 13
 Present-day climate .. 14
 Past climatic contexts ... 16
 Holocene climate change in the Sahara ... 16
 Palaeo-environmental indicators in the Project study areas ... 18
 Results of environmental survey work ... 20
 Approach and methodology ... 20
 Results from the Northern Sector ... 21
 Results from the Southern Sector ... 26
 Discussion ... 31

Chapter 3: Typology of Stone Features
Nick Brooks, Salvatore Garfi and Yves Gauthier .. 34

 Introduction ... 34
 Features, structures and monuments .. 34
 Typologies of stone features .. 35
 Morphological groups .. 36
 Cairns ... 36
 Falcate monuments ('Falcates') ... 44

	Petroforms	44
	Other types of stone feature	44
	Descriptions of stone features by groups and types	44
	Cairns	44
	Falcate monuments ('Falcates')	47
	Petroforms	50
	Other monument types	53
Chapter 4:	The Extensive Survey Nick Brooks, Joanne Clarke, Yves Gauthier and Maria Guagnin	56
	Introduction	56
	Approach and methodology	56
	Rationale and approach	56
	Identification of stone features using Google Earth imagery	58
	Presentation of data	59
	Results	60
	Types and numbers of features recorded	60
	Frequencies and distributions of stone features by morphological group and type	63
	Use of quartz in association with stone features	89
	Artefact concentrations (lithics and ceramics)	90
	Rock art	92
	Discussion	99
	Affinities with the central Sahara	99
	Regional innovation	100
	Relative dating of monumental stone features	101
	Differences between the Northern and Southern Sectors	102
	Conclusions	104
Chapter 5:	Intensive Survey Salvatore Garfi and Joanne Clarke	106
	Introduction	106
	Methods	106
	Topography of the TF1 Study Area	108
	Zone I: inselberg and pediment (central south)	108
	Zone II: dissected plain with tors (south)	108
	Zone III: rising and undulating ground (central north)	108
	Zone IV: dissected plain (north)	108
	Overview of archaeology	108
	Differing landscapes	108
	Other monument types	119
	Discussion	119
	Relationsip of monuments to the landscape	119
	Patterns in monument types – spatially and to do with associated features	121
	Relationships with monuments farther afield	121
	Description of monuments and artefact scatter sites from the TF1 Study Area noted in the text	123
Chapter 6:	The Excavations Joanne Clarke, Vicky Winton and Alexander Wasse	146
	Introduction	146
	2005 Excavations	146
	WS023	147
	WS024	153
	Chipped stone from the vicinity of WS023 and WS024 (V. Winton)	158

	Degree of modification and raw material reduction...158	
	Raw materials...160	
	Comparisons and interpretation...160	
	Dating of the tumuli...161	
	Discussion...161	
	2007 surface collection and excavation...162	
	WS100...162	
	WS103...164	
	WS104...165	
	WS107...170	
	Dating...173	
	Ceramics from the 2007 surface collections and excavations...173	
	Discussion...174	

Chapter 7: The Chipped Stone
Anne Pirie...177

Introduction...177
WS100...177
 WS100.101...177
 WS100.102...179
 Discussion...181
WS103...182
 WS103 test pit (F023)...185
 Discussion...185
WS104...185
 WS104.105...185
 WS104.106, Area 14...185
 WS104.106, Area 23...187
WS107...187
 Areas 15–19 transects...187
 WS107, Area 20...190
 Area 21...190
 Area 22...192
The small assemblages...193
 WS226, WS228, WS229...193
 WS400...193
Discussion...193
 Palaeolithic occupation...193
 Early Holocene occupation...193
 Early Middle Holocene occupation...195

Chapter 8: Western Sahara in Local and Regional Context
Joanne Clarke and Nick Brooks...197

Introduction...197
The changing face of the TF1 Study Area...198
A landscape of meaning...199
Burial monuments and social complexity...200
An 'Atlantic' connection?...200
 Use of quartz and contrasting materials in funerary contexts...201
 Monument locations and alignments...202
Western Saharan funerary practices in regional context...203
Environmental contexts and human-environment interaction...203
Conclusions...204

Bibliography...205
Index...215

Acknowledgements

The authors are grateful to the Office of the President and the Ministry of Culture of the Sahrawi Arab Democratic Republic for permission to conduct fieldwork in the Free Zone of Western Sahara, and for providing the logistical support which made these seasons of fieldwork possible. Special thanks are extended to Bey Hussein, Director of the Sahrawi National Museum, for his support for the Project and assistance in the field. We are grateful to the Polisario representatives in London for their help in organising travel to the field. Our particular thanks go to Bachir Mehdi Bhaua, whose tireless efforts in organising and coordinating the logistical aspects of the work ensured the smooth running of the field seasons. We would like to thank all the members of our Sahrawi support teams for their hard work and enthusiasm, the Polisario personnel at Rabuni, Tifariti, Bir Lahlou, Dugej, Mijek, Mheres and Zoug, and all the people of Western Sahara who have shown us so much hospitality. Polisario military personnel have provided vital guidance on safety issues in the field, as have Land Mine Action.

The work of the Western Sahara Project has been supported by finance from a number of sources, including the British Academy, the University of Edinburgh (through the Tweedie Exploration Fellowship), and Ophir Energy. The financial contributions of volunteers have been vital, and without this support a number of field seasons would not have gone ahead. Contributions to the expenses of individual specialists were also provided by the University of Cambridge, the University of Munich and the University of Cologne. Financial support for a round of radiocarbon dating was provided by the University of Rome La Sapienza.

The Western Sahara Project was initiated by Margaret Raffin, and without her none of this work would have taken place. Particular thanks are extended to Nick Drake (King's College, London), Savino di Lernia, Hélène Jousse, Stefan Kröpelin (University of Cologne), Mark Milburn and Toby Savage for their support to the Project during individual field seasons. Savino di Lernia and Hélène Jousse each sponsored a round of radiocarbon dating. John Crisp, Federica Crivellaro (University of Cambridge), Anne Maher (University of Southampton), Emma Markeiwicz, Matt Nicoll, Rachel Robinson, Alex Wasse and Vicky Winton contributed their time and expertise to the project free of charge during key field seasons.

Pierre Mein identified the small mammal remains, and the Natural History Museum in London identified the shells from the excavations.

Radiocarbon dating was carried out by the University of Paris RC Lab, which undertook the CO_2 extraction from the bone bioapatite, and by the University of Arizona RC lab at Tucson which undertook the AMS dating on the CO_2 obtained.

Illustrations for the book were provided by Sarah Lucas, Lucy Martin and Jeannette van der Post.

List of Figures

Fig. 1.1 Location and key features of Western Sahara
Fig. 2.1 Simplified map of the large-scale geology of Western Sahara
Fig. 2.2 Illustrative landscapes associated with the Tindouf Basin and Reguibat Massif
Fig. 2.3 Principal topographic features of the Northern Sector
Fig. 2.4 Landscapes of the Northern Sector
Fig. 2.5 Principal topographic features of the Southern Sector
Fig. 2.6 Landscapes of the Southern Sector
Fig. 2.7 Well-vegetated wadi and temporary wells dug into the sediments of the Wadi Tifariti (Northern Sector)
Fig. 2.8 Playa surface in the Northern Sector and carbonate crust at the fringe of the area of dunes in far southeast of the Southern Sector
Fig. 2.9 Savanna species that require more humid conditions than exist in Western Sahara today, as represented in the prehistoric rock art of the Northern Sector
Fig. 2.10 Distribution of environmental sites in the Northern Sector
Fig. 2.11 Carbonate deposits near sub-site N1-1 and N1 feature (N1-3/N1-4)
Fig. 2.12 Site N4
Fig. 2.13 Carbonate surface at site N11
Fig. 2.14 Carbonate mound at site N12
Fig. 2.15 Carbonate surfaces at site N24-2 and N24-1
Fig. 2.16 Carbonate surfaces at site N39
Fig. 2.17 Raised cemented fluvial gravels at Site N40 and view along palaeochannel deposits
Fig. 2.18 Carbonate cliffs at site N44
Fig. 2.19 Raised carbonate deposits at site N45
Fig. 2.20 Humic deposits in rock shelter at Irghraywa and view across plain to the north
Fig. 2.21 Locations of environmental sites visited/sampled in the Southern Sector
Fig. 2.22 Root casts at site S5 and ostrich eggshell fragment
Fig. 2.23 Fragmented carbonate crust and gypsum crystals at site S6
Fig. 2.24 View north from site S18 towards centre of depression and carbonate surface
Fig. 2.25 Area northwest of Mijek containing sites S19–24
Fig. 2.26 Site S24
Fig. 2.27 Tufa deposit S26 at Lajuad in context
Fig. 2.28 Materials recovered from the altered tufa deposit at site S26 at Lajuad
Fig. 2.29 Rock art from the Lajuad area (shelter LD0-9)
Fig. 2.30 Engraving of giraffe from Lajuad
Fig. 2.31 Cattle in the rock art from the environs of Lajuad (shelter LD0-9)
Fig. 3.1 Sketch drawings of different types of cairns
Fig. 3.2 Sketch drawings of different falcates
Fig. 3.3 Sketch drawings of different types of falcates and petroforms
Fig. 4.1 Proportion of the Free Zone covered by high-resolution (HR) Google Earth imagery in 2009
Fig. 4.2 Examples of monumental stone features visible in high-resolution Google Earth imagery, northeast of Tifariti
Fig. 4.3 Designated survey areas in the Northern Sector
Fig. 4.4 Designated survey areas in the Southern Sector
Fig. 4.5 Examples of tumuli recorded during the extensive survey
Fig. 4.6 Annexes and standing stones defining tumulus orientations
Fig. 4.7 Orientations of tumuli recorded during the extensive survey work, including tumuli with arms and tumuli on platforms
Fig. 4.8 Stone platforms or pavements in the vicinity of Lajuad
Fig. 4.9 Examples of stone discs
Fig. 4.10 Examples of single course bazinas
Fig. 4.11 Examples of stepped bazinas
Fig. 4.12 Examples of corbeilles
Fig. 4.13 View along one of the arms of V-type monument IR3-3 and mounded crescent in Mauritania

Fig. 4.14　Crescents, crescent antenna and complex monuments
Fig. 4.15　Orientations of crescent and antenna-type monuments
Fig. 4.16　Examples of apparent paved crescents in Mauritania near the border with Western Sahara, on Google Earth imagery
Fig. 4.17　Features with the footprints of regular crescents and other antenna-type forms on Google Earth imagery
Fig. 4.18　Locations of complex monuments in the Northern Sector
Fig. 4.19　Complex monuments
Fig. 4.20　Monument with auxilliary towers
Fig. 4.21　Distribution of known Type-1 goulets
Fig. 4.22　Type-1 goulets
Fig. 4.23　Goulet IR1-12 and small stone feature with form of complex monument adjacent to goulet TF6-44
Fig. 4.24　Possible pictograms associated with goulets
Fig. 4.25　Standing stones and cairns
Fig. 4.26　Stone rings
Fig. 4.27　Arrangement of half circles
Fig. 4.28　Stone alignments
Fig. 4.29　Kerb burials
Fig. 4.30　Stone structures
Fig. 4.31　Stone outlines
Fig. 4.32　Quadrilith recorded in the east of the Northern Sector, near the border with Mauritania
Fig. 4.33　Stone concentrations
Fig. 4.34　Stone features at the top of the hill of Garaat al-Masiad
Fig. 4.35　Funerary complex south of Bir Lahlou
Fig. 4.36　Funerary complex (LD0-3) at Lajuad
Fig. 4.37　Tumuli in funerary complex ZG19 and ZG25
Fig. 4.38　Decorated ceramics
Fig. 4.39　Decorated ceramics from Lajuad (LD0-8)
Fig. 4.40　Decorated rockshelters at Bou Dheir
Fig. 4.41　Rock paintings at Bou Dheir
Fig. 4.42　Paintings at Bou Dheir
Fig. 4.43　Engraving of a bovid containing a smaller engraving of an animal in area ER1
Fig. 4.44　Rockshelter LD0-7
Fig. 4.45　Engravings at LD0-6
Fig. 4.46　a. Zoomorphic engraving at Zoug, most likely representing cattle based on other similar engravings elsewhere; b. possible engravings of antelope at Zoug.
Fig. 5.1　The TF1 Study Area showing the distribution of all built stone features and artefact scatter sites recorded during the 2005, 2007 and 2008 field seasons
Fig. 5.2　Topography of the TFI Study Area
Fig. 5.3　Distribution map of all tumulus (cairn) types and complex monuments, paved crescents, mounded crescents and stone alignments
Fig. 5.4　Density plot of all tumuli in 200m quadrats

Fig. 5.5　Distribution of bazinas and tumuli with offering niches/annexes
Fig. 5.6　Distribution of tumuli with associated standing stones
Fig. 5.7　Distribution of corbeille monuments
Fig. 5.8　The corridor of Goulet WS006 showing alignment with flat-topped hill
Fig. 5.9　Stone circles associated with Goulet WS006
Fig. 5.10　The distribution of crescent antenna monuments and goulet sites
Fig. 5.11　Distribution of stone half ring sites
Fig. 5.12　Standing stone monument WS001
Fig. 5.13　Standing stone monument WS302
Fig. 5.14　Distribution of 'other' monument/feature types
Fig. 5.15　View shed from WS001
Fig. 5.16　View shed from WS302
Fig. 5.17　Sketch plan of WS004
Fig. 5.18　WS015 view looking northeast
Fig. 5.19　WS016 view looking north-northwest
Fig. 5.20　Partial view of paved crescent WS032 looking south-southwest
Fig. 5.21　WS039 view looking west at tumulus, showing standing stones
Fig. 5.22　WS043 view of square bazina, looking southwest
Fig. 5.23　Sketch plan of composite monument WS002
Fig. 5.24　WS089 view of stone alignment, looking west-southwest
Fig. 5.25　WS134 (with WS135) view, looking south
Fig. 5.26　WS265 view of small open-air mosque
Fig. 5.27　Sketch plan of arced arrangement of stone half rings, WS307
Fig. 5.28　Sketch plan of mounded crescent WS326 with an area of pavement in front
Fig. 5.29　Sketch plan of large crescent antenna monument WS352 with complex monument WS353
Fig. 5.30　Sketch plan of goulet WS354 and associated features
Fig. 5.31　View to east-northeast showing a small number of the approx. eighty stone half rings that make up site WS359
Fig. 5.32　Sketch plan of complex monument WS376
Fig. 5.33　Sketch plan of roughly rectilinear arrangement of stone emplacements WS382
Fig. 5.34　View to northwest, showing two of the stone half rings making up site WS386
Fig. 5.35　Composite image of crescent antenna monument (WS387), looking toward its central mound. View to south-southwest
Fig. 6.1　WS023 and WS024 in relationship with other built stone features
Fig. 6.2　The tumulus, WS023, looking southwest
Fig. 6.3　Plan of WS023, showing the burial chamber and possible false entrance/offering niche
Fig. 6.4　Plan of the burial within the chamber of WS023

List of Figures

Fig. 6.5 Cut through the burial chamber of WS023
Fig. 6.6 Pottery from WS023
Fig. 6.7 Pottery from WS023
Fig. 6.8 Small finds from the burial chamber of WS023
Fig. 6.9 Ostrich eggshell and stone beads
Fig. 6.10 WS024 prior to excavation
Fig. 6.11 WS024 with large, formally standing, stones to the east of the cairn
Fig. 6.12 North–south section through WS024
Fig. 6.13 Plan of WS024 showing possible 'spiraling' of stone infill
Fig. 6.14 Plan of WS024 burial chamber
Fig. 6.15 Burial in the chamber of WS024
Fig. 6.16 Copper earring
Fig. 6.17 Worked shells
Fig. 6.18 Illustration of the basalt grinding stone
Fig. 6.19 Photo of the basalt grinding stone showing ochre staining
Fig. 6.20 Flakes, blades and cores
Fig. 6.21 Flakes and blades
Fig. 6.22 Flakes and blades
Fig. 6.23 Plan of WS100.101, Areas 1–3
Fig. 6.24 Plan and section of WS100.101, Area 2 following excavation
Fig. 6.25 Plan of WS100.102, Areas 4–6
Fig. 6.26 Plan and section of WS100.102, Area 5 following excavation
Fig. 6.27 Plan of WS103, showing layout of transects and placement of hearths
Fig. 6.28 Plan and section through the hearth (F023) associated with WS103
Fig. 6.29 Ground stone axe
Fig. 6.30 Ground stone axe
Fig. 6.31 Stone bracelet fragment
Fig. 6.32 Ground stone palette
Fig. 6.33 Chipped stone axe
Fig. 6.34 Plan of WS104 showing WS104.105 (Areas 13, 14 and 23) and WS104.106 and WS104.108
Fig. 6.35 Plan and section through the test pit, Area 13 of WS104.105
Fig. 6.36 Plan and section of excavations of test pit, Area 14 of WS104.106
Fig. 6.37 Plan and section of excavations of test pit, Area 23 of WS104.106
Fig. 6.38 East section through the hearth, F049
Fig. 6.39 Plan of WS107 showing features such as hearths, stone alignments and graves and showing the position of transects across the site
Fig. 6.40 Plan and section of WS107, Area 20
Fig. 6.41 Plan and section of WS107, Area 21
Fig. 6.42 Plan and section of WS107, Area 22
Fig. 6.43 Plan and section of F042
Fig. 6.44 Pottery from WS107
Fig. 7.1 Chipped stone from WS100.101
Fig. 7.2 Percentage frequency of tool blanks in the upper (surface), middle (silt wash) and lower (ashy silt) layers in the three test pits excavated at WS100.101
Fig. 7.3 Chipped stone from WS100.102
Fig. 7.4 Percentage frequency of tool blanks in the upper (surface), middle (silt wash) and lower (ashy silt) layers in the three test pits excavated at WS100.102
Fig. 7.5 Percentage frequency of different tool types at WS100.101 and WS100.102
Fig. 7.6 Chipped stone from WS103, Palaeolithic material
Fig. 7.7 Chipped stone from WS103, Holocene material
Fig. 7.8 Chipped stone from WS104.105 and WS104.106
Fig. 7.9 Chipped stone from WS107, Palaeolithic material
Fig. 7.10 Chipped stone from WS107, Holocene material
Fig. 7.11 Chipped stone from WS107, Holocene material

List of Tables

Table 2.1 Locations of sites of environmental interest visited in the Northern Sector
Table 2.2 Locations of sites of environmental interest identified visited in the Southern Sector
Table 3.1 List of the different types of stone features found in Western Sahara
Table 4.1 The different levels of detail associated with the various approaches to the recording of stone structures in the extensive survey
Table 4.2 Types of stone features and other archaeological features identified during the extensive survey work, with brief descriptions, listed in alphabetical order
Table 4.3 Summary of areas subject to detailed survey as part of the extensive survey work
Table 4.4 Stone features associated with quartz
Table 5.1 Site/monument listing
Table 5.2 Nearest Neighbour Analyses (WS) TF1 Study Area rounded to three decimal points
Table 6.1 Measured value of radiocarbon age taken on a femur from each of the adult interments in WS023 and WS024
Table 6.2 Measured values of radiocarbon age for charcoal from WS100.101 and WS107
Table 6.3 Sequence of contexts
Table 7.1 Frequency of technological types from WS100.101
Table 7.2 Frequency of raw material use at WS100.101
Table 7.3 Frequency of tool materials at WS100.101
Table 7.4 Frequency of retouch at WS100.101 in different raw materials
Table 7.5 Percentage of retouched pieces at WS100.101
Table 7.6 Frequency of artefact types at WS100.102
Table 7.7 Frequency of raw material use at WS100.102
Table 7.8 Frequency of tool materials at WS100.102
Table 7.9 Frequency of retouch at WS100.102 in different raw materials
Table 7.10 Percentage of retouched pieces at WS100.102
Table 7.11 Raw counts of collected chipped stone from each of the transects (Areas) in WS103

Table 7.12 Total counts and percentage frequencies of artefact types overall from WS103
Table 7.13 Total counts and percentage frequencies of tool types from WS103
Table 7.14 Total counts and percentage frequencies of artefact types from WS104.105
Table 7.15 Total counts and percentage frequencies of tool types at WS104.105
Table 7.16 Total counts and percentage frequencies of artefact types at WS104.106, Area 14
Table 7.17 Total counts and percentage frequencies of tool types at WS104.106, Area 14
Table 7.18 Total counts and percentage frequencies of artefact types at WS104.106, Area 23
Table 7.19 Total counts and percentage frequencies of tool types at WS104.106, Area 23
Table 7.20 Total counts of artefact types at WS107, by transect
Table 7.21 Total counts of tool types at WS107, by transect
Table 7.22 Total counts and percentage frequencies of artefact types at WS107, Area 20
Table 7.23 Total counts and percentage frequencies of tool types for WS107, Area 20
Table 7.24 Total counts and percentage frequencies of tool blanks for WS107, Area 20
Table 7.25 Total counts and percentage frequencies of artefact types at WS107, Area 21
Table 7.26 Total counts and percentage frequencies of tool types at WS107, Area 21
Table 7.27 Total counts and percentage frequencies of blades/flakes at WS107, Area 21
Table 7.28 Total counts and percentage frequencies of artefact types at WS107, Area 22
Table 7.29 Total counts and percentage frequencies of tool types from WS107, Area 22
Table 7.30 Percentage frequencies of tools made on flakes or blades from WS107, Area 22
Table 7.31 Breakdown of sites into chronological periods using presence/absence of material types

List of Plates

Plate 1a	Painting of buffalo at Bou Dheir	Plate 7c	Goulet WS006 west alignment
Plate 1b	Painting of rhino and cow at Bou Dheir	Plate 7d	Goulet GF2-6
Plate 2a	Tumulus LD1-32	Plate 8a	Stone ring TF0-34
Plate 2b	Tumulus with annex TR2-5	Plate 8b	Stone half rings TF0-41
Plate 2c	Tumulus on platform ZG1-12	Plate 8c	Standing stones WS001
Plate 2d	Stone platform LD1-41	Plate 8d	Standing stone circle TF0-38
Plate 3a	Tumulus with arms TF5-4	Plate 9a	Pictograms at Goulet IR1-12
Plate 3b	Bazina LM2-1	Plate 9b	More pictograms at IR1-12
Plate 3c	Stepped bazina DR1-1	Plate 10a	Quartz on tumulus MS1-4
Plate 3d	Corbeille ER1-5	Plate 10b	Quartz scatters at TF0-38
Plate 4a	Regular crescent LD1-21	Plate 10c	Quartz concentrations at LD0-3
Plate 4b	Crescent with tails TF4-1	Plate 10d	Quartz crescent AZ3-1
Plate 4c	Paved crescent WS018	Plate 11	Paintings with cattle at MH2
Plate 4d	Crescent antenna TF5-4	Plate 12	Abstract paintings at MH2
Plate 5a	Kerbing on crescent antenna with characteristics of paved crescent MH1-34	Plate 13	Main panel (recess 3) at Bou Dheir
Plate 5b	V shape IR3-3	Plate 14	Recess 5 at Bou Dheir
Plate 5c	Axle monument TF3-1	Plate 15a	Abstract engravings at ER2
Plate 5d	Mounded crescent SL6-3	Plate 15b	Engraved gazelle at ER2
Plate 6a	Cairn with orthostats TF1-X	Plate 15c	Geometric forms and Libyco-Berber script at LD0-7
Plate 6b	Ridge monument LD0-3	Plate 15d	Cattle (domestic) at LD0-9
Plate 6c	Complex monument LM1-4	Plate 16a	Mask or shield engraving at LD6-1
Plate 6d	Auxilliary tower monument MH0-1	Plate 16b	Concentric circle engravings at ZG1
Plate 7a	Goulet Type 1 TF6-34	Plate 16c	'Ram's head' engraving at ZG1
Plate 7b	Goulet Type 2 IR1-11	Plate 16d	Giraffe at ZG1

Chapter 1

The Archaeology of Western Sahara in Context

Joanne Clarke and Nick Brooks

Introduction

Throughout its history, the Sahara has been a stage for human evolution and cultural development, with human habitation, movement and life ways shaped by a dynamic environment of successive phases of relative humidity and aridity driven by wider global climatic changes. Recently, a large body of archaeological and environmental data has been generated by work carried out in the central and eastern Sahara, which has enabled researchers to construct a range of individual Saharan narratives involving linked environmental and cultural changes (Cremaschi and di Lernia 1998; di Lernia 1999a; di Lernia and Manzi 2002; Kröpelin 2007; Kuper and Kröpelin 2006; Lézine *et al.* 2011; Mattingly *et al.* 2003, 2007, 2010, 2013). While much is now known about the prehistory of the central and eastern Sahara, and to a lesser extent the Atlantic Sahara (Vernet 1998, 2007a, 2007b), less is known about the western region of the Sahara, inland of the Atlantic coast (but see, Amara and Yass 2010; Rodrigue 2011; Vernet 2014).

Between 2002 and 2008 the Western Sahara Project undertook archaeological and environmental research in the territory of Western Sahara, in the areas under the control of the indigenous Sahrawi Government (Fig. 1.1). This research is beginning to address gaps in our knowledge and understanding of the environmental and cultural evolution of the western regions of the Sahara Desert.

The choice of Western Sahara is a region of great archaeological and palaeoenvironmental interest because of its environmental conditions and the history of archaeological investigation in the region. As in the rest of the Sahara, evidence of past human occupation in Western Sahara is plentiful. Surface scatters of pottery and worked stone are abundant, prehistoric rock paintings and engravings are numerous, and built stone structures including prehistoric funerary monuments are present in great numbers. However, due to its history of conflict, detailed archaeological and palaeoenvironmental research in Western Sahara has been extremely limited. With the exception of studies of rock art, almost nothing has been published in the international research literature. While a number of studies dating from the colonial and post-colonial periods have been published in Spanish and the languages of the Spanish regions (Almagro Basch 1945–1946, 1946; Sáenz de Buruaga 2008) the archaeological map of Western Sahara remains literally and figuratively almost blank as far as the wider international archaeological research community is concerned, particularly away from the Atlantic Coast (Brooks *et al.* 2009; Vernet 2014).

Conflict and remoteness mean not only that the archaeological record of Western Sahara is poorly known, but also that it is relatively undisturbed, particularly in the less accessible areas in the east in which the Western Sahara Project operates. Built stone features in these areas are startling in their richness and diversity, but few studies have been undertaken with some notable exceptions (*e.g.* Balbin Behrmann 1975; Milburn 1996a, 2005; Pellicer and Acosta 1991; Sáenz de Buruaga 2008). It is clear that these regions were either relatively well populated at certain times in the past, or at least that they were frequently visited and used as places for the burial of the dead, and perhaps also for associated mortuary rituals.

The role of climate change in mediating the occupation and exploitation of Saharan landscapes over time has been demonstrated by numerous studies (Cremaschi and Zerboni 2009; di Lernia 2002, 2006; Jousse 2004; Kuper and Kröpelin 2006; Nicoll 2004; Sereno *et al.* 2008). As in

Fig. 1.1. Location and key features of Western Sahara, including major drainage systems, key locations, and the wall or 'Berm' that separates the areas controlled by Morocco (north and west of the Berm) from those controlled by the indigenous Sahrawi (Polisario) government (south and east of the Berm).

other Saharan regions, climate change would have affected the prehistoric populations of Western Sahara via its impact on local environments. For example, a shift from humid to arid conditions during the Middle Holocene (Brooks 2006, 2010; deMenocal *et al.* 2000a, 2000b) may have meant that regions that were initially habitable subsequently became unviable for permanent human occupation. Moreover, the extent to which parts of the desert were (or were not) viable for human occupation may have fluctuated even within generally humid periods, given the evidence for short, abrupt episodes of aridity punctuating these longer humid trends (Cremaschi 2002; Cremaschi and di Lernia 1999). Environmental trajectories of such a nature may have contributed to the creation of social links and territorial boundaries that were reinforced during arid phases by burying the dead in places that had been inhabited in the past but that had become largely uninhabitable due to aridity (Brass 2007; di Lernia 2006).

Western Sahara may be viewed as a marginal environment, and such environments have long been

considered by archaeologists to be sensitive barometers of cultural adaptation and change. In this context, marginal environments are those in which small changes in climate can have significant impacts on the viability of existing subsistence and livelihoods necessitating adaptation that might be visible in the archaeological record. A desert is not *a priori* a marginal environment, because the economic strategies of those who inhabit it will not necessarily be significantly affected by small changes in climate. For example, a change in already-low rainfall in a region that cannot sustain rain-fed agriculture or wild grasses may be insignificant to those who practice oasis agriculture based on groundwater. However, on the fringes of the desert, where rain-fed agriculture is practiced in times of relative humidity, even a small change can lead to a region no longer being viable as a place to live and may result in a significant displacement of people during periods of drought. This scenario constitutes what we would call a marginal environment. Changes in temperature can have similar effects, for example when they result in tolerance thresholds being crossed (*e.g.* for particular plant and animal species). When rainfall is adequate a marginal environment may support a wide variety of plant and animal species. However, a few consecutive years of drought may have profound impacts on a landscape with no standing bodies of water or deep aquifers. Western Sahara, and particularly the areas studied by the Western Sahara Project, represents precisely this kind of environment.

Aims and approach of this volume

This book presents the results of initial archaeological and environmental exploration in the 'Free Zone' of Western Sahara. It begins to address the gaps in our knowledge of the archaeology and palaeoenvironments of the region, and also develops narratives of prehistoric cultural adaptation and change from the end of the Pleistocene to the Late Holocene. The diversity and quality of the archaeological record in Western Sahara means that it is not sufficient simply to present in a descriptive manner archaeological and environmental data acquired by reconnaissance work. Such an approach would not do justice to the depth of cultural meaning preserved in the landscapes of the region. Instead, our work is presented within its wider Saharan context, drawing on evidence and insights from a variety of archaeological and environmental studies undertaken in other regions of the Sahara (di Lernia 2002, 2013a; Huysecom *et al.* 2001; Mattingly *et al.* 2003, 2007, 2013, 2018), and set in current theoretical perspectives on the phenomenology of landscapes. Continuing the tradition of other Saharan studies, this volume also considers the way in which human adaptation and cultural change plays out in marginal environments.

A key theme of this book is the changing nature of human utilisation of the landscape, from the ephemeral and ill-defined pottery and lithic scatters of the Early and early Middle Holocene, to the dense and complex funerary landscapes of the Middle and Late Holocene. Perhaps the most striking feature of this period of human occupation in Western Sahara is the contrast between the ways in which people impacted the desert. Generally speaking, the living left very little trace of their existence on the desert and only the occasional hearth, stone emplacement or artefact scatter attests to their presence. The exception is the extraordinary rock art that characterises the Sahara more generally. Yet, the features that they erected for burying their dead and for their funerary rituals are both monumental and enduring, stamping the landscape with a cultural timelessness that marks certain regions of the desert as 'special'. In essence, some parts of the desert have been 'shaped' by a continuous blending of the natural topography with built features that reference both the desert landscape and each other, and are themselves extended and enhanced by the desert topography. In so doing, the monument builders created cultural landscapes, which in their construction have become embodied with social meaning. Thomas (2013, 317) describes prehistoric European monuments as 'mnemonic devices ... engendering memory ... a landscape of language'. He argues that small monuments can trigger memories just as effectively as large ones, but there is a temptation to distinguish between truly monumental monuments and minor architectural features as different in both scale and significance. There is no doubt that the funerary landscapes of Western Sahara embodied memory and identity in the fashion described by Thomas and these ideas will be explored later in the book.

The archaeology of Western Sahara lends itself well to a phenomenological approach as espoused by Thomas and others. Throughout the book we draw upon recent studies in landscape phenomenology from contexts in Europe and farther afield (Bradley 2007; Tilley 2004; Thomas 2013). Yet, our research aims to expand upon these approaches by contextualising the ways in which the prehistoric inhabitants of the desert experienced both the tangible elements of their environment and the intangible elements. By including environmental studies we have been able to address the relationship people had with the environment, with the desert landscape in which they built monuments, and with time as a changing dimension in which they created memories and changing identities. At the heart of landscape phenomenology is its holistic approach to the dynamic relationship between environment, place and people. But it is not just about the way in which people impacted landscapes; it is also about the way in which landscapes impacted people.

Geopolitical context

Western Sahara is located in northwestern Africa, at the westernmost extremity of the Sahara Desert, between the

Atlantic Ocean to the west, Morocco to the north, Algeria to the east, and Mauritania to the east and south. Formerly Spanish Sahara, Western Sahara is designated by the United Nations Special Committee on Decolonisation as a non-self-governing territory, one of 17 such territories in which the decolonisation process has not yet been completed. Following the withdrawal of the Spanish colonial authorities in 1975–1976, Morocco and Mauritania fought a military conflict with the indigenous Sahrawi independence movement, the Frente Popular para la Liberación de Saguía el Hamra y Río de Oro or Polisario Front, named after the administrative districts of the former Spanish Sahara. Mauritania withdrew from the conflict in 1979, after which the territory was contested between Morocco and the Polisario. In 1991 the United Nations brokered a ceasefire between these two parties pending a referendum on self-determination for the territory, and installed a peacekeeping force tasked with facilitating the referendum and monitoring the ceasefire. This peacekeeping force, the United Nations Mission for the Referendum in Western Sahara (known by its French acronym, MINURSO) remains in Western Sahara today, and the referendum has been postponed repeatedly. Prospects for a political solution to the conflict currently appear remote.

By the time of the ceasefire in 1991, the Moroccan Armed Forces had constructed a series of defensive works to secure the territory under their control: 'In six sweeping movements, the Moroccans created a "spider's web of earthworks", measuring approximately 4000km in length, across more than seventy five percent of the territory of Western Sahara' (Garfi 2014, 42). Today, the legacy of this programme of 'enclosure' is the 'wall' or 'Berm', which extends for some 2400km through Western Sahara, making excursions into Mauritanian territory where the border between Western Sahara and Mauritania switches from an east–west to a north–south orientation, and along the southernmost east–west border between Western Sahara and Mauritania (Fig. 1.1). The Berm effectively partitions Western Sahara into a Moroccan-controlled zone and a Polisario-controlled zone. Under the terms of the UN ceasefire and Military Agreement #1, there is parity between these zones with respect to permitted activity of the two parties to the conflict. A 'buffer strip' is defined under the terms of ceasefire, extending 5km from the Berm into the Polisario-controlled zone. The excursion of the Berm into Mauritania where the border changes direction means that the Polisario-controlled zone is divided into a 'Northern Sector' and a 'Southern Sector', which are non-contiguous. The areas in the Polisario-controlled zone are often referred to locally as the 'Liberated Territories' or the Free Zone. We use the latter term as shorthand for the parts of Western Sahara under Polisario control.

Today, the majority of the indigenous Sahrawi inhabitants of Western Sahara live in refugee camps around the town of Tindouf in neighbouring Algeria. A 2008 report by Human Rights Watch (HRW) estimated the population of the camps at 125,000, although it is likely that this figure is based on the 125,000 rations distributed to the 'most vulnerable' people in the camps (a subset of the population, albeit a large one) every month by the World Food Programme (http://www.wfp.org/countries/algeria). Fiddian-Qasmiyeh (2009) cites a figure of 155,000 for the population of the Sahrawi refugee camps. The United Nations High Commission for Refugees (UNHCR) has used a figure of 90,000 'most vulnerable refugees' since 2012 or earlier.[1] The Danish Refugee Council cites a figure of 'up to 165,000', based on Algerian government data.[2] A smaller number of Sahrawi continue to live in the Moroccan-controlled areas of Western Sahara, along with an increasing number of Moroccan settlers. Sahrawi from the camps around Tindouf sometimes reside temporarily in the Free Zone when rainfall results in good pasture for the herds of camels, sheep and goats that are kept there by some families. An unknown but small number of Sahrawi live in the Free Zone permanently, but a lack of resources and infrastructure means the capacity of the Free Zone to support settlement is currently extremely limited.

The refugee camps near Tindouf also house the government of the Sahrawi Arab Democratic Republic (SADR), declared by the Polisario on 27 February 1976. The SADR is a member state of the African Union, and has been recognised by a total of some 80 foreign governments, although the diplomatic landscape has been highly dynamic in this context, and the SADR is currently recognised by around 50 governments.

The Western Sahara Project: history, context and aims

The Western Sahara Project was initiated by Margaret Raffin and Nick Brooks, following a visit by the former to the Sahrawi refugee camps and the Free Zone of Western Sahara, during which the potential for archaeological work was discussed with the Sahrawi Minister of Culture. This discussion resulted in an invitation from the Ministry of Culture to Margaret Raffin to establish a UK-led project whose purpose would be to conduct archaeological research in the Free Zone. Since 2005, the Project has been co-directed by Nick Brooks and Joanne Clarke, of the University of East Anglia (UEA).

The invitation from the Sahrawi Ministry of Culture to undertake archaeological research in the Free Zone specified that this research should have a particular focus on funerary monuments. The Sahrawi people are Muslims and had, until the conflict, not really identified with the people buried in the prehistoric necropoli, but this perception has changed. Even while we were working in Western Sahara we saw the relationship between the past (as represented by the funerary monuments) and the present (as represented

by the local people) strengthen and consolidate. Hodder (2003) emphasises the importance of archaeology as giving a voice to local people. The Sahrawi Ministry of Culture is acutely aware of the importance of heritage for building a sustainable society. In the fragile conditions in which they live (in refugee camps where connection with the past can be all too easily lost). The SADR see their cultural heritage as important to affirming their cultural rights to Western Sahara, while publishing in English ensures wide dissemination to the outside world. Hodder (2003, 56) says that monumentality [in particular] is often central to the construction of social memory as it gives materiality to what is often intangible. Thus, our work serves not just to reveal the prehistory of the region, but also to strengthen the links between the SADR and the cultural heritage of a landscape from which the population it represents has been largely forcibly removed. Until our work, the funerary landscapes of the Free Zone had received relatively little attention, with most of the archaeological work conducted since the 1991 ceasefire (principally by the University of Girona) focusing on rock art (Serra Salamé 1999; Soler i Subils *et al.* 2001, 2005, 2006a, 2006b) and published in Spanish. Ours would be the first major research project that would reach English speaking audiences and present the prehistory of Western Sahara as the heritage of the Sahrawi people.

Throughout the Sahara, funerary monuments and associated features represent a time span of many millennia; in the central Sahara, monumental funerary structures have been dated as early as *c.* 6000 calendar years before present (BP) with the latest excavated funerary monuments dating from the historical period (di Lernia 2013a, 176). Given the time span represented by these features, the Western Sahara Project has concerned itself with the Holocene (approximately the last 10,000 years). The Holocene represents the period in which the last major global reorganisation of the northern hemisphere climate regime occurred and during which the 'Green Sahara' became the desert we recognise today. It is also the epoch in which the whole of the Neolithic period is contained, including the hunter-gatherer populations that preceded the monument building cultures and which probably benefited from the savannah-like conditions of the Holocene Humid Phase. Later, the Holocene is also characterised by the pastoral communities that created rock art and built monuments to their dead, and who used pottery and lithics that we find scattered across the desert floor and which are often associated with casual hearths.

Between 2002 and 2009, five seasons of extensive survey and reconnaissance work, and three seasons of intensive survey and excavation work, were conducted by the Western Sahara Project in the Free Zone. Extensive survey work has encompassed both archaeological and environmental reconnaissance, with intensive survey work focusing on the archaeological record within its landscape context.

Two field seasons (spring 2005 and autumn 2007) involved extensive survey and reconnaissance work in the Southern Sector of the Free Zone. Three seasons (autumn 2002, 2006 and 2009) involved extensive survey and reconnaissance in the Northern Sector. Two funerary monuments were excavated in autumn 2005, in the principal Study Area (area TF1) north of Tifariti, in the Northern Sector. Two further seasons of extensive survey and test excavation of surface scatters of worked stone were carried out in spring 2007 and 2008. In total, eight field seasons represent the initial phase of the Project. Although a second phase was planned for 2013–2015, security considerations associated with the situation in neighbouring Mali and Mauritania resulted in these plans being suspended.

The purpose of the initial phase of the Project was to perform a preliminary assessment of the nature, diversity and distribution of funerary monuments and related features throughout the Free Zone, to undertake test excavations, and to identify, sample and analyse geomorphological indicators of past climatic and environmental conditions. Other aspects of the archaeological record have also been addressed, with a number of new rock art sites identified and sites containing significant artifact scatters also being recorded. The results provide a foundation for realising the wider goals of the Project, which are the development of linked chronologies of cultural and environmental change in Western Sahara, in order to illuminate the ways in which prehistoric populations responded and adapted to significant changes in climatic and environmental conditions that affected the Sahara throughout the Holocene. These changes are discussed in more detail in Chapter 2. Already, the results from the initial phase of the Project enable us to draw some conclusions about past environments and culture, and the links between them in this part of the Sahara. In addition, these results are casting light on how the archaeological record of Western Sahara relates to that of other regions, both within and outside North Africa.

Previous archaeological and environmental research in Western Sahara

Archaeological research in Western Sahara dates back to the Spanish colonial period, when a number of researchers published studies addressing various aspects of the territory's archaeological record. The majority of this early work focused on rock art and took place in the western (now Moroccan controlled) part of Spanish Sahara (Martinez Santa Olalla 1941a, 1941b; Morales 1942, 1944). Studies by Almagro Basch (1945–1946, 1946) focused on chipped and ground stone, with some limited consideration of rock art and funerary monuments in the western and northern regions of Western Sahara in the earlier volume.

During the 1970s, before the start of the conflict, further archaeological work was undertaken in the south, again

focusing on rock art (Nowak and Ortner 1975; Pellicer and Acosta 1972; Pellicer Catalán *et al.* 1973–1974). A study by Delibrias *et al.* (1976) presented dates relating to past environmental conditions and human occupation of the Atlantic coast, from Cap Timiris in Mauritania to El Ouaar in southern Morocco, including eight sites on the coast of Western Sahara. A later publication by Pellicer and Acosta (1991) discussed funerary monuments, based on the results of earlier work in the 1970s. In 1995, a team from the University of Girona began surveying and documenting the archaeological record of the Free Zone, in cooperation with the Polisario and the SADR Ministry of Culture (Serra Salamé *et al.* 1999). Once again, the main focus of this and other Spanish research has been on rock art (Escolà Pujol 2003; Soler i Subils 2005b, 2006, 2007a, 2007b; Soler Masferrer *et al.* 1999b, 2001a, 2001b, 2001c; Soler i Subils *et al.* 2006a, 2006b). Searight and Martinet (2002) describe a rock painting site 130km southwest of Tan Tan, which would place it several kilometres into Western Sahara, although no coordinates or map are provided.

A number of publications have arisen from the work of the Western Sahara Project. Brooks *et al.* (2003) present the results of the Project's first reconnaissance season in the Northern Sector of the Free Zone, detailing the then newly identified rock art site at Bou Dheir, and scatters of worked stone including stone tools. A later publication by the Western Sahara Project team members (Brooks *et al.* 2006) provides an overview of the funerary archaeology of the Free Zone, detailing the preliminary results of excavations of two tumuli north of Tifariti, and presenting an initial typology of stone monuments in both the Northern and Southern Sector. The general characteristics of a variety of stone monuments (including orientations) are discussed, along with the context provided by other archaeological materials (worked stone, pottery, rock art) and a tentative, speculative model of linked environmental and cultural change is developed. Most recently, Western Sahara Project team members presented a synthetic discussion of the archaeology of the principal Study Area of the Western Sahara Project (area TF1) in an environmental and regional context (Brooks *et al.* 2009) and the burial monuments have been discussed in detail in Clarke and Brooks (2018). Other work on the region includes Brass (2007) who cites the work of the Project in discussions of the emergence of social complexity based on the excavations of funerary monuments across the Sahara, while other related articles include the archaeology of Western Sahara in relation to the military and political conflict (Brooks 2005). Two short articles on a specific type of monument known as a goulet (for a full description of these monuments see Chapters 3 and 4 this volume), found in Western Sahara have been published by Milburn (1996a, 2005), and Ehrenreich and Fuchs (2012) describe the results of an excavation of a goulet in the Northern Sector, near Tifariti. Finally, a significant body of work on the archaeology of the Southern Sector of the Free Zone has been published by Sáenz de Buruaga (2008, 2014). This provides a synthetic discussion of the archaeological record of the Pleistocene and the Early to Middle Holocene, followed by an inventory of archaeological sites recorded between 2005 and 2007, in Arabic, Basque, French and Spanish. This was complemented by a more general, popular volume on Western Sahara and aspects of its archaeology (Sáenz de Buruaga 2010).

Research into past environmental conditions in Western Sahara has been much more limited in scope. With the exception of the coastal work by Delibrias *et al.* (1976) mentioned above, the only published work of this nature appears to originate with the Western Sahara Project. As discussed in Chapter 2, this work has yielded a small number of dates from palaeoenvironmental indicators, which are consistent with what is known about Holocene humid and arid phases in the wider Sahara. Some of these dates are discussed in Brooks *et al.* (2003). The lack of environmental dates from Western Sahara is in stark contrast to the Central and Eastern Sahara, parts of which are represented by well-established environmental chronologies (e.g. Armitage *et al.* 2007; Cremaschi *et al.* 2006; Drake *et al.* 2006; Kröpelin *et al.* 2008). Detailed environmental data have been retrieved from marine sediments off the coast of Western Sahara and the adjacent areas in southern Morocco and Mauritania, including pollen records spanning the entire West African coast (Hooghiemstra *et al.* 2006) and records of terrestrial dust input into ocean sediments at a site just south of the latitude of Western Sahara's southern border with Mauritania (deMenocal *et al.* 2000a, 2000b). However, these records are representative of regional environmental conditions, and tell us little about the more localised changes that are most relevant to our understanding of diverse human-environment interactions that would have been mediated by local topographic, geological and hydrological factors.

In summary, the University of Girona have led the way in documenting the rock art of Western Sahara but less is known of the other elements of the territory's archaeological record. Most of the work undertaken during the Spanish colonial period focused on areas that today are controlled by Morocco, with the more remote areas in what is now the Polisario-controlled Free Zone attracting little attention. This has changed since the cessation of military conflict in 1991, and the vast majority of recent archaeological work in Western Sahara has taken place in the Free Zone, facilitated and supported by the Polisario and the government of the SADR via the Sahrawi Ministry of Culture. Nonetheless, our understanding of the funerary record remains very poor, particularly when compared with the Central Sahara. Archaeological and environmental dating remains almost non-existent, meaning that reliable chronologies of environmental and cultural change cannot yet be developed. Existing dates from work conducted at

the end of the Spanish colonial period are restricted to the coast, and were taken in the relatively early days of radiometric dating, meaning that they should be treated with a degree of caution. Vernet (2007a, 135ff) has attempted a chronology for the Atlantic Sahara, stretching from Tichitt in the south to the Wadi Draa in Morocco, however this is based principally on evidence from sites quite distant from Western Sahara. He brackets the Holocene into a number of cultural phases, which begin at different times across the region. In northern Mali for example, he suggests that the Neolithic period begins *c.* 7000 BP, but later on the Mauritanian coast (*c.* 6700 BP). The whole of the region he argues is 'neolithicised' by *c.* 5000 BP. The Neolithic for Vernet encompasses the whole of the pastoral period to the introduction of metallurgy around *c.* 2800–2000 BP and the beginning of the Historic period begins between *c.* 2000 and 1000 BP (Vernet 2007a, 143).

In addition, a nascent chronology based on stylistic characteristics and superimposition of rock art imagery has been developed by Soler i Subils *et al.* (2006a, 2006b). The earliest 'dancer style' painted human figures have been dated between 3800 and 3200 BP on the basis of the depiction of figures carrying halberds (Soler i Subils *et al.* 2006b, 138). Later styles (the 'shaped style', 'stroked style' and 'dark figures style' appear to be contemporaneous on the basis of superimposition and Soler i Subils *et al.* (2006b) have dated these to between 3200 to 2400 BP. Finally, the 'linear style' has been dated to the period between 2400 and 2000 BP on the basis of their relationship with Libyco-Berber text. Earlier studies of the rock art by Balbin Behrman (1977) have explored links between Atlantic Europe (in particular the Iberian Peninsula) and the rock art of Western Sahara. Certainly, the presence of halberds point to a link and this is explored in greater detail in reference to other 'Atlantic' traits present in the funerary monuments in Chapter 8.

In this volume, we have chosen to refer to geological periods of time, *e.g.* the Early, Middle and Late Holocene. This is because we do not know exactly when hunter-gatherer populations were replaced by pastoral populations in Western Sahara, or indeed when metal was first introduced. What we do know is that the built stone structures were constructed by people who appear to have practiced a pastoral way of life. It is hoped that when the political situation improves we will be able to return to the region to answer some of these outstanding questions.

The archaeology of Western Sahara in regional context

The archaeological record of Western Sahara is extremely rich with stone tool technologies representing every period from as early as the Lower Palaeolithic, through to the historic period. Pottery of all periods is represented, including what appear to be *in situ* sherds found in association with Ounan points in small soundings, WS100, WS101, WS104 and WS107, and which have been dated to the 6th millennium BP. The beginnings of rock art may date as early as the Early Holocene Humid Phase on the basis of the species of animals represented (giraffe, elephant, crocodiles) (Soler i Subils *et al.* 2006a, 2006b) but firm dating to the 4th millennium BP has been confirmed on the basis of shared stylistic traits with the Iberian Peninsula (see above). Finally, the numerous funerary monuments that cluster in 'special' places throughout the region probably begin somewhere toward the end of the Middle Holocene with the introduction of pastoral economies to the region.[3]

Archaeological and palaeoenvironmental records show that changes in human occupation and exploitation of Saharan landscapes were intimately connected with changes in climatic and environmental conditions. The most pronounced changes in environment occurred at the beginning of the Holocene (*c.* 10,000 BP) when the Sahara experienced a transition from arid to humid conditions, and again in the Middle Holocene (*c.* 6000–5200 BP), when the Holocene Humid Phase came to an end. The timing of this transition varied with location, and occurred in a series of steps extending over many millennia, but the major shift to aridity appears to have occurred throughout the 6th millennium BP, with a cessation of rainfall around 5000 BP in many regions (Brooks 2010). Humid periods were also punctuated by short, transient episodes of aridity, most notably around 8000 BP (Bouimetarhan *et al.* 2009); Saharan environmental trajectories are discussed in more detail in Chapter 2.

The Early Holocene inhabitants of the Sahara subsisted by hunting and gathering, and there is evidence from the Central Sahara that hunter-gatherers occupied certain sites more-or-less permanently (di Lernia 1999a; Wasylikowa *et al.* 1997). With the shift to a drier, more seasonal climate in the Middle Holocene cattle herding expanded throughout the Sahara (Jousse 2004), and this has been interpreted widely as an adaptation to more marginal, variable and unpredictable climatic conditions (di Lernia 2006; Holl 1988; Smith 1984). A full adoption of cattle husbandry in Africa can be dated to approximately 7500–7000 BP (di Lernia 2013b) and appears to have originated in the eastern Sahara, around the Nabta Playa and adjacent regions. The spread of cattle herding throughout the Sahara was subsequently quick with full exploitation of domesticated cattle by Middle Pastoral groups in central Libya during the 6th millennium BP (di Lernia *et al.* 2013; Gifford-Gonzales and Hanotte 2011, 6).

According to di Lernia (2013a, 176) major chronological divisions in the central Sahara can be defined by adaptations to changing environmental conditions. In the Late Pleistocene (9300–7800 BC) the 'Early Acacus' phase was characterised by hunter-gatherer-fisher groups with specialised hunting of Barbary sheep. By the beginning of the Holocene Humid Phase, during the 'Late Acacus' (*c.* 8300–6100 BC), Barbary

sheep were beginning to be corralled and wild cereals exploited as residential mobility increased. The late Early Holocene was marked by the Early Pastoral period in the central Sahara, *c.* 6400 BC, which sees the introduction of domesticated cattle and small livestock, again combined with wild cereal cultivation. With the impact of aridity after 5200 BC in the Middle Holocene, or Middle Pastoral period, new adaptations to a changing environment were established. Seasonal transhumance between mountainous regions in the dry season and lowlands in the wet season and the full exploitation of cattle, including dairying, increased food security. By 3900 BC the Sahara had fully desiccated and human adaptation during the Late Pastoral period included large-scale mobility, aggregation around transient ephemeral sites in lowlands and specialised winter sites in the mountains. The Final Pastoral period (*c.* 1900–1100 BC) is characterised by increasing aggregation of populations in fluvial valleys and intensive use of oases as an adaptation to a now arid environment (di Lernia 2013a, 176, tab. 1). Although in Western Sahara we do not yet have the data to create a detailed chronological and cultural sequence like the one that exists for the central Sahara, we can say that during the Early Holocene it is likely that hunter-gatherer populations occupied the region and as the Sahara dried, east to west, these populations were replaced by pastoral groups, sometime in the Middle or Late Holocene.

Throughout the Sahara, monumental funerary structures have been associated with prehistoric cattle herders (Chaix 1989; di Lernia, 2006; di Lernia *et al.* 2013; Ferhat *et al.* 1996; Paris 1997, 2000). Di Lernia (2006, 2013) describes the rapid spread of a 'cattle cult' throughout the central Sahara after *c.* 6400 BP. Hassan (2002) suggests a model in which small pastoral groups 'leap-frog' from one location to another, rather than a steady expansion. Di Lernia (2006) explicitly links this with climatic deterioration in the Middle Holocene, with aridity being the principal factor driving mobility. This interpretation is consistent with historical and present-day pastoralism, which represents an effective livelihood strategy that allows people to respond to scarce, highly variable and unpredictable rainfall. As stated by Hill (1989, 175) in a discussion of pastoralism in the context of drought and food insecurity in the semi-arid Sahel region of Africa immediately south of the Sahara, 'The principal individual-level strategy for coping with drought in the Sahel is to move.'

Excavations of funerary monuments in the central Sahara also tell us something about changes in prehistoric pastoral societies and trends towards greater social complexity. The earliest excavated and dated Saharan funerary monuments, from the mid- to late 8th-millennium BP, are all associated with faunal (principally cattle) burials (Sivili 2002). By the middle of the 7th millennium BP, interments in these structures included both faunal and human remains, and monuments dating from the middle of the 6th millennium BP onwards are associated only with human burials (Sivili 2002). The earliest excavated human burials in the Sahara are of single adult males, and di Lernia (2006) infers from this that these burials – and the associated monumental structures – reflect a trend towards social stratification at a time of deteriorating environmental conditions and resource availability, with special funerary status afforded to key individuals in pastoral groups. This development is consistent with moves towards greater social stratification against a backdrop of inferred climatic deterioration in the Middle Holocene in a number of regions, including Egypt and the Nile Valley, Mesopotamia, and north-central China (Brooks 2010).

Another important phenomenon evident from the archaeological record of the 6th millennium BP is the concentration of human populations in environmental *refugia* in regions that were becoming more arid (Brooks 2006, 2010). Throughout the northern hemisphere sub-tropics at this time there is evidence of in-migration to, and increased exploitation of, riverine areas and oases (mentioned briefly above). In many areas this went hand-in-hand with a shift to more sedentary lifestyles, although this was by no means universal; for example, in the Fezzan region of Libya, increased sedentism of cattle herders in oasis areas occurred in parallel with an increase in the mobility of groups practicing pastoralism based on sheep and goats in upland areas (di Lernia 2002; Gatto 2018). Both of these phenomena may be interpreted as responses to reductions in the availability of water, pasture and wild food resources, in parallel with a concentration of resources in certain privileged locations on the one hand, and the need for mobile groups to cover a larger area in order to procure necessary livelihood resources on the other.

The corollary of population agglomeration in environmental *refugia* was the abandonment of areas where resource availability fell below certain critical thresholds, and this phenomenon was particularly pronounced in the Sahara. Vernet and Faure (2000) present data indicating a collapse in the number of occupation sites in the Sahara north of 22° around 5200–5000 BP, which combines with evidence of in-migration in regions such as the Nile Valley and the Libyan Fezzan to support the model of population agglomeration in *refugia* resulting from climatic and environmental deterioration. The same data show a steady increase in the number of occupation sites in the Sahara and Sahel south of 22°N throughout the 6th millennium BP, while the number of occupation sites north of this latitude remained steady. This is suggestive of an expansion of population in these more southerly latitudes, perhaps facilitated by drier conditions that removed disease barriers to the spread of pastoralism (Smith 1984).

The above observations are pertinent in the context of Western Sahara, and particularly the principal TF1 study areas in the Northern Sector. Today, the inland areas of

Western Sahara receive more rainfall than the Saharan regions at similar latitudes to the east, supporting abundant vegetation in places. The Wadi Tifariti, astride which the TF1 study areas are situated, is one such location. This small difference in humidity, coupled with its role as the 'final destination' for the expansion of cattle pastoralism in the west between approximately 21° and 28°N, makes Western Sahara a potential candidate as a Saharan refuge. This must be balanced against its status as a marginal environment, in which small environmental changes can have large impacts on livelihoods and subsistence.

The evidence collated by Jousse (2004) indicates the presence of cattle in southern Algeria (at Meniet and Adrar Tiouyine) by the final centuries of the 7th millennium BP, and on the Moroccan coast at Kehf el Baroud by the early 6th millennium BP. In the west of Mali (Ine Sakane and Tessalit), cattle remains have been dated to the early and middle 5th millennium BP, with slightly later dates at Arouane to the southwest. In southern Mauritania cattle remains are dated to the late 5th millennium and early 4th millennium BP (Jousse 2004). These dates suggest a westward spread of cattle herding from the central Sahara through the southern Sahara and northern Sahel after the acceleration of the trend towards more arid conditions throughout the 6th millennium BP.

That cattle herding reached Western Sahara is apparent from the abundant depictions of cattle in rock art (Brooks *et al.* 2003; Sáenz de Buruaga 2010; Soler i Subils *et al.* 2006a, 2006b, 2006c, 2007a). However, Western Sahara is conspicuous as a blank space on maps showing Neolithic sites in the Sahara (see *e.g.* Jousse 2004), due to the lack of archaeological work carried out in the region. As a result, we can only speculate as to when cattle pastoralism – and by association monumental funerary architecture – arrived in this part of the Sahara, although dates from adjacent areas suggest that it must have been sometime after *c.* 6000 BP (Brooks *et al.* 2009).

In the following chapters, all of the questions outlined above regarding how and when people occupied the most western inland regions of the Sahara will be examined through the existing evidence. The aim is to provide a detailed synthesis of the current state of knowledge of the archaeology of Western Sahara, in a wider Saharan archaeological and palaeoenvironmental context and within current concepts of the phenomenology of landscape.

Note

1 UNHCR website at: http://reporting.unhcr.org/node/7039. Accessed 20 November 2017.
2 https://drc.ngo/where-we-work/middle-east-and-north-africa/algeria. Accessed 20 November 2017.
3 In order to protect the cultural heritage of Western Sahara the precise (i.e. GPS) locations of archaeological features are not included in this publication. On request the authors can provide details of the locations of archaeological features to other researchers for the purposes of further archaeological investigation, subject to the consent of the Sahrawi Ministry of Culture. Details can also be made available under conditions where development activities place archaeological sites at potential risk.

Chapter 2

The Environmental Survey

Sue J. McLaren, Nick Brooks, Helena White, Marijke van der Veen, Tony Gouldwell and Maria Guagnin

Introduction

Between 2002 and 2009, environmental survey work was conducted alongside archaeological reconnaissance and extensive survey (Chapter 4), in five seasons covering large parts of the Northern and Southern Sectors of the Free Zone of Western Sahara. The purpose of the environmental survey work was to identify, describe and sample features in the landscape that provide information about past climatic and environmental conditions. These palaeoenvironmental indicators typically consist of deposits formed by the presence of surface or groundwater, but also include organic materials such as humic deposits in caves and rock shelters and freshwater mollusc shells in now dry lakes. Sampling focused on materials that could be subject to radiometric dating and geochemical, mineralogical and micromorphological analysis to yield information on the timing and nature of past humid episodes and humid-arid transitions.

This chapter begins with a description of the physical environment of the Free Zone, including major geographical and topographic features and current climatic conditions, and a summary of regional knowledge pertaining to past climatic and environmental conditions focusing on the Holocene period (approximately the last 10,000 years). This is followed by a description of the results of the environmental survey work in the Northern and Southern Sectors of the Free Zone, and a discussion of their relevance for palaeoenvironmental reconstruction.

The text of this chapter makes reference to a variety of geographic features, the names of which are derived from a combination of historical maps and local knowledge (the latter from members of the Project's Sahrawi support team). The most comprehensive documentary source of topographic and toponymic information identified relating to Western Sahara is the *Mapa de las Provincias de Ifni y Sahara y Archipielago de Canarias* (hereafter referred to as the MPISAC), published in 1960 by the Spanish Army's geographical service, the *Talleres del Servicio Geografico del Ejercito*.

Geology and topography

Overview

The three principal elements of the large-scale geology of Western Sahara are the Aayoun Basin, the Tindouf Basin, and the Reguibat Massif (Fig. 2.1). The Aayoun Basin runs from the northern border with Morocco to the southern border with Mauritania in the west of the territory and (along with the Mauritanides fold belt in the south) covers approximately half of Western Sahara, and is contained within the Moroccan-controlled zone. The Aayoun Basin contains the youngest deposits, including Quaternary marine sediments and terrestrial sand dunes, as well as various Cretaceous sediments in the central and northern areas (Schlüter and Trauth 2008). The lowest elevation areas of Western Sahara are situated adjacent to the coast in the area of the Aayoun Basin, where the land slopes to sea-level.

The Tindouf Basin extends from Algeria and Morocco into the northeastern-most part of Western Sahara and into the northern part of the Northern Sector of the Free Zone (Fig. 2.1). The Tindouf Basin contains a succession of deposits including stromatolitic carbonates that are probably Proterozoic in age; Ordovician sandstones and shales with graptolites; Silurian clays and shales with graptolites; Silurian limestones with corals; Devonian limestones, sandstones, siltstones and clays with corals,

Fig. 2.1. Simplified map of the large-scale geology of Western Sahara, focusing on the geology of the Free Zone in the east of the territory associated with the Tindouf Basin and the Reguibat Massif (after Schlüter, and Trauth 2008; SADR Petroleum Authority 2006).

brachiopods and bryzoans; and Cretaceous sediments (Fig. 2.2a). In the northeastern parts of the Northern Sector the Devonian deposits form dramatic fossil rich pavements (Fig. 2.2b). The extension of the Tindouf Basin into the most northeasterly parts of Western Sahara is associated with the highest elevations in the territory, of up to about 500m.a.s.l.

The Reguibat Massif covers an area approximately corresponding to the Southern Sector of the Free Zone, and the southern and central parts of the Northern Sector (Fig. 2.1). These areas contain the oldest surface rocks in Western Sahara, consisting mostly of Neoproterozoic granites in the north and palaeoproterozoic migmatites in the south (Schlüter and Trauth 2008). The landscapes associated with the Reguibat Massif consist largely of wide sand and gravel plains bisected by shallow drainage systems, most of which are filled with wind-blown and fluvial sediments. These plains are broken by weathered granite hills and outcrops, and bisected by basalt dykes (Fig. 2.2c, d).

Northern Sector

The Northern Sector of the Free Zone contains a diversity of landscapes, with the younger deposits of the Tindouf Basin near the Berm in the north and west incised by a network of large wadis that drain into the Saguia al-Hamra (the 'Red River'), the largest drainage system in Western Sahara (Fig. 2.3). The Saguia al-Hamra runs for some 650km from

Fig. 2.2. Illustrative landscapes associated with the Tindouf Basin & Reguibat Massif; a Sandstone plateau in the northwest of the Northern Sector of the Free Zone; b. fossil-rich limestone in the northeast of the Northern Sector; c. basalt dyke and rounded granite hills at Aij in the Southern Sector; d. granite range at Zoug in the Southern Sector.

east to west to El Aayoun, in the Moroccan-held areas of Western Sahara, before dissipating in a number of smaller channels that flow into the Atlantic. Near the Berm in the west and northwest respectively, the Wadis Weyn Tergit and Lejcheibi converge before flowing into the Saguia al-Hamra (Fig. 2.3). The Wadi Weyn Tergit is fed by a number of south–north flowing drainage channels including the Wadis Tadaiegat, Ratnia and Jenneig Ramla (Fig. 2.3). The Wadi Lejcheibi is fed by the east–west flowing Wadis Dirt, Erni and Ternit, which dominate the central northern areas of the Free Zone (Fig. 2.3). These tributaries to the Wadi Lejcheibi originate in a watershed formed by the southward extension of Cretaceous sediments north of Bir Lahlou. Also originating in this watershed are the west–east flowing drainages of the Wadis Ben Amera, Sluguiat, and Lemmuil-Lihien, that terminate in the Dait el-Aam basin, and along the length of which are located extensive playa surfaces. South of these wadis is the Wadi Um Hamra, which also flows from west to east to terminate in the desert of northern Mauritania (Fig. 2.3).

The Wadi Ternit and the Wadi Um Hamra delineate the approximate boundary between the Tindouf Basin and the Reguibat Massif (Figs 2.3 and 2.4). South of this boundary, the central and eastern regions of the Northern Sector are characterised by open sand and gravel plains with shallow, in-filled drainage channels and granite outcrops.

The western regions of the Northern Sector, around and to the west of Tifariti, are characterised by much more topographic variation, due to the presence of prominent granite ridges and granite and sandstone hills and plateaux (Figs 2.3 and 2.4). Upland areas extend south and west of Mheres in the far southwest of the Northern Sector; these uplands terminate some 25km west of Mheres, where they give way to sand and gravel plains that extend to the edge of the Reguibat Massif (Fig. 2.3). At the boundary between the deposits of the Reguibat Massif and the Tindouf Basin a series of escarpments rise, before elevation drops again towards the Wadi Weyn Tergit (Fig. 2.3). These escarpments form an arc that curves to the northeast before becoming aligned in a more-or-less west–east direction, and are

Fig. 2.3. Principal topographic features of the Northern Sector.

Fig. 2.4. Landscapes of the Northern Sector; a. View from cliffs overlooking Wadi Ternit in the north of the Northern Sector; b. gravel plain with granite boulders looking towards upland areas in the southwest of the Northern Sector, west of Mheres, near the boundary between the Tindouf Basin and the Reguibat Massif.

responsible for the distinctive dark arc in the Northern Sector apparent on satellite imagery.

Southern Sector

Most of the Southern Sector of the Free Zone is characterised by extensive sand and gravel plains bisected by low granite and basalt ridges and dykes, and intermittently broken up by heavily weathered granite hills and outcrops. Such features are particularly notable in the areas of Aguanit, Dugej, Mijek and Lajuad (Figs 2.5 and 2.6). The settlement of Zoug is located towards the northern end of a series of approximately south–north trending granite peaks that run intermittently for almost 150km, straddling the Western Sahara-Mauritania border (Figs 2.5 and 2.6). The far southeast of the Southern Sector (and of Western Sahara) is traversed by approximately northeast–southwest trending

Fig. 2.5. Principal topographic features of the Southern Sector.

dunes, which are partially stabilised by vegetation in some areas (Fig. 2.5). Thin carbonate deposits are found in many of the inter-dune depressions.

Drainage channels are less apparent in the Southern Sector than in the Northern Sector due to infilling with fluvial and aeolian sediments. However, some major drainage systems do exist, and the Southern Sector contains numerous basins housing clay playas/sebkhas and carbonate deposits. The largest of these is the Sebkhet Agzoumal, and other similar features are located on the Mauritanian side of the border, such as the Sebkhet Idjil (Fig. 2.5).

Present-day climate

Western Sahara today is characterised by arid climatic and environmental conditions. Nonetheless, rainfall today is higher than in other Saharan regions located at similar latitudes, and significant rainfall is not uncommon,

particularly in autumn and winter. While there are currently no meteorological stations in the vicinity of the Free Zone, mean annual rainfall was estimated at 30–40mm, rising to over 50mm in the elevated region of the Guelta Zemmour (Fig. 2.5), for the period 1926–1950 (Dubief 1953). Precipitation is sufficiently abundant for the local Sahrawi people to have a concept of drought and to practice mobile pastoralism, exploiting savannah-like vegetation after periods of significant rainfall. Many of the wadis in the Northern Sector are well-vegetated, with a dense cover of mature *Acacia* (Fig. 2.7).

Western Sahara's position at the western edge of the Sahara, and its proximity to the Atlantic Ocean, Atlas Mountains and West African monsoon zone, means that it is subject to a diverse set of climatic influences. Today, the territory lies between two distinct climatic regimes, in which rainfall is generated by different mechanisms.

To the south, rainfall is associated with the passage of easterly convective disturbances in the African monsoon circulation, which moves over the Sahel in summer with the northward displacement of the inter-tropical convergence zone (ITCZ). Immediately south of the southernmost parts of Western Sahara, the isohyets (lines of constant rainfall) representing average rainfall associated with the West African monsoon, bulge northwards over the region around Atar in neighbouring Mauritania (Dubief 1953), indicating a geographical extension of the monsoon. As a result, the southern regions of Western Sahara are subject to occasional monsoonal influences.

To the north of Western Sahara, rainfall is generated by the passage of extra-tropical westerly cyclones that bring rainfall to North Africa north of the Sahara in the cooler months. These systems generate the majority of Morocco's rainfall during the winter, and some rainfall during this

Fig. 2.6. Landscapes of the Southern Sector. a. View across sand and gravel plain towards granite hills at Lajuad; b. stony desert looking east towards part of the Zoug range.

Fig. 2.7. a. Well-vegetated wadi emerging from the upland area at Rekeiz Lemgassem, Northern Sector; b. temporary wells dug into the sediments of the Wadi Tifariti (Northern Sector) to access the elevated groundwater table after rainfall.

period also occurs in the northern parts of Western Sahara. Rainfall in northwest Africa is influenced strongly by North Atlantic sea surface temperatures and the difference in atmospheric pressure between the Azores high pressure and the Icelandic low pressure regions (Li *et al.* 2003) which influences the development and trajectories of these westerly weather systems.

The dominant climatic regime over Western Sahara is characterised by subsidence associated with anti-cyclonic circulation and the northeasterly trade winds, which in this region take the form of the Harmattan. However, interactions between the extra-tropical and monsoonal circulation, involving the southward extension of low-pressure troughs from mid-latitudes deep into the tropics, can trigger heavy showers, thunderstorms and dust storms (Flohn 1975; Nicholson and Flohn 1980).

Along the West African coast, the terrestrial climate is influenced by coastal upwelling, in which the ascent of cold water from the deeper ocean lowers sea surface temperatures and stabilises the overlying atmosphere, inhibiting convection and thus precipitation (Williams and Balling 1996). As a result, the coastal zone of Western Sahara is more arid than the interior. The present-day coastline of Western Sahara more-or-less corresponds to the zone of permanent coastal upwelling, which is largely confined to sub-tropical latitudes and extends from Cap Juby in the north to Cap Blanc in the south. Immediately to the south, seasonal upwelling occurs along the West African coast, as far south as about 10°N (Matsuzaki *et al.* 2011; Zhao *et al.* 2006).

Past climatic contexts
Holocene climate change in the Sahara

During the last glacial period, which reached its peak around 21,000 BP, the Sahara experienced conditions more arid than those of today (Talbot 1984; Yan and Petit Maire 1994). Relatively stable humid conditions were established throughout the Sahara after the end of the last glacial period by the beginning of the Holocene around 10,000 BP (deMenocal *et al.* 2000b). Humid conditions in the Holocene Sahara were associated with higher levels of summer insolation, which increased the thermal contrast between land and ocean, strengthening the African monsoon (Lézine 2009). Summer insolation at mid-latitudes peaked around 10,000 BP at about 8% greater than the present day, and the resulting strengthening of the monsoon and its extension hundreds of kilometres north of its present limit resulted in the 'African Humid Period' from *c.* 10,000–5000 BP (deMenocal *et al.* 2000). The African Humid Period can be viewed as a regional manifestation of the 'Holocene Climatic Optimum', characterised by humid conditions throughout the northern hemisphere subtropics, and warmer conditions at middle and high latitudes (Brooks 2010).

The Holocene African Humid Period was associated with the 'greening of the Sahara', when desert was replaced by savannah and steppe vegetation, and the Sahara was occupied by human populations and by wild fauna typical of today's African savannah environments (Cremaschi and di Lernia 1999; Cremaschi and Zerboni 2009; Jolly *et al.* 1998; Petit-Maire *et al.* 1983). During this period, Lake Chad reached its maximum extent of around 340,000km, making it comparable in extent to the present-day Caspian Sea (Leblanc *et al.* 2006). Other large lakes also existed in the Sahara at this time, such as the West Nubian Palaeolake, the now dry basin of which straddles the borders of present-day Egypt, Sudan, Libya and Chad (Elsheikh *et al.* 2011). Based on optically stimulated luminescence (OSL) dating of shoreline deposits near Awbari and el Ghrayfah in the Fezzan region of southwestern Libya, Armitage *et al.* (2007) propose the existence of a large lake with a surface area of at least 76,250sq. km in the Fezzan during the Early Holocene, between about 11,000 BP and 9000 BP. Sedimentary deposits and geochemical crusts indicate that lakes were common throughout the Sahara and Sahel in the Early to Middle Holocene (Damnati 2000).

A long-term trend towards drier conditions throughout the Saharan region appears to have commenced in the middle of the 9th millennium BP. Evidence from isotopic analysis of terrestrial dust fractions in sediments from both the Arabian Sea and the Eastern Tropical Atlantic indicate an increase in terrestrial dust input to ocean sediments from around 8500 BP and 8000 BP respectively, suggesting a shift to drier conditions over northern Africa and parts of Western Asia (deMenocal *et al.* 2000a,b; Jung *et al.* 2004). In both of these marine records, increased variability in terrestrial dust input on centennial timescales suggests an increasingly unstable climate from the middle to late 9th millennium BP onwards. Global palaeoclimate records indicate a well-defined century-scale cold/arid episode around 8200 BP (Dykoski *et al.* 2005), superimposed on a longer-term trend of cooling at middle and high latitudes and drying at lower latitudes from around 8600 BP to 8000 BP, indicating that increased aridity in northern Africa as at this time was a manifestation of a wider global climatic phenomenon (Rohling and Pälike 2005).

The trend towards aridity in northern Africa appears to have accelerated further towards the end of the 7th millennium BP. Linstädter and Kröpelin (2004) find evidence for a climatic transition in the Gilf Kebir region of south-western Egypt around 6400 BP, with the collapse of the summer monsoon rainfall regime and its replacement with one of winter rainfall. Evidence from the majority of analysed palaeolake deposits throughout the Sahara is indicative of increased aridity between about 7500 and 6000 BP (Damnati 2000; Pachur and Hoelzmann 2000). A similar timing has been proposed also for the Acacus Mountains in the Fezzan region of Libya (di Lernia 2002).

By around 6000 BP, a second, and much more pronounced, aridification step is apparent in the Arabian Sea sediment records, continuing well into the 4th millennium BP (Jung *et al.* 2004). Further lake recessions are evident in records from Mali, Chad and Sudan (Gasse and van Campo 1994). It has been proposed that an acceleration of aridity around this time may have been associated with a weakening of the meridional overturning circulation in the North Atlantic, and a cold North Atlantic episode around 5900 BP, evident in ice-rafted debris in marine sediments (Bond *et al.* 1997; Brooks 2010).

Globally, the 6th millennium BP was a time of climatic transition, with widespread desiccation throughout the northern hemisphere sub-tropics and adjacent regions, cooling at middle and high latitudes, and the development of a regular El Niño regime, after a long period during which El Niño was rare or absent (Brooks 2010; Mayewski *et al.* 2004; Sandweiss *et al.* 2007; Thompson *et al.* 2006). During the 6th millennium BP, the eastern tropical Atlantic sediment records indicate a second aridification step commencing around 5800–5600 BP (de Menocal *et al.* 2000b). This coincides with evidence from terrestrial records from the Libyan Fezzan, which indicate a severe and abrupt transition to aridity around 6400–6100 BP (di Lernia 2006, 60).

A period of significant climatic disruption, involving a transient cold/arid episode centred around 5200 BP, effectively marked the end of the Holocene Climatic Optimum and the African Humid Period (Brooks 2010). Terrestrial dust input to marine sediments in the Eastern Tropical Atlantic had reached its maximum by this time (de Menocal *et al.* 2000b) and evidence from several Saharan regions indicates a transition to hyper-aridity. Hoffmann *et al.* (1986) identify the formation of the final fluvial deposits at Nekhen in the Nile Valley around 5200 BP, indicating the effective cessation of significant rainfall, while Linstädter and Kröpelin (2004) find evidence for the cessation of winter rainfall in the Gilf Kebir region around 5300 BP. In the context of the central Sahara, di Lernia (2006) describes the period around 5100 BP as the 'hinge' between the humid early Middle Holocene and arid Middle to Late Holocene.

Climate models suggest that the abrupt changes in Saharan climate associated with the 'aridification steps' evident in both regional and more localised records may have been related to biogeophysical feedbacks between vegetation and precipitation, which amplified aridification (Renssen *et al.* 2006). Brooks *et al.* (2005) speculate that the transient cold, arid episodes around 5900 BP may have disrupted a weak monsoon regime sustained by such feedbacks, which subsequently only partially recovered, and was terminally disrupted by the cold, arid episode around 5200 BP. Earlier in the Holocene, stronger insolation resulted in a stronger monsoon that was able to recover after similar climatic perturbations.

Nonetheless, the timing of the final transition to aridity in the Sahara varied widely with location, generally occurring later in more westerly regions (Gasse 2002; Lancaster *et al.* 2002; Nicoll 2004), and in some upland or adjacent areas such as the Tannezuft Valley in the Libyan Fezzan, where relatively humid conditions (compared with those of today) persisted into the 3rd millennium BP (Cremaschi and Zerboni 2009). While the transition from humid to arid conditions in the Sahara at large may be said to have occurred around 5000 BP, and regional and even global scale Holocene climatic contexts are important in framing Holocene climatic and environmental transitions in the Sahara, more localised climatic and environmental trajectories are important if we are to understand human-environment interactions in specific Saharan regions.

The Early–Middle Holocene in the wider Western Saharan/Northwest African region

The proximity of the southern parts of Western Sahara to the present-day monsoonal zone means that any intensification and northwards displacement of the monsoon, as occurred throughout the Early and Middle Holocene, would have brought summer monsoonal rainfall to these areas.

A stronger monsoon, extending further north, would also have had implications for rainfall-generating interactions between monsoonal and extra-tropical air masses, which may have occurred more frequently than they do today, further increasing rainfall in the territory. It is likely that such interactions lie behind the much more extensive greening of the Sahara at large than would be expected from an intensification and northward displacement of the monsoon alone.

A northward displacement of the monsoon, and enhanced interactions between monsoonal and extra-tropical air masses, are not the only mechanisms that may have influenced the early Middle Holocene climate in Western Sahara. Any changes in the behaviour of the Atlantic Westerlies or in coastal upwelling would have had implications for climate in the northern and coastal parts of the territory respectively. The proximity of Western Sahara to the Atlantic, and the role of these mechanisms in shaping the climates of the Atlantic Sahara, means we cannot assume that the Holocene climatic evolution of Western Sahara simply reflected that of the wider Sahara region.

While quantitative data relating to past climatic and environmental conditions in Western Sahara are lacking, as evident from maps showing the locations of proxy data on past Saharan climates (*e.g.* Nicholson and Flohn 1980), a significant body of research has examined Pleistocene and Holocene climatic and environmental changes in the wider western Saharan region.

Nicholson and Flohn (1980) present data indicating greater precipitation than at present in the far south of Morocco and the far north of Western Sahara (based

on data from the Soltanian Terrace) between 20,000 and 15,000 BP. Data indicated as originating in Tarfaya suggest decreased precipitation in the same region between 10,000 and 8000 BP, when increased precipitation and river discharge is inferred for much of Mauritania, south of about 22°N. Nicholson and Flohn (1980) conclude that while enhanced humidity (compared with the present day) pertained throughout most of the Sahara and other parts of northern Africa during the Early Holocene, the northwestern Sahara experienced aridity. They describe arid conditions throughout much of the Maghreb during the Early to Middle Holocene, depending on location, present a complex picture in which aridity in the northwestern Sahara was punctuated by humid episodes. At locations throughout Morocco and in south-central Algeria,[1] and in the northeastern-most parts of Western Sahara, data indicate increased precipitation relative to the present day during the Early Holocene. This complex picture is reinforced by Kuhlmann (2003), who concludes, based on an analysis of iron inputs to marine sediments from aeolian and fluvial sources off Cap Juby in the far southwest of Morocco, that the influence of the African monsoon extended as far north as 30°N in northwest Africa during the African Humid Period, but that this situation only pertained during the Early Holocene. Together, these results suggest a geographically complex situation during the Early Holocene, with parts of northwest Africa experiencing aridity, but the northernmost parts of Western Sahara experiencing humid conditions.

Desiccation trajectories in the wider Western Saharan/Northwest Africa region
Climatic desiccation in the wider Western Saharan region (*i.e.* the region encompassing western Algeria, the Saharan areas of Morocco, Western Sahara and Mauritania) appears to have followed a broadly similar trajectory to that in other Saharan regions. Lancaster *et al.* (2002) conclude that local aeolian activity increased in parts of Mauritania south of 20°N around 5000 BP, resulting in the formation of the widespread dune fields present in these areas today. They argue that this reflects a desiccation of the Sahara west of 15°E at around the same time. However, aeolian deposition is not necessarily a good indicator of past arid phases as the development of sand dunes is also affected by the availability and supply of sediment as well as the transport capacity of wind (Kocurek and Lancaster 1999; McLaren *et al.* 2009). Gasse (2000) also places the desiccation of the southern Sahara around 5000 BP, with the transition to aridity occurring somewhat later (around 4500 BP) on the northern margins of the Sahara.

Gasse (2002) presents data from a number of specific palaeolake sites in the Sahel and Sahara west of 15°E. At Hassi el-Mejnah on the western edge of the Great Western Erg (approximately 30°N) sediment profiles indicate two Holocene lacustrine episodes, from around 10,500–8000 BP and 7500–4500 BP. In the Taoudenni basin of northern Mali (approximately 22°N) Holocene palaeolake sediments indicate an elevated water table between 7600 BP and 4200 BP. The former palaeolake site is located almost 400km north of the Northern Sector and some 600km east of its easternmost extremity. The latitude of the latter site lies between that of Mijek and that of Lajuad in the Southern Sector, but over 900km to the east. To the south of the Taoudenni palaeolake site, groundwater studies along a transect between 16° and 21°N suggest intensive recharge events between about 15,000 BP and 4000 BP. Petit-Maire *et al.* (1983) identify a major lacustrine phase from about 11,000–6800 BP, followed by a minor lacustrine phase from about 5700–4500 BP in the area of the Erg Ine Sakane and Tagnout-Chaggeret based on the dating of aquatic mollusc shells, with human occupation continuing well into the 3rd millennium BP and indicating a more benign environment than exists today in this region, even after the lakes had dried.

It appears that in areas to the east of the Free Zone, but located at similar latitudes humid conditions gave way to arid conditions at various times throughout the 5th millennium BP. Nonetheless, even after surface water had largely or completely disappeared, a more productive environment persisted in some areas. Some rare radiocarbon dates from Western Sahara itself, presented by Delibrias *et al.* (1976) and cited by Nicholson and Flohn (1980) seem to reflect this wider regional picture, and 'confirm a lacustrine episode in the Spanish Sahara and northern Mauritania from *c.* 7,000 to *c.* 4,000 B.P.', with a trend towards present-day aridity that 'did not begin until at least 4,800 B.P.' and wetter-than-present conditions 'as late as 4,450–3,700 B.P.' (Nicholson and Flohn 1980, 326).

Even after this period, episodes of relative humidity in Western Sahara cannot be discounted. Evidence from elsewhere in the wider northwest African region indicates that centennial-scale periods of increased humidity and enhanced aridity occurred after the widespread desiccation of northern Africa in the Middle Holocene. For example, in Senegal, both continental and oceanic environments show that arid conditions were interrupted by a rapid and strong increase in humidity between 2900–2500 BP, known as the 'Little Humid Period' (Bouimetarhan *et al.* 2009).

Palaeo-environmental indicators in the Project study areas

Both the Northern and Southern Sectors contain abundant indicators of past humid conditions, reflecting the evidence of a much wetter past that is widespread throughout the Sahara at large, as discussed above. In Western Sahara, the most common and obvious of these indicators are the

numerous wadi systems that are either inactive or whose active channels cover only a small proportion of the wadi floor, and the extensive playa deposits in numerous topographic depressions (Fig. 2.8). The low but significant and regular rainfall in Western Sahara means that some of these features are still active occasionally.

The presence of extensive sheets of fluvial gravels containing Acheulean and Mousterian lithics on the margins of major wadis and on the flanks of the surrounding hills in the Northern Sector suggests an extensive river system in the Pleistocene (Brooks *et al.* 2003, 64). Thick, highly indurated carbonate deposits (Fig. 2.8) at a number of locations are most likely indicative of long-lived bodies of surface water during the Late Pleistocene and Early Holocene.

Despite the abundance of evidence of wetter conditions in the past, readily datable palaeoenvironmental indicators are scarce in the Free Zone. Extensive sand seas, such as those found elsewhere in North Africa, are absent in Western Sahara, except in the far southeast. Sand seas commonly house closed (endorheic) basins containing palaeolake deposits in inter-dune depressions. These deposits have been used extensively for dating past humid episodes in other parts of North Africa such as the Fezzan region of Libya (*e.g.* Armitage *et al.* 2007; Cremaschi 2002). The majority of water-related deposits in the Free Zone of Western Sahara consist of thick layers of silt and clay in the playas, which are of very limited value in terms of environmental dating, and carbonate crusts in shallow pans (Fig. 2.8).

Nonetheless, dates have been acquired from cave deposits (environmental sites N47 and S26; see Tables 2.1 and 2.2 and Figs 2.10 and 2.22) and mollusc shells (site N4), as detailed below in the descriptions of individual sites of environmental interest in the Northern and Southern Sectors. These dates are consistent with our understanding of past environmental change in the wider Saharan region, in which humid conditions in the Early to Middle Holocene were followed by desiccation between about 6000 and 4000 BP. There is further potential for dating sediments from at least one palaeolake site, Muyalhet Awaadi (site S1, described below), in the southeastern Sand Sea.

Although the frequency with which animal species are depicted in rock art is culturally driven and not generally a reflection of their scarcity or abundance in the landscape, their presence in rock art shows that the engravers or painters were familiar with the species in question. Faunal identifications from rock art can therefore complement skeletal remains, and enhance our understanding of prehistoric animal distributions. The species, and combinations of species depicted in paintings or engravings that are likely to be broadly contemporaneous (*e.g.* based on style, appearance and location, *e.g.* on the same panel or recess), can therefore provide additional information on past environments (Guagnin 2015). Remarkably, the faunal depictions in the rock art of Western Sahara include a wide range of species that are not adapted to aridity. While giraffe, which are commonly represented in the rock art of the Free Zone, are tolerant of semi-arid Sahelian type environments, depictions of savanna species such as reedbuck, roan antelope, rhinoceros, buffalo, and possibly eland, indicate that water may once have been readily available and that vegetation was abundant in this part of the Sahara (Fig. 2.9 and Pl 1). These animals need to drink regularly, are generally found within 20 to 25km from water, and require habitats consisting of a mixture of trees and grassland. Critically, the faunal representations in the rock art of the Free Zone (Chapter 4) show a wider range of savannah species than comparable rock art surveys in the central Sahara, possibly reflecting more extensive humid conditions in the past.

Fig. 2.8. a. Playa surface in the Northern Sector; b. carbonate crust at the fringe of the area of dunes in far southeast of the Southern Sector.

Fig. 2.9. Savanna species that require more humid conditions than exist in Western Sahara today, as represented in the prehistoric rock art of the Northern Sector; a. giraffe (Rekeiz Lemgassem); b. reedbuck (Sluguilla); c. roan antelope (Bou Dheir); d. possible representation of eland (top image, Sluguilla Lawaj).

Results of environmental survey work
Approach and methodology

Very little is known about past environmental conditions in Western Sahara which, unlike many other Saharan regions, has not been the subject of palaeoenvironmetnal research. The environmental work of the Western Sahara Project therefore has been highly exploratory in nature, consisting of reconnaissance work informed by remote sensing and local knowledge.

The focus of the environmental work of the Western Sahara Project has been on the identification and sampling of indicators of past humid conditions that are amenable to radiometric dating. Field survey has been targeted using satellite imagery, including Landsat Thematic Mapper (TM) imagery and Google Earth (GE) imagery. Carbonate and gypsum rich sediments appear as bright areas in both TM and GE imagery (as indicated in some of the figures below) allowing the easy identification of basins and deposits associated with the presence of surface or ground water in the past. Satellite imagery also facilitates the identification of hills, escarpments and outcrops that may contain caves or rock shelters housing organic rich deposits that can be subject to radiocarbon dating. Other features potentially identifiable on satellite imagery are alluvial fans and wadi systems containing travertine deposits, although neither of these features has been confirmed during field survey work to date.

Prior to each season of environmental survey work, a number of sites of potential interest were identified

using satellite imagery, and their coordinates noted. These sites were then located in the field using hand-held GPS units. However, other sites of environmental interest were identified in an opportunistic manner while in the field. Where these sites were associated with material amenable to radiometric dating or other analysis that might yield information about past environmental conditions (*e.g.* geochemical, mineralogical or micromorphological analysis) they were sampled.

Results from the Northern Sector

Environmental survey work in the Northern Sector was conducted in 2002, 2006 and 2009 in short field seasons of two to three weeks that combined the identification and sampling of palaeoenvironmental indicators with archaeological reconnaissance and extensive survey work. The areas of the Northern Sector subject to environmental survey (Fig. 2.10) are predominantly highly deflated stony desert. Depositional elements in the landscape that are suitable for the quantitative reconstruction of past climatic and environmental conditions have not been identified in the course of environmental survey in the Northern Sector to date. Sand dunes along some escarpments and wadis might be subject to optically stimulated luminescence (OSL) dating, although this would not necessarily yield useful information on the periods of interest to the archaeological work of the Western Sahara Project, due to the currently active nature of the landscape. Features identified on satellite imagery as possible alluvial fans close to Wadi Erni prior to the 2006 field season proved to be thin veneers of fluvial material (pediment). A few sections through these features were apparent, and these suggest that the record contained within the deposits is not extensive and could relate to only a few flood events, providing an insufficiently complete or long record to date past fluvial activity associated with wet periods.

A number of potential lakebeds were visited in the Northern Sector based on initial detection from satellite imagery. Some of these were found to consist of indurated carbonate deposits; subsequent preferential erosion of loose sediment surrounding these carbonates has resulted in local topographic inversion (*e.g.* sites N1 and N45 as described below). Other potential lakebeds as identified on satellite imagery were found to be active playa surfaces consisting of clay and silt and lacking any obvious stratification or deposits suitable for direct dating (based on the digging of test pits at some of these playa sites).

The majority of sites of palaeoenvironmental interest visited in the Northern Sector consist of hardened carbonate crusts associated with past surface water bodies or groundwater. The topography and high level of induration of some of these deposits suggests they may date from the (Late) Pleistocene, pre-dating the Holocene, which is the

Fig. 2.10. Distribution of environmental sites in the Northern Sector.

main focus of the Western Sahara Project. Nonetheless, Pleistocene deposits can yield important information about climatic and environmental change that is of considerable interest given the lack of palaeoenvironmental research in the region.

Nineteen sites were visited or 'sampled' in the Northern Sector, seventeen of these sites consisted of carbonate crusts. Samples of freshwater mollusc shells were taken at one site (N4), and a sample of humic material was obtained from a rock shelter at another site (N47). It is the latter two sites that have yielded the most useful information for the purposes of dating past environmental conditions. Summary data relating to sampled sites are provided in Table 2.1. The site numbers in Table 2.1 are non-contiguous as site numbers were assigned to other sites of potential environmental interest based on features evident in satellite imagery, which were either not visited for logistical reasons, or which were visited but were of little interpretive value.

Site N1, west of Mheres

Site N1 consists of carbonate deposits exposed in a large elongated basin, situated approximately 15km northwest of Mheres and originally identified on Google Earth imagery. The highly indurated carbonate deposits form a roughly oval-shaped feature extending approximately 1.50km in a northwest–southeast direction along its long axis, and up to about 0.80km across from southwest to northeast. Erosion of the surrounding loose sediment has resulted in inverted relief of the indurated carbonate, which is interpreted as indicating the presence of a lake during the Pleistocene. The deposits rise up to 8–10m above the surrounding surface, with the greatest elevation on the northern side, where the edge of the palaeolake is most well defined (Fig. 2.11).

A sequence of cemented granite gravels on the northern edge of the palaeolake indicates that the carbonates have been eroded by fluvial activity, which has transported the gravels from the adjacent elevated granite area to the east and north. Patches of geochemical accumulations are preserved in the landscape up to the edge of this elevated area. These preserved remnants are up to two metres in thickness and the upper surfaces are shiny in appearance due to abrasion and polishing by sand grains being transported by the wind.

Many Palaeolithic stone artefacts were identified at the north-eastern edge of the palaeolake, where they appear to have been transported by fluvial activity from the adjacent uplands. Artefacts identified included bifacial hand axes and scrapers.

Other carbonate deposits within 10km of site N1 in both easterly and southerly directions (including site N40 described below) are indicative of an extensive landscape of lakes and rivers in this area during the Pleistocene.

Table 2.1. Locations of sites of environmental interest visited in the Northern Sector.

Code	Coordinates	Description
N1-1	26°14'46.8"N; 11°10'9.1"W	Southern edge of extensive, highly indurated carbonate deposits in large elongated basis with inverted relief, NW of Mheres. Broken lithics on surface.
N1-2	26°14'44.2"N; 11°10'7.4"W	Indurated carbonate deposit incised by a small river, with accumulated cemented fluvial material. Near N1-1.
N1-3	26°15'12"N; 11°9'38.9"W	Northern edge of carbonate deposits described in N1-1. Highly indurated, crystalline limestone.
N1-4	26°15'12"N; 11°9'38.9"W	As N1-3 but different lithology-cemented fluvial material.
N4	26°30'18.9"N; 11°7'5.9"W	Mollusc shells (*Melanoidies tuberculata*) situated on surface near shoreline of palaeolake/playa surface, north of Mheres.
N11	26°19'27.2"N; 10°57'12.6"W	Carbonate deposits on E bank of Wadi Ghaddar. Sequence of carbonates that are 6–7m above the surrounding landscape.
N12	26°11'9.7"N; 11°12'10.6"W	Sequence of flat-topped white, indurated carbonates some 10 m above the surrounding landscape, in form of small peaked hill, west of Mheres.
N18	26°4'30.1"N; 10°3'7.7"W	Grey nodular carbonate with quartz clasts forming a flat surface, south of Elous Lajaram.
N24-1	26°34'26.5N; 9°39'34.6"W	Carbonate nodules scattered on sand, north of Bir Lahlou.
N24-2	26°34'58.6N; 9°39'32.2"W	Carbonate topped hill, north of Bir Lahlou.
N39	26°20'8.6"N; 10°54'54"W	Carbonate nodular cap, east of Wadi Ghaddar and site N11.
N40	26°14'30.2"N; 11°5'47.6"W	Carbonate nodular cap on apparent fossil river deposits, east of sites N1(1-4), north of Mheres, and east of Wadi Ratnia.
N41	26°23'27.3"N; 10°45'27.1"W	Scatter of carbonate nodules, north of Mheres.
N42	26°23'30.5"N; 10°45'21.5"W	Carbonate cemented gravels near northernmost extension of uplands at Rekeiz Lemgassem.
N43	26°23'40.9"N; 10°45'35.9"W	Cemented carbonate gravel/nodular mound, just north of N42.
N44	26°39'12.1"N; 9°34'58.6"W	Carbonate nodules from high carbonate cliffs at head of Wadi Lmmuil-lihien, north of Bir Lahlou.
N45	26°13'20.3"N; 9°33'18.9"W	Indurated boulders of carbonate micrite, south of Bir Lahlou.
N46	26°33'22.2"N; 9°10'44.9"W	Carbonate deposits south of main, extensive playa deposits at Sluguilla Lawaj.
N47	26°10'8.6"N; 111°13'22.6"W	Humic material in rockshelter at Irghraywa, west of Mheres.

The locations of the sites are shown in Fig. 2.10. Geographical coordinates refer to the locations of 'sample' sites. Numbers are non-sequential as only sampled sites are listed.

Fig. 2.11. a. View along southern edge of carbonate deposits near sub-site N1-1; b. detail of carbonate deposits at northern edge of N1 feature (N1-3/N1-4).

Site N4

Site N4 is a sebkha situated in the system of wadis that feed the Wadi Weyn Tergit (Fig. 2.12), identified using Landsat TM imagery. It is situated along a tributary that is located close to the apparent position of the Wadi Jeneig Ramla as represented on the MPISAC. In the first season of fieldwork of the Western Sahara Project, in September–October 2002,

Fig. 2.12. Site N4; a. View from escarpment on western edge of sebkha; b. from the surface of the sebkha.

Bulinus truncatus shells were collected at this location. These were subject to accelerator mass spectrometry (AMS) dating and yielded an age of 4020 ± 40 uncal. BP, or 4495 ± 47 cal. BP (Brooks *et al.* 2003).[2]

Site N11

Site N11 is an undulating carbonate surface on the east bank of Wadi Ghaddar Talhu, identified in the field while in transit between Tifariti and Mheres (Fig. 2.13). It is located just north of two hearths recorded as archaeological features GT3-1 and GT3-2, and some 5km north-northeast of two monuments on the west bank of Wadi Ghaddar Talhu recorded as GT4-1 and GT4-2.

Site N12

Site N12 is a mound composed of carbonate, identified in the field while in transit from Mheres to Bou Dheir (Fig. 2.14). The deposit is preserved as inverted relief about 6–7m above the surrounding flat surface.

Fig. 2.13. Carbonate surface at site N11.

Fig. 2.14. Carbonate mound at site N12.

Fig. 2.15. a. Raised carbonate surface at site N24-2; b. detail of carbonate surface at site N24-1.

Site N18

Site N18 is located some 17km south of Elous Lajaram, and 8km north of the east–west oriented border with Mauritania, and was identified on satellite imagery during the 2009 field season.

Site N24

Site N24 is located in the watershed formed by the southward extension of the Cretaceous deposits of the Tindouf Basin, near the origin of the Wadi Um Hamra. This location was identified from Google Earth satellite imagery as of potential interest because of the many channels present and the possibility of exposed carbonate deposits.

- Sub-site N24-1. At this location, grey, gravelly carbonate deposits occur above and immediately north of a wide (approx. 500m) sandy, well-vegetated wadi bed (Fig. 2.15). Some worked stone was identified at this site.
- Sub-site N24-2: This site consists of a small sub-circular hill composed of carbonate, some 50m across and immediately north of a second wadi, which converges with the wadi adjacent to N24-1 approx. 1km downstream.

Site N39

Site N39 is an area of carbonate rubble situated some 4km east of site N11, around a metre thick (Fig. 2.16).

Site N40, west of Mheres

Site N40 is situated towards the western end of a series of cemented fluvial gravels raised 10–12m above the surrounding surface, approximately 1km northeast of the Wadi Ratnia, which were identified in the field from site N1 (Fig. 2.17). These raised gravels are interpreted as the remains of a Pleistocene palaeochannel. Holocene worked stone artefacts were identified on top of these deposits.

Site N41

Site 41 consists of a scatter of carbonate nodules, and was identified while in the field. The nodules are situated on the

Fig. 2.16. a. General view of carbonate surface at site N39; b. detail of sample site at N39.

west bank of one of the many wadis that ultimately drain into the Wadi Weyn Tergit.

Fig. 2.17. a. Raised cemented fluvial gravels from assumed Pleistocene river channel constituting site N40, looking east from site N1; b. view along palaeochannel deposits to southeast from north western extremity of deposits.

Sites N42 and N43

Sites N42 and N43 are situated immediately west of the northernmost extension of the narrow plateau of Rekeiz Lemgassem, just to the south of a small watershed. They consist of carbonate cemented gravels, with N43 located just north of N42, where mounds of carbonate nodules form a gentle hill formed by inversion of the local relief due to the deflation of the surrounding, softer sediments.

Site N44

Site N44 was identified in the field en route to a location (allocated site code N28, but which ultimately was not visited due to difficulty of access and time constraints). It was judged to be of potential interest for the reasons outlined for Site N24, being located at the source of one of the major wadis (most likely identified as the Wadi Lemmuil Lihien from the MPISAC) that drains into the Dait el-Aam basin.

Site N44 is situated on the northeastern edge of the upland area formed by the southward extension of the Cretaceous deposits of the Tindouf Basin, where a number of channels debouch onto a lower elevation area to join the upper reaches of the wadi, tentatively identified as the Wadi Lemmuil Lihien. It consists of a spur of raised carbonate extending northeast from the upland area onto the lower elevation plan. The carbonate forms cliffs, now largely covered in blown sand, rising tens of metres above the plain, representing the thickest carbonate deposits identified to date in the Free Zone (Fig. 2.18).

Site N45

Thick palaeolake deposits resembling those at site N1 are also present at site N16, located south of Bir Lahlou. Site N45 is a small (approx. 200m diameter) raised area of carbonate, located at the southeastern extremity of a much

Fig. 2.18. Carbonate cliffs at site N44.

Fig. 2.19. Raised carbonate deposits at site N45.

Fig 2.20. a. Humic deposits in rock shelter at Irghraywa; b. view across plain to north from elevated area in which this rock shelter is located (right).

larger expanse of carbonate indicative of a palaeolake some 6km long from north to south and some 2km wide from east to west (Fig. 2.19).

Site N46

Site N46 is a carbonate mudstone mound in which calcified roots are preserved, situated on an elevated sandy area to the south of, and overlooking, the large playa surface at Sluguilla Lawaj. Numerous braided channels drain into the playa depression from the south.

Site N47

Site N47 is a small rock shelter at Irghraywa, in the region of Wadi Kenta (Soler i Subils 2005b; Soler i Subils *et al.* 2006a, 2006b) in the southwest of the Northern Sector, identified in the field in 2002. While this rock shelter has been subject to significant wind erosion, which has removed the majority of the fill, some fill remains (Fig. 2.20). The fill deposits were sampled in 2002 and found to contain humic material, which was subjected to AMS dating, yielding an uncalibrated radiocarbon date of 6210 ± 80 uncal. BP, or 7115 ± 105 cal. BP (Brooks *et al.* 2003).

Results from the Southern Sector

Environmental survey work was conducted alongside extensive archaeological survey in the Southern Sector in 2005 and 2007. As in the Northern Sector, a number of sites of potential palaeoenvironmental interest were identified using satellite imagery and as many of these sites as was practical were visited in the field (see Fig. 2.21). Table 2.2 provides a summary of the sites that were sampled.

Site S1

Site S1 is a well-defined palaeolake in a topographic depression, known locally as Muyalhet Awaadi. It is located near the northern edge of the area of semi-stabilised sand-dunes that extends across the far southeastern corner of Western Sahara, trending from northeast to southwest. Clearly visible on satellite imagery, this is the only unambiguous example of a palaeolake to be identified in the study areas. The lake sediments extend for some 2km

Fig. 2.21. Locations of environmental sites visited/sampled in the Southern Sector.

from southwest to northeast, and 1km from southeast to northwest, at their maximum extent.

Bulinus truncatus shells were found in some of the inter-dune depressions in the areas immediately adjacent to the palaeolake, indicating freshwater environments in the past. This species is found in freshwater environments in West Africa today.

Evidence of prehistoric human occupation was identified in the area around Muyalhet Awaadi, with dense concentrations of artefacts on partially cemented aeolian sediments elevated above the southern shore of the palaeolake. These are described in more detail in Chapter 4.

This site is extremely promising in terms of potential future palaeoenvironmental and archaeological work.

Site S5

Site S5 is situated approximately 28km east of the Zoug hills, near the northern edge of the extensive area of sand

Table 2.2. Locations of sites of environmental interest identified visited in the Southern Sector.

Code	Coordinates	Description
S1	21°56'37.7"N 13°09'15.8"W	Surface exposures and sediment pit. Geochemical crusts, aeolianite and fossils
S5	21°42'18.7"N 13°51'07.6"W	Surface exposures. Geochemical crusts
S6	21°44'02.2"N 13°50'58.1"W	Surface exposures. Geochemical crusts
S16	22°48'21.4"N 13°34'18.6"W	Surface exposures. Sediments
S18	23°04'20.0"N 13°39'55.8"W	Surface exposures. Geochemical crusts
S22	23°42'17.7"N 12°59'18.1"W	Surface exposures. Geochemical crusts
S23	23°30'59.1"N 12°59'56.9"W	Surface exposures. Geochemical crusts
S24	23°35'19.1"N 12°54'24.4"W	Surface exposures. Geochemical crusts
S26	22°25'37.7"N 13°53'45.8"W	Cave site. Sediments, fossils and geochemical (tufa) crusts

The locations of the sites are shown in Fig. 2.21. Geographical coordinates refer to the locations of sample sites.

dunes that crosses the southeastern most parts of Western Sahara. It consists of a sandy surface within which are embedded carbonate nodules, root casts and ostrich eggshell fragments (Fig. 2.22).

Site S6

Site S6 is located some 3km north of site S5, in a shallow depression on a rocky surface covered with sand and fragmented geochemical crust. The sample site is characterised by flakes of carbonate and gypsum crystals on a sandy surface (Fig. 2.23).

Site S16

Site S16 is located at the southern edge of a depression extending some 7km from east to west, and some 3km from north to south, and containing geochemical deposits that are visible as bright areas in visible satellite imagery.

Site S18

Surface exposures of geochemical crusts were sampled at site S18, at the southern edge of a small depression some 2km across. The central regions of this depression contain light coloured carbonate deposits visible on satellite imagery and on the ground (Fig. 2.24).

Site S22

Site S22 is located at the northern edge of a small circular basin some 2km in diameter, in which are located carbonate deposits that are visible as bright areas on visible band satellite imagery. This is one of a series of basins containing geochemical crusts situated adjacent to small ranges of hills rising from sand and gravel plains, concentrated in an area of about 200sq. km.

Fig. 2.22. a. Area of root casts at site S5; b. ostrich eggshell fragment.

Fig. 2.24. View north from site S18 towards centre of depression and carbonate surface (light area).

Fig. 2.23. a. Fragmented carbonate crust; b. gypsum crystals at site S6.

Site S23

Site S23 is situated in the same general area as site S22, in a basin at the western end of a range of approximately northeast–southwest trending hills (Fig. 2.25). This site is characterised by carbonate rubble that forms slight mounds and small sand dunes that form around vegetation (*nebkhas*).

Site S24

Site S24 is situated north of S23, south of S22, and to the east of both these sites. It lies some 2km east of the nearest of the several small basins that sit adjacent to the hills in this area, and which are filled with sediments and geochemical crusts. Site 24 comprises a 2–2.5-metre-thick section of white to cream coloured, highly indurated geochemical deposit with no clear structure (Fig. 2.26).

Site S26

A large rock shelter containing paintings and engravings at Lajuad (east of the hills containing the locally well-known Cueva del Diablo or 'Devil's Cave') was identified during the March 2005 field season as of potential palaeoenvironmental interest. During the winter 2007 field season, the team identified and sampled a deposit of tufa, a geochemical sediment associated with the presence of water at some time in the past (Fig. 2.27). Thin section and scanning electron microscope (SEM) analyses carried out at the University of Leicester revealed that the deposit displays evidence of significant geochemical alteration from its original carbonate form. Mineralisation of the deposit by phosphate was revealed by SEM analysis, suggesting contact with urine and animal dung (Fig. 2.28).

A number of poorly preserved floral and faunal remains were apparent in the sampled sediment, alongside some small ceramic fragments and remnants of a grinding stone. The floral remains include *Citrullus colocynthis* seeds (Fig. 2.28), a *Zizyphus* fruit stone (an African savanna woody species) and spikelet fragments of Poaceae. Two of the Poaceae fragments have been identified as bristles of cf. *Pennisetum divisum* and cf. *Cenchrus ciliaris*, both of which are common desert grasses. Today these plants provide grazing for animals, and are also used as fodder. All the floral remains identified represent wild rather than cultivated species. *Citrullus colocynthis* is a wild species of the melon family, widely dispersed across the Sahara, North Africa and parts of the Near East. The seeds can be eaten by humans; the fruits and the seeds are also eaten by animals. The fruit is a powerful purgative.

Faunal remains include the burnt bone of a small mammal, the remains of a burnt tooth from a large mammal (a sheep, goat or cow) and a possible mineralised fish vertebra (Fig. 2.28).

Painted and engraved rock art was recorded inside the shelter as well as at a number of other shelters and open-

Fig. 2.25. Area northwest of Mijek containing sites S19–24.

Fig. 2.26. Site S24; a. General situation; b. detail of carbonate deposits.

air sites in the vicinity. Frequent superimpositions and differences in weathering and preservation suggest human presence over a considerable time span. Species represented in the rock art include addax, oryx, Barbary sheep and camels, which thrive in desert environments (Fig. 2.29). However, the rock art also includes depictions of giraffes (Fig. 2.30) and a probable representation of a Gerenuk gazelle, typical of dry savanna environments characterised by tall bushes and trees. In addition, numerous depictions of domestic cattle suggest that grazing was once more abundant in the area (Fig. 2.31).

Some *Citrullus colocynthis* seeds from this deposit have been radiocarbon dated to 5930–5740 cal. BP. These dates broadly coincide with what appears to be an abrupt shift to more arid conditions in the Sahara at large (deMenocal *et al.* 2000) and coincide with the transition from the central Saharan Middle to Late Pastoral phase (Cremaschi and di Lernia 1999; di Lernia 1999a).

Fig. 2.27. a. Tufa deposit S26 at Lajuad in context; b. detail of tufa.

Discussion

The study areas in the Northern and Southern Sectors reveal abundant evidence of past humid conditions. However, readily datable materials likely to yield information on the timings of past humid-arid transition remain elusive, due to a combination of ongoing sporadic fluvial activity and the relative lack of endorheic basins associated with past standing water bodies controlled by groundwater levels.

Nonetheless, some dates have been obtained from humic deposits and organic inclusions in tufa deposits sampled from rock shelters, and from mollusc shells associated with a sebkha. These dates are broadly consistent with our understanding of Holocene climatic and environmental change in the wider Saharan region, indicating humid conditions between about 7000 BP and 4500 BP, during the wider Holocene Saharan humid phase.

The earliest of these dates, from humic deposits in a rock shelter at the edge of the uplands in the southwest of the Northern Sector, represents the early Middle Holocene, when conditions were still humid, but after the

Fig. 2.28. Materials recovered from the altered tufa deposit at site S26 at Lajuad; a. SEM image of phosphate mineralisation of the deposit; b. mineralised fish vertebrae; c. Citrullus colocynthis seed.

Fig. 2.29. Rock art from the Lajuad area (shelter LD0-9) depicting kudu, which thrives in desert conditions.

Fig. 2.30. Engraving of giraffe from Lajuad, suggesting savannah environment.

Fig. 2.31. Cattle in the rock art from the environs of Lajuad (shelter LD0-9), suggesting much more humid conditions in the past compared with those of today.

onset of a multi-millennial trend towards generally direr conditions following the widespread arid episode that occurred *c*. 8200 BP (Brooks 2010; deMenocal 2000a and 2000b; Dykoski *et al.* 2005). However, while there may have been a shift to a more seasonal, semi-arid climatic regime after *c*. 8200 BP, the Sahara was considerably wetter than today for some millennia after 8200 BP the arid episode.

The date of *c*. 5800 BP, from the edge of a Tufa deposit in an elevated rock shelter at Lajuad in the Southern Sector, coincides with an acceleration of the trend towards aridity apparent in marine sediments representing the Sahara at large (deMenocal 2000a and b), and in regional records from the central Sahara (Cremaschi 2002; di Lernia 2002). The date of *c*. 4500 BP, from *Bulinus truncatus* shells recovered from a playa in the western part of the Northern Sector, coincides with the transition to aridity on the northern margins of the Sahara identified by Gasse (2000). Whether these coincidences are significant can only be established through a much more comprehensive programme of dating, and the development of regional chronologies of environmental change for Western Sahara. Nonetheless, it is reasonable to propose that organic materials deposited near the end of a humid period may have a greater chance of preservation than those deposited near the beginning

or middle of a wet phase. The latter are more likely to experience transport, decomposition or other disturbance which may prevent their preservation *in situ*. These dates therefore are suggestive of a climatic and environmental trajectory consistent with that of the wider Saharan region during the Middle Holocene.

Despite the need for further environmental dating, the evidence presented here represents an important first step in understanding prehistoric environmental contexts in the study areas. Site S26 at Lajuad also provides evidence for human activity in the Southern Sector during the Middle Holocene, in an environment consisting of a mix of savanna and arid zone wild plant species, at a time when the wider Saharan region was experiencing a shift towards aridity (Cremaschi 2002; di Lernia 2002; deMenocal *et al.* 2000).

A key question for future palaeoenvironmental work is the nature of Early Holocene conditions in the study areas. The literature reviewed here suggests a wet Early Holocene in the northwestern Sahara (Kulhmann *et al.* 2003), which is consistent with evidence of intensive use of the landscape around Tifariti up until around 8000 BP (Chapter 4 and Brooks *et al.* 2009).

A promising site of the latter type is site LG1 to the north of Lajuad, identified during rapid reconnaissance in 2007. This site consists of a large rock shelter at ground level, containing a layer of recent animal dung over sediments of unknown depth.

While the dates acquired for the study areas are consistent with regional trends, the environmental evolution of Western Sahara is likely to have been complex and spatially heterogeneous, due to its extension into the monsoon zone coupled with its proximity to the Atlantic and the Atlas mountains, resulting in this region being subject to influences from a variety of different climatic regimes and hydrogeological systems. Further palaeoenvironmental work will not only provide a context within which archaeological data may be interpreted, but will enhance our understanding of processes of environmental change in this climatically sensitive and neglected region.

Notes

1 Tarfaya, Ougarta, Saouar, Touat and the Erg Chech.
2 Based on the CalPal2007_HULU calibration curve, converted using the CalPal facility at http://www.calpal-online.de.

Chapter 3

Typology of Stone Features

Nick Brooks, Salvatore Garfi and Yves Gauthier

Introduction

As in many Saharan regions, built stone cairns and other stone structures associated with prehistoric human occupation are a ubiquitous feature of the landscape in Western Sahara. However, little has been written about these aspects of Western Sahara's archaeological record, with the majority of the published literature on the territory's archaeology focusing on rock art and other aspects of prehistoric material culture, namely chipped stone and (to a much lesser extent) ceramics (*e.g.* Almagro Basch 1945–1946; Almagro Basch 1946; Soler Masferrer *et al.* 1999; Soler i Subils *et al.* 2001a, 2006). For example, Almagro Basch (1946) devotes just 18 out of 280 pages to stone monuments, compared with 69 pages on rock art, and 193 pages on (mostly) chipped stone and ceramics. Rodrigue (2011) includes a brief discussion of stone monuments in a wider survey of the prehistoric record of the Saguia al-Hamra region, based largely on the identification of these features from satellite imagery. Vernet (2014) includes a short general discussion of funerary monuments in a survey of archaeological work covering a large region straddling the borders of Algeria, Mali, Mauritania, Morocco and Western Sahara, extending into the Northern Sector of the Free Zone of Western Sahara. Milburn discusses some stone monuments recorded in Western Sahara (Milburn 1974a), alongside others recorded in Mauritania and the far south of Morocco (Milburn 1974b).

Where built stone structures have been described in any detail, this tends to have been in a somewhat non-systematic fashion, based on descriptive treatments of individual funerary monuments or sets of monuments, rather than the systematic study and analysis of these features as elements of a cultural landscape. An exception is Sáenz de Buruaga (2008, 2014), who takes a synthetic approach to the archaeological record of the Southern Sector of the Free Zone, identifying a variety of types of stone structure and presenting an inventory of archaeological features for selected areas, focusing on the regions around Zoug, Aguanit and Mijek.

More fundamentally, virtually no research has been undertaken on the relationship of Western Sahara's prehistoric stone structures to those of other Saharan regions. Gauthier (2009) and Gauthier and Gauthier (2007, 2008a) have examined distributions of different types of funerary monuments throughout the central and western Sahara, the areas broadly coincident with the Lybico-Berber tradition, using a combination of literature review, field data and Google Earth satellite imagery, the latter of which can be used to identify some of the larger monumentals in areas covered by high-resolution bands. These studies do not specifically address Western Sahara, but involve analysis of data covering a very large area that includes the territory of Western Sahara, and assessments of differences in monument frequencies and styles between the central and western Saharan regions at large.

In response to the dearth of systematic research on the prehistoric stone structures of Western Sahara, and to a request from the Ministry of Culture of the SADR to focus on burial monuments, the Western Sahara Project has focused principally on recording and understanding the nature, variation and diversity of the vast array of prehistoric monuments and other stone features that abound in the wider Study Area incorporating both the Northern and Southern Sectors of the Free Zone.

Features, structures and monuments

Many of the larger prehistoric stone structures present in Western Sahara can be identified as burial monuments

with a high level of confidence, based on excavations of similar structures in other parts of the Sahara (Camps 1986; di Lernia and Manzi 2002; di Lernia and Tafuri 2013; di Lernia *et al.* 2013; Gauthier 2009; Lihoreau 1993; Mattingly *et al.* 2003, 2010, 2013; Mori *et al.* 2013; Paris 1996; Paris and Saliège 2010; Roset 1974; Saliège *et al.* 1995; Souville 1959; Tafuri *et al.* 2006). The excavation of two tumuli near Tifariti revealed that these structures contained human burials (Chapter 6). It is therefore appropriate to describe many of the built stone structures present in the Western Sahara Project's study areas as burial or funerary monuments, and to conclude that these have been built to mark the burials of valued individuals and to associate particular landscapes with specific cultural and ancestral groups (di Lernia 2006, 2013a).

Nonetheless, we cannot assume that all the stone structures recorded in the study areas are burials, or that they are associated with funerary practices. Some structures may have served astronomical purposes (Gauthier and Gauthier 2003a; Wendorf *et al.* 1993), in a manner analogous to some of the megalithic monuments of Europe. These might include individual standing stones or groups of standing stones, as well as other structures with specific alignments. Of course, the division between funerary and astronomical functions might be blurred or non-existent, and such a distinction might be meaningless. For example, astronomical functions might have been integrated into burial monuments. Structures that are not burials and that served an astronomical purpose may have associations with other features in the landscape that are associated with funerary practices (Chapter 5).

The nature of some stone features may be much more prosaic. Certain structures may be the remains of shelters or food stores. Stone alignments may represent way markers, or the remains of camps, for example where they have been used to anchor tents. Some features may be the by-products of other, unknown activities; indeed, the origins and functions of many of the stone features recorded in the Free Zone remain unclear, as discussed in Chapters 4 and 5.

In summary, not all of the stone features encountered in the study areas can be said to be monuments, and some features may not have been constructed deliberately. For this reason, the term 'monument' is inappropriate when talking about the generality of stone features in the Sahara, although it may be applied accurately to a large subset of these features. Throughout the rest of this volume, the term 'stone feature' is used when talking in general terms about the 'built' stone environment, with the term 'monument' being reserved for those features that we are confident served a funerary, ritual or territorial purpose. The general term 'feature' is used more widely to describe any aspect of the archaeological record, including concentrations of chipped stone (tools, cores, flakes and debitage) and/or ceramic remains, and concentrations of rock art, as well as the above stone features.

Typologies of stone features

There is a significant body of literature relating to pre-Islamic stone features and (particularly) monuments in the Sahara, as illustrated in the numerous works of Milburn (1978, 2005), Gauthier and Gauthier (1998, 2000, 2002, 2003a, 2003b, 2004, 2007, 2008a, 2008b, 2011), di Lernia *et al.* (2002a, 2002c), Mattingly *et al.* (2003, 2007), di Lernia (2006), Gauthier (2009) and others. Some of these authors present typologies of stone features, most of which can be confidently described as monuments.

Milburn (1993) has published a comparative chart of types of stone feature in four languages, while Paris (1996, 341–344) has compiled a listing of the different classifications applied to these features by four of his archaeological predecessors. Paris (1996) also presents his own list of 24 types of monument, which he classifies into two broad groups: simple and complex. Vernet (2014, 43) includes a figure illustrating five different types of monumental stone structure found in the wider western Saharan region, based on the classification of Monod (1948). Rodrigue (2011, 84) presents a figure illustrating 17 different types of stone feature, most (but not necessarily all) of which can be described as monuments. A typology of stone features/monuments, with textual, photographic and diagrammatic descriptions, is available on the website of the *Base d'Anthropologie Physique du Niger* (BANI 1994), which is supported by the French *Institute de Recherch pour le Développement* (www.ird.fr/bani/). This appears to be closely related to the typology of Paris (1996); while there are some differences in terminology, both typologies use the same three-letter codes to designate monument types. di Lernia (2013a) presents a typology of 'stone structures' mapped in the Wadi Tanezzuft in the Fezzan region of Libya, consisting of 11 types, some of which are associated with two or three variants. Gauthier (2015) also describes 11 different types of stone monument for the central and western Sahara, although this typology is quite different from that of di Lernia (2013a).

The above typologies have much in common with one another, and with the terminology used in the wider body of literature on Saharan stone monuments and related features, which they inform. However, they do not represent a single, universally applicable typology, nor provide a uniform nomenclature for the prehistoric stone features that occur throughout the Sahara. For example, Paris (1996) defines six different types of 'simple' tumulus, and four 'complex' types, whereas di Lernia (2013a) uses the single term 'tumulus' to describe three variants of a particular form. One of the six types of tumulus described by Paris (1996), the '*tumulus à couloir et enclos*' (Paris 1996, 176), is also referred to as a

'*monument en trou de serrure*' (Gauthier and Gauthier 2006; Milburn 1988) or 'keyhole' monument (di Lernia 2013a; Gauthier 2009). The term '*tumulus à couloir et enclos*' has been applied by Rodrigue (2011) to features commonly known as goulets (Gauthier and Gauthier 2003a; Milburn 1974b), which are distinct from the keyhole monuments that also fall under the '*tumulus à couloir et enclos*' type.

The same term may be used to describe features that are quite different in their construction, as in the descriptions of a diverse range of monuments as either antennae or 'V' monuments or tumuli (e.g. di Lernia 2013a; Gauthier and Gauthier 2003a; Gauthier *et al.* 1997; Mattingly with Edwards 2003; Milburn 1993; Reygasse 1950; Rodrigue 2011; Searight 2003). The grouping of a set of quite different monuments under these categories contrasts with the disaggregation of the 'tumulus' type into a multitude of distinct types by Paris (1996) described above. Typologies also evolve over time, as apparent from the inconsistencies between the BANI (1994) typology and the typology of Paris (1996), which otherwise use the same three-letter codes to identify monument types.

In addition, there are geographical variations in stone features that mean the nomenclature developed in one region cannot be simply transplanted to another region. This last point is particularly pertinent to the stone features of Western Sahara; while these have much in common with those of the central Sahara, there are also a number of notable differences. For example, there are monuments in Western Sahara that are absent from the above typologies, such as the 'ridge monuments' described below. Conversely, some of the monuments listed in the existing typologies have not been recorded in Western Sahara to date, for example crater tumuli and monuments '*à puit*' (*i.e.* with a hollow centre resembling a well) as described by Paris (1996). In addition, monuments occur in Western Sahara that are similar to forms listed in existing typologies, but deviate from the type descriptions presented in these typologies. For example, the BANI (1994) typology describes bazinas as having a circular plan, but examples have been recorded in Western Sahara with square or rectangular plans.

For the above reasons, we have developed our own regional typology of stone features for Western Sahara. Where we can apply existing terminology to the stone features recorded in the Free Zone, we have done so. However, this has not always been possible or appropriate given the distinctive nature of some of the forms of stone monuments and related features identified in Western Sahara, and the inconsistencies in the existing typologies. Nonetheless, where there are similarities between stone features described in this volume and those present in typologies from other Saharan regions these are highlighted. Table 3.1 lists the different types of stone feature we define for Western Sahara, along with summary descriptions of these types, other terms that have been used to describe them, and date ranges where these are available from other Saharan regions.

The existing typologies of Saharan stone features all consist of simple 'lists of monument types'. Such an approach is pragmatic, straightforward and logical, and it can provide a firm foundation for further analysis. However, during our surveys it became apparent that the stone features of Western Sahara can be categorised into different 'meta' forms on the basis of the ways in which their morphology relates to, and interacts with, the surrounding topography and environment. Each category comprises different attributes in terms of form and composition, and relationships between height, density and distribution across the landscape. These differences indicate to us that morphology and location are non-random key variables that interact dynamically with each other. The builders of the monumental stone features evidently made careful choices about the location, type, size and orientation of each monument, and the density and distribution of different types of monument. Given these parameters, there was a restricted range of meta-categories from which these monument builders could choose. Recognising this, we are able to go beyond simple typologies based on individual monument types by noting trends in construction, shape and disposition. These different properties of form and location may have had different roles or functions, specific ritual and funerary meanings, or general lifeway meanings.

Morphological groups

To attempt an appreciation of the various types of stone feature within the Free Zone of Western Sahara, we can identify three main morphological groups, with a fourth group made up of features that cannot easily be placed in the first three groups. These groups, and the various types of stone feature associated with each group, are described below. There are undoubtedly overlaps in some of the types of features placed within each group; indeed, the features in some of these groups appear to represent a continuum of construction styles rather than separate and distinct forms. Therefore, these groupings should be seen as being somewhat fluid.

All of the features described below have been recorded in the Free Zone, as discussed in Chapters 4 and 5. Feature types are illustrated in the sketch drawings, Figs 3.1, 3.2 and 3.3, which show the forms of most types of feature, with the exception of the simplest features (*e.g.* stone alignments, stone concentrations, *etc.*). 'Type photos' for specific features are presented in the colour plates, referenced in the text.

Cairns
Stone feature types within this group include:
Basic, simple or conical tumuli
Platform tumuli (tumulus on a pavement)

3. Typology of Stone Features 37

Table 3.1. List of the different types of stone features found in Western Sahara

Feature type	Other terminology	Description	Dates
Cairns			
Tumulus	Tumulus coniques simples (TSS) (BANI 1994; Paris 1996) Cairn (Mattingly 2003 & 2007)	Tumulus with shape closer to conical than hemispherical. BANI (1994) specify dimensions of 3–15m × 0.5–2.5m (BANI 1994) but some conical tumuli recorded in the Free Zone ('giant tumuli') are much larger than this (up to ~5m in height).	~4700 BC Niger (BANI 1994) 6500–6100 BP for cattle burials; 5600–1200 BP for human burials (Sivilli 2002, 23 fig 3.2)
	Tumulus a à plateforme (TTP) (BANI 1994) Tumulus tronconiques à plate-forme (TTP) (Paris 1996)	Tumulus truncated to create flat top. In Niger, 3–20m × 0.5–4m, with burial in a chamber in most cases (BANI 1994).	~2200 BC in Niger (BANI 1994) 3350–3200 BP Niger (Paris 1996, 270–1 tbl 42)
	Flat-topped tumulus (Milburn 1993) Tumulus à cratère (TAC) (BANI 1994) Tumulus tronconiques à cratère (TAC) (Paris 1996) Crater-topped tumulus (Milburn 1993) Ring cairn (Kennedy)	Truncated tumulus with hollow interior that is not due to collapse. In Niger, 3–20m × 0.5–4m with burial in a chamber (BANI 1994).	~2200 BC to ~800 AD Niger (BANI 1994) 4050–1160 BP in Niger (Paris 1996, 270–1 tbl 42) 1700–1300 BP* Red Sea hills & Nubia (Kennedy)
	Tumulus lenticulaire (TSL) (BANI 1994) Tumulus surbassés en lentille (TSL) (Paris 1996)	Spherical cap-shaped tumulus whose height is less than 25% its maximum diameter. In Niger 3–15m × 0.5–2m with pit burial (BANI 1994)	Undated but appears late (post-Neolithic) (BANI 1994)
	Tumulus en calotte de sphère (TCS) (BANI 1994; Paris 1996)	Spherical cap-shaped tumulus whose height is 25–70% its maximum diameter. In Niger 4–15m × 1–4m with burial chamber (BANI 1994)	From ~1700 BC Niger (BANI 1994)
Platform tumulus	Roundish bordered/unbordered platform with a central tumulus (Milburn 1993)	Tumulus constructed on a low-relief stone platform or paved area. Not described as distinct type in any other typologies examined, although di Lernia (2013) depicts rounded tumulus on platform under the general category of 'tumulus'	4095 BP South Libya (Milburn 1981, 211)
Stone platform	Platform (di Lernia 2013) Plate-forme cylindrique (PCG) (BANI 1994) Plate-forme cylindrique à gravillons (PCG) (Paris 1996) Disc/roundish paved platform (Milburn 1993)	Circular or rectangular stone pavement, constructed from a single and more-or-less flush with ground. Interior may contain stones similar to those forming perimeter, or smaller pebbles. BANI (1994) describes such structures of 2–8m diameter and 0.4–1m high, with interior filled with small pebbles, housing pit burials.	~4200–1500 BC Niger (BANI 1994)
	Plate-forme cylindrique empierrée (PCE) (BANI 1994; Paris 1996) Dallage circulaire (CER) (BANI 1994; Paris 1996)	As platform but interior constructed with same materials as perimeter. In Niger 2–8m × 0.4–1m with pit burial.	4200–1500 BC Niger (BANI 1994)
		Flat (i.e. single course) circular structure with stone perimeter, infilled with stones. In Niger 8–20m, housing pit burial (BANI 1994).	Undated in Niger (BANI 1994)
	Plate-forme cylindrique (PCG) (BANI 1994) Plate-forme cylindrique à gravillons (PCG) (Paris 1996)	Platform constructed using small pebbles (in interior – photo shows large stones forming perimeter), often quartz or gravel. 2–8m × 0.4–1m; pit burial (BANI 1994)	~4200–1500 BC in Niger (BANI 1994)

(Continued on next page)

Table 3.1. List of the different types of stone features found in Western Sahara (Continued)

Feature type	Other terminology	Description	Dates
Disc tumulus	Tumulus discoïde (PTS) (BANI 1994) Tumulus en plate-forme surbaissée (PTS) (Paris 1996) Roundish bordered platform/platform cairn (Milburn 1993)	Large platform with concave surface, built with same technique as tumulus. In Niger 8–25m × 0.6–0.8m housing pit burial, and grouped with platforms in BANI typology (BANI 1994).	Final Neolithic in Niger, does not persist into post–Neolithic (BANI 1994) 5020–2770 BP Niger (Paris 1996, 270–1 tbl 42); 5000–1200 BP Sahara (Sivilli 2002, 23 fig 3.2)
Bazina	Bazina Choucha/chouchet (Milburn 1993) *Similar to Drum cairns, drum tombs (di Lernia 2013; Mattingly 2003, 2007)*	Structure in the form of a low tower, with an outer, more-or-less vertical stone wall. In Niger bazinas are circular in plan with 'hollow' interior housing a burial chamber, from 2.5–15m × 0.4–1.5m (BANI 1994). di Lernia (2013) distinguishes between bazinas, with dry stone courses capped by a dome of smaller rocks (mostly likely covering a burial chamber), and 'drum-shape tombs' with dry stone walls in a single storey and large slabs forming a flat 'roof'.	~2200 to ~800 AD in Niger (BANI 1994) 4494–3550 BP Nubia; 4300–3180 BP Niger (Paris 1996, 270–1 tbl 42); 2500–1600 BP Fezzan (Mattingly 2007, 6, 11 tbl 0.1); 1700 bp Fezzan (di Lernia et al. 2002, 115); 1600–1300 BP Fezzan (Castelli et al. 2005, 91)
	Bazina à dome (BAD) (BANI 1994; Paris 1996) Bazina à puit (Paris 1996)	Described in BANI (1994) typology as Bazina with convex top surface, access to burial chamber not apparent. Bazina with a 'well' type hollow in centre, resulting from construction rather than collapse. As previous type but with wall instead of series of cairns or towers. In Niger wall is aligned north–south (BANI 1994) Monument with a well-defined 'false-entrance'.	In Niger undated but 'certainly post–Neolithic' (BANI 1994)
Chapel monument	Chapel monument (Milburn 1993)		In Niger ~2200 BC – 800 AD (BANI 1994) 2100–1500 BP* West Sahara (Camps 1986, 162)
Corbeille	Corbeille (di Lernia et al. 2013; Gauthier 2004)	Circular monument defined by upward facing flat stones angled outwards from centre of monument; may contain (larger) standing stones in centre or perimeter. Associated with animal burials in Fezzan region of Libya (di Lernia et al. 2013)	Mid–late 6th millennium BP, Libyan Fezzan (di Lernia et al. 2013)
Boulder burial		Burial inside hollow boulder sealed by rock wall.	
Tumulus with arms/wings		Tumulus with low relief extensions forming arms or 'wings' (distinct from crescents).	
Falcates			
V-type monument	*One of several types under following umbrella terms:* Antenna monument (Rodrique 2014)) V-shaped monument (Baistrocchi 1987) Monument en V, Reygass (1950) Antenna tombs or V-burials (Mattingly and Edwards 2003) Antenna tumulus (di Lernia 2013) Platform-cairn with 2 parallel-sided arms forming a type of V (Milburn 1993)	Small circular mound or platform from which emanate two linear features, often constructed from infilled parallel stone alignments.	5400–3000 BP Sahara (Sivilli 2002, 23 fig 3.2)

3. Typology of Stone Features

Crescent (regular)	Croissant/Crescent (Monod 1948) Tumulus en croissant (TEC) (Paris 1996; Rodrigue 2014)	In Niger, main axis always N–S, with arms most often towards the east (>90%), and rarely to the west. Major axis 6–35m × 1–2.5m height (BANI 1994).	~3500–2000 BC in Niger (BANI 1994)
Crescent with tails	Dune-shaped crescent (Milburn 1993) Dune-shaped crescent with tails (Milburn 1993)	Regular crescent whose arms are extended by linear stone arrangements. Tumulus from which extend paved arms of uniform width, similar to V-type but with elongated rather than round tumulus.	
Crescent antenna	As per V-type monument		
Paved crescent	As per V-type monument *Also:* Antenna monument (Searight 2003) Bulb & antenna (Gauthier and Gauthier 2003; Rodrique 2014) V monument (Gauthier *et al.* 1997; Milburn 1993) Arced platforms (Brooks *et al.* 2006) Crescent (di Lernia 2013)	Paved area from which extend paved extensions; tumulus near centre.	4095 BP South Libya (Milburn 1981, 211)
Mounded crescent	Pot-bellied crescent (Milburn 1993) Crescent tumulus (Paris 1996)	Tumulus with short extensions, shaped like a pastry croissant	4720–2280 BP Niger (Paris 1996, 270–1 tbl 42)
Axle monument	Propeller monument (Milburn 1981) Navette (Rodrigue 2014)	Elongated monument tapering to point at each end of its long axis.	
Cairns with (short) lines of orthostats	Tumulus entourés de pierres dressées (Monod 1948)	Usually rough, low cairn, with 3–5 flat slabs erected at a tangent to its perimeter.	
Ridge monuments		Monument whose principal apparent feature is a line of vertical flat stones, typically pointed to give tooth-like appearance.	
Composite monument		Structure in which multiple monument types are combined	
Complex monuments Monument with auxiliary towers	Tumulus à antennes courtes, plate-forme et renflement (Searight 2003) Monument à alignement (MAA) (Paris 1996) Tumulus à alignement (TAA) (BANI 1994) Bazina à alignement (BAA) (BANI 1994) Bazina à alignement de tours (BAT) (Paris 1996) Bazina à murette (BAM) (BANI 1994; Paris 1996)	Tumulus with long line of orthostats at 'front' and usually square enclosure or pavement at 'back'. Monument (tumulus or bazina) with small auxilliary towers, generally arranged in a line or arc. In Niger: Tumulus or bazina surrounded by circle of stones marked to W by small cairn, to E by erected stones or, with a north–south aligned line of small cairns or towers, or a continuous 'wall', a few m to the east of the first set; corbeille type burial chamber (BANI 1994).	~2200 BCE to ~800 AD Niger (BANI 1994) 3485–1055 BP for all monuments; 3335–1055 BP for bazinas; Niger (Paris 1996, 270–1 tbl 42)
Petroforms Goulet (Type 1)	Goulet (Monod 1948) Monuments en trou de serrure (Rodridgue 2014)	Tumulus on pavement from which corridor emerges before curving back to form enclosures; tumulus at edge of monument, at narrow end. Some resemblance to Keyhole monuments but some key systematic differences. Similar to Type 1 goulet, but with more circular shape and tumulus off-centre.	Undated (Milburn 2013)

(Continued on next page)

Table 3.1. List of the different types of stone features found in Western Sahara (Continued)

Feature type	Other terminology	Description	Dates
Stone ring	Cercle de pierre (Rodrigue 2014)	Simple circumference delimited by more-or-less contiguous blocks or pebbles, with empty interior space (Rodrigue 2014)	
Stone half ring	Horse-shoe/Fatima tend (Milburn 1993) U structure (di Lernia et al. 2002) Monument en demi cercle ou en quadrilatère ouvert (Rodrigue 2014) 'Monuments en fer à cheval', Abalessa, Hoggar, Reygass (1950, 50)	Semi-circular arrangement of stones, often several layers deep and flush with ground, or series of such arrangements.	1850–1700 BP Fezzan (di Lernia et al. 2002, 115) (from adjacent bazina and small stone features)
Stone alignment	Stone alignment (di Lernia 2013) Monument en L (Rodrigue 2014) U-structure (di Lernia 2013)	Features depicted by di Lernia (2013) – more than one row of stones, so like a pavement, includes feature very like those at Lajuad	
Standing stone site		Individual upright stone or group of such stones occurring in isolation or as dominant element of a stone feature (e.g. large standing stone with low crude tumulus). Does not include orthostats otherwise embedded in or associated with tumulus or other monument.	
Other types			
Stone emplacements	Small features (di Lernia et al. 2002)	Small pile of stones or cairn, too small to be described as a tumulus.	1850–1740 BP Fezzan (di Lernia et al. 2002, 115)
Kerb burial	Enceinte rectangulaire (REC) (Paris 1996) Islamic tomb (di Lernia 2013)	Monument outlined by kerb stones with or without interior stones and of low relief. Often Islamic in nature. Described by BANI (1994) as monument of rectangular plan totally enclosed by low wall. 3–5m × 0.7–1.2m, containing a pit burial; one excavated example was post-Islamic but position of body did not correspond to usual Islamic custom.	1200 AD Niger (one example) (BANI 1994)
Stone outline	Include (Rodrigue 2014): Quadrilatère fermé Monuments en L Monuments en demi cercle Monuments en quadrilateral ouvert 'Monuments en fer à cheval' Reygasse (1950)	Circular or other stone outline, with stones generally placed on ground or (less frequently) embedded in ground, and not necessarily close together.	
Stone concentrations/ spreads	Petit cercle de pierre (CPG) (BANI 1994; Paris 1996)	Concentration of stones in a circular area (BANI 1994)	

3. Typology of Stone Features 41

Fig. 3.1. Sketch drawings (plan) of different (elevation) types of cairns: a. simple tumulus (elevation); b. platform tumulus (elevation); c. platform or pavement without tumulus (plan); d. tumulus with arms or wings; e. bazina; f. stepped bazina (elevation); g. corbeille (elevation).

Platforms (a pavement without a tumulus)
Disc tumuli
Bazinas
Chapel monuments
Corbeilles
Boulder burials
Tumuli with arms/wings

Cairns, or cairn-like monuments, appear to be one of the most numerous funerary monument types across the Sahara (di Lernia *et al.* 2002a, 2013, 32; Mattingly *et al.* 2007) and they, or earthen burial mounds, can be found in many other parts of the world. They are usually round or sub-circular, and often superficially appear to be simply comprised of piled stones. However, the group includes monuments which can have coursed dry-stone masonry, such as bazinas. These are usually round, but they can be polygonal, square or rectangular, or stepped. There are pavement and platform-like structures in this group too.

Integrated into some cairns are niches, stone emplacements, and built stone elements that serve to extend and/or orient the cairn in a particular direction. Some of these correspond to what Mattingly *et al.* (2018) describe as offering spaces or tables. However, the nature of these features is often

Fig. 3.2. Sketch drawings (plans) of different falcates: a. mounded crescent; b. regular crescent; c. mounded crescent; d. paved crescent; e. crescent antennae; f. v-shape antennae monument with mound; g. axle monument.

ambiguous, particularly in the case of built stone extensions, which may be little more than low-relief protrusions from the base of a cairn. We refer to these features collectively as 'annexes', for example in Chapter 4 where we explore how such 'annexes' serve to define the orientations of monuments. However, where we can be confident in identifying a feature as a niche or stone emplacement, we do so explicitly.

Adjacent to some cairns, and in apparent association with them, are built stone features (*e.g.* smaller cairns, stone rings and alignments, standing stones) that may also serve as annexes, for example defining an orientation for a larger monument or monument group. These associated features are critical to our understanding of monument orientations, which are very often easterly or southeasterly.

3. Typology of Stone Features 43

Fig. 3.3. Sketch drawings of different types of falcates and petroforms: a. mounded crescent (plan); b. cairn with orthostats (elevation); c. ridge monument (elevation); d. complex monument (plan); e. complex monument (plan); f. goulet Type 1 (plan); g. goulet Type 2 (plan).

What is striking about cairn-type monuments and relates to the discussion above about how monument morphology is linked to placement in the landscape and probably to purpose and meaning, is that they give the obvious appearance of being self-contained. This is a subjective observation, but cairns are not expansive in the way falcates are, as will be described below. Regardless of annexes and associated features such as standing stones, they are relatively unitary in their build and self-enclosed, making them more of a punctuation on the landscape. Their

simple shape can allow them to be beacons on a hilltop, or easily facilitate a density of distribution that many other monuments do not attain.

Falcate monuments ('Falcates')

Stone features within this group include:
V-type antennae with mound
Crescents (regular)
Crescents with tails
Crescent antennae
Paved crescents
Mounded crescents
Axle monuments
Composite monuments
Cairns with (short) lines of orthostats
Ridge monuments
Complex monuments
Monuments with auxiliary towers

The term 'falcate' is used here as an overall term for monuments that are either crescent or 'V' shaped. What links the monuments in this group together is a morphology that is made up of elements, or a single structural (or super structural) element that is essentially arcing or embowing in nature (and in most instances facing easterly or southeasterly).

Monuments in this group, especially the larger ones, can be described as 'embracing' the landscape. Their aspect is an outward one in contrast to cairns. Larger falcate features also need space, and therefore tend to be found in lower densities than other features in any given area. Nonetheless, there are significant geographic variations in the densities of different types of falcates, and clustering of these features does occur, as discussed further in Chapter 4. We may talk about locations with high densities of falcates, which cover larger areas than analogous concentrations of cairns; the density of variations of falcates, and of crescents in particular, might be seen as manifest on a different (larger) scale from analogous variations in the density of other features such as tumuli.

All of the falcates listed above can be reasonably described as monuments. Two monument types that are included in this group, but are also probable crossovers between cairns and falcates, are mounded crescents and complex monuments. Also, some falcates include cairns or platform cairns as structural components.

Petroforms

Stone features within this group include:
Goulets
Stone rings
Stone half rings
Stone alignments
Standing stone sites

This term is not often heard in British archaeology, and in its broadest sense it can be used for all types of stone monuments from pavements to cairns, and to standing stones. But its more restricted and relevant definition is that petroforms are outlined figures or shapes formed by the placement of stones to create features on the ground. Some falcate monuments, such as paved crescents and V-shaped antenna monuments, could be classed as petroforms, but this category is best reserved for structures like goulets with their ancillary features, and keyhole monuments (Savary 1966) (though keyhole monuments have not as yet been documented in Western Sahara).

If archaeological landscape features can be described as inscriptions on the land, then petroforms are exemplars of this. They can vary from low lying, simple stone rings only a few metres in diameter to extensive stone arrangements such as goulets which can be hundreds of metres in length. They might include burials – they are obviously embedded within a funerary landscape in the main TF1 Study Area (Chapter 5) – or they may have been built solely for ritual purposes, of either a funerary or non-funerary nature.

Other types of stone feature

There are other types of stone features found in Western Sahara that do not fit easily into the morphological groups described above. And though they are consigned to a group called 'other' this does not mean that they are inconsequential in the study of funerary landscapes in the Sahara. They can include:

Stone emplacements
Kerb burials
Stone outlines
Hearths
Walled Shelters
Stone concentrations/spreads

Of the above types of stone features, kerb burials may be described accurately as monuments, and some stone concentrations, emplacements and outlines might also be 'monumental' in nature. However, these types are also likely to include features deriving from more practical uses, including way markers, and remnants of camps and occupation sites. Stone features that are not obviously hearths or shelters may nonetheless be the remains of fireplaces or crude wind-shelters. The former may appear as stone emplacements or concentrations, and the latter as stone alignments or outlines. Stone emplacements may be small cairns positioned to mark ancient routeways or locations of importance.

Descriptions of stone features by groups and types

Cairns

Tumuli

Stone tumuli, or cairns (Plate 2a), are the most numerous type of built stone feature in the Sahara and in the TF1

Study Area. They are the feature most commonly recorded in the course of the extensive survey work outside the TF1 Study Area. In their simplest form, they are a simple mound of stones ranging from around 1m to over 10m in diameter by up to around 1.75m in height. Their plans can be circular, elliptical or oval. Kerb stones are visible around the circumference of some tumuli, and false entrances, niches and paved extensions ('annexes') are evident in some tumuli.

Some tumuli are high and truly tend to the conical, while others are broad and shallow in height; at the lower size limit the boundaries between tumuli and stone discs or stone concentrations can be blurred when classification is based purely on non-invasive survey work (*i.e.* without clearing or excavation). Typologically situated between such shallow tumuli and prominently conical tumuli are tumuli of varying heights and forms, including tumuli with flat tops and tumuli with concave tops.

Flat topped tumuli are treated as a separate type, '*tumulus tronconique à plate-forme*', by Paris (1996), and simply as '*tumulus à plate-forme*' in the BANI typology. Gauthier and Gauthier (2011) refer to these features as '*tumuli tronconique*', and present photographs of a number of such monuments from Algeria and Niger that appear quite distinct from any stone monuments recorded in the Free Zone to date; while many tumuli recorded during the intensive and extensive survey work have flattened tops, they generally do not exhibit the very sharp changes in slope apparent in these examples.

Tumuli with concave tops are described using the term '*tumulus tronconique à cratère*' by Paris (1996), which is shortened to '*tumulus à cratère*' in the BANI (1994) typology and by Gauthier and Gauthier (2011). The concavity or 'crater' in these tumuli is an integral part of their construction and should be distinguished from plundered tumuli. A number of tumuli of concave appearance have been recorded in the Free Zone; in most if not all of these cases, the concavity appears to be the result of the tumuli being opened, most likely by people searching for grave goods as a result of a (mistaken) perception that these monuments contain items of contemporary economic value. To date, we cannot securely identify this form of tumulus in the Free Zone.

Paris (1996) also defines a '*tumulus en calotte de sphère*' (tumulus with a circular cap), described in the BANI (1994) typology as a rounded tumulus whose height is between 25% and 70% of its maximum diameter. He also defines a '*tumulus surbaissés en lentille*', abbreviated to '*tumulus lenticulaire*' in the BANI typology, which describes this monument as a form of the *tumulus en calotte de sphère* with a height less than 25% of its maximum diameter.

External features can be found associated with some tumuli. These may be small rings of stone or very small mounds. Standing stones (sometimes described as 'stelae' or 'menhirs') are also associated with some tumuli. Sometimes they can be found at or near the top of a tumulus, though more commonly they will be set in the ground nearby. It is not unusual for them to align with a niche or other type of 'annex', for example an extension of the tumulus perimeter in a particular direction, the incorporation of larger stones or stones of a different type at a specific point around the base/perimeter (Plate 2b), or another associated external feature.

The intensive and extensive survey work has used the single classification of 'tumulus' for all of the variants discussed above; here we do not distinguish between shallow, conical, truncated conical and crater tumuli. However, the survey records do record the dimensions and shapes of tumuli, and whether they are associated with, or incorporate, annexes or standing stones. Where this is the case, the 'orientation' of a tumulus is defined as the bearing or deviation from north of a line from the centre of the tumulus to an associated single standing stone, or through the centre of an associated annex or standing stone assemblage.

When determining the orientations of a tumulus or other monument, bearings as measured in the field using a magnetic compass are corrected to account for magnetic declination, which is approximately 4° in the Northern Sector and 5° in the Southern Sector. A higher degree of precision for this correction is not warranted, given the margin of error inherent in the measurement of orientations, estimated to be up to ± 5°, depending on the nature of the stone feature in question.

Platform tumuli (tumulus on a pavement)

Platform tumuli are cairns situated on top (in the centre or off-centre) of a circular or sub-circular pavement of stones usually no more than *c.* 0.20m high and in most cases outlined by a kerb (Plate 2c). In some cases, platforms have been formed by modifying the bedrock on which a tumulus is constructed, for example by extending or accentuating a natural platform through the use of boulders as kerb stones to 'complete' the platform or perimeter. In some cases, the 'platform' associated with such a tumulus is little more than a circular or sub-circular arrangement of kerb stones, within which is a poorly defined pavement or even no pavement. Platform tumuli have been recorded throughout the Free Zone of Western Sahara, but are absent from the main Saharan monument typologies.

Stone platforms (pavements without a tumulus)

Here we define stone platforms as pavements constructed by the placing of large flat stones on the ground, the embedding of more rounded or angular large stones in the ground to present a more-or-less flat surface at ground level, or the concentration of closely packed smaller stones in a well-defined area, with no more than a single course (Plate 2d). Platforms therefore are very low-relief, being either flush

with the ground or raised only slightly above ground level by a single course of stones. This is in contrast with some authors (*e.g.* Paris 1996), who has defined platforms as raised features. Here we opt for a terminology that is consistent across the low relief platforms of platform tumuli, and similar low-relief features that occur in the absence of an associated tumulus. Platforms can be round or rectilinear, and can occur in isolation or in association with other stone features.

Disc tumuli (raised stone discs)
Disc tumuli, or stone discs, are relatively flat circular features, up to *c.* 0.50m high by *c.* 7.50m in diameter, outlined by small boulders, or boulders piled to at least two courses. Both Milburn (1993) and Paris (1996) refer to this type of tumulus as a 'platform' cairn or monument. Paris goes further to subdivide his '*monuments en plate-forme*' into '*tumulus en plate-forme surbaissée*' (also presented as '*tumulus discoïde*' in his more specific excavation citations), '*plate-formes cylindriques à gravillons*' and '*plate-formes cylindriques empierrées*' (Paris 1996, 21). In the BANI (1994) typology, these forms are described as *tumulus discoïde*, *plate-forme cylindriques*, and *plate-forme empierrées* respectively. In our typology discs and platforms are differentiated by their height and the number of stone courses. Whereas a platform is at or just above ground level and consists of just one course or layer of stones, a disc is higher and constructed from multiple courses.

Tumuli with arms/wings
Some tumuli display features that may be described as 'arms' or 'wings'. With the exception of these arms, these tumuli have essentially the same form as other (*e.g.* shallow or conical) tumuli, and are very different in construction and appearance from crescents or mounded crescents. The arms or wings of these tumuli are neither sufficiently developed in extent (*i.e.* around the perimeter of the monument), to constitute platforms, nor as long as the large 'antennae' that characterise falcate monuments as described below (Plate 3a). However, they extend further from the main body of the monument than an integral 'annex' (see above), and a single such tumulus will generally have more than one arm/wing.

Bazinas
Bazinas are monuments whose perimeter is constructed of dry stone courses, producing a wall-like appearance (Plate 3b). They may be equated with monuments described as 'chouchet' (or 'choucha' in the singular) (Milburn 1974b; Monod 1948; Reygasse 1950). They bear some resemblance to features described as 'drum monuments' (Mattingly *et al.* 2018) or 'drum-shaped tombs' (di Lernia 2013a), although di Lernia distinguishes bazinas and drum-shaped tombs, with the former exhibiting a domed layer above the stone 'wall', and the latter having a flat upper surface capped using rocks of similar size and appearance to those of the outer wall.

Bazinas are usually circular (indeed this is one of their definitional criteria in the BANI (1994) typology, but they can also be rectangular and even polygonal. They may be mounded or flat on top and they apparently have a rubble infill. Bazinas can include annexes, also referred to as false entrances by di Lernia *et al.* (2002a, 30; 2002c, 103; 2002b, 315).

Some bazinas are stepped, and a number of very large examples were identified during the extensive survey (Plate 3c). While most bazinas recorded in the study areas to date are, like tumuli, less than 2m in height, these large stepped bazinas are up to 5m in height. These monuments, which appear to be of the same nature as monuments described as 'triple(-storey) chouchets' (Gauthier and Gauthier 2005; Milburn 1974b; Monod 1948), are described in more detail in Chapter 4.

Here (Chapters 4 and 5) we distinguish between mounded bazinas, stepped bazinas, and other types of bazina.

Chapel monuments/tumuli
Chapel tumuli can be cairn like, or built of dry stone courses as a bazina, either drum shaped or rectangular. They have an obvious 'false entrance' and it will be relatively well constructed. The entrance can extend out from the body of the monument or it can appear to be a niche. Internally, the niche or false entrance does not open up into the burial chamber, but is self-contained. It is a 'chapel' or 'sanctuary' with a varying size from 1m square to as much as *c.* 5m by *c.* 2.50m in area. Columns are sometimes required in such large areas. These 'chapels' can have a variety of shapes from square to elliptical and to cruciform, even with multiple galleries (Camps 1986).

Milburn (1974a), and Milburn and Köbel-Wettlaufer (1975), have definitely recorded funerary monuments that can be described as chapel tumuli in other parts of Western Sahara and in Morocco. Mercer (1976, 67) also notes probable chapel tumuli in Western Sahara, while Camps (1986) has reviewed what was known about this type of monument, at the time of his writing, and compiled a typology and distribution map. Three structures in the TF1 Study Area may tentatively be identified as chapel monuments, including a large rectangular bazina with an annex (WS043), a round bazina with a very poorly preserved false entrance (WS063) and a tumulus (WS206). A more unequivocal chapel monument (TF4-5) has been identified northwest of the TF1 Study Area in the extensively surveyed area of TF4, and this is described in Chapter 4.

Corbeilles
The defining feature of a corbeille is a circular or sub-circular perimeter constructed from flat stones or slabs embedded in the ground and usually angled outwards.

These structures have been studied in detail in the Fezzan region of Libya, where they are often associated with one or more interior or central standing stones and/or exterior stone rings or annexes (di Lernia *et al.* 2013; Gauthier and Gauthier 2004). Their perimeter may comprise a single or double ring of stones/slabs, or be constructed from several layers stacked obliquely, giving what Gauthier and Gauthier (2004, 45) describes as a 'mille-feuille' appearance. Their interior may be bare, or filled with stone blocks or slabs laid apparently randomly, stacked at an angle, or forming a pavement, and they frequently occur as components of more complex structures (Gauthier 2004). Gauthier and Gauthier 2004 distinguish between corbeilles, as described above and measuring 1–5m in diameter, and larger structures consisting of elongated blocks or upright slabs up to 1m in height placed vertically or slightly obliquely in a circular or sub-circular pattern, inside which is a fill of blocks, pebbles or plates forming a platform several tens of centimetres above the surrounding surface.

Di Lernia *et al.* (2013) have excavated 26 corbeilles on the Messak Settafet (Libyan Fezzan) and published radiocarbon dates from 17 of these features, demonstrating that (along with tumuli, stone platforms and stone rings) they were associated with the ritual slaughter of large animals, predominantly cattle, and the interment of their remains, during the middle to late 6th millennium BP. Some of these monuments, including corbeilles, incorporate or are associated with standing stones on which cattle have been engraved (di Lernia 2006; di Lernia and Gallinaro 2010; di Lernia *et al.* 2013). The earliest date for a corbeille from the Messak Settafet is 5660 ± 30 BP (di Lernia *et al.* 2013).

Corbeille-like structures have been recorded in Western Sahara, and the term has been adopted here for these features, which are rings of upright stones measuring *c*. 1.50m to *c*. 6m in diameter (Plate 3d). The interior of the ring is usually more or less at the same level as the ground outside, and in the TF1 Study Area there is one instance where the feature is a double ring (WS092). The stones making up this monument type are often slab like and angled outwards but in most instances in the TF1 Study Area, they are thick set, or more like small boulders. In contrast to the corbeilles of the Libyan Fezzan, the examples from Western Sahara tend to occur in isolation and generally are not associated with standing stones or annexes, although they often have a pair of stones that are larger, more upright, and/or of a different composition, and mark a particular point around their circumference and define an orientation.

Boulder burials

The term 'boulder burial' is used to refer to a burial inside a hollow boulder, which is then sealed by a stone wall or cairn. Such a burial might be viewed as a kind of tumulus, and whether such a practice constitutes a particular style of monument, or simply the opportunistic use of a natural feature, is a matter of interpretation. Only one such feature has been recorded to date in the Free Zone, at Garat el-Masiad (MS1-3).

Falcate monuments ('Falcates')

General description

Broadly speaking, falcates can be split into (i) antenna-type monuments with a crescent or 'V' shape, (ii) mounded crescents that have a crescent shape but lack the long extensions of antenna-type monuments (Plate 4a), and (iii) features that might be referred to as monuments characterised by lines of orthostats or standing stones, usually associated with a cairn or tumulus.

Within category (i) we may distinguish between crescents and V-type monuments. The former are characterised by curved extensions or arms, and include 'regular' crescents and crescents with tails (Plate 4b, c). The latter exhibit more linear extensions or arms, and include paved crescents, crescent antenna monuments, and other V-shaped features (Plate 4c, d; Plate 5a, b). A key defining characteristic of V-type features is that their extensions are very low-relief, comprising elongated pavements, often bounded by kerb stones. In contrast, crescents are characterised by extensions whose width and height reduce as the distance from the central cairn increases. Axle-shaped monuments (Plate 5d) may be viewed as representing a particular type of crescent with a very shallow curvature; curvature aside, their construction is much closer to that of crescents than to V-type monuments.

Monuments with orthostats include complex monuments and ridge monuments, and other monuments that include rows of flat upright stones but which do not exhibit the other identifying characteristics of either complex or ridge monuments (Plate 6a–c). In most of these monuments, the line of orthostats runs along one side of a cairn or tumulus.

Defining orientations of falcates

The orientations of falcates are defined as the direction towards which they 'open' (Fig. 3.2). Depending on the type of monument, this can be the direction of a line (i) perpendicular to the long axis of the central tumulus (where this is elongated), (ii) from the centre of the monument (*i.e.* the central cairn) through a point mid-way between the ends of the arms, or (iii) bisecting the angle between the arms (where arms are linear and make an angle of less than 180° with each other, as with many V-type monuments). Crescent-type monuments, and particularly regular crescents, may lend themselves to techniques (i) and (ii) above, and generally these will yield orientations that are very similar, and essentially coincident within the margin of error. However, for monuments whose arms are highly asymmetrical, technique (ii) may yield a significantly different orientation to technique (i).

The orientation of an axle-shaped monument is defined as the angle perpendicular to its long axis in an easterly direction. The definition to the east is somewhat arbitrary, although this reflects a general (but not universal) orientation preference in monument construction, and some axle-shaped monuments exhibit a slight concavity to the east.

The orientation of a monument with a line of orthostats, including complex monuments and ridge monuments, is defined as the direction perpendicular to the line orthostats, on the eastern side of the monument. Where the orthostats are associated with a cairn or tumulus beyond which they extend in a non-linear fashion, the direction is defined adjacent to the cairn and away from it.

'Regular' crescents

'Regular' crescents consist of a central elongated mound that is extended by curved arms that gradually reduce in height and taper to a point (Plate 4a). These crescents are quite elegant in form and can range in size from *c.* 15m up to *c.* 280m wide. Their central and broadest part can be *c.* 4m to 6m wide by *c.* 0.50m to 1.50m high. di Lernia *et al.* (2002a, 30) equate dune-shaped crescents with Milburn's (1993) 'pot-bellied' crescents, and these monuments appear to be more or less the same as Paris's (1996) crescent tumuli recorded in Niger. Crescents typically are oriented approximately east, although a minority face west.

Mercer (1976, 67) noted two such crescent monuments in the very southwest of Western Sahara, while Milburn and Köbel-Wettlauffer (1975) recorded a number in Mauritania and one in Morocco. Vernet (2007a) has also recorded similar crescent monuments in Mauritania, south of Western Sahara.

Crescents with tails

Crescents with tails are essentially 'regular' crescents in which the arms are extended by single lines of stones (Plate 4b), in contrast to the mounded arms that form the bulk of the extensions, or the paved extensions of crescent antennae. Such stone lines may extend from the tip of one or more long mounded arms for tens of metres creating crescents with tails (Milburn and Köbel-Wettlauffer 1973). However, they may also extend from the ends of monuments that are essentially truncated regular crescents, in which the 'tails' take the place of the long mounded arms.

Paved crescents

These monuments have been referred to as 'arced platforms' (Brooks *et al.* 2006), and *monuments à antennas* or antenna monuments (Searight 2003). In the Sahara at large they generally have been described as 'V' monuments (Gauthier *et al.* 1997) or 'V shapes' (Milburn 1993). However, the 'V' label has been applied to a variety of different types of feature. For example, Reygasse (1950) describes a number crescent/antenna monuments as '*monuments en V*', including at least three different forms identified in the Free Zone.

The central Saharan Vs that most closely resemble the paved crescents of Western Sahara are usually described as consisting of a platform cairn or monument with outlined arms, extending approximately to the northeast and southeast (di Lernia *et al.* 2002a, 30 and Milburn 1993), although sometimes the central platform monument can be lozenge shaped (Mattingly 2003, 201). In Algeria, they can be bulbous in their larger central section, with paved extensions pointing to the approximate northeast and southeast which can be antenna like in nature (Gauthier and Gauthier 2003a, 160, fig. 10).

The paved crescents of Western Sahara are large structures that are boomerang-like in plan with sweeping outlines that are usually delineated by kerb stones (Plate 4c). The area inside the kerbing is infilled with a pavement of smaller stones placed in variable density on the ground, generally in a single layer. There is usually a tumulus on the pavement, in the broadest part, and there may be a tumulus immediately adjacent, off the pavement area. Whereas the arms of a crescent antenna (see below) are well defined and distinct from the central tumulus, those of a paved crescent are continuations of the pavement on which the tumulus is (usually) constructed.

In relation to the V-shaped monuments of the central Sahara, paved crescents might be described as V-shaped monuments consisting of a pavement (usually) outlined with kerb stones, with or without a tumulus on the widest part of the pavement.

Crescent antennae

Crescent antenna monuments consist of a long (elliptical or oval shaped) tumulus some 6–14m wide, on a more or less north–south alignment, with arms (antennae) that may be arced but are often straight extending out from the ends of the tumulus, usually to the northeast and southeast (Plates 4d). These arms are on average *c.* 2m wide, pavement like, and outlined with kerb stones. The full extent of the arms from end to end can be *c.* 60m to *c.* 190m, and they may have different lengths. In the TF1 Study Area (Chapter 5) a number of these monuments exhibit a longer northern arm which rises up onto higher ground.

The distinction between crescent antennae and paved crescents is not always clear, with some crescent/antenna monuments exhibiting a platform-like central area on which a tumulus has been constructed like a paved crescent, or a wide flat tumulus that grades into a pavement, from which emanate arms of uniform width like a crescent antenna (Plate 5a). These generally have been classified as crescent antennae on the basis of the character of the arms and the fact that the entire monument is not defined by a perimeter of kerb stones in which is a paved area. However, they remain ambiguous and illustrate the provisional and contestable nature of some typological classifications. MH1-34 (Plate 5a) is an example of such a feature.

Crescent antennae might be described as V-type monuments with a central elongated tumulus instead of a pavement, with extensions/antennae of uniform width.

Other V-type monuments
While most of the V-type monuments identified in the Free Zone to date can be classified as paved crescents or crescent antennae as described above, not all V-type monuments conform to these types. Some monuments have linear paved arms like those of a crescent antenna, but do not exhibit the elongated, mounded cairn associated with crescent antennae. Instead, the arms may emerge from a circular cairn or other stone arrangement (for example a ring of orthostats). Alternatively, linear paved arms may emerge from a central platform, but lack the integrated form of a paved crescent in which the arms are continuations of the central platform. Such monuments occur in the central Sahara and have been described variously as V-shaped monuments or antenna monuments/tumuli (*e.g.* di Lernia 2013; Gauthier 2015).

Only one such V-type monument has been identified in the Free Zone that cannot be classified as a paved crescent or crescent antenna. This feature (IR3-3, Chapter 4) consists of arms (resembling those of a crescent antenna) that emanate from a central rounded cairn (Plate 5b).

Axle-shaped monuments
Axle-shaped monuments (also known as propeller-shaped monuments) have been described for other regions of the Sahara by Gauthier (2015), Mattingly *et al.* (2003), Milburn (1981), and di Lernia *et al.* (2002a). The main characteristics of these features are a central platform or tumulus from which two arms extend in opposite directions from each other, usually at something close to 180° (Plate 5c). Occasionally the arms can be slightly wavy, and the entire monument slightly concave on one side. Axle-shaped monuments might be viewed as occupying part of a continuum also inhabited by regular crescents, with some of the former exhibiting a slight crescent-like character (where they are slightly concave on one side), and some of the latter exhibiting a shallow curvature that results in an appearance that approaches that of the axle-shape.

Mounded crescents
Mounded crescents can be described as elliptical tumuli with wings, and are shaped like pastry croissants (Plate 5d). The 'wings' are integral parts of the main structure of monument, rather than the appendages or extensions associated with tumuli with arms or wings (described above under Cairns). Some of these monuments are associated with paved areas, and others with possible collapsed standing stones, both of which suggest a possible relationship to complex monuments as described below. However, they can also resemble regular crescents that have been truncated, lacking as they do the long curved arms of these monuments. The mounded crescents recorded to date are less than 10m in length.

Composite monuments
Composite monuments as defined here are monuments incorporating one or more antenna, within, on top of, or at the end of which, one or more smaller tumuli have been constructed. The construction of these monuments suggests that the various elements (main tumulus, antennae, and smaller tumuli) may be integral to the monument, although smaller tumuli may have been incorporated after the construction of the main body of the monument. These monuments differ from instances of materials from an original monument being reused to construct a later monument, in that the main body of the monument remains intact, suggesting its deliberate preservation during any later additional construction.

Three examples of composite monuments have been recorded, in the Northern Sector, in the TF1 Study Area (WS082), TF0 (TF0-41) and TF4 (TF4-3). WS082 is made up of a long, elliptical tumulus on a north to south alignment. A straight 'antenna' arm, outlined by kerb stones extends to the south southeast for *c.* 52m, while extending north northeast out of the tumulus is a second, very short arm (*c.* 6.50m long), at whose end a simple, smaller tumulus has been built (WS083). There is no obvious evidence to suggest that the northern arm extended any further than its present limit, therefore the arm and small tumulus might be integral. If this is the case, then this type of monument is in effect an asymmetrical antenna monument with multiple tumuli.

TF0-41 is made up of the same basic features, and similarly aligned. However, the way in which this monument has been constructed is different. It is more 'organic' in the way in which its arms and tumuli are articulated. Its parts seem to merge into each other while at WS082 the component parts appear 'jointed'.

Cairns with (short) lines of orthostats
Some structures have been recorded in the Free Zone that consist of a cairn or tumulus, along one side of which is a short row of orthostats placed very close together (Plate 6a). The cairns are often very rough in appearance, with no obvious structure, and the number of orthostats is typically 3–5. The closely packed alignment of the (usually wide and flat) orthostats makes them distinct from other monuments that incorporate standing stones (*e.g.* ridge monuments and complex monuments, described below) or are associated with standing stones that do not abut the cairn; in the latter, the standing stones tend to occur in isolation or in groups, but not in closely packed linear arrangements.

The orthostats incorporated into these features can bear a striking resemblance to the orthostats or 'hands' (Mattingly *et al.* 2018) and particularly to the 'early proto stele' associated with Garamantian tombs in the Libyan Fezzan,

described by Mattingly with Edwards (2003). In the Fezzan, these features appear to have evolved into more stylised orthostats including 'hands' consisting of 'four vertical and symmetrically arranged "digits",' often associated with 'offering tables' (Mattingly with Edwards 2003, 206). While elements of some other monuments recorded in Western Sahara seem to represent offering spaces, such features have not been identified in association with cairns with lines of orthostats. However, as with most Garamantian tombs, the orthostats incorporated into theses cairns are found against the eastern side of the monument.

Ridge monuments
Ridge monuments consist of a line of orthostats that can be straight, sinuous, or arced, and can run either in front of a tumulus, or over it (Brooks *et al.* 2006) (Plate 6b). The orthostats tend to be highest in the centre of the monument, reaching in some instances well over 1m in height, and tapering down close to ground level at the opposite ends of the line. Ridge monuments with straight lines of orthostats seem to be the same as, or very similar to, Milburn and Kobel-Wettlauffer's (1975, 116–120) 'tumulus associated with a line of menhirs' found in Mauritania and Western Sahara. However, two ridge monuments (described in Chapter 4) were recorded at Lajuad with very sinuous arrangements of orthostats, that do not appear to have been recorded elsewhere in the Sahara.

Milburn and Kobel-Wettlauffer (1975) state that the greatest preserved height of any orthostat, or 'menhir', they recorded for one of these monuments was 2.35m. They also recorded no monument more than 22 'menhirs' long. However, ridge monuments have been recorded in the Free Zone with something in the region of 40 orthostats (Chapter 4 and Brooks *et al.* 2006, 78). Arcangioli and Rossi (1994) describe monuments in the Erg Djourab in Chad that exhibit the characteristics of ridge monuments, with many dozens of orthostats.

Ridge monuments may be seen as a variant of cairns with lines of orthostats, with the former distinguished from the latter by the large number of orthostats, which together constitute the dominant characteristic of the monument. Here we use the term 'ridge monument' instead of Milburn and Kobel-Wettlauffer's (1975) existing 'tumulus with a line of menhirs', as the latter could apply to ridge monuments, complex monuments, and other cairns with lines of orthostats. In Western Sahara these three features are sufficiently distinct to warrant classification as different types, so a more detailed typology is required.

Complex monuments
Complex Monuments are very distinctive. Unless they have been heavily disturbed, they are characterised by an alignment of orthostats (between *c.* 5m and 12m long), either straight or slightly curving, which serves as a 'facade' for a tumulus that usually faces northeast, to east, or south (Plate 6c). The orthostats extend beyond the limit of the tumulus and very often, up to three or so of the stones in the centre of the face will be noticeably higher than the rest. In some instances, a small mound of stones might be present up against the centre of the face and a false entrance can be made out. There is usually a rectangular, paved area of stones marked out and attached to the rear of these monuments, and these can sometimes be subdivided by stone alignments. External annexes can also be found both to the front and the rear, even occasionally attached to the end of an orthostat face. In many instances, there are oval like configurations of small boulders in front of these monuments, often a few metres distant.

Like ridge monuments, complex monuments may be seen as a variant of, or at least related to, cairns with lines of orthostats.

It is possible that Searight (2003) has recorded a complex monument in the Tan Tan Province of southern Morocco. She simply refers to it as a *tumulus à antennes courtes, plate-forme et renflement* – a tumulus with short antennae, a platform and a bulge. But it is also possible that this feature is a type of mounded crescent as described above.

Monuments with auxiliary towers
Monuments with auxiliary towers are present throughout the central and western Sahara, from the Fezzan region of Libya to the Atlantic coast, and from the Draa Valley in Morocco to the Sahelian latitudes. These monuments consist of (i) a tumulus or a bazina that may be at the centre of a stone ring, disc or platform, or occur without these elements, and (ii) a line of more-or-less circular cairns, towers or other stone arrangements, or a low-relief linear stone arrangement of a similar form to the arms of a crescent antenna (Gauthier and Gauthier 2005) (Plate 6d). The second element of the monument generally is situated on the eastern side of the tumulus or bazina, although some of these monuments also exhibit towers or cairns to the west, north or south. In some instances, the line of towers/cairns curves back to encircle the tumulus or bazina, and some of these monuments are associated with double lines of towers/cairns. Paris (1996) describes such monuments as tumuli or bazinas '*à alignement*', and distinguishes between monuments (tumuli or bazinas) '*à alignement de tours*' and '*à murette*'. The former are associated with a line of 'towers'; the latter with a 'wall'.

To date, only one such monument (RT2-10) has been identified in the Free Zone, north of Mheres on the west bank of the Wadi Ratnia and near the MH1 detailed survey area (Chapter 4).

Petroforms
Goulets (Type 1)
Goulet monuments, first described by Gobin (1937) and Monod (1948) some kilometres east of Bir Moghrein

(Mauritania), can be very large indeed, especially when seen as complexes with multiple parts (*i.e.* stone rings and stone concentrations). The most usual form of goulet in the Free Zone (referred to here as a Type 1 goulet), based on those recorded to date, consists of two low relief, parallel stone alignments (forming a 'gulley' or 'corridor'), usually extending from the edge of an area densely paved with small stones (Plate 7a). After some distance the stone alignments forming the corridor diverge and curve back towards the paved area, converging behind it (Brooks *et al.* 2006, 76). The paved area partly covers both enclosures (but not the corridor) and tends to extend some 5–10m from the edge of the monument into its interior. A small, low tumulus is often constructed on the paved area, at or near the very edge of the monument. However, not all goulets include such a tumulus (Plate 7). Where a tumulus is absent the corridor sometimes extends all the way through the paved area to the rear perimeter of the monument. The enclosures are narrower at the end of the monument where the paved area (and in many cases tumulus) is located.

Due to their low relief and the nature of their construction, goulets are easily disturbed, and portions of them are often reused. As a result, the extant outlines of goulets are often incomplete. Nonetheless, some 'half-goulets' have been recorded (*e.g.* in the TF1 Study Area) that consist of only one, well-preserved enclosure, with no trace of a second enclosure. There are two such monuments in the TF1 Study Area (WS355 and WS356, Chapter 5).

Low relief stone rings (*c.* 5m to *c.* 10m wide) are often found just beyond the wider end of goulets, where the stone arrangements of the 'corridor' diverge. It is not uncommon for there to be two of these. The rings might be a single circle of stones simply placed on the ground, or a double-faced circle, with a circumference *c.* 0.5m thick. Entrances to these circles (often turning inwards) are sometimes evident and the double-faced rings almost always have a thickening along the side furthest away from the goulet (sometimes even the single rings have this thickening). Stone rings may be aligned with the corridor, or offset from it. Alignment or marker stones have been recorded in some instances, 'extending' the monument or complex (of which the goulet is the major part) a significant distance beyond the end of the corridor and any associated stone rings.

Stone concentrations may also occur beyond the main body of a goulet, at its wider end. In some instances (*e.g.* in the TF1 Study Area, Chapter 5) these are very numerous. These stone concentrations are often associated with scattered quartz fragments. Geometric motifs created using stones of the same type and colour occasionally are observed in the vicinity of the outer rings/circles, and sometimes inside or just outside the enclosures. Two goulets have been recorded in the Free Zone in which assemblages of stones of different colours inside and outside the enclosures may represent animal motifs (IR1-12 and TF6-44, Chapter 4).

The goulets recorded in the Free Zone to date vary in size from *c.* 25m long by *c.* 15m wide to more than 80m long by more than 30m wide. The TF1 Study Area (Chapter 5) includes the largest goulet found to date in the Sahara (WS006), which measures *c.* 290m in length. However, this feature is part of a larger complex comprising two stone rings, numerous stone concentrations and an apparent marker stone in line with the corridor and the tumulus at the western end of the goulet, with the entire complex covering a distance of *c.* 630m (Brooks *et al.* 2006; Milburn 2005).

The orientation of a goulet is defined as the direction along the corridor away from the paved area. Goulets may, like many other monuments, be oriented in a more-or-less easterly direction or (apparently) towards prominent landscape features (Plate 7c). However, goulets exhibit a wide range or orientations. Preliminary (unpublished) analysis by one of us (Gauthier) of data relating to 50 goulets in Morocco shows that 40 have orientations between 54° and 178°, with the 10 remaining structures oriented to the west (242° to 337°). Goulets may occur in groups, sometimes constructed almost head-to-tail, with neighbouring goulets exhibiting quite different orientations, suggesting that goulets are oriented neither with respect to remarkable local features nor in the direction of the rising sun or moon. The situation is somewhat different in the central Sahara, where goulets appear to be oriented uniformly in easterly directions. The central Saharan goulets also tend to be characterised by larger, better defined tumuli of the order of about 1m in height, and by enclosures that are less tapered and more circular in shape than those of the western parts of the Sahara. In the latter region goulets may have multiple corridors all converging on a tumulus or paved area, in contrast to the single-corridors of their central Saharan counterparts, although all the goulets recorded in the Free Zone to date have had single corridors.

Gauthier (2015) distinguishes between western goulets, found in Western Sahara, southern Morocco and northern Mauritania and described above, and eastern goulets. The latter are found in the central Sahara in the vicinity of Immidir and the Tassili n'Ajjer, and include a larger or 'true' tumulus, in contrast with the low-relief tumuli, or lack of tumuli, of their western counterparts. Based on superpositions and 'rearrangements', Gauthier concludes that the eastern goulets are likely to predate keyhole monuments.

Western goulets (both Types 1 and 2, the latter of which are described below), eastern goulets and keyhole monuments might all be grouped under the type '*monuments à couloir et enclos*', which accurately defines their main distinguishing features, namely corridors and enclosures (BANI 1994; Paris 1996; Paris and Saliège 2010). However, this term is applied by these authors to what are often referred to as 'keyhole' monuments (di Lernia 2013; Gauthier 2009; Gauthier and Gauthier 2006; Milburn 1983, 1988), which are

quite distinct from goulets, although these monument types share some common elements. Keyhole monuments exhibit greater relief than goulets, with raised enclosure perimeters. Keyhole monuments have an inner and outer enclosure giving them the appearance of a cairn surrounded by two concentric circles or ellipses. In contrast, goulets have a single perimeter that curves back towards the narrow end of the monument in two parallel lines, giving the appearance of two 'wings'. In a keyhole monument, the outer perimeter tends to be complete, closing the end of the corridor; in a goulet, the single perimeter curves back on itself to form a corridor that is open at the end. Type 1 goulets have a narrow end and a wide end, with the former being located nearer the tumulus or platform, whereas keyhole monuments do not exhibit such a pronounced asymmetry, and may be wider at the end housing the tumulus.

Keyhole monuments have been demonstrated to contain human burials, and Paris and Saliège (2010) have dated these monuments (which they describe as '*monuments à couloir et enclos*') to the mid-late 5th millennium BP. However, to date there have been no confirmed burials associated with goulets (Milburn 2013).

Goulets (Type 2)

The second type of goulet (the 'Type 2 goulet') is different from the Type 1 goulet in a number of respects, and superficially resembles a keyhole monument (di Lernia *et al.* 2002a; Gauthier 2009; Gauthier and Gauthier 2003a; Paris 1996; Savary 1966), although it represents a distinct type of monument in its own right. In Type 2 goulets, the enclosures generally are more circular, without the narrowing at one end as in a Type 1 goulet (Plate 7b). In contrast with a Type 1 goulet, in which the tumulus (if present) is adjacent to the perimeter of the monument at its narrower end, in Type 2 goulets the tumulus is situated some distance inside the perimeter, near but not at the centre of the monument. The Type 2 goulets recorded in the Free Zone to date are smaller than the Type 1 goulets, although the former type may be very large in other parts of the Sahara.

Stone rings

This monument type includes the shallow stone rings associated with goulets, as well as those which occur on their own, or in groups. One group in the TF1 Study Area (WS170, Chapter 5) comprises 10 double faced, low relief stone circles forming an enclosure. Where they are well preserved, there is no apparent evidence for entrances. The rings are *c.* 4.25m to *c.* 6.50m in diameter, and with a circumference up to *c.* 0.5m thick, and usually no more that *c.* 0.20m high (Plate 8a). Small cobble sized stones are spread within some of the rings giving the impression of a pavement, and some are structurally linked together.

It is easy to jump to the conclusion that these rings are the foundations of some kind of huts, but where they are well preserved, they are very uniformly constructed with no tumble that might indicate that they were higher (serving as low hut walls), or with obviously dislodged stones that might represent the former positions of timber uprights, branches or boughs, that could have been embedded (*i.e.* chocked) in the rings as a frame for a hut and were subsequently removed.

It is possible that these rings are funerary but in the 1930s a ring was excavated by a non-professional and produced, as Mark Milburn has remarked, 'nothing recognisable' (pers. comm.). Another possibility might be that stone circles are incomplete tumuli, where the outer kerb has been laid in place, perhaps to mark the location of the future burial monument, but the tumulus is not built until the intended incumbent dies. In the case of prehistoric burial cairns in the UK it is understood that the construction of a monument was not a single event but in some circumstances a series of events that took place over a number of years (Bradley 1998). The kerb of the tumulus (in this case perhaps the stone circle) marks the burial location prior to the death of the individual, with the tumulus being constructed later, after death (see Chapter 8 for a fuller discussion of the concept of funerary monuments as part of protracted ceremony).

It is possible that these rings are petroforms in the truest sense. Like the outlines of goulets, with which they are so often associated, they may simply be 'inscriptions' on the ground integral to rituals, funerary or otherwise, of which we know nothing.

Stone half rings

These low-lying features are half, or five eighths, circles of stone with diameters ranging from *c.* 2m to *c.* 4m (Plate 8b). Like stone rings, they are usually made up of a double faced (*c.* 0.50m thick by 0.20m high) arc of low relief stones with an infill of further stones, including large pebbles and cobbles. The areas within and in front of these partial circles are relatively free of surface stones, in contrast to the greater concentration of surface stones immediately behind them. There are no instances of these features being opened to the north and they are usually found in slightly curving alignments ranging in number from two to 14. However, site WS359 is made up of at least 80 such half circles creating a partial ellipse in plan, and with all constituent features facing into the ellipse, southwards, eastwards and westwards.

When looking at these features in plan, it might be possible to ascribe them to a group of structures known in other parts of the Sahara and described, for instance, by di Lernia *et al.* (2002a, 30) as 'U' structures (and including features known as 'fatima' tents, 'horseshoes' and 'basket handles'). These can be shallow like the features recorded in the TF1 Study Area, or they can be built of dry stone courses up to *c.* 0.75m in height. Di Lernia *et al.* (2002c, 102–116), working in the Wadi Tanezzuft, southwest Libya, investigated a 'U' structure as part of their excavations of

the elaborate bazina complex they referred to as the 'Royal Tumulus'. They found no burial remains in the 'U' structure, but considered it a ceremonial feature since they found a sizable stone slab which they have interpreted as a possible offering table, in line with similar features associated with other monuments elsewhere in the Wadi Al Ajal to the northeast of the Wadi Tanezzuft. The 'Royal Tumulus' has been dated to *c.* 1740 ± 25 uncal. BP on a date stone found in association with skeletal remains. This yields a calibrated date range of 1618–1693 cal. BP (di Lernia *et al.* 2002c, 115), and this Garamantian period date has been ascribed to the excavated 'U' structure.

'U'-type structures invariably seem to have stone emplacements (see below), or short, linear stone constructions associated with them, and positioned in front of their openings. The 'Royal Tumulus' and its associated 'U' structures, in the Wadi Tanezzuft, has at least 55 'small features' associated with it. But this is apparently not the case with the stone half rings recorded in the TF1 Study Area, where the areas in front of the structures are quite clear of stones and any easily recognisable features.

Concerning di Lernia's generalised category of 'U'-type monuments, however, it should be pointed out that Gauthier and Gauthier (2004) have argued that 'U'-type structures, such as the ones which are part of the 'Royal Tumulus', are a monument type distinct from 'Fatima Tents' (including the sub-rectangular 'basket handle' type). Gauthier also classifies the stone half rings, described here, as a separate monument type. The differences between these three monument types are mainly constructional, involving the presence or absence of external features, their orientation, and their distribution.

It should also be noted that broadly open-sided circular monuments – in particular what appear to be half or five eighths circles, and with some not that dissimilar to the stone half rings found in the TF1 Study Area – have been documented in the far east of northern Africa, in the Danakil desert. Nesbitt (1930, 557) clearly describes some stone memorials to dead men in the Danakil, as a 'low ring of cobbles three to six feet in diameter, rather like the stone border of a flower-bed' with a small stone 'cone' sometimes placed in the centre. In fact, the comparison with cobbles outlining a flower bed is a very apt description of the way in which many of the whole and partial stone rings in the TF1 Study Area have been delineated. Thesiger (1935, 9–12) goes on to point out that these contemporary monuments were in fact cenotaphs, and he illustrates them further by describing them as invariably circular and opened along one side and made up of either low walls, or shallow stone outlines, comprising either one ring of stones or a double-sided ring infilled with smaller stones. These could be 10 to 15 feet (*c.* 3m to *c.* 4.50m) across with rough stone piles or neater 'pillars' marking the entrance. Very often, hearths indicated by mounds of fire blackened stones would be located outside of these structures with a small platform of stones inside of them, where meat cooked on the hearth stones would be placed when the memorials were built.

It is very striking that the burial customs recorded by both Nesbitt and Thesiger were contemporary within the first third of the 20th century. Besides the cenotaphs described, tumuli and other funerary monuments were still in use in the Danakil region, an area that was nominally Muslim.

Stone alignments

Various stone alignments are found throughout the Sahara, and have been recorded at a number of locations in the Free Zone. In this volume, stone alignments refer to linear or quasi-linear features consisting of stones placed adjacent to one another, as well as to non-linear alignments of stones placed next to each other in 'single file'.

There are two sizeable stone alignments in the TF1 Study Area (Chapter 5), measuring *c.* 48m and *c.* 87m. They are very close to, and in line with, one another, each consisting of a simple line of stones placed on the ground with occasional short, upright stones, and small integral groupings of stones usually tending to the circular. Lines of stones, standing or otherwise, are associated with some funerary monuments, although these tend to be much shorter than those described above. Other stone alignments are much more contemporary, and date from the recent conflict.

Standing stone features

Standing stones are frequently associated with tumuli and other monumental stone features. However, they also occur, singly or in groups, as 'monumental' stone features in their own right (Plate 8c, d). Large, isolated standing stones in the region of 2m in height occur in the Southern Sector, often associated with small, low-relief cairns that are little more than concentrations of stones (Chapter 4). The most striking assemblage of standing stones recorded to date is feature WS001 in the TF1 Study Area (Plate 8c), a substantial rectilinear arrangement of more than 60 stones ranging in height from *c.* 0.30m to *c.* 1.30m, described in detail in Chapter 5. A second, more circular arrangement of standing stones (TF0-38) (Plate 8d) is located some 9km southwest of the TF1 Study Area, and is described in Chapter 4. It is interesting to note that at least eight kerb burials have impinged on the standing stone assemblage at WS001, and some have been positioned in such a way as to incorporate, *in situ* standing stones.

Here, features whose dominant characteristic is one or more standing stones are classified as standing stone features.

Other monument types

Stone emplacements

These features are very small, slightly mounded stone groupings or piles. They are probably the same as di

Lernia et al.'s (2002a, 2002c) 'small features', distinctively associated with the 'Royal Tumulus' in the Wadi Tanezzuft in the Fezzan, where there are at least 55 such features laid out in front of the bazina that is the 'Royal Tumulus' and its associated 'U'-type structures. Similar stone emplacements are found outside 'U'-type structures throughout the Sahara (Gauthier and Gauthier 2004), and even in the Danakil (Thesiger 1935). There is one group (site WS382) of c. 20 of these that are laid out in a rectilinear fashion covering an area c. 7.8m × 6.5m in extent, in the far southwest of the TF1 Study Area. Each individual emplacement is c. 0.3m by c. 0.5m in area, with one c. 1.75m by c. 1.5m, either irregularly shaped or rectilinear, and made up of local red and black stones.

Di Lernia et al. (2002c, 113, 115) excavated a number of these types of features associated with the 'Royal Tumulus' and they have been dated to the Garamantian period, like the 'Royal Tumulus' itself. They have been interpreted as small fireplaces made up of a number of ring-like layers of stones within which are layers of grey sand and gravel, with charcoal and faunal remains suggesting ritual activity. Their repeated use has caused them to rise to c. 0.60m in height. This is very much in keeping with the account given by Thesiger (1935, 12), where he describes similar features in use in the 1930s outside 'U'-type structures in the Danakil country:

> In front of the das [the 'U'-type monument – a cenotaph] there are always two or three fire-blackened heaps of small stones, where the animals killed when it was built were cooked, and there is usually another platform of small stones inside on which the meat is placed. To cook it small stones are piled on top of heaps of wood, stacked outside, and the wood being burnt away the meat is roasted on the red-hot stones. When they built the das to the Sheikh of Badhu, they claim to have killed 220 cows.

Such a cooking method, if carried out repeatedly, could eventually raise these fireplaces to the height that they have been recorded at by di Lernia et al. at the 'Royal Tumulus'. The three features excavated in association with the 'Royal Tumulus' yielded the remains of at least 14 gazelles, 10 sheep or goats, and one bull (di Lernia et al. 2002b).

Although there are no monumental features near WS382, it is possible that this is a site of hearths as described above. But only further fieldwork can verify this.

Kerb burials

These are small monuments, usually flush with the ground and outlined by low relief kerbs. They range in size from under a metre to c. 2m long, and up to c. 1m wide. They can be round, elliptical or oval shaped, usually on an approximate north to south alignment. It is common for them to have higher, if not standing, stones at their north and/or south ends. Very rarely, there are additional upright stones, in particular a central stone, as is the case with WS149. Such a stone has been described as a 'fecundity' stone by Mercer (1976, 67), which can indicate a woman's grave. It is highly likely that the majority of these features are Islamic, but their overall date range is probably very great. Some of them are situated as satellites to tumuli, though one very distinctive group is associated with the standing stones site WS001. Others date to the conflict of 1975–91, as apparent from the incorporation of shell cases and modern Arabic inscriptions (and confirmation of their nature by the Sahrawi military). With this in mind, kerb burial WS261 is a rough rectangle c. 3m × 4m which has a *qibla* wall associated with it, very similar to the contemporary *qibla* walls visible, e.g. along the roads in the Tindouf area, and throughout desert areas in the Islamic world.

Stone outlines

These features include low lying stone circles, sub-circular outlines, and other irregular outlines. The stones are not necessarily close together, and some stone outlines are likely to represent the footings of temporary shelters, while the nature of others is unknown. It is very hard to suggest a date for these features. Some may have great antiquity while others may be associated with tents put up during the hostilities of 1975–91. At least one such feature, WS265, is an open-air mosque.

Hearths

There are a small number of locations where hearths have been recorded. They usually consist of a grouping of stones less than a metre in diameter and relatively flush with the ground. Evidence of burning, as ash, is only evident once they are dug into. We have no dates for them at present. Some might be associated with chipped stone sites while others could be relatively recent.

N-liths

Structures consisting of upright stones supporting a capstone are found throughout the Sahara. The capstone may be supported by three or more uprights, and such a structure with N uprights is referred to here has an N-lith; such Saharan monuments have been referred to as triliths ('*trilithe*' in French) where the capstone is supported by three upright stones (e.g. Gauthier and Gautheir 1998). To date, just one such structure (SL6-1) has been recorded in the Free Zone. This is described in Chapter 4.

While these structures are similar in construction to certain megalithic monuments found in Europe, such as the coits or cromlechs of the British Isles (Cooke 1996; Joussaume 1988), the dimensions of most Saharan examples are an order of magnitude smaller than those of their superficially similar European counterparts. Whereas the latter have been associated with funerary functions, with the entire structure covered by a mound and housing a

burial, the size of most Saharan N-liths precludes such a function. Exceptions are some large monuments at Roknia and Tebessa in north-eastern Algeria, with upright stones and capstones, described and presented in photographic and sketch form by Reygasse (1950, after Bourguignat 1868), who refers to these monuments as dolmens, a somewhat generic term used to refer to this and other types of megalithic monument in Europe (*e.g.* Bradley 2007).

Walled shelters

These dry-stone structures are presumed to be shelters or windbreaks for people and/or animals. They vary in size, with some sites or locations housing many such structures, some of which are carefully constructed and several metres wide and/or deep and up to 1m high. Other locations may have just one or two shelters that are only large enough to accommodate one person. In the main, they consist of three sides, appearing 'horseshoe' shaped. These structures are likely to span a long time period, and to have been used well into the historical period (and up to the present day in some areas), for example by people tending animal herds. To date, these features have been recorded at only one site in the Free Zone (MS1-8), described in Chapter 4.

Stone concentrations/spreads

The term 'stone concentration' or 'stone spread' is used to describe features that appear to be anthropogenic in origin, but which are too dispersed and low-relief to be classified as tumuli, cover too large an area to be classed as stone emplacements, which do not appear to be the remains of fire hearths, and which are too haphazard in form to be classed as stone outlines. Such features are common in some areas, such as area TF6 near Tifariti and area LD1 at Lajuad. In the TF1 Study Area they occur frequently in association with goulets or goulet remains. The nature and function of stone concentrations is unknown, but these features are likely to be diverse in origin and purpose. It is possible that some stone concentrations are the disturbed remains of pictograms or other motifs, such as those associated with features IR1-12 and TF6-44 (see above and Chapter 4).

Chapter 4

The Extensive Survey

Nick Brooks, Joanne Clarke, Yves Gauthier and Maria Guagnin

Introduction

This chapter provides a synthetic discussion of the results of extensive survey work throughout the Northern and Southern Sectors of the Free Zone of Western Sahara. Extensive survey work was conducted over five short field seasons, each of two to three weeks duration, in 2002, 2005, 2006, 2007 and 2009. These field seasons combined archaeological reconnaissance and survey with environmental reconnaissance and sampling. The archaeological elements of the extensive survey work have consisted of opportunistic recording of features of interest, and detailed surveys of small sample areas, focusing on stone features. The extensive survey work focused on the recording of stone features/monuments (Chapter 3); however, rock art, worked stone and ceramics were also recorded.

Given the lack of previous systematic work on the built stone environment of Western Sahara (Chapter 3), and the dearth of any detailed study of distributions and densities of morphologically distinct categories of stone features in the territory, an approach was required that balanced the need for detailed recording of individual features within necessarily small areas with a wider survey of the characteristics of each type of feature over large geographical areas. For this reason, the Project has pursued a combination of *intensive* and *extensive* survey work. Intensive survey work, described in Chapter 5, involved the recording of individual features with a high level of detail, within a clearly defined Study Area of approximately nine square kilometres (the TF1 study area, Tifariti Northern Sector). In contrast, extensive survey work, described in this chapter, involved the recording of individual features and groups of features in a wide variety of locations in both the Northern and Southern Sectors of the Free Zone. In practice, the extensive survey comprised a combination of both archaeological and environmental reconnaissance and survey work, with much of the archaeological recording taking place during sojourns dedicated to environmental sampling (Chapter 2).

In addition to information about the types, orientations and distributions of stone features, the extensive survey also yielded information about other aspects of Western Sahara's archaeological record, including chipped stone, ceramics, and rock art (in the form of both paintings and engravings). Extensive survey work therefore represents a vital stage in the investigative process, and is a necessary precursor to intensive survey work and excavation. For example, the TF1 intensive survey Study Area was identified through initial reconnaissance work during the extensive surveys that took place in late 2002 and early 2005.

The remainder of this chapter discusses the results of wide-ranging extensive survey work throughout the Northern and Southern Sectors of the Free Zone. A description of the approach and methodology employed in the survey is followed by a presentation of the results of extensive survey organised by stone feature types as described in Chapter 3, and a synthetic discussion that addresses the variations in and distribution of stone features across both sectors.

Approach and methodology

Rationale and approach

Extensive survey work consisted of vehicle-based reconnaissance and the systematic surveying of selected areas throughout the Northern and Southern Sectors, the purpose of which was to identify areas of archaeological and environmental interest, to provide detailed recordings of selected groups of stone features, and to draw some tentative initial conclusions regarding the nature of these

features and their distribution. The extensive survey was assisted by local informants and informed by the use of Landsat Thematic Mapper and Google Earth satellite imagery. Satellite imagery allowed extensive survey work to be targeted at locations with particular geomorphological characteristics known to be associated with prehistoric human activity elsewhere in the Sahara (*e.g.* major wadis, escarpments, palaeolake shorelines, *etc.*). The use of Google Earth imagery to identify individual stone features is discussed below.

Wide-ranging extensive survey enabled project members to develop a broad understanding of the relationships between archaeology, landscape and environment. This ensured that project members acquired a familiarity with features that would have been important to the region's prehistoric inhabitants, such as the wadi systems, which would have provided routeways and grazing, and the highly distinctive landforms of the Southern Sector, which would have been invaluable aids to navigation in prehistoric times, as they are today.

A combination of systematic surveying of predefined areas, and rapid opportunistic recording of features as they were encountered while traversing the wider Study Area, resulted in records with varying degrees of detail. Consequently, records have been grouped into four categories, each of which is associated with a different level of detail, as summarised in Table 4.1. Just as the project as a whole required a combination of intensive and extensive survey work, so the extensive survey required a combination of detailed survey in order to provide representative samples of stone features, and more opportunistic survey to yield information on the types of features present and their distribution over large areas. Given the lack of detailed baseline archaeological knowledge in Western Sahara, such a flexible approach was desirable in order to provide contextual information for the intensive survey and the detailed area surveys carried out as part of the extensive survey, and to relate the archaeological contexts of the Northern and Southern Sectors to the wider Saharan archaeological context.

The highest level of detail (level 1 in Table 4.1) is associated with detailed, systematic survey carried out in selected areas with high concentrations of stone features (hereafter referred to as 'detailed surveys'). These surveys emulate the approach taken by the intensive survey in the TF1 Study Area (Chapter 5) but were generally carried out on a much more modest scale and thus lack some of the finer detail of the TF1 intensive survey. These detailed surveys involved the systematic recording of all individual stone features within a specified area of anything from a few tens of thousands of square metres to several square kilometres. Locations of structures were determined using GPS handsets, and their characteristics were noted on dedicated recording sheets designed specifically for the extensive survey, with the description of one feature per recording sheet. The purpose of the detailed survey was (i) to record cross-samples of stone features in different sub-regions of the Free Zone that exhibit different topographic, geological and geomorphological characteristics; (ii) to develop a tentative understanding of the nature of these features and their variation and distribution over the small spatial scales associated with the individual survey areas and (iii) to understand the variation in form and distribution of these features at much larger scales by comparing the results from different areas in the Northern and Southern Sectors.

Recording sheets were also used for the opportunistic survey of some individual stone features and small groups of features outside of the areas designated for systematic, detailed surveys (level 2 in Table 4.1). This approach was generally adopted when groups of features were identified as being of particular archaeological interest, but where time did not permit systematic survey work.

Table 4.1. The different levels of detail associated with the various approaches to the recording of stone structures in the extensive survey

Level	Key features	Nature of recording process
1	Detailed survey: recording sheets, systematic survey within defined area.	All features recorded within a pre-defined area, using recording sheets to provide detailed descriptions of individual structures, supported by photographic records.
2	Recording sheets, opportunistic survey of individual structures or groups of monuments.	Individual features recorded using recording sheets, based on opportunistic identification or visiting features for ground-truthing of identifications based on satellite imagery. Groups of structures may be recorded, but survey does not represent systematic recording of all structures within a particular area. Survey may be viewed as quasi-random sample of structures within wider vicinity, biased towards larger structures that are more easily identified.
3	Field notebook, basic description, opportunistic survey.	Similar to (2) but based on notes recorded in field notebooks rather than on recording sheets. More rapid survey with less detailed descriptions, focusing on key characteristics of stone features (e.g. type, dimensions, orientation).
4	Location only, little or no further detail	Features recorded rapidly, usually while in transit, and often from moving vehicle. Approximate locations recorded using GPS handsets, with type of structure noted if possible. More likely to result in identification of large structures and groups of structures.

In many instances, particularly where features were identified in the course of environmental survey work, these were recorded in field notebooks rather than on recording sheets (level 3 in Table 4.1). In such cases, the information may be similar in its level of detail to that noted on a recording sheet, or somewhat more superficial and generally less systematic. However, records in field notebooks typically include information on the type of feature, its dimensions, and (where applicable) orientation. For example, basic descriptions were obtained in this fashion for a large number of structures in an area of some 3sq. km at Azaig Bedrag (area AZ1, Southern Sector).

The lowest level of detail is associated with structures noted either from a distance, for example sighted at the top of an escarpment from the floor of a wadi, or from vehicles while in transit between areas of interest (level 4 in Table 4.1). The nature of such recordings means that they inevitably represent larger features. The locations of these features are by their very nature approximate, with coordinates representing the point of transit closest to the structure, or estimated relative to the positions of other structures.

Identification of stone features using Google Earth imagery

Geographic coverage of high-resolution (HR) Google Earth satellite imagery has been increasing since its introduction in 2006, and now covers approximately 35% of the Free Zone (Fig. 4.1). Many 'monumental' stone features are visible in this HR imagery. Detection of such features depends not only on their size, but also on the quality of the image, the height of the sun above the horizon (for good contrast and shadow), the nature of the surface on which they are built, and the way they are constructed: features consisting of stone outlines formed from arrangements of small stones, or formed from loose paving may be difficult to identify (*e.g.* goulets). Nonetheless, many large, prominent features, particularly falcate monuments (Chapter 3), are clearly visible in the high-resolution strips (Fig. 4.2) (Gauthier 2009, 2015; Gauthier and Gauthier 2007; 2008a.

One of us (Gauthier) has used the HR imagery to identify some 1500 stone features of various types including tumuli, crescents (all types), bazinas, platform tumuli, platforms, V-type monuments, complex monuments, half circle series, stone rings, and goulets. A small fraction of these features was visited during the 2009 field season (Northern Sector) for 'ground truthing'.

While many larger stone features may be identified from HR satellite imagery with a high level of confidence, the risk of misidentification remains, particularly in the case of features with circular outlines such as tumuli, bazinas, stepped bazinas, platforms and platform tumuli, which cannot easily be distinguished from one another in the HR imagery. Similarly, it is sometimes difficult to distinguish between different types of crescent/antenna features, and between these features and complex monuments, due to similarities in their footprints. Firm identification of these features can be achieved through field survey, and closer

Fig. 4.1. Proportion of the Free Zone covered by high-resolution (HR) Google Earth imagery in 2009, when the last season of extensive survey work was conducted (white, outlined areas), and in 2017 (all white areas).

Fig. 4.2. Examples of monumental stone features visible in high-resolution Google Earth imagery, northeast of Tifariti; a. large crescent and tumulus; b. two mounded crescents. Small circles to the right of the features indicate locations as determined using GPS handsets, entered into Google Earth, showing location error of the order of 10m.

examination of their vertical structure. Some monuments may be partially buried under blown sand, which may also result in an incorrect identification. For example, the components of falcate monuments such as goulets may not be visible in the imagery due to such partial burial, and burial of the antennae of crescents may result in their being identified as circular or elongated tumuli with one arm or no arms. The mis-identification of features, and the potential difficulty in resolving different types within a morphological group, has the potential to bias the analysis of populations of stone features, and represents a quite different sampling methodology to the field survey (even considering the different sampling approaches in the field survey as described in Table 4.1).

Nonetheless, ground-truthing during the 2009 field season indicated that the Google Earth imagery can be employed to detect larger stone features and in most cases at least determine which morphological group they belong to, with a high degree of confidence, even if it cannot necessarily be used to differentiate between specific types of feature within a morphological group. For example, features identified in the satellite imagery as either crescent or antenna-type monuments were found to belong to one of the associated types (crescent antennae, paved crescents, regular crescents, or linear V-type monuments) in over 90% of cases, with the precise type having to be identified on the ground. Satellite imagery can therefore be used for very broad classification of certain, larger monumental stone features, but does not provide a functionally equivalent methodology to the identification of features on the ground through field survey. Therefore, the results of analysis of satellite imagery are used here principally as context for discussions of the data obtained through field survey.

Of the areas subject to systematic, detailed survey during the extensive survey work (level 1 in Table 4.1), only two (out of eight) were covered by HR imagery in 2009, when the last season of extensive survey work was conducted (Fig. 4.1). One of these areas, north of Mheres (area MH1, Northern Sector), was selected as an area for detailed survey in 2009, partly on the basis of indications from Google Earth imagery. The second, at Zoug (area ZG1, Southern Sector) was subject to detailed survey in 2007, before HR imagery was available for this area; however, the HR imagery over Zoug reveals very little detail, due to a combination of the image quality and the very dark land surface. Ground truthing of individual stone features identified in the HR imagery was also carried out north and east of Tifariti (area TF0), in an area southeast of the intensively surveyed TF1 Study Area (Chapter 5) and the adjacent area subject to detailed extensive survey (TF6, discussed below), which lie outside the HR strip.

Presentation of data

Where specific archaeological features are mentioned in this chapter, they are identified using a code of the form AAX-Y, where AA is a two-letter code referring to a geographic region, X is a number identifying a specific area within that region, and Y is a number identifying a unique feature in that area. Generally, a new area code (AAX) is assigned for a feature or group of features separate from other features or groups of features by more than a few kilometres. Area codes are thus a convenient convention, and no functional or cultural significance should be assigned to the 'boundaries' between areas.

Typically, a feature is a single stone structure or agglomeration, a concentration of chipped stone or ceramics, or an assemblage of rock art. However, in some instances a feature may be a group of stone structures, for example where multiple stone cairns have been identified but not individually recorded (*e.g.* while in transit between areas of interest). This means that the number of stone structures or agglomerations represented by the records presented in this chapter is greater than the number of features noted. A feature may also represent more than one *type* of archaeological material, for example where chipped stone or ceramic fragments are found around a stone structure.

This report does not attempt to provide full details of, or precise locations for, every feature recorded during the extensive survey. Such a level of detail is not required in order to provide a general synthetic understanding of the archaeology of the areas subject to extensive survey, which is the intention of this study. In addition, publication of precise locations of features increases the risk that sites will be looted or disturbed, either deliberately or inadvertently (*e.g.* when being visited for 'touristic' purposes). While the majority of stone features are generally fairly robust (barring risks associated with opening monuments mistakenly believed to contain potentially valuable grave goods), certain types of low-relief features (*e.g.* goulets) are vulnerable to damage as a result of vehicular, animal or foot traffic, which can displace stones and thus degrade the structure of these features. Other archaeological sites are highly vulnerable to damage. Rock paintings are particularly susceptible to disturbance and degradation, and rock art in general is highly vulnerable to vandalism, as demonstrated at the sites of Rekeiz Lemgassem and Lajuad, where rock art has been deliberately vandalized by foreign visitors, United Nations peacekeepers, and local people (Soler i Subils 2007a; Merrill 2011). Concentrations of artefacts are also highly vulnerable to looting, as evidenced by the 'sterilisation' of such sites throughout the Sahara (Keenan 2005). Prehistoric artefacts from the Sahara can be found for sale on the internet and chipped stone artefacts (principally arrowheads) from the Free Zone have been observed for sale in the Sahrawi refugee camps. The Sahrawi Ministry of Culture is sensitive to these risks, and has also expressed a wish that the precise locations of certain sensitive sites are not published.

In order to balance the need to protect vulnerable sites with the need to provide a transparent record of the

archaeology of the Free Zone, this chapter includes maps showing the general locations where archaeological features have been recorded, with detailed maps of a number of areas that have been the subject of detailed, systematic surveys of stone features within the context of the extensive survey work. Coordinates are not provided for rock art or artefact concentrations, although some rock art sites such as those at Lajuad and Rekeiz Lemgassem are already well known.

Results

Types and numbers of features recorded

Between 2002 and 2009, the extensive survey recorded a wide variety of stone features, representing 38 types as described in Chapter 3. In addition, the extensive survey recorded three other manifestations of prehistoric material culture, in the form of rock paintings and engravings (rock art), ceramics, and worked stone.

A total of 591 codes were assigned to stone features and assemblages of rock art, chipped stone and ceramics throughout the Free Zone, in 105 areas (Figs 4.3 and 4.4). The lowest number of codes assigned in a single area is one, resulting from the opportunistic identification of individual stone constructions while in transit, and the highest number is 54, representing detailed survey within a specified area (in this case LD1 at Lajuad, Southern Sector). While most of the assigned codes are associated with individual stone features, a significant number represent groups or assemblages of such features, meaning the number of actual stone features represented is greater than the number of feature codes. For example, some funerary complexes or compound monuments may be assigned a single code, but be recorded as containing multiple features (*e.g.* different types of monuments and stone alignments). Goulets can be assigned a single code but are often associated with 'subsidiary' features such as stone rings. During intensive survey work (Chapter 5) these features would all be assigned their own codes and described individually, but the rapid recording of the extensive survey frequently mitigated against such a level of detail. In rare cases, a single monument may span multiple types; an

Fig. 4.3. Designated survey areas in the Northern Sector. Numbers correspond to the following area codes; 1: TF0 (Tifariti); 2: TF5 (Tifariti); 3: TF6 (Tifariti); 4: TF3 (Tifariti); 5: TF4 (Tifariti); 6: RL1 (Rekeiz Lahmara); 7: RK1 (Rekeiz Lemgassem); 8: MS1 to MS2 (Garat al Masiad); 9: GT4 (Wadi Ghadar Talhu); 10: GT3 (Wadi Ghadar Talhu); 11: GT1 (Wadi Ghadar Talhu); 12: GT2 (Wadi Ghadar Talhu); 13: WT1 (Wadi Weyn Tergit); 14: WT2 (Wadi Weyn Tergit); 15: RT1 (Wadi Ratnia); 16: RT2 (Wadi Ratnia); 17: RT3 (Wadi Ratnia); 18: MH1 to MH2 (Mheres); 19: IR1 (Irghraywa); 20: IR3 (Irghraywa); 21: IR4 (Irghraywa); 22: BD1 to BD6 (Bou Dheir); 23: BD50 (Bou Dheir); 24: DR1 (Wadi Dirt); 25: LM1 (Limsharha); 26: LM2 (Limsharha); 27: LM3 (Limsharha); 28: ER1 (Wadi Erni); 29: ER2 (Wadi Erni); 30: TR1 to TR2 (Wadi Ternit); 31: LS1 (Elous Lajaram); 32: LL1 (Bir Lahlou); 33: LW1 (Wadi Lawaj); 34: SL1 (Sluguilla Lawaj); 35: SL2 (Sluguilla Lawaj); 36: SL3 (Sluguilla Lawaj); 37: SL4 (Sluguilla Lawaj).

Fig. 4.4. Designated survey areas in the Southern Sector. Numbers correspond to the following area codes; 1: MJ1 (Mijek); 2: MJ2 (Mijek); 3: GB1 (Gleibat Barkat); 4: GB2 (Gleibat Barkat); 5: AZ1 (Azaig Bedrag); 6: AZ2 (Azaig Bedrag); 7: AZ3 (Azaig Bedrag); 8: AZ4 (Azaig Bedrag); 9: SE1 (Sidi Emhamad); 10: SE2 (Sidi Emhamad); 11: SE3 (Sidi Emhamad); 12: LG1 (Legleia); 13: LG2 (Legleia); 14: GK1 (Garat al Khayl); 15: DT1 (Galb Um Dueiat); 16: DT2 (Galb Um Dueiat); 17: LF1 (Lajuaf); 18: LD0 to LD2 (Lajuad); 19: LD3 to LD4 (Lajuad); 20: LD5 to LD6 (Lajuad); 21: LD7 (Lajuad); 22: AJ1 (Aij); 23: DG1 (Dugej); 24: DG2 (Dugej); 25: DG3 (Dugej); 26: DG4 (Dugej); 27: GF1 to GF3 (Tin Gufuf); 28: BS1 (Jabal Basfuf); 29: DK1 (Dukhen Hills); 30: DK2 (Dukhen Hills); 31: LK1 to LK2 (Lektaytayghra); 32: LK3 (Lektaytayghra); 33: LK4 (Lektaytayghra); 34: MT1 (Muyalhet Awaadi); 35: MT2 (Muyalhet Awaadi); 36: GS1 (al Ghashwa); 37: ZG0 to ZG1 (Zoug); 38: ZG18 to ZG22 and ZG25 (Zoug); 39: ZG24 (Zoug); 40: ZG26 (Zoug); 41: ZG27 to ZG28 (Zoug); 42: ZG29 (Zoug); 43: ZG30 (Zoug); 44: ZG31 (Zoug).

example is (Tifariti, Northern Sector), a bazina that also fits the definition of a chapel monument and therefore contributes to the count of both types of feature, resulting in 'double counting'.

Avoiding double counting of individual stone features, the 591 codes represent 660 stone features or agglomerations of stone features (including some funerary complexes and groups of monuments recorded rapidly as single features), 48 assemblages of rock art, 51 locations at which chipped stone was recorded, and 31 locations at which ceramics were recorded. Some of the locations at which rock art, chipped stone and ceramics were recorded overlap with each other and with recorded stone features (*i.e.* they share the same code). Recorded rock art assemblages include some that

Table 4.2. Types of stone features and other archaeological features identified during the extensive survey work, with brief descriptions, listed in alphabetical order

Stone features Type	Code	Description	Frequency N. Sector	S. Sector	TF1
Axle-type monument	AX	Elongated monument tapering to point at each end of its long axis.	5	2	0
Bazina	BZ	Monument with perimeter of layered dry-stone wall constructed with flattish slabs, round or square.	14	14	2
Bazina, stepped	BZs	Bazina whose construction consists of stepped layers decreasing in size from base.	5	0	0
Bazina with mound	BZm	Bazina monument on which tumulus-type mound has been constructed.	2	0	0
Boulder burial	BB	Burial inside hollow boulder sealed by rock wall.	1	0	0
Cairn with (short) line of orthostats		Usually rough, low cairn, with 3-5 flat slabs erected at a tangent to its perimeter.		4	1
Corbeille	CB	Circular monument defined by upward facing flat stones angled outwards from centre of monument.	8	1	10
Chapel monument	CH	Monument with well-defined false-entrance.	1	0	2
Composite monument	CP	Structure in which multiple monument types are combined.	2	0	1
Complex monument	TOc/CM	Tumulus with line of orthostats at 'front' and enclosure at 'back'.	13	0	15
Crescent antenna	CRa	Tumulus from which extend paved arms of uniform width.	14	0	3
Crescent, mounded	CRm	Tumulus with short extensions shaped like a pastry croissant.	12	1	3
Crescent, paved	CRp	Paved area from which extend paved extensions; tumulus near centre.	2	0	8
Crescent, regular	CR	Monument with curved arms that taper and reduce in height away from a central elongated tumulus.	7	18	3
Crescent with tails	CRt	Regular crescent whose arms are extended by linear stone arrangements.	1	0	0
Funerary complex	FC	Assemblage of stone monuments physically linked, or enclosed by stone alignments.	2	9	0
Goulet (Type 1)	GL1	Tumulus on pavement from which corridor emerges before curving back to form enclosures; tumulus at edge of monument, at narrow end.	11	1	18
Goulet (Type 2)	GL2	Similar to Type 1 goulet, but with more circular shape and tumulus off-centre.	3	0	0
Half circle/half ring	HC	Semi-circular arrangement of stones, often several layers deep and flush with ground, or series of such arrangements.	0	0	11
Hearths	HT	Remnants of fire hearths not obviously dating from the 20th or 21st century.	4	0	2
Kerb burial	KB	Monument outlined by kerb stones with or without interior stones and of low relief. Often Islamic in nature.	19	11	29
Monument with auxilliary towers	MAA	Monument (tumulus or bazina) with small auxilliary towers, generally arranged in a line or arc.	1	0	0
N-lith	NL	Flat stone balanced on a number (N) of upright stones.	1	0	0
Orthostats, cairn with	TO	Mound/tumulus associated with line of orthostats but lacking size of ridge monument or characteristic structure and enclosure of complex monument.	0	5	1
Other stone structure	OT	Structure outside of categories defined here.	1	2	2
Stone platform	SP	Circular or rectangular stone pavement, constructed from a single course/layer of stones and more-or-less flush with ground.	0	12	0
Ridge monument	TOr/RM	Monument whose principal apparent feature is a line of vertical flat stones, typically pointed to give tooth-like appearance.	0	4	0
Standing stones	SS	Individual upright stones or groups of such stones occurring in isolation or as dominant element of a stone feature (e.g. large standing stone with low crude tumulus). Does not include orthostats otherwise embedded in or associated with tumulus or other monument.	4	7	5
Stone alignment	SA	Linear or quasi-linear arrangement of stones.	4	4	2

Table 4.2. Types of stone features and other archaeological features identified during the extensive survey work, with brief descriptions, listed in alphabetical order (Continued)

Stone features			Frequency		
Type	Code	Description	N. Sector	S. Sector	TF1
Stone concentration or spread	SC	Artificial concentration of stones of greater density than those in surrounding area, more-or-less flush with ground.	9	31	9
Stone disc/disc tumulus	SD	Round stone structure built from more than one course of stones, with top surface elevated above ground level, but of low relief.	2	4	2
Stone emplacement	SE	Small pile of stones or cairn, too small to be described as a tumulus.	5	0	1
Stone outline	SO	Circular or other stone outline, with stones generally placed on ground or (less frequently) embedded in ground, and not necessarily close together.	7	18	5
Stone ring	SR	Circular arrangement of stones evenly and usually tightly spaced, often associated with goulets but also occurring in isolation.	3	2	22
Stone shelters	SH	Typically 3-sided windbreak-type structures up to ~1.5m high.	1 (group)	0	1
Tumulus	TM	Monument constructed from piling stones into a cairn, varying from very low relief to over 1.5m in height, and from around 1m to over 10m in diameter.	189	129	228
Tumulus with arms	TMa	Tumulus with low relief extensions forming arms or 'wings' (distinct from crescents).	8	5	0
Tumulus, platform	TMp/PT	Tumulus constructed on an actual or 'symbolic' platform, the latter consisting of circular pavement or augmented bedrock around the tumulus.	7	11	8
(Linear) V-type monument	VT	Small circular mound or platform from which emanate two linear features, often constructed from infilled parallel stone alignments.	1	0	0
Other features					
Ceramics	C	Significant concentrations of pottery fragments.	11	20	–
Rock art	ART	Rock paintings and/or engravings.	29	19	0
Worked stone	WS	Stone tools or concentrations of chipped/worked stone.	28	23	–

See Chapter 3 for more detailed descriptions and discussion of individual types. The frequency of each type is listed for the Northern Sector, Southern Sector, and (for comparison) the intensively surveyed TF1 Study Area (Chapter 5).

are already well known and have been described by other authors, and some that have not been identified or published (at least to our knowledge). Generally, chipped stone and ceramics were recorded only where they were identified in dense concentrations or where specific diagnostic artefacts were identified.

Table 4.2 details the types of archaeological features recorded during the extensive survey, provides a brief summary description of each type, and lists the numbers of features of each type recorded in the Northern and Southern Sectors. Table 4.3 describes the nine areas in which detailed surveys were carried out, and summarises the types of features recorded, and the numbers of each type, for each detailed survey area. The detailed survey areas and the features recorded within them are referred to throughout the remainder of this chapter where this is relevant to specific types of feature, and again in the discussion at the end of the chapter.

Frequencies and distributions of stone features by morphological group and type

There is considerable geographical variation in the frequency with which different types of stone feature, rock art, ceramics and worked stone were recorded, and significant differences are apparent between the Northern and Southern Sectors in the nature and abundance of some of these recorded features. The abundance and distributions of different features are discussed below, starting with stone features, organised by morphological groups (cairns, falcates, petroforms and others) and feature types (Chapter 3). Discussion of the stone features is followed by summaries of the worked stone, ceramics, and rock art recorded opportunistically during the extensive survey.

The following discussions are based on data collected during the extensive survey work only, and exclude data from the intensively surveyed TF1 Study Area (Chapter 5), unless otherwise stated. Inclusion of the TF1 Study Area data would skew the discussion, given the much greater level of detail employed in the TF1 survey, the very large number of features recorded in the TF1 Study Area, and the lack of any similar survey in the Southern Sector. Nonetheless, consideration of the TF1 Study Area is appropriate in some instances, for example where it reveals an absence of features that are common elsewhere, or where it reinforces or refutes interpretations based on apparent differences in the abundance of certain features between the Northern and Southern Sectors.

Table 4.3. Summary of areas subject to detailed survey as part of the extensive survey work

Area code	Location	Area (km²)	No. features	Description	Types of feature recorded
Northern Sector					
MH1	Mheres	2.25	26	Narrow strip 0.5km wide, beginning approximately 3.5km north of Mheres, and extending approximately 4.5km to the north along the west bank of the Wadi Ratnia. Undulating area of sand and gravel broken up by approximately east–west basalt ridges and outcrops, and dissected by minor drainage channels.	CR(3), GL1(3), CRp(2), SP(1), PT(5), SC(1), SR(2), TM(11)
MS1	Garaat El-Masiad	0.72	12	Isolated hill to east of elongated plateau of Rekeiz Lemgassem, at its southern end. Area encompasses hill, flanks and surrounding pediment.	AX(1), BB(1), SH(1), TM(4)
TF6	Tifariti	6.3	49	Area approximately 4.5km × 1.4km straddling a large basalt ridge running immediately south of the TF1 Study Area on a bearing of 64°, on either side of which are smaller ridges. In the east, the survey area is bisected by the Wadi Tifariti where it flows approximately northwest through a gap in the ridge.	CB(2), OTc(2), CR(3), GL1(5), CRm(1), TMp(1), SE(5), TM(3)
TR2	Wadi Ternit	0.21	15	Edge of plateau immediately to north of Wadi Ternit, where the wadi changes direction from west–east to southeast–northwest. Flat sand and gravel plain with well-varnished pavement of course gravel and limestone chippings.	CRm(1), OT(2), TMp(1), SC(1), TM(16)
Southern Sector					
AZ1	Azaig Bedrag	2.76	26	Area approximately 3.25km from north to south and 0.85km from east to west, straddling an approximately north–south oriented, low-relief dyke that represents a local topographic maximum in an otherwise flat sand and gravel plain, with other dykes and low outcrops.	AX(1), SP(1), TMp(1), OTr(1), SS(3), TM(20)
GF2	Tin Gufuf	0.13	15	Concentration of stone features in area c. 550m × 230m on sand and gravel plain with some exposed bedrock, 2.5km east of a prominent, rounded granite hill with a distinctive rock formation (Tin Gufuf), and 8km southwest of another rounded hill (Jebel Basfuf). Pottery is abundant on and around these hills respectively. Grinding hollows and associated worked stone (e.g. grinding stones and pounders), and tumuli are present at both, and a shelter at Jebel Basfuf contains rock paintings.	CB(3), CR(3), GL1(1), SO(2), TM(5), TMa(1)
LD1	Lajuad	0.14	54	Approximately 700m × 200m area straddling a north–south oriented low-relief dyke between areas of outcropping bedrock, whose northernmost point is some 300m from a pair of hills about 1km south–southeast of the main group of hills at Lajuad that house the 'Devils Cave' (LD0-4), known for its unique rock engravings, and funerary complex LD0-3 (described below). The site is some 2km west-southwest of LD0-7, a cave containing abstract and geometric paintings, below which is a single crescent monument with abundant pottery fragments.	CR(2), KB(1), SP(2), PT(1), SD(14), SO(6), SC(7), TM(21)
LD2	Lajuad	0.81	10	Area approximately 1km × 0.8km, immediately north of the easternmost granite hill within the main concentration of hills at Lajuad, including pediment at base of hill and extending north onto sand and gravel plain housing low ridges and outcrops of bedrock.	CR(3), FC(1), BZ(1), KB(1), SR(1), TM(3)
ZG1	Zoug	0.04	28	250m × 150m area representing section of low ridge, one of many in the low-relief areas west of the north–south oriented chain of mountains at Zoug. Rocky terrain with abundant exposed bedrock and flat areas of sand and gravel.	FC(1), OT(1), SP(1), TMp(2), SC(1), SO(2), SR(6), TM(16), TMa(1)

For comparison, the TF1 Study Area (Chapter 5) covers approximately 9.5sq. km and contains 411 recorded features.

Cairns

TUMULI

As indicated by Table 4.2, tumuli (including tumuli with arms and tumuli on platforms) are by far the most commonly recorded features, representing 56% and 50% of the stone features recorded in the Northern and Southern Sectors respectively, and 54% of the stone features recorded throughout both areas, The proportion of tumuli recorded is slightly greater (58%) in the intensively surveyed TF1 Study Area.

Most tumuli recorded during the extensive survey can be classified as such without ambiguity. Nonetheless, these tumuli encompass a wide range of forms, from wide and shallow to tall and conical. Some are truly conical (Fig. 4.5a), while others are much more rounded in form, strongly resembling the '*tumulus lenticulaire*'/'*tumulus surbassés en lentille*' and '*tumulus en calotte de sphère*' defined by BANI (1994) and Paris (1996) (Plate 2a). Others have flattened tops and are reminiscent of the '*tumulus (tronconique)*

Fig. 4.5. Examples of tumuli recorded during the extensive survey; a. large conical tumulus in area ZG24 with large adjoining tumuli in the background; b. tumulus TF0-13, apparently undisturbed and with a flat top; c. tumulus with arms (TR2-13), with plan resembling mounded crescent.

à plate-forme' (BANI 1994; Paris 1996; Fig. 4.5b). The smallest features that can be classified unambiguously as tumuli are just tens of cm in height, while the largest 'free-standing' tumuli can be in the region of 2m high. Some tumuli are constructed on the edges of ridges or dykes so that they are elevated above adjacent lower-elevation areas and their apparent height is greater than the actual height of the built structure, except perhaps for a section of the cairn that reaches to the level of the ground adjacent to the ridge or dyke. In the Southern Sector, in the sand sea east of Zoug, aggregations of joined and superimposed tumuli exist in which the largest tumuli are up to around 5m in height (Fig. 4.5a, see discussion of funerary complexes below).

Tumuli with arms/wings and platform tumuli (Plate 3a) represent only a tiny fraction of the tumuli recorded (around 4% and 5% respectively). Four of the tumuli with arms in the Northern Sector were recorded in area TR2 on the Wadi Ternit, and are quite different from the other examples of this type, variously exhibiting characteristics of complex monuments, mounded crescents, and even paved crescents (Fig. 4.5c). Those with a footprint resembling that of a mounded crescent are nonetheless much smaller than 'true' mounded crescents, and of very low relief (Fig. 4.5c). Like many very small and low-relief tumuli, classification of these is ambiguous, and they might even be described as pavements or stone concentrations. Indeed, at the extreme end of the continuum of size occupied by the smallest tumuli, the distinction between tumuli and stone concentrations is often unclear and subjective.

A significant minority (33 out of 347, or about 10%) of tumuli incorporate annexes that serve to orient them in a particular direction (Fig. 4.6). A smaller number (18, or about 5%) are associated with standing stones, either within their main body or adjacent to them, that can also define orientations (Fig. 4.6). Orientations of other tumuli are suggested by their shape; for example, a tumulus may be somewhat elongated in a particular direction, or on an elliptical platform, and in such cases an orientation might be associated with the direction of the long axis of the tumulus or platform. The four tumuli with arms in area TR2 have the footprint of a mounded crescent and, bearing in mind their crescent-like forms, the orientations of these structures have been defined in the same was as for crescent forms (*i.e.* from the centre of the mound through a point mid-way between the arms).

Orientations have been defined for 60 tumuli, including tumuli with arms/wings and on platforms. These range from 0° to 335° after being corrected for declination (Chapter 3). However, the majority (47) of these tumuli have orientations with an easterly component, in the northeast or southeast quadrant, and 34 of these are oriented between northeast and southeast, with a quite uniform distribution and a weak and broad maximum clustering of orientations between about 85° and 140° (Fig. 4.7). Only a small fraction of the orientations are compatible with an alignment on the setting/rising moon or sun (Gauthier 2009).

STONE PLATFORMS/PAVEMENTS

Twelve stone platforms or pavements (Chapter 3) were recorded in the Southern Sector, at Lajuad (eight examples in areas LD1, LD2 and LD3), Zoug (3 examples in areas ZG0 and ZG1), and Tin Gufuf (one example in area GF2). All but two of these platforms were identified during detailed survey

Fig. 4.6. Annexes and standing stones defining tumulus orientations; a. tumulus WS087 in area TF1 with annex just left of image centre; b. tumulus GT2-1 showing annex aligned with group of standing stones (foreground); c. tumulus LD2-6 with single small upright stone defining orientation to north; d. detail of annex built into perimeter of tumulus WS039 in area TF1.

work, which is perhaps unsurprising due to the low relief and associated poor visibility of these features. No platforms were recorded in the Northern Sector (including in the TF1 Study Area, although eight platform tumuli were recorded there).

The platforms at Lajuad include round, rectangular and narrow elongated features (Fig. 4.8a–d). The majority of these features are outlined by large, closely packed boulders (or kerb stones), with their interiors consisting of a concentration of stones of varying sizes (Fig. 4.8a–d). Once again, there is ambiguity in the identification of some of these features. Some are constructed from boulders of sufficient size to result in the feature being raised above ground level to the extent that it has a disc-like appearance (e.g. LD1-3, Fig. 4.8a), even though only a single course of stones appears to have been used (although without clearing or excavation it is difficult to determine whether the interiors of some features consist of a single course or multiple courses).

In other platforms (e.g. LD1-34, Fig. 4.8b and Plate 2d) large boulders enclose a relatively low density of stones of much smaller size, suggestive of a stone outline (although the presence of infill, even at low density, is used as a criterion for classification as a platform rather than an outline). Feature LD1-19 (Fig. 4.8c) has been constructed on a slight slope at the edge of a ridge, and has kerb stones only on the higher northern and western parts of its perimeter (Fig. 4.8c). While this feature appears to be made of a single course of boulders for the most part, some additional relief is apparent on the northwest (Fig. 4.8c). The slope of this feature, and the accumulation of blown sand in its interior, mean that it could be interpreted as a low stone disc or even a very low-relief tumulus.

The three linear stone platforms were all recorded in the vicinity of Lajuad. Two of these (LD1-59 and LD1-60) form a pair of similar features in close proximity to each other in the detailed survey area LD1 (Fig. 4.8d). The third consists of a double line of small boulders some 2m in length that could almost be classified as a stone alignment, within the northern arm of a regular crescent (LD3-3). Indeed, di Lernia (2013a, Figure 5.1) includes a drawing of what he refers to as a stone alignment, that bears a close resemblance to these features.

Fig. 4.7. Orientations of tumuli recorded during the extensive survey work, including tumuli with arms and tumuli on platforms. Numbers of tumuli are indicated by the integers on the concentric circles. NMS and SMS indicate the positions of the northern and southern moon standstill respectively (the extreme azimuths achieved by the rising/setting moon). SSS and SMS indicate the positions of the rising/setting sun on the summer and winter solstices respectively. Azimuths have been corrected for declination (Chapter 3).

STONE DISCS

Three possible stone discs were identified in the Southern Sector (in areas LD1, Lajuad and ZG0, Zoug), and two in the Northern Sector (area MH1, Mheres). However, without excavation, it is often difficult to distinguish these features from stone platforms or very low tumuli. The largest of these features, ZG0-10, is c. 14m in diameter, with small standing stones c. 20–70cm in height situated around its perimeter, which is also marked by loose larger boulders. The examples at Lajuad, LD1-2 and LD1-20, have generally less well defined, more sloping perimeters, and resemble very shallow tumuli (Fig. 4.9a). One of the examples at MH1 (MH1-30) has a clearer structure (in part due to the absence of blown sand), with large boulders around the perimeter retaining a dense volume of large stones (Fig. 4.9b). The other (MH1-16) is much less well defined.

BAZINAS, INCLUDING CHAPEL MONUMENTS

Bazinas are the third most numerous type of recorded stone feature, after tumuli and crescent/antenna-type monuments (discussed below). Twenty bazinas were identified throughout the western part of the Northern Sector, and 14 were identified in three areas in the Southern Sector.

Both round and square bazinas have been identified, occurring alongside other types of stone monuments, and in isolation. Some bazinas are associated with annexes and standing stones (Fig. 4.10a), and these features enable orientations to be defined for 16 of these monuments. All of these orientations have an easterly component, with 13 bazinas oriented between 85° and 130° from True North.

Two 'domed' bazinas with mounds or cairns were recorded, both in the northern sector: ER1-4, Wadi Erni, and TR2-1, Wadi Ternit (Fig. 4.10b). Both of these monuments are situated near the edges of elevated plateaus, overlooking wide, well-vegetated wadis to the east and south respectively. Both are located in close proximity to other monuments.

One bazina (TF4-5, Tifariti, Northern Sector) is also a clear example of a chapel monument, with a large false entrance or annex facing east on a bearing of 96°. The annex consists of two large horizontal slabs supported by narrow drystone walls, forming an annex some 1.50sq.m and c. 0.75m high (Fig. 4.10d).

Five very large cairns, c. 5m in height and c. 12m in diameter, and all located in the Northern Sector, have been identified as stepped bazinas. One of these (DR1-1, Wadi Dirt) has four levels that can be seen clearly on one side, but has collapsed on the other side giving the appearance of an undifferentiated mound of flattish slabs (Fig 4.11a). The remaining four monuments appear as such undifferentiated mounds, but their size and resemblance to the collapsed section of DR1-1 mean that they can be identified with a high level of confidence as highly degraded stepped bazinas (Fig. 4.11b and Plate 3c). ER1-1 exhibits some possible structural detail, suggestive of a stepped construction (Fig. 4.11b).

CORBEILLES

Nine corbeilles were identified during the extensive survey work, eight of which are located in the Northern Sector. The smallest examples (TF6-25 and TF6-27, Tifariti) are approximately a metre in diameter, exist alongside stone emplacements and concentrations, and consist of outward angled upright stones on one side only, although this may be due to degradation (Fig. 4.12a). The largest is a heavily disturbed corbeille at Elous Lajaram (LS1-3) approximately 3m in diameter, that has been used as a source of material for several Islamic burials. This corbeille is part of a small assemblage of monuments that also includes a crescent and a tumulus. Pieces of white carbonate have been scattered in its interior, echoing the use of quartz on the central tumulus of the nearby crescent, and in the area enclosed by its arms.

Other corbeilles in the Northern Sector are found alongside complex monuments (LM1-7, Limsharha), a large stepped bazina (RT2-4, Wadi Ratnia), and an assemblage including a bazina with mound and tumuli (ER1-5 and ER1-8) (Fig. 4.12b). Corbeille SL4-1, Sluguilla Lawaj is a structure superimposed on (or perhaps part of) a mounded crescent, while the small corbeilles in detailed survey area TF6 (Fig 4.12a) are part of a much wider assemblage of stone features representing a variety of types.

The single corbeille recorded in the Southern Sector (ZG0-18) is located in the sand sea east of Zoug, in an area

Fig. 4.8. Stone platforms or pavements in the vicinity of Lajuad; a. features LD1-3; b. LD1-34; c. LD1-19, d. linear platform LD1-59.

Fig. 4.9. Stone discs; a. possible stone disc LD1-2 at Lajuad; b. MH1-30 north of Mheres.

containing abundant stone features (many situated in closely packed assemblages or funerary complexes as discussed below) and artefact scatters.

The assemblage of monuments including the two corbeilles in area ER1 (Wadi Erni, Northern Sector), situated on a small flat-topped hill and an adjacent saddle with a good view of the surrounding plains, is of particular interest. A few engravings are present at this location, including one representing what appears to be a cow with another zoomorph depicted inside its body

Fig. 4.10. a. Bazina with annex and standing stone defining orientation of 131° up-slope (ZG31-1); b. bazina with mound (TR2-1); c. western side of bazina TF4-5; d. 'chapel' or annex feature on easter side of TF4-5.

Fig. 4.11. a. Stepped bazina DR1-1, showing collapsed section; b. inferred degraded stepped bazina ER1-1.

(see below). This is suggestive of the association of corbeilles and other monuments with cattle burials in the Libyan Fezzan, where these monuments are sometimes accompanied by cattle engravings (di Lernia 2006; di Lernia and Gallinaro 2010; di Lernia *et al.* 2013).

Falcates

CRESCENT AND ANTENNA-TYPE MONUMENTS

After tumuli, crescent and antenna-type monuments (Chapter 3) are the most commonly recorded stone features, occurring throughout the Free Zone. These features include

Fig. 4.12. a. Small corbeille TF6-25; b. corbeille ER1-5.

regular crescents (Plate 4a), crescents with tails (Plate 4b), paved crescents (Plate 4c), crescent antennae (Plates 4d and 5a), V-type monuments (Plate 5b), axle-shaped monuments (Plate 5c), and mounded crescents (Plate 5d). The survey of crescent/antenna-type monuments further emphasises that the boundaries between some of the types of crescent/antenna monuments are very porous, and classification can be problematic even when based on careful recording in the field. Indeed, we are imposing these typological conventions on structures whose characteristics represent a continuum of construction techniques rather than conform to strict typological boundaries. While the classification of these features into the different types listed above is useful for differentiating between quite different monuments that are often described using the same terminology (Chapter 3), it is also useful to approach them collectively.

Crescent and antenna-type monuments together represent approximately 10% of the stone features (63 out of 660) recorded throughout the Free Zone, and 12% and 7% of the stone features in the Northern and Southern Sectors respectively. If mounded crescents are excluded, leaving just 'antenna-type' monuments (which include crescents with long tails or arms) the percentage of these features for the Northern Sector falls to 8%.

In the intensively surveyed TF1 Study Area, in which more stone structures were recorded than in either the Southern Sector or the remainder of the Northern Sector during the extensive survey, antenna-type monuments represent just over 3% of stone features. This suggests that the percentage of these features represented in the extensive survey results may be inflated by the fact that they tend to be large and prominent, meaning that they are more likely to be identified than many other types of feature during opportunistic survey work. The results of the extensive survey suggest that antenna-type monuments tend to occur in isolation from each other (they may occur in areas housing a high density of other monuments, or in areas with low densities of stone features), with regular crescents sometimes occurring in small groups. Groups of three regular crescents occur in detailed survey areas LD1 (Lajuad, Southern Sector) and GF2 (Tin Gufuf, Southern Sector), both of which cover less than 0.15sq. km and house other monumental stone features. Two regular crescents were recorded in close proximity to one another at Aij (Southern Sector), while single regular crescents were recorded at Elous Lajaram (Northern Sector), LD0 (Lajuad, Southern Sector), and in a number of locations in the large area designated TF0 around Tifariti (Northern Sector).

While the proportions of antenna-type monuments initially do not suggest any significant differences between the Northern and Southern Sectors, there is considerable variation between the two sectors in terms of the *types* of antenna-type features identified during the extensive survey, and the abundance of different types of antenna monuments in the survey records. Most striking is the lack of any recorded crescent antennae or paved crescents in the Southern Sector, compared with the significant (although still relatively small) numbers recorded in the north (17 and 10 respectively).

Only one V-type monument (IR3-3, Irghraywa, Fig. 4.13a Plate 5b), and one crescent with tails (TF4-1, Tifariti, Northern Sector, Plate 4b) have been recorded in the Northern Sector (including the TF1 Study Area), although Saenz de Buruaga (2014, 122) presents a photograph of what appears to be a V-type monument in the northern part of the Southern Sector, in the area of Azaig Bedrag. Crescents with tails may be under-reported due to the subtlety of the 'tails' and their vulnerability to disturbance or removal.

The single V-type monument recorded during the extensive survey (IR3-3, Fig. 4.13a) has been constructed on a slightly raised area on an extensive sand and gravel plain north of the upland areas west of Mheres in area IR1. In plan it is similar to monuments described by di Lernia *et al.* (2002a, c), Faleschini (1997), Gauthier and Gauthier (1998), and Merighi *et al.* (2002), from the Fezzan region

Fig. 4.13. a. View along one of the arms of V-type monument IR3-3; b. mounded crescent in Mauritania, near the southern border with Western Sahara.

of Libya. This feature is very similar in some respects to the crescent antenna monuments recorded elsewhere in the Northern Sector; the two straight arms that extend from the central cairn are some 2m wide and 20m long, and consist of loosely packed stones, closely resembling those of crescent antennae. However, rather than an elongated cairn, the centre of the monument consists of a circular tumulus just under a metre in height and some 7m in diameter. Crescent antennae TF5-4 and TF5-5 are quite similar in appearance to IR3-3, with less elongated central cairns than the other crescent antennae recorded in the Northern Sector (Plates 4d and 5b).

Only one mounded crescent has been recorded in the Southern Sector, at Lajuad (LD1-51), suggesting that this type of monument may be more typical of the Northern Sector. More detailed investigation might indicate that the mounded crescent at Lajuad is different in nature from those in the north; it is certainly smaller than many of the examples in the Northern Sector. However, mounded crescents have been sighted by one of us (Gauthier) in Mauritania, south of the Southern Sector of the Free Zone and close to the border between Western Sahara and Mauritania, indicating that such features are not restricted to the latitudes of the Northern Sector (Fig. 4.13b).

While regular crescents (Fig 4.14a) have been recorded in both the Northern and Southern Sectors, significantly more (18) have been recorded in the latter than in the former (6). The largest antenna-type monument recorded to date in the Free Zone is a regular crescent at Aij (feature AJ1-1), whose southern and northern arms terminate c. 180m and c. 270m respectively from the middle of the central cairn, with the ends of the arms separated by a distance of c. 280m.

Some of the examples in the north (*e.g.* BD1-6, Fig. 4.14b) have a very shallow curvature, in contrast with the much more pronounced curvature of the crescents in the south (Fig. 4.14a). The shallow-curvature crescents of the north arguably bear as much resemblance to axle-shaped monuments as they do their counterparts in the Southern Sector. In the Northern Sector, the distinction between regular crescents, paved crescents and crescent antennae is often somewhat blurred, with many individual crescent-type monuments exhibiting characteristics of more than one of these types. For example, some of the crescent antennae in area MH1 exhibit a low tumulus that grades into what might be interpreted as a narrow pavement like a paved crescent, despite having extensions faithful to the crescent antenna type (Fig. 4.14c and Plate 5a).

One crescent antenna monument in detailed survey area TF6 north of Tifariti (TF6-4) has been reworked, with materials from the central area re-used to construct a complex monument (Fig. 4.14d). This is significant as it rules out the possibility that complex monuments represent a distinct earlier phase of monument building than crescent antennae. Either complex monuments represent a later phase of construction, or the construction of these two monument types overlapped.

Of the 61 crescent and antenna-type monuments that have been recorded to date, information on orientation (Chapter 3) is available for 56. Of these, only four (two mounded crescents, one regular crescent and one crescent antenna) have a westerly component to their orientation (Fig. 4.15). Three of these monuments (two mounded crescents and a crescent antenna in the Northern Sector) are oriented at approximately 286°, and the fourth (AZ2-1, a regular crescent in the Southern Sector) is oriented at 291° to True North. The remaining examples all have orientations between northeast (65°) and southeast (131°).

There is a strong clustering of orientations between 80° and 111°, with regular crescents making the largest contribution to this clustering. The orientations of crescent/antenna-type monuments exhibit a much more pronounced clustering than those of tumuli, with 46 out of 56 such features oriented in a direction between the extreme positions of the sun on the summer and winter solstices. Allowing for a measurement error of ±5°, up to 48 orientations fall within this range (assuming the error increases the

Fig. 4.14. a. Regular crescent LD3-1; b. crescent BD1-6, showing shallow curvature; c. view from central tumulus of crescent antenna MH1-32, the central area of which also exhibits the platform-like character of a paved crescent; d. complex monument constructed on top of, and using materials from, a crescent antenna near Tifariti (feature TF6-4).

measured bearing of the more southerly orientations). Of the remaining eight orientations, four are westerly and in opposite directions to orientations within the range of the summer and winter solar solstices. The remaining four are potentially within 2°, 3°, 4° and 9° of the extreme position of the sun on the winter solstice when a ±5° error margin is applied (*i.e.* to reduce the measured orientation).

An even greater proportion of crescent/antenna-type monuments fall within the range of the northern and southern moon standstills. 48 measured orientations fall in this range, potentially rising to 51 when the margin of error is considered. Of the remaining five orientations, four are westerly as discussed above, and one is potentially within 4° of the southern moon standstill if the margin of error is considered.

Of the 24 regular crescents recorded, 22 have orientations between 81° and 115°, with one at 65° and one (AZ2-1, mentioned above) having a westerly component to its orientation (291°). Within the margin of error, all of these orientations are compatible with a lunar alignment (*i.e.*

between the extreme positions of the rising and setting moon), with the possible exception of one axle-type monument in the Northern Sector, whose orientation is only 4° beyond the southern moon standstill (Fig. 4.15). In the Southern Sector, where recorded crescent/antenna-type monuments are represented solely by regular crescents, the orientations of these features are constrained between 65° and 110°, with the exception of the westerly oriented crescent (AZ2-1), which is paired with an easterly crescent. In the Southern Sector, crescent orientations exhibit a strong clustering between 90° and 110° (15 out of 18 orientations).

These results are compatible with the findings of Gauthier (2009), who reports an average orientation for crescent and antenna-type monuments of 97° for the whole Sahara, 102° for the region around Tindouf, and 108° for the Sahara west of Atar (Mauritania). These orientations, determined by a combination of field survey and examination of crescent monuments in high-resolution bands of Google Earth imagery, are based on an analysis of 1041, 133, and 302 east-oriented crescents respectively. The number of west-oriented

Fig. 4.15. Orientations of crescent and antenna-type monuments, including regular and paved crescents, crescent antenna monuments, crescents with tails, mounded crescents, axle-shaped monuments and linear V-type monuments, for which secure orientation figures are available. Numbers of monuments are indicated by the integers on the concentric circles. NMS and SMS indicate the positions of the northern and southern moon standstill respectively (the extreme azimuths achieved by the rising/setting moon). SSS and SMS indicate the positions of the rising/setting sun on the summer and winter solstices respectively. Azimuths have been corrected for declination (Chapter 3).

Fig. 4.16. a. Examples of apparent paved crescents in Mauritania near the border with Western Sahara, on Google Earth imagery; b. quartz feature with plan of crescent antenna in Western Sahara, west of the berm near the coast 100km north of the border with Mauritania.

crescents is less than a tenth of the number of those oriented to the east, with the corresponding number of crescents having a west orientation being 87, 8 and 2 (Gauthier 2009). Gauthier (2009) points out that in the Sahara at large, there is a strong tendency for stone monuments to be aligned along azimuths within the angular range of the rising moon. However, only 85% of crescents are thus aligned, suggesting that other factors are also important, and Gauthier (2009) suggests that a significant number of crescents are aligned along ridges, with the orientation of the ridge determining, or at least influencing, the orientation of the monument. This certainly fits the pattern of crescents recorded in the Free Zone, which tend to be constructed adjacent to the ridges from whose material they are constructed, and whose topography necessarily influences their layout.

Of the 667 antenna-type monuments identified in the Free Zone on the high resolution, Google Earth imagery, only 27 (4.4% of 214 examples) have a westerly component to their orientation. Westerly orientations among these monuments are more common in the Northern Sector (9.8% of 394 examples) than in the Southern Sector (1.5%).

The above observations suggest differences between the Northern and Southern Sectors in the types of crescent/ antenna monuments present, and in the way in which these monuments have been constructed. Of course, caution must be exercised in drawing conclusions about the differences, given the small sample of these features; for example, the number of antenna-type monuments identified in the field is less than 10% of the total number of monuments provisionally identified on the Google Earth imagery throughout the Free Zone. This imagery suggests that paved crescents and crescent antennae may be present in the latitudes south of the Northern Sector, although, as discussed above, it is often difficult to distinguish between certain types of crescent (particularly regular crescents and crescent antennae) based purely on Google Earth imagery. Figure 4.16a shows a Google Earth capture of two possible paved crescents south of Western Sahara in Mauritania, and a very low-relief feature made from quartz gravel that, in its plan, resembles a paved crescent, east of the coastal road in the Moroccan-controlled part of Western Sahara some 100km north of the border with Mauritania.

Nonetheless, the high resolution, Google Earth imagery does support the conclusion that there are differences between northern and southern latitudes in the prevalence of

Fig. 4.17. Features with the footprints of regular crescents (dots) and other antenna-type forms (circles) as identified in the high resolution bands of Google Earth imagery.

different monument types. Fig. 4.17 shows the distribution within the HR bands of features with the footprint of regular crescents (with prominently curved arms), and of the more V-type shape characteristic of paved crescents, crescent antennae and other V-type monuments (with much more linear arms). While these two forms – 'crescents' and 'Vs' – appear to coexist at all latitudes at which antenna-type monuments are found, there is a striking predominance of regular crescent type forms in the more southerly latitudes, versus other, 'V-type' antenna monuments in more northerly latitudes (Gauthier and Gauthier 2008b). Only a few of the latter features have been identified in the Southern Sector of the Free Zone on the Google Earth imagery.

MONUMENTS WITH LINES OF ORTHOSTATS, INCLUDING COMPLEX MONUMENTS AND RIDGE MONUMENTS

Monuments incorporating lines of orthostats have been recorded throughout the Free Zone, with complex monuments (Chapter 3) being the most numerous among these types. However, to date, complex monuments have been recorded only in the Northern Sector, and ridge monuments only in the Southern Sector. Monuments with short lines of orthostats that cannot be classified as complex or ridge monuments were recorded in only the Southern Sector during the extensive survey, although such monuments are present in the TF1 intensive survey area (Plate 6a), illustrating that they are not restricted to the south. Sáenz de Buruaga (2010, 121) describes monuments of this type and presents a photograph of one such example with around a dozen orthostats, including a very large (c. 3m), collapsed central orthostat.

Complex monuments have been recorded in relative abundance in the Northern Sector, with 15 of these features recorded in the TF1 Study Area, and a further 13 identified during the extensive survey (Fig. 4.18). As discussed above, a number of tumuli with arms/wings in area TR2 exhibit characteristics reminiscent of complex monuments (footprint, possible collapsed orthostats), despite their small size and low relief. Notable clusters of complex monuments occur in the TF1 Study Area and at Limsharha (area LM1) north of Tifariti near the Berm (Fig. 4.18). Some of the complex monuments in the vicinities of Limsharha, Sluguilla Lawaj and Tifariti have very well defined, outlined rear enclosures (Plate 6c), and in at least one case (LM1-1) the rear enclosure is paved and partly delimited by four small orthostats (Fig. 4.19a). In other examples, such as those at Wadi Ghaddar Talhu (GT4-1) and Irghraywa (IR4-5), this well-defined rear enclosure is replaced by a more

Fig. 4.18. Locations of complex monuments (dots) in the Northern Sector (these features have not yet been identified in the Southern Sector).

extensive and less well constrained pavement of loosely packed boulders (Fig. 4.19b). Also as discussed above, feature TF6-4 is a crescent antenna monument on top of which, and from which, a complex monument has been constructed (Fig. 4.14d), indicating a later date for the latter.

Measured orientations of complex monuments range from 86° to 216° (corrected for declination). Of the eight complex monuments for which orientations were obtained, two are oriented approximately east (86° and 94°), two approximately south (176° and 180°), two approximately southwest (216°), and two approximately southeast (130° and 152°).

Only three ridge monuments were recorded, all in the vicinity of Lajuad. Two of these form elements within a funerary complex (LD0-3, discussed in more detail below). One of these monuments is linear in form, with a line of *c.* 50 orthostats extending for many tens of metres (Plate 6b). The highest orthostats reach *c.* 1m in height (although the largest have collapsed) and have been placed at the centre of the monument, where they traverse a central cairn, running to the east of the centre of the cairn. The second ridge monument at LD0-3 has a sinuous appearance, with shorter and less well defined ridge-line extensions. The orthostats of this monument curve around a central cairn, giving this element of the monument a corbeille-like appearance on its eastern side (Fig. 4.19c). We are not aware of any similar strctures elsehere in the Sahara, suggesting that this second ridge monument may be specific to the Study Area.

Other cairns associated with a small number of orthostats were identified in both the Northern and Southern Sectors. Two such features were recorded in area AZ1 (Azaig Bedrag, Southern Sector), and a further two in area ZG0 (Zoug, Southern Sector). In ZG1, these features consist of very low-relief, poorly-defined cairns with two and five small orthostats placed in series on the eastern (ZG0-14a) and north-northeastern (ZG0-16) sides. Similar features were recorded in AZ1, but with larger orthostats numbering three (AZ1-17) and five (AZ1-18), with two of the orthostats of the former angled towards each other (Fig. 4.19d), and those of the latter being more-or-less vertical. The largest orthstat of AZ1-17 is *c.* 1.75m long above the ground; these features are in an area containing a number of isolated standing stones (see below). Only one such feature (WS410) has been recorded in the Northern Sector, in the TF1 Study Area, on the raised gravel plain that forms the west 'bank' of the Wadi Tifariti, half a kilometre southeast of the standing stones that form the focus of this concentration of stone features (WS001, Chapter 5). This has three extant orthostats, and a space that appears to have housed a fourth. These are flat slabs set vertically into the ground on the southeast side of a rough cairn.

Fig. 4.19. a. Complex monument LM1-1a, with well defined rear paved area with orthostats; b. complex monument GT4-1, with less well defined rear paved area; c. sinuous ridge monument, part of funerary complex LD0-3; d. other monument with orthostats, AZ1-17.

MONUMENTS WITH AUXILLIARY TOWERS

A monument with auxilliary towers was recorded just north of the MH1 detailed survey area, on the west bank of the Wadi Ratnia (Plate 6d). This feature comprises a large tumulus that appears to have been reworked as a way marker (with a tall pile of stones on top of the cairn), to the east of which are ten low (less than 1m high) 'towers' arranged in a row oriented north–south, giving the entire assemblage an eastward orientation (Fig. 4.20a, b and Plate 6d). Between the main cairn and the towers are an enclosure with walls c. 0.50m high (interpreted as a mosque constructed after, and using material from, the original monument), and a U-shaped enclosure flush with the ground and opening to the northeast (Fig. 4.20a, b).

The large stepped bazina DR1-1 (Wadi Dirt, Northern Sector) may be associated with auxilliary 'towers', that take the form of circular and U-shaped structures. However, these are accompanied by apparent kerb burials and upright, flat slabs, and it is possible that some or all of these structures have been built using material from the collapsed section of the bazina itself. Alternatively, structures that were contemporaneous with, and associated with, the bazina, may have been reworked.

Petroforms

GOULETS

Eleven Type 1 and three Type 2 goulets (Chapter 3, Plate 7a, b) have been recorded in the Northern Sector, while only one goulet, a Type 1 (GF2-6, Tin Gufuf, Southern Sector), has been identified in the Southern Sector (Fig. 4.21). The largest of these goulets (a Type 1, IR1-12, Irghraywa, Northern Sector) is c. 85m in length, and the smallest (a Type 2, IR1-11) is some 12m across at its widest point, perpendicular to the corridor (Plate 7b). As noted in Chapter 5 and described by Brooks *et al.* (2006), an exceptionally large goulet (WS006), more than three times larger than IR1-12, has been recorded in the TF1 Study Area.

The Type 1 goulets recorded include features whose narrow end houses a cairn (GF2-6, IR1-12, MH1-17, TF6-36, TF6-44) (Fig. 22a) or a platform/paved area without a

cairn (TF6-14) (Fig. 22b), or where the corridor extends to the perimeter at the narrow end. In the latter, stone paving is present at the ends of the enclosures either side of the corridor, but absent within the corridor. Some goulets have a more ambiguous structure at their narrow end, with loose scatters of larger boulders, rather than a cairn, on the paved area (*e.g.* TF6-38) (Fig. 4.22c). Dense quartz scatters are associated with many goulets, of both types.

As in the TF1 study area, some goulets are associated with stone rings (including multiple concentric rings), stone outlines and stone concentrations/spreads (*e.g.* IR1-12 and MH1-17). Type-1 goulets IR1-12 and TF6-44 are both associated with stone rings which differ in character and location, with that of the former offset to the north of the line of the corridor, and that of the former more-or-less in line with the corridor. TF6-44 is also associated with a number of stone concentrations (see below), much like the very large goulet (WS006) in the TF1 Study Area (Plate 7c), as well as with features that have the form of complex monuments but that are much smaller than the complex monuments recorded elsewhere (Fig. 4.23a). Like many goulets, IR1-12 houses a later kerb burial, constructed from materials taken from the goulet (Fig. 4.23b).

IR1-12 is particularly notable for the presence, within its enclosures and just outside, of stone concentrations and outlines that may be representations of animals. These putative pictograms or 'zoomorphs' are formed by dense concentrations of small stones of different types and colours, in a mosaic-like style (Fig. 4.24 and Plate

Fig. 4.20. Monument with auxilliary towers north of detailed survey area MH1, viewed from the south (a) and southeast (b).

Fig. 4.21. Distribution of known Type-1 goulets, based on field observations, identification on Google Earth imagery, and literature (Gauthier, 2012/2013).

Fig. 4.23. a. Goulet IR1-12 photographed from the paved area at the narrow end, showing corridor and kerb burial (just right of centre) apparently constructed from materials taken from the near end of the corridor; b. small stone feature with form of complex monument adjacent to goulet TF6-44.

Fig. 4.22. a. Type-1 goulet with prominent cairn at narrow end (MH1-17); b. Type-1 goulet with platform but no cairn (TF6-14); c. Type-1 goulet with platform and scatter of large boulders (TF6-38).

9a), and are situated close to other stone arrangements within the same goulet enclosure (Plate 9b). The 'head' of one of the zoomorphs is represented by red stones and white quartzite, in contrast to the grey used for the remainder of the 'body' (Plate 9a). The pictograms may represent wild animals or possibly domestic cattle, given the association of stone monuments with prehistoric cattle herding cultures across the Sahara (Chaix 1989; di Lernia 2006; di Lernia *et al.* 2013; Ferhat *et al.* 1996; Paris 1997 and 2000) although their precise nature remains enigmatic. Other such pictograms are suggested by concentrations of coloured stones in the enclosures of goulets BD1-11 (Bou Dheir, Northern Sector), MH1-17 (Mheres, Northern Sector) and TF6-44 (Tifariti, Northern Sector), although if these are indeed pictograms they are more degraded than those identified within IR1-12.

Orientations have been determined for 12 goulets, and range from 36° to 282° (corrected for declination). All but two goulets (one Type 1 and one Type 2) have orientations with an easterly component (*i.e.* on bearings of less than 180°). The single example in the Southern Sector has an orientation of 75°. The giant goulet (WS006) recorded in the TF1 Study Area is aligned east–west, with the paved area at the west, with the corridor aligning with a flat-topped hill to the west (Chapter 5, Plate 7c).

The imbalance in the numbers of goulets recorded in the Northern and Southern Sectors suggest that these

Fig. 4.24. Possible pictograms associated with goulets; a. Large possible zoomorph resembling an elephant within the south enclosure of IR1-12; b. possible remains of pictogram outside enclosure of TF6-44.

features are more characteristic of the north. Figure 4.21 shows the locations of known Type 1 goulets, based on a combination of field observations, literature review and the identification of goulets on the high-resolution Google Earth imagery (Gauthier, 2012/2013). The single goulet recorded to date in the Southern Sector (GF2-6, Plate 7d) is situated some 300km beyond the previously established southern limit of these features. It has a true tumulus at its eastern end suggestive of the 'eastern goulets' in the central Sahara descrined by Gauthier (2015), and its corridor is aligned approximately on a cone-shaped hill on the horizon. Goulets were noted during the March 2005 field season at Bir Lemuesat in Mauritania, south of the Northern Sector, while en route from Tindouf to Mijek. However, this latitude corresponds to the northernmost extremity of the Southern Sector, and these monuments, already noted by Gobin (1937) and Monod (1948), may be viewed as the southernmost examples in the main cluster of known goulets, with GF2-6 representing a geographic anomaly, at least on the basis of current data. This observation, combined with the evidence for pictograms in association with some goulets, and the largest known goulet identified in the Sahara to date (WS006) being located in the TF1 area (Chapter 5; Brooks *et al.* 2006; Milburn 2005), underlines the importance of the Free Zone for the study of these types of stone features.

STANDING STONES

Both isolated standing stones and groups of standing stones were recorded during the intensive survey. Four large, isolated standing stones were recorded in the Southern Sector, in areas AZ1, LD7 and SE1. Each of these is associated with a concentration of stones, generally on the west side of the standing stone, that in some instances might be interpreted as a very crude and low-relief cairn or tumulus. Nonetheless, the standing stones are by far the dominant elements of these features, exceeding 1.50m, and in some cases 2m, in height (Fig. 4.25a, b). Similar features have been recorded by Sáenz de Buruaga (2010, 123), with one example of a single standing stone *c.* 3.50m high.

In the Northern Sector, four standing stone features were recorded during the extensive survey, each very different in character. TF0-38 is an incomplete circle of upright stones up to *c.* 1m in height, open to the southeast, with two larger standing stones east of the centre of the circle (Fig. 4.25c, Plate 8d). Kerb burials (presumably Islamic) have been constructed on the east-northeast side of the circle, most likely through re-use of materials from the original structure. TF0-38 includes the largest number of standing stones after the assemblage of around 65 standing stones (WS001, Plate 8c) in the nearby TF1 Study Area (Chapter 5), and is also situated on a slighlty elevated sand and gravel plain, at the confluence of two major drainage channels which merge immediately to the north to pass through a gap in a prominent ridge. The surrounding area, housing broadly east–west ridges to the north and south that enclose a sand and gravel plain incised by wadi channels, has not yet been the target of detailed survey, although a very rapid inspection of the section of the ridge nearest to the stone circle revealed no obvious evidence of monumental stone features. Clearly this feature and the surroundig area is a priority for future study.

RK1-1 (Rekeiz Lemgassem, Northern Sector) is an assemblage of around 25 standing stones adjacent to a heavily disturbed tumulus, material from which has been used to construct a kerb burial. Most of these standing stones are less than 0.75m in height, but two are *c.* 2m high.

TF0-33 (Tifariti, Northern Sector) is an arrangement of four small (30–60cm) standing stones arranged as approximate corners of a square. SL6-6 is a single standing stone *c.* 0.75m high, in the vicinity of a large tumulus and smaller tumulus, with which it may be associated (Fig. 4.25d).

Numerous other standing stones are associated with or embedded in stone monuments throughout the areas

Fig. 4.25. a. Single standing stone northeast of Lajuad (LD7-1); b. standing stone with low, poorly-defined cairn in the central part of the Southern Sector (SE1-1); c. standing stones forming circle north of Tifariti (TF0-38); d. single, small standing stone probably associated with adjacent tumulus in northeast of Northern Sector (SE6-6).

surveyed in both sectors, and often act to orient these monuments in particular directions.

STONE RINGS

Outside the TF1 Study Area, the only stone rings identified to date in the Northern Sector are those associated with goulets. A single stone ring is situated beyond the wide end of goulet IR1-12 (Fig. 4.26a), and rings constructed from single and multiple (concentric) circular arrangements of stones are associated with TF6-44 (Fig. 4.26b and Plate 8a).

In the Southern Sector, stone rings have been identified at Lektaytayghra (LK3-3 and LK3-4) and Lajuad (LD1-48). As discussed in more detail below, LK3-3 may be associated with a number of geographic and topographic alignments (Fig. 4.26c, d), while LD1-48 is an ambiguous feature that could be interpreted as a stone platform/pavement.

LK3-3 and the ring associated with goulet IR1-12 are distinct from the other stone rings recorded during the extensive and intensive survey, in that they are formed from boulders placed on the ground (Fig. 4.26a, c, d), rather than stones embedded in the ground (Fig. 4.26b). In contrast with other stones rings, LK3-3 is formed from quite loosely spaced boulders (Fig. 4.26c, d). Nonetheless, these two features are distinct from stone outlines in that their construction suggests they are 'monuments' with ritual or other purpose, rather than the remnants of some more mundane activity.

LK3-3 is of particular interest as it exhibits possible relationships and alignments with other built stone features and elements of the landscape. This feature consists of low, squarish boulders arranged in a ring and quite widely spaced, situated on a low, northwest–southeast trending ridge. The centre of the ring is marked by a single boulder. A tumulus is situated directly north of the centre, in line with a gap in a series of hills on the horizon. In the opposite direction, a prominent, isolated peak lies on the horizon on a to the south (Fig. 4.26c). On a bearing of 326° from the centre of the circle (corrected for declination), two closely spaced boulders in

Fig. 4.26. a. Stone ring situated beyond wide end of goulet IR1-12 and to north of corridor alingment; b. stone ring situated beyond wide end of goulet TF6-44 and in line with corridor; c. view to south from centre of stone ring LK3-3, towards prominent peak on the horizon; d. view through centre of LK-3 on a bearing of 168° through two closely spaced stones in an otherwise empty section of the feature's perimeter.

an otherwise open section of the circle's perimeter frame a peak at the western end of the range of hills to the north. In the opposite direction, on a bearing of 168°, a gap in another series of hills can be seen on the horizon (Fig. 4.26d). While these orientations may be fortuitous, they suggest a strong possibility that the circle has been constructed with some navigational or astronomical purpose. Deliberate orientations are also suggested by the construction of LK3-4, although this feature was not examined in detail.

HALF CIRCLES

One assemblage of half circles (TF0-42) was recorded north of Tifariti, a few hundred metres west of the Wadi Tifariti and some 5km southeast of the TF1 Study Area, in which further half circles were recorded (Chapter 5). This assemblage consists of over a dozen U-shaped arrangements of stones, each some 3m across, placed on the ground rather than embedded in it, arranged in a large semi-circle (Fig. 4.27a, b) (Plate 8b). This assemblage is similar to others recorded in the TF1 Study Area (Chapter 5), for example WS359, which incorporates 80 half circles with an average 'diameter' of 2.80m and thickness of *c.* 0.50m,

arranged in a large arc. Similar circles have been observed by one of us (Gauthier) in southern Morocco and Algeria, and the existence of further such features in the Northern Sector of the Free Zone is indicated by satellite imagery. Typically, the arc formed by the individual half circles opens towards the south-southeast, although at least one opens to the west.

STONE ALIGNMENTS

Stone alignments were identified in the Northern Sector in detailed survey area TF6 (Tifariti), area RK1 (Rekeiz Lemgassem), and area LL1 near Bir Lahlou. In the Southern Sector, stone alignments were recorded in areas GF2 (Tin Gufuf), LD0 (Lajuad), ZG0 and ZG1 (Zoug). In area LL1, two stone alignments (one diverging from the other) form part of a funerary complex, physically linking a number of other stone features (Fig. 4.28a). An arced stone alignment serves a similar purpose in funerary complex LD0-3, where it encloses a number of stone features (Fig. 4.28b). These funerary complexes are discussed in more detail below.

The alignment at ZG0-15 is most likely an open-air mosque, situated as it is by a number of Islamic kerb burials and with a slightly convex form towards the east

Fig. 4.27. a. Arrangement of half circles, arranged in a semi-circle, feature TF0-42; b. detail of one of the half circles.

Fig. 4.28. a. Stone alignment joining monuments in funerary complex at LL1, showing section running to rear of crescent visible to right of centre; b. section of arced stone alignment forming boundary of funerary complex LD0-3 (beyond kerb burial and small tumulus in foreground); c. alignment whose most likely function is an open-air mosque at ZG0-15, with kerb burials visible in background and enclosure of burial complex left of centre; d. short alignment of large stones forming feature ZG1-8.

(Fig. 4.28c). The remaining stone alignments are somewhat more enigmatic. One of these is associated with a group of standing stones some 10m east of a large disturbed tumulus that has been used as a source of material for an adjacent kerb burial. This entire assemblage constitutes feature RK1-1. The stone alignment itself runs for some 10m in a northerly direction away from the assemblage of standing stones. Another alignment is formed by a line of boulders and smaller stones emanating from the main body of crescent antenna monument TF6-23, approximately in the direction of this monument's orientation (70°). This alignment physically joins TF0-23 with a nearby ridge, which the monument faces. The nature of the other two alignments at Zoug (ZG1-1 and ZG1-8) is unknown. These are constructed from *c*. 12 and six stones, and are concave in a westerly and easterly direction, respectively (Fig. 4.28d). They may represent low windbreaks (perhaps for fires), or have some other purpose that is lost to us; indeed, their status as stone alignments is arguable.

Other features

KERB BURIALS

Kerb burials are among the most abundant stone features in the Free Zone, after tumuli, antenna-type monuments, and stone concentrations. Kerb burials may be outlined with vertical flat slabs or with rounded boulders, and some incorporate a single standing stone at one or both ends (Fig. 4.29a, b). The vast majority of these features appear to be Islamic burials, which frequently occur in groups, and are often constructed from materials scavenged from prehistoric monuments. Typically, these are oval enclosures outlined by a single course of slabs or boulders that nonetheless protrude noticeably from the ground, by some tens of cm. The enclosure itself is usually unfilled. However, some kerb burials may be pre-Islamic.

One example of a possible pre-Islamic kerb burial is a linear feature some 2m long with a standing stone at its eastern end, within the funerary complex LD0-3 (Lajuad, Southern Sector) (Fig. 4.29b). Another is a pair of kerb burials in the nearby detailed survey area of LD2, together designated as feature LD2-2. These are situated just a metre apart with their long-axes aligned approximately north-northwest by south-southeast, and with short upright slabs at each end. These features are all significantly narrower than typical Islamic kerb burials, and differ from them in that their interiors are paved or 'bridged' by slabs laid in a single course.

A pair of features (TR2-3) on the east bank of the Wadi Ternit (Northern Sector) have been classified as kerb burials, but are quite different in nature to the other kerb burials recorded in the Free Zone, and indeed are unique among the features identified to date. These features consist of elongated sandstone slabs placed horizontally and embedded into the ground to define approximately rectangular enclosures of dimensions 1.72 × 0.72m and

Fig. 4.29. a. Examples of (presumed) Islamic kerb burials (part of assemblage of seven such features designated IR4-1); b. possible prehistoric kerb burial with a funerary complex at Lajuad (LD0-3).

2.80 × 0.84m, situated side by side and separated by a minimum distance of 57cm (Fig. 4.30). The long axes of both are aligned approximately northeast–southwest. One end of each enclosure is defined by a single boulder, with the other end defined by a row of short upright stones. The orientation of the features, defined as the direction along their long axes towards the latter end, was measured as 232° ± 5°. Three upright slabs protrude up to 0.20m from the ground beyond the foot of the shorter enclosure and adjacent to the lower end of the longer enclosure. Further upright slabs have been placed to the southeast of these uprights, suggesting a possible alignment of around 125°. A notable feature of these structures is the similar appearance of the desert pavement inside and outside the enclosures, suggesting either that (i) the desert pavement both inside and outside the structures has formed since the structures were constructed, or (ii) the existing desert pavement was disturbed during construction, but has since had sufficient time to recover more-or-less to its previous state. In some

Fig. 4.30. Structures recorded as TR2-3; a. viewed from the north with platform tumulus TR2-1 in the background; b. viewed from the southwest with possible reworked tumulus TR2-2 in the background.

areas this might be indicative of very great age; however, the rate of formation of desert pavement and desert varnish varies greatly depending on climatic conditions (Liu and Broecker 2000), and the rate of formation in this part of the Sahara has not been assessed.

It is tempting to interpret these features as graves and the dimensions and appearance of the enclosures would suggest the (probably contemporaneous) burial of an adult and child. However, such an interpretation is speculative, and it is unclear whether these features are funerary in nature: currently, their function remains unknown.

STONE OUTLINES

Stone outlines have been recorded at numerous locations throughout the Free Zone, but most frequently in the Southern Sector, and particularly in the detailed survey areas LD1 (Lajuad) and ZG1 (Zoug). Most stone outlines consist of stones placed in a roughly circular arrangement, or in an arrangement that forms part of a circle, with the stones much more loosely spaced than in a stone alignment or ring. These stone outlines range from less than a metre to around 6m in diameter. The smallest such outlines may be the remains of hearths, while the nature of the larger ones is unknown. Some stone outlines are very distinct, and easily distinguisable from stone rings and platforms. An example of such a feature is LD1-62 (Fig. 4.31a). Other stone outlines are much more ambiguous in terms of classification, and perhaps could be classified as stone platforms or stone rings (*e.g.* LD1-45, Fig. 4.31b). Generally, such features are classified as outlines where there is a lack of sufficiently distinct infill (for pavements) or other characteristcs suggesting their deliberate construction as long-lived 'monumental', navigational or astronomical structures (*e.g.* dense packing of stones or obvious alignments), although of course such purposes cannot be discounted.

Other stone outlines may be the remains of camps, for example TR2-21 (Wadi Ternit, Northern Sector), a squarish outline in which most of one side consists of a gap in the middle of which is a single long slab, giving the appearance of a hut foundation with two adjacent entrances (Fig. 4.31c). This may be the remains of a tent pitch.

Some outlines are much less distinct, such as LD1-33, which consists of six short upright stones embedded in the ground, four of which form two pairs facing each other in an east–west direction reminiscent of a kerb burial, and two of which are situated south of these pairs (Fig. 4.31d).

QUADRILITHS

A single structure consisting of a horizontal flat stone supported by four flat upright stones was recorded at site SL6-1 in the east of the Northern Sector, some 20km south-southeast of Sluguilla Lawaj and approximately 10km from the border with Mauritania (Fig. 4.32). While this structure is similar in construction to certain megalithic monuments found in Europe, such as the coits or cromlechs of the British Isles (Cooke 1996; Joussaume 1988), it is only 0.75m high and less than 2m in extent along its longest axis. The function of this feature therefore must be quite different from that of the superficially similar, but much larger, European structures.

The horizontal cap stone is supported by four upright stones rather than three, meaning that it cannot properly be described as a trilith, although its size is more in line with that of these structures (see, for example, a trilith recorded in the Fezzan region of Libya by Gauthier and Gauthier 1998). Next to this extant 'quadrilith' are four more upright slabs among a rough heap of flattish stones, beside which a large flat stone lies on the ground, suggesting that a second, similar structure once stood immediately next to the first (Fig. 4.32). The long axis of the composite structure (comprising the extant and the assumed collapsed structure) is aligned approximately north–south. The monument is situated on a raised gravel area on the east bank of a shallow wadi, approximately 1km southwest of a small concentration

Fig. 4.31. a. Stone outline LD1-62 at Lajaud; b. partial stone outline LD1-45 that exhibits some characteristics of a platform (boulders embedded in ground, some internal structure); c. possible remains a camp at Wadi Ternit (TR2-21); d. pooly defined stone outline LD1-33, with elements suggestive of a kerb burial.

Fig. 4.32. Quadrilith (feature SL6-1) recorded in the east of the Northern Sector, near the border with Mauritania.

of stone monuments, which include a crescent (SL6-4), a mounded crescent (SL6-3), two tumuli (SL6-2 and SL6-5) and a standing stone (SL6-6). This is the only structure of its kind recorded to date in the entire Free Zone. However, it is not unique in the wider western Saharan region: one of us (Gauthier) has observed a trilith west of the Adrar (Mauritania) and a structure including a quadrilith associated with a destroyed trilith is reported 15km east of Tidjikja, Mauritania (Siméoni 1991).

During a visit to Libya in February 2011, one of us (Gauthier) was informed that similar structures are used in circumcision rituals. However, the Tuareg of the Fezzan, as well as those from Ahaggar, believe these structures to be very old, and appear not to concern themselves with their original function(s).

STONE CONCENTRATIONS/SPREADS

Stone concentrations are the second most common recorded stone feature, after tumuli. The greatest density of stone concentrations recorded during the extensive survey work is in detailed survey area LD1 (Lajuad, Southern Sector). Some of these are very loose concentrations of a relatively

Fig. 4.33. a. Small, loose concentration of stones LD-37; b. concentration of larger boulders LD1-18; c. feature LD1-40, which is classified as a stone concentration but may be a poorly defined tumulus; d. stone concentration associated with crescent GF2-1.

small number stones (*e.g.* LD1-37, Fig. 4.33a), others are agglomerations of larger boulders (*e.g.* LD1-1, LD-17 and LD-18, Fig. 4.33b), while some are quite dense and extensive and might be very roughly made and low-relief tumuli or their remnants (*e.g.* LD1-10, LD1-15 and LD1-40, Fig. 4.33c). These variations are reflected in the other two detailed survey areas in the Southern Sector (GF2, Tin Gufuf and ZG1, Zoug). In GF2, stone concentrations occur in isolation, and also in association with crescent GF2-1 (Fig. 4.33d). Stone concentrations also occur in apparent association with monuments at Azaig Bedrag, specifically platform tumulus AZ1-2 and crescent AZ3-1. The cairns associated with the standing stone features in the Southern Sector (see discussion above) are also sufficiently small, coarsely constructed and low-relief that they might be described as stone concentrations; again, the boundary between different types of stone features is ambiguous and somewhat subjective, at least in the absence of evidence from excavation.

In the Northern Sector, stone concentrations have been recorded in detailed survey areas TR1, TR2 (Wadi Ternit) and TF6 (Tifariti). In area TR2, a single feature (TR2-1) consists of a number of small concentrations of stones, some of which might be classified as stone emplacements. In TR2, a single stone concentration (TR2-15) has the footprint of a rough mounded crescent, but consists of just a single course of loosely packed, flattish stones. This feature resembles the nearby features classified as tumuli with arms, and may be related (functionally and/or architecturally) to them.

Three stone concentrations designated as TF6-21 reflect the variations described above for the Southern Sector. The remaining stone concentrations recorded in TF6 occur in association with goulet TF6-44, and echo the association of these features with the very large goulet in TF1 (WS006, Chapter 5), with a number of stone concentrations occurring beyond the corridor and the wider ends of the enclosures of the goulet. In light of the apparent zoomorphic pictograms associated with goulet IR1-12 (above, Fig. 4.24, Plate 9a) and possibly other goulets, it is speculated that some of these stone concentrations may also be the remnants of pictograms (see above discussion of goulets). It is likely that an intensive mapping of some of the larger goulets throughout

the Free Zone would reveal a much larger number of stone concentrations; stone concentrations within the enclosures have not been recorded as independent features, and more of these features would probably be revealed outside the enclosures by intensive survey.

STONE EMPLACEMENTS, HEARTHS AND SHELTERS

Stone emplacements were recorded at a number of locations within detailed survey area TF6. Their small size means that these features are much more likely to be identified during detailed survey work, although even within a detailed survey it is likely that some of these features will be missed, and systematic fieldwalking is the most reliable means of detecting them.

Hearths were identified at four locations in the Northern Sector, in areas GT3 (Wadi Ghadar Talhu), RL2 (Rekeiz Lahmara) and RT3 (Wadi Ratnia). It is possible that some stone concentrations and stone outlines may also be the remains of hearths.

A number of three-sided (or in some cases four sided with gap/entrance) structures were recorded on the summit of the flat-topped hill of Garaat al-Masiad west of Tifariti (detailed survey area MS1, collectively classified as feature MS1-8), concentrated on the eastern side of the plateau forming the top of the hill, and situated near its edge (Fig. 4.34a, b). Most of these structures have the appearance of shelters, with walls constructed from layers of stone slabs, up to c. 1m in height, although at least one is made of a single course of large boulders and could be classified as a stone outline (Fig. 4.34b). Some of these structures evidently have been used in recent decades, apparent from the presence of spent cartridges, plastic bottles and modern fabrics, and recent disturbance of the materials from which some of the shelters are constructed. Some small structures have the appearance of gun emplacements and most likely date from the recent conflict between the Polisario and Morocco. Some scant metal remains of a modern structure were noted at the centre of the plateau, and local accounts indicate that the MINURSO peacekeeping force has been active on the plateau. It is plausible that some of the shelter-like structures date from older historical or prehistoric periods, having been reused in recent times, although this is conjecture.

FUNERARY COMPLEXES

Stone features most reasonably interpreted as funerary monuments are often concentrated in particular locations, as evident from the intensive and intensive survey work. The construction of some of these monuments is likely to have been influenced by the nature and position of pre-existing structures in these locations, for example through the positioning and orientation of a new structure so that it aligns with older structures. However, in rare instances distinct structures may be associated with each other very explicitly. This association might be apparent through the construction of monuments on top of or immediately

Fig. 4.34. Stone features at the top of the hill of Garaat al-Masiad; a. 3-sided structure that may have functioned as a shelter or windbreak; b. rounded structure that may be the remains of a shelter but that could be described as a stone outline.

adjacent to each other so that they are physically linked, from stone alignments that physically join together or 'enclose' a number of monuments, or through the setting out of monuments according to a plan that is repeated in multiple locations. The term 'funerary complex' is used here to describe collections of monuments that are linked together in such a way.

One such funerary complex, located some 11.50km southeast of Bir Lahlou (Area LL1) was subject to rapid recording during environmental survey work. This complex consists of a crescent monument (LL1-1) and two tumuli (LL1-2 and LL1-3), that are physically linked by a linear stone arrangement oriented at 200–210° and extending for some 100m. The northern end of the line is marked by two standing stones, some 4m south of which is a small outcrop of bedrock on which further stones have been piled (Fig. 4.35a). One of the tumuli is situated on the line, 52–57m south of the northern end of the line. A second line of stones diverges from the main line near this tumulus, at an angle of 160°, linking it with the second tumulus some

Fig. 4.35. Funerary complex south of Bir Lahlou (LL1); a. part of crescent monument showing linear stone arrangement that extends north to a modified outcrop beyond which are two standing stones; b. standing stones at end of alignment (foreground) with modified outcrop (centre of image).

Fig. 4.36. a. Funerary complex (LD0-3) at Lajuad, viewed from south; b. boulder with hollow filled with quartz pebbles at southwestern extremity of complex.

5m along the second line and east of the main line. The second stone line extends beyond the second tumulus. A concentration of quartz is located between the two tumuli. The crescent monument is situated on a naturally raised area just east of, and at the southern end of, the main stone line, which is constructed from larger boulders at this end (Fig. 4.35b).

A number of funerary complexes have been identified in the Southern Sector. LD0-3 at Lajuad is an assemblage of stone features contained within a well-defined stone perimeter spanning some 180° from north to south on the eastern side of a prominent hill (Fig. 4.36a). A ridge monument is embedded in the stone perimeter at the eastern edge of the complex. A collapsed standing stone at the centre of the line of orthostats associated with this monument appears to be aligned with a marker stone a few metres from the tumulus to define an orientation of 110°. The lines of upright stones emanating from the centre of this structure merge into the stone perimeter. The perimeter encloses two further ridge monuments (Plate 6b), a kerb burial, and a number of small circular structures/tumuli up to 2m across and of low relief, constructed from granite boulders on and between which quartz pebbles have been scattered (Plate 10c). The long axis of the kerb burial is oriented approximately northwest to southeast, with a single upright stone at the eastern end. The kerb burial and one of the tumuli are in a part of the enclosure containing a dense concentration of quartz gravel (Fig. 4.36a). In the southwest of the complex, at the foot of the hill, a boulder with a large hollow has been filled with quartz pebbles (Fig. 4.36b), which have also been placed on naturally occurring outcrops within the complex. Milburn (2012) suggests that such features might be ritual in nature (also see below).

In the far south of the Southern Sector, in the fringes of the Erg Azefal sand sea east of Zoug, three assemblages of tumuli have been identified (ZG19, ZG24 and ZG25), that may be described as funerary complexes. All three of these assemblages appear, based on rapid and superficial

examination, to have a similar configuration, as if laid out to a standard plan. In each assemblage individual tumuli physically merge with one another, with smaller tumuli constructed on the tops and sides of larger monuments (Fig. 4.37a). The largest tumulus (*c.* 12m in diameter and *c.* 4–5m in height in ZG24 and ZG25, and *c.* 20m in diameter and *c.* 5m in height in ZG19) is situated at the southeastern corner of the assemblage, with lines of tumuli extending to the north-east from a core of densely packed monuments (Fig. 4.37b). These are the largest tumuli recorded in the Free Zone, and are likely to be among the largest in the entire Sahara. They are broadly conical in nature, and the individual tumuli do not exhibit any obvious structural detail. Saenz de Buruaga (2014) describes these as 'mega-tumuli', and the complexes that contain them as unique in the Sahara. He argues that their great size indicates the existence of a society whose ability to organise labour exceeded that of a clan or nomadic family group.

A much less extensive assemblage of merged tumuli (BD6) has been identified at Bou Dheir. This complex consists of some 15 low-relief tumuli on a slightly elevated outcrop of stone and gravel. Three distinct tumuli are situated at the southern end of the complex. North of these, the remaining tumuli grade into each other, with the boundaries between individual monuments becoming indistinct.

Use of quartz in association with stone features

Quartz outcrops are common throughout the Free Zone, and quartz is found within, on top of, and around monumental stone features in many of the areas examined by the extensive survey (Plate 10a, b, c). Quartz may be present in these contexts in the form of bright white chipped fragments, or in the form of yellowish pebbles. In rare cases, monuments may be made entirely from quartz (see below and Plate 10d), at least as far as can be ascertained without excavation. The abundance of quartz in these various contexts in the areas subject to extensive survey is of particular interest because of its widespread association with funerary rituals in other parts of the world (Bradley 1998a, 104; Darvill 2002; Tilley 2004, 60–66; Warren and Neighbour 2004). Quartz chippings are also present at some sites where high concentrations of chipped stone indicate prehistoric stone-working took place. Locations and features associated with significant quantities of quartz are listed in Table 4.4.

Quartz chippings are scattered on and around some tumuli, such as feature MS1-4 (Plate 10a). Quartz is frequently found inside and adjacent to the 'enclosures' of petroforms, including both Type 1 and Type 2 goulets, and assemblages of standing stones. At least four goulets are associated with quartz concentrations (Plate 7b, Plate 9a and b), and quartz is present at the two locations north of Tifariti where large assemblages of standing stones have been erected (Plate 8c, Plate 8d, Plate 10b). Yellowish quartz pebbles are extremely abundant at funerary complex LD0-3 at Lajuad, which is 'contained' within an enclosure that might be interpreted as exhbiting the qualities of a petroform (Fig. 4.36a, Plate 6b). Here, dense quartz concentrations are present on and around ridge monuments and small, low cairns that may be tumuli or modified outcrops of bedrock. An eroded boulder with a concave feature is filled to overlowing with quartz pebbles (Fig. 4.36b). Milburn (2012) cites a report by Lhote (1980) that describes a practice near Tamrit in southeastern Algeria involving throwing stones into a rock hollow and making a wish; this provides one possible, albeit speculative, explanation of what may have occurred at LD0-3, and suggests a possible ritual function of the site in which the living interacted with the dead and/or other non-corporeal entities presumed to inhabit or otherwise associate with this location.

Feature AZ3-1 is of particular note, being a regular crescent and associated small circular tumulus made entirely from quartz (Plate 10d). On the one hand this might be the result of expediency, as these structures are located on a large outcrop of quartz, which is the most (indeed only, in the immediate vicinity) readily available construction material.

Fig. 4.37. a. Shallow tumuli constructed on top of very large tumuli in funerary complex ZG19; b. line of tumuli extending to the northeast in funerary complex ZG25.

This raises questions about the care with which prehistoric populations selected the sites of such monuments: were such locations sought out, or were the sites of monuments selected on the basis of other factors? Other rare examples of monuments constructed from 'unusual' materials include tumuli built from carbonate rocks on palaeolake surfaces of the same composition (e.g. RT3-2); again, whether the location was chosen because of the nature of the materials available (like quartz, carbonate is white and so might have been seen as having similar 'properties'), or for other reasons, remains uknown.

Artefact concentrations (lithics and ceramics)

While the extensive survey principally focused on the identification and recording of built stone features, other classes of archaeological material were noted where they were present. As well as rock art, the extensive survey identified a number of concentrations of chipped or ground stone (lithics) and pottery, both in association with monuments and in the form of separate surface scatters. Rather than collecting and exporting artefacts, lithics and ceramics were photographed in the field and left *in situ* during the extensive survey, with identification being based on interpretation of photographic records. More detailed analyses of collected material in the intensively surveyed TF1 Study Area are presented in Chapters 6 and 7, to which the reader is referred for a fuller understanding of the types and extent of artefacts recorded.

Lithics

Chipped or ground stone artefacts were identified at 52 locations throughout the Northern and Southern Sectors. Lithics were the only archaeological materials at 10 of these locations, and were noted alongside pottery at a further 11 locations. At five locations lithics were identified alongside rock art. Lithics occurred alongside built stone features at just over half (29) of these locations.

A wide range of lithic technologies can be identified, from the earliest handaxe and Levallois technologies associated with early humans, often found in isolated concentrations of water dispersed deposits, to the flake and blade technologies of the Upper Pleisetocene and Holocene traditions, more likely to be *in situ*. Chipped and ground stone artefacts are numerous on the desert surface and their exposure in large numbers is due in part to the extensive deflation that wind erosion causes in many parts of the desert.

The representation of stone tool types in the archaeological record is affected by a variety of factors, particularly the uncontrolled collecting of artefacts by local people, tourists and other visitors (Keenan 2005). Based on the authors'

Table 4.4. Stone features associated with quartz

Feature	Context/description
Northern Sector	
IR1-11	Type 2 goulet, with concentrations of quartz chippings in interior of enclosures in front of tumulus, either side of corridor (Plate 7b).
IR1-12	Low-density of quartz chippings throughout enclosures of Type-1 goulet, with higher density concentrations in certain areas, including in association with pictograms, e.g. inside triangular arrangement of small pebbles (Fig. 4.24a, b and Plate 9a, b). Also inside stone ring to east of goulet and just north of corridor axis (Fig. 4.26a).
MH2	Dense quartz concentration in area with abundant chipped stone (workshop site?) adjacent to and west of series of painted rockshelters (see Plates 11 and 12).
MS1-4	Bright quartz chippings scattered on prominent conical tumulus constructed on slope of wadi bank (Plate 10a), and on adjacent surface between tumulus and low stone cairn.
MS2-2	Quartz chippings in area with other chipped stone, in vicinity of area used as prehistoric stone workshop (MS2-3).
MS2-3	Dense quartz chippings on talus in front of rockshelter, which chipped stone indicates served as a workshop.
TF0-23	Crescent antenna with stone alignment emanating from centre, joining crescent with nearby natural ridge. Quartz scattered between arms of crescent.
TF0-38	Low density scatter of medium quartz pebbles and chippings in association with circle of standing stones, mostly absent from interior of circle, and mostly concentrated on the east side of the circle, around opening in circle.
TF6-44	Quartz chippings in high densities in association with stone concentrations (possible degraded pictograms) and inside stone rings in area beyond corridor and enclosures of Type-1 goulet.
Southern Sector	
AZ3-1	Crescent monument constructed entirely from large quartz boulders and pebbles, with small circular quartz tumulus enclosed in arms, constructed on extensive outcrop of quartz slightly elevated above surrounding plains.
GF2-6	Dense concentrations of quartz within enclosures of Type-1 goulet (only goulet recorded in Southern Sector to date). Presumably from small natural quartz oucrop adjacent to concentration of stone features in this (detailed survey) area.
GF3-1	Quartz pebbles scattered on and around tumulus.
GF3-2	Quartz pebbles scattered on and around platform tumulus.
LD0-3	Very dense concentration of yellowish quartz pebbles within funerary complex defined by stone arc, and adjacent to complex outside arc beyond narrow clear area (Fig. 4.28b, Fig. 4.36a and Plate 10c). Quartz pebbles placed on circular stone outcrop and cairns. Large hollow boulder filled with quartz pebbles (Fig. 4.36b).

encounters throughout North Africa with other foreigners and nationals from Saharan countries, it is common for people working in the Sahara to amass significant 'amateur collections' of prehistoric artefacts. Earlier archaeological research may also have involved the collection of large numbers of artefacts. The materials observed in any specific location therefore may not be representative of the original archaeological record of that location.

Nonethelesss, the extensive survey has identified a wide range of artefacts, and has demonstrated that similar technologies and raw materials are present at diverse and widely separated locations, suggesting long-distance exchange over considerable distances. Gaps in the artefact record exist, but appear to be confined to particular regions and particular periods, and are not pan-regional. This might indicate different patterns of occupation in different parts of the desert, perhaps related to diverging trajectories of environmental deterioration and amelioration.

The worked stone assemblages identified during the extensive survey exhibit patterns of preservation typical of erosional processes associated with desert environments, with assemblages usually being mixed and often quite abraded. Wind and water abrasion are significant problems that hamper the analysis of artefact assemblages. Nonetheless, there are some broad general statements that can be made about the stone tool assemblages observed during extensive survey.

The raw materials used for making stone tools include a variety of rocks and minerals, from quartz to fine-grained igneous rocks such as basalt and quartzite, and a variety of cryptocrystalline, siliceous rocks including jasper, translucent chert, and grey flint. The widespread use of all of these materials within the extensive survey area suggests curation of lithics over considerable distances, or exchange of these rock types between neighbouring social groups. Equally, the wide range of raw materials found may relate to high levels of mobility. In contrast, ground stone artefacts are not made of the cryptocrystalline cherts so common in the assemblage but instead from coarser, harder rocks such as basalt, which appear ubiquitous throughout the region and which make good materials for grinding into expedient tools.

Tool types are specific to different periods and can indicate the exploitation of a specific region at a particular time. Flake and blade technologies are common and represent a variety of tool forms, including endscrapers, denticulates, points and burins. Some tools are type markers for chronological periods. For example, materials associated with the Aterian cultural complex, and Ounan points, have both have been found in relative abundance throughout the extensive survey region (Chapters 6 and 7).

Ceramics
Ceramics from the extensive survey were identified at 31 locations, in a variety of contexts. Pottery was recorded in isolation at two locations, alongside lithics at 16 locations, in association with built stone features at 11 locations, and in association with rock art at ten locations.

The proportion of ceramics collected from the Southern Sector in comparison to the Northern Sector is startling, and will be discussed in more detail below. The relative scarcity of ceramics in the Northern Sector may reflect a general absence of pottery in the region as a whole but this cannot be confirmed without further study. That said, the pottery sample collected during intensive survey of the TF1 Study Area was very small (*c.* 150 sherds in total) indicating a much lower density than at many locations in the south.

Logistical factors and obstacles to exporting pottery and other artefacts from the Free Zone has meant that none of the extensive survey pottery was studied first hand; the observations made here are on the basis of the photographic evidence only. The following short report gives a broad indication of some of the types of pottery represented at different locations in the Southern Sector where much of the pottery from the extensive survey derived. A more comprehensive account of the pottery collected from the TF1 Study Area, based on actual analysis in the field of the sherds from the intensive survey, is presented in Chapter 6.

Notwithstanding the limitations mentioned above, some important general statements can be made. Almost all of the pottery collected from locations in the Southern Sector was concentrated in two specific regions: a band of territory running from Lajuad (location 18 in Fig. 4.4) in the northwest to Dugej and Tin Gufuf (locations 23 and 27 in Fig. 4.4) in the southeast, and the general vicinity of Zoug (locations 37 and 38 and Fig. 4.4). The sherds appear, on inspection of the photographic evidence, to be remarkably homogeneous and mostly Neolithic pastoral in date, representing handmade and relatively coarse pottery characterised by a combination of both mineral and vegetal temper. However, there are exceptions, for example at Lajuad near the crescent monument LD0-8, as discussed below. Sherds are generally small but in fairly good condition. Rims and body sherds are represented. Three decorative techniques can be identified, sometimes with more than one technique occurring on the same sherd: stamped/impressed, flexible and non-flexible roulette, and incised decoration.

Sites with larger collections of sherds include Tin Gufuf (Fig. 4.4, 27), Jabal Basfuf (Fig. 4.4, 28), Dugej (Fig. 4.4, 24), Lajuad (Fig. 4.4, 18, 19) and Zoug (Fig. 4.4, 27 and 38). Most sites were characterised by stamped designs using various implements. The exception is Jebel Basfuf, where some sherds appear to have been decorated with a flexible roulette (Fig. 4.38a). Other sherds from Jebel Basfuf are stamped (Fig. 4.38b) Tin Gufuf sherds included both rim and body sherds and all are decorated using a stamping technique on the rim or shoulder (Fig. 4.38c) (using a spatula

Fig. 4.38. a. Ceramics with flexible roulette decoration from Jabal Basfuf (BS1); b. sherds with stamped patterns from BS1; c. rim and body sherds decorated using a stamping technique on the rim or shoulder from Tin Gufuf (GF1); d. sherds with herringbone pattern from GF1.

to produce a herringbone design (Fig 4.38d)) or on the body with a punch or comb. At Lajuad, a similar stamped herringbone design is present on the rim sherd of a jar which was mended in antiquity (as it has a visible mend hole) (Fig 4.39a). Other, mainly body sherds from Lajuad include both stamped and roulette design (Fig 4.39b). Two examples (Fig 4.39c) are rim sherds decorated using a roulette and a pivoting tool (shell edge or fingernail) to produce the rim decoration. Similar sherds (Fig 4.39d) utilise a pivoting punch to produce a similar design. All the sherds from Lajuad were in the immediate vicinity of a large crescent monument, LD0-8, at the foot of a hill (LD0-7) housing a rockshelter containing a tufa deposit (Chapter 2) and an assemblage of paintings including animals in the linear style (Soler i Subils *et al.* 2006b and below), Libyco-Berber script, and abstract forms.

The ceramics from the Southern Sector can be broadly compared with examples from Mauritania (Holl 1988, figs 29, 32, 46I) and with regions further east, for example pottery from the Wadi Teshuinat (Ponti *et al.* 1998, figs 2 and 3) and the Tadrart Acacus (Barich 1987, fig. 7.28, 7.31 and 7.36). Comparisons with these regions suggest a date for the pottery in the Neolithic 'pastoral' period between *c.* 4000 BP and *c.* 2000 BP.

Rock art

Assemblages of rock paintings and engravings occur throughout the Free Zone, and a number of rock art sites have been described by other authors. Previously published rock art sites in the Northern Sector are Rekeiz Lemgassem (Soler i Subils *et al.* 2006a; Soler i Subils 2007b), Wadi Kenta (Soler i Subils *et al.* 2006b), Sluguilla Lawaj (Soler Masferer *et al.* 2001c), Rekeiz Ajahfun (Soler Masferrer *et al.* 2001a, 2001b) and Wadi Ymal (Nowak *et al.* 1975 and Soler i Subils *et al.* 2006b). Soler i Subils *et al.* (2006b) identify the following different styles of rock paintings in the Zemmour region of the Northern Sector:

> Dancers' style: dynamic posture with bent legs ahead of the body in human figures, which are often wearing belts or skirts and head-dresses or elaborate hairstyles, and

Fig. 4.39. Ceramics from Lajuad (LD0-8); a. stamped herringbone design on rim sherd of a jar mended in antiquity; b. body sherds with stamped and roulette design; c. rim sherds decorated using roulette and pivoting tool; d. sherds with design made using pivoting punch.

holding bows or sticks, with children often depicted. Similar dynamic or unstable poses for animals, including cattle.

Shaped style: humans with one leg behind the body, often holding bows. Bichromatic, highly natural representations of animals with rounded muzzles and bellies. This style also includes animals rendered in bold outlines with feet not depicted. Fauna are dominated by antelopes, with a few less common species such as rhinoceros.

Stroked style: depictions of animals (bovids and giraffe) with narrow solid outline filled with other pigment, often bichromatic, with legs and feet shown.

Dark figures: rendered in very dark pigment and rounded in shape, with just one side depicted (i.e. two legs for animals and one leg for humans). Humans and animals often deptcited in long rows, in many cases tending towards the schematic.

Linear style: schematic, often stick like depictions of humans and animals rendered with wide straight lines in light red pigment, with some human figures holding spears and shields but not bows, and riding horses but not camels. More abstract motifs including lines, crosses, circles, crosses within circles. Libyco-Berber symbols.

Soler i Subils *et al.*, (2006b) reports that these different styles usually appear in the order listed above, where one style is superimposed on another. However, superpositions suggest that shaped, stroked and dark figures styles may be contemporaneous, or at least associated with some chronological overlap. Based on the appearance of halberds and analogy with the Iberian peninsula, Soler i Subils *et al.* (2006b) propose that the oldest style, that of the dancers, might be dated to between 3800 and 3200 BP, although Soler i Subils (2010) does not preclude a much earlier date for this style and the Tazina-style engravings at Sluguilla Lawaj that may be associated with it. The presence of Libyco-Berber symbols in the linear style suggests dates younger than 2400 BP, while the absence of camels in the sites examined by Soler i Subils *et al.* (2006b) suggests that

this style predates 2000 BP. Soler i Subils *et al.* (2006b) place the stroked, shaped and dark figures styles between the dancers and linear styles, between 3200 and 2400 BP.

Information on rock art sites in the Southern Sector has been published for Blugzeimat near Mijek (Soler i Subils 2007a) and the *Cueva del Diablo* at Lajuad (Soler i Subils 2007a). Soler i Subils (2007a) also presents a map on which are marked *c.* 20 rock art sites in the Free Zone, based on Monod (1932, 1951) and also Huysecom (1987), although the locations of those based on the former source are approximate. Soler i Subils (2007a) reports that the records of many rock art sites in Western Sahara, obtained during the colonial period, are in private hands or that their location is unknown. Finally, a number of rock art sites around Zoug, Aguenit, Dugej, Mijek and Lajuad in the Southern Sector, including paintings and engravings, have also been published by Sáenz de Buruaga (2008 and 2010).

New rock art sites continue to be identified in Western Sahara, and the work of the extensive survey has identified a number of sites that do not appear to have been described in the literature. Here we provide a summary of the sites recorded, including details of new sites identified by the Western Sahara Project and discussions of some previously recorded sites with references to other sources. We also briefly discuss a series of decorated rock shelters recently identified by the Sahrawi (area MH2). Other, known sites are also mentioned where relevant, for example for comparison and contextualisation purposes.

Recently identified decorated rock shelters, Wadi Kenta area

During the 2009 field season, the Project team was shown, by representatives of the SADR government and the Polisario military, a recently discovered series of decorated rockshelters in the Wadi Kenta area, at the northern edge of the uplands west of Mheres. The paintings in these shelters (designated with the area code MH2) share some similarities with those at Rekeiz Lemgassem (Soler i Subils 2005a; Soler i Subils *et al.* 2006a and b) and Bou Dheir (Brooks *et al.* 2003 and below), including the presence of hand prints, naturalistic representations of wild fauna and cattle, numerous human figures, and densely packed lines of vertical lozenge features that can be interpreted (with varying degrees of confidence depending on the degree of abstraction) as representing human figures.

As well as cattle, the paintings in area MH2 depict an assemblage of wild fauna that is clearly dominated by Sahelian and desert adapted species. Ten gazelles could be identified, as well as two Dama gazelles, with animals depicted in linear arrangements that are typical for the rock art of Western Sahara (Plate 11). A depiction of a large antelope probably shows a Roan antelope, and a further four bovids are unidentifiable. In addition, and rather unusual for the rock art of the region, three naturalistic depictions of ostrich are evident, along with a linear sequence of four unidentifiable birds. Animals and human figures have been painted with a reddish pigment. Superimposed over some of these paintings are larger human figures rendered in a darker pigment (Plate 11).

There is some limited use of multiple colours/pigments in individual images at MH2, for example on the belly of a prominent painting of a cow (Plate 11). Human figures with exaggerated posteriors (Plate 11) echo similar features at Rekeiz Lemgassem and in other shelters in vicinity of MH2 (Soler i Subils 2005a). One of the shelters at MH2 houses some abstract and very well preserved geometric forms (Plate 12), some of which bear a superficial resemblance to features recorded in other shelters in the Wadi Kenta area (Soler i Subils 2005a), suggestive of tents or enclosures. This shelter also houses a row of four human figures depicted face-on, which are fainter than the geometric forms, and remnants of other paintings that are too faint to identify.

Adjacent to the series of rock shelters in area MH2 are surfaces covered in a high density of stone chippings, indicating a site at which stone was worked.

New rock art at Bou Dheir

The most notable new rock art site to be identified during the extensive survey is a series of decorated rock shelters at Bou Dheir, situated a few kilometres north of the border with Mauritania in the far southwest of the Northern Sector, southwest of Mheres and Wadi Kenta. A brief description of the rock art at Bou Dheir is provided by Brooks *et al.* (2003). The main concentration of paintings (BD1-1) occurs in a series of five approximately east-facing recesses set back from a narrow ledge a few metres below the top of an escarpment on the eastern side of an elevated plateau, lying west of a northward draining, well-vegetated wadi in-filled with sand (Fig. 4.40). There is a degree of thematic organisation to the representations in these recesses, with some containing depictions mostly of animals, and others focusing on human figures. The centrepiece of the most heavily decorated recess (recess no. 3) is a large, hornless antelope, possibly a female of the genus *Tragelaphus* (Plate 13). Around this large zoomorph are paintings of Roan antelope, a buffalo (Plate 1a), a single small ostrich, and hand prints made using different pigments, (Plate 13).

To the left of the above assemblage, recess no. 1 contains paintings of two antelopes with short horns (possibly *Tragelaphus*) (Fig. 4.41a), and recess no. 2 hand prints (Fig. 4.41b), a giraffe (Fig. 4.41b), a row of three human figures in a walking motion (Fig. 4.41c), a further three standing figures, a single figure apparently running with a bow (Fig. 4.41d), a rhinoceros, some possible bovids and theriomorphs with canine heads, and other figures too faint to identify (Fig. 4.41d).

To the right of the main assemblage, recess no. 4 depicts human figures including individuals apparently dancing

4. *The Extensive Survey*

Fig. 4.40. a. Main series of decorated rockshelters at Bou Dheir; b. eastward view over plain and wadi from the shelters.

Fig. 4.41. Rock paintings at Bou Dheir; a. antelopes in recess 1; b. human figures walking in recess 2; c. giraffe and hand prints in recess 2; d. rhinoceros, bovid and Figure running with bow in recess 2.

(Fig. 4.42a), on all fours (Fig. 4.42b), and holding an object that may be a bow or musical instrument (Fig. 4.42c). Some of these figures are rendered in more than one colour of pigment, and many appear to be wearing head-dresses, (Fig. 4.42a) which are also suggested by figures in the other recesses. One figure is associated with what appears to be a small zoomorph (Fig. 4.42d), but faunal depictions are otherwise absent.

Recess no. 5 depicts a pair of domestic cattle, the leading one of which appears to be led by a human figure. Behind and to the right of the cattle, three human figures are apparent, two of which are wearing head-dresses (Plate 14). The figure with the most prominent head-dress has legs outlined in red but filled with an orange/yellow pigment. Other elements in this assemblage include faint animal shapes likely to represent domestic cattle, a large ostrich-like bird, a rhinoceros (Plate 1b), a zoomorph tentatively identified as a large cat, a large shape that is difficult to identify but which may be a somewhat abstract anthropomorph, a long series of vertical lozenge shapes terminating in a large triangle (Plate 14), a series of vertical lines at the top of the assemblage, and a series of red dots possibly in association with some of the human and animal figures including a bovid (Plate 1b and Plate 14).

Below the series of recesses described above is a collapsed rock shelter in which painted depictions of giraffes, as well as other zoomorphs and vertical lozenges can be seen. Slightly downslope from the above recesses, and separated from them by a narrow sandy gulley, is a large outcrop housing more decorated shelters, again depicting roan antelopes and other wild fauna, lines of lozenges, and human figures (some holding objects). In the wider vicinity, other shelters house the remnants of paintings that are now too faint to be interpreted through visual inspection alone, and a single low shelter now partially filled with blown sand houses a large anthropomorph with raised arms on its ceiling.

Engravings near Wadi Erni

Numerous engravings were identified in an area 3km north of Wadi Erni (ER2), in apparent association with a number of

Fig. 4.42. Paintings in Recess 4 at Bou Dheir; a. figures with head-dresses; b. figure on all fours with red and white pigment; c. figure holding an object that may be a bow or musical instrument; d. figure with small zoomorph.

Fig. 4.43. Engraving of a bovid containing a smaller engraving of an animal in area ER1.

Fig. 4.44. Rockshelter LD0-7. See Plate 15c for example of paintings in this shelter.

stone features resembling bazinas and rough cairns (features ER2-1 to ER2-4). The engravings were recorded on flat horizontal slabs embedded on a raised area. The majority of engravings are abstract in nature (Plate 15a), although anthropomorphs are also present, and an engraved slab some distance from the main site also includes a stylised rendering of a gazelle (Plate 15b).

Some 32km west of area ER2, engravings occur in conjunction with an assemblage of stone monuments (corbeilles, a bazina with mound, and some tumuli) in area ER1, situated on a small plateau on the west bank of the Wadi Erni where its course changes from east–west to south–north and where it is joined by a major tributary. At the very edge of the plateau an engraved slab depicts a small animal inside the body of a larger engraving of an unidentifiable bovid. The latter apparently combines a mixture of features from a number of different species (Fig. 4.43). This slab is also engraved with a number of abstract linear patterns, and similar linear markings are apparent on other loose slabs in the vicinity.

Rock art around Lajuad

Six decorated rockshelters and two open-air rock art sites were examined in the vicinity of Lajuad. Some of these sites are known to have been recorded and discussed by other researchers, while some may be new. All six shelters are described briefly below.

LD0-1 is a rock shelter at the southeastern base of a hill at the centre of Lajuad, containing faded anthropomorphic figures rendered in red pigment. LD0-4 is the elevated rock shelter known as the *Cueva del Diablo* that has been studied extensively by the University of Girona (Balbín Behrmann 1975, Pellicer and Acosta 1972, Soler i Subils *et al*. 2005; Soler i Subils 2007a) and discussed by other authors (*e.g.* Sáenz de Buruaga 2010). LD0-4 contains numerous engraved zoomorphs and anthropomorphs, and unusual engravings of human feet with toes, pecked into the floor of the shelter. The shelter also houses a variety of graffiti from the recent historical period, and was subject to vandalism in 2006 when personnel from the United Nations peacekeeping force MINURSO, stationed at Agouanit, spray-painted large graffiti on the rear wall of the shelter (Merrill 2011; Soler i Subils 2007a). LD0-4 is also known as the Cueva del Diablo, and has been described by Balbín Behrmann (1975) and Pellicer and Acosta (1972).

Shelter LD0-7 is another large, elevated shelter, located at the top a steep rocky slope where it meets the near-vertical face of a large rounded hill at the eastern edge of the Lajuad hills (Fig. 4.44). A crescent monument is located at the base of the hill on the approach to the shelter (LD0-8), and numerous pottery shards are present in the immediate vicinity of this monument (see above). This shelter also houses a deposit of tufa, which was sampled for environmental dating (see Chapter 2, site S26). The rear wall of the shelter houses numerous paintings in at least two different types of red pigment, consisting of a mixture of Libyco-Berber script (tifinagh characters), other abstract symbols of an unknown nature, depictions of zoomorphs in the linear style (Soler i Subils *et al*. 2006a), and some Arabic script (Plate 15c). At least one motif painted in darker red pigment appears to show a camel and rider, and some zoomorphs are rendered in black pigment. The site also contains a series of heavily eroded animal engravings along a lower ridge of the shelter. These depictions are stick-like and can only be identified as quadrupeds. Paintings from LD0-7, also known as the Cueva Pintada, have been recorded and published previously by Pellicer Catalán *et al*. (1973–74), and this location is described as Lajuad Station 3 by Nowak *et al*. (1975).

A variety of paintings and engravings were recorded in shelter LD0-9, some 40m above the surrounding plain, in the north-facing slope of a small hill at the northeastern edge of the Lajuad hills. The shelter is some 35m wide, 20m deep, and up to 4m high, with three levels and collapsed

slabs towards the rear. It is well protected, with a view across the plain from the northeast to the east, towards groups of hills smaller than those at Lajuad. The paintings include depictions of cattle and antelope (Figs. 2.29 and 2.31, Chapter 2), as well as more abstract zoomorphs and Tifinagh and Arabic inscriptions. The cattle have large upward pointing horns and hide markings suggesting domestic cattle herds, which must have been depicted at a time when pastures were available in the region (Plate 15d). One of the depicted wild bovids has spiral horns and may be a representation of a kudu; another is depicted with short straight horns. Two further, stick-like depictions show a quadruped with its young. At the back of the shelter, a small number of engravings feature stick-like representations of animals, with all four legs depicted. This site has also been described by Sáenz de Buruaga (2010, 112–114).

Faint red images were also recorded in a very small, low shelter in a single large boulder, some 4km southeast of the Lajuad hills (LD5-1). These predominantly consist of heavily eroded markings and animal shapes. The only recognisable depiction shows a stylised camel associated with a Tifinagh character or tribal marking. Heavily eroded paintings and unidentified zoomorphic depictions were also recorded at location GK1-1 at Garat al-Khayl, a small hill some 35km north of Lajuad.

Open air rock art was identified at the northwestern extremity of the Lajuad hills (LD0-10) consisting of engraved spiral forms carved into the surfaces of an approximately north–south oriented ridge. Similar engravings were identified alongside representations of animals some 6km southwest of Lajuad (LD6-1), along a north-northwest–south-southeast oriented ridge that continues to the site of Aij, where a number of monuments including a very large regular crescent (AJ1-1) were recorded. The faunal representations recorded at LD6-1 include four identifiable depictions of giraffe and a number of unidentifiable other bovids (Fig. 4.45a). Also present are concentric circles (Fig. 4.45b) and an unusual engraving that resembles a mask or a shield (Plate 16a). The engravings at both of these locations exhibit many similarities with those recorded at Zoug (see below).

Other rock art sites in the Southern Sector

Remnants of paintings were identified in a rockshelter at the northeastern extremity of the hill of Jabal Basfuf (area BS1). Some of these were identified as giraffes and some as human figures, but many of the images were too faint to be identified through visual examination.

The engravings at Zoug (areas ZG0 and ZG1) have been represented in the work of Sáenz de Buruaga (2008 and 2010), but are worth discussing briefly here. They occur on (usually near-horizontal) slabs situated on a number of approximately north–south ridges that also house and provide material for the construction of numerous stone features. The engravings are dominated by spiral forms

Fig. 4.45. Engravings at LD0-6. a. Giraffe with concentric circles and possible bovid; b. assemblage of spiral forms and concentric circles.

and concentric circles (Plate 16b), and depictions of cattle are also quite common. The latter vary in style but are predominantly depicted in a crude outline with two wide 'u' shapes forming the legs (Fig. 4.46a), similar to engravings north of Mijek at a location designated as MJ1-2, which appears to be the site of Blugzeimat as described by Soler i Subils (2007a). In addition, double spiral shapes are often arranged in a form that resembles a ram's head (Plate 16c and d). These 'ram's head' symbols are a recurring theme throughout the area and have been executed in different styles which range from more abstract spiral shapes to what might be more naturalistic depictions of rams' heads (Plate 16c). This interplay between spiral forms and animal shapes appears to be characteristic of the site; in two cases spirals have also been found integrated into the horn of a cow. In addition, one anthropomorph was recorded at Zoug as well as a single depiction of a giraffe (Plate 16d); another engraving may depict a giraffe but this identification is uncertain. Other engravings may represent antelope (Fig. 4.46b). The site also houses a number of features resembling cup marks, as well as indistinct engraved lines. The degree of weathering varies on individual panels and across the site and indicates a prolonged engraving history.

Fig. 4.46. a. Zoomorphic engraving at Zoug, most likely representing cattle based on other similar engravings elsewhere; b. possible engravings of antelope at Zoug.

Discussion

The extensive survey has revealed an extremely rich and diverse archaeological record that exhibits affinities with both the central Sahara and the western/Atlantic Sahara, and also suggests more local traditions. While the Northern and Southern Sectors have much in common archaeologically, there are also significant differences between them, suggesting a degree of divergent cultural development that may be associated with differences in their climatic and environmental trajectories in the Middle to Late Holocene. Here we present a tentative synthesis of the material presented earlier in this chapter, based on considerations of the apparent abundance and distributions of the different stone features recorded during the extensive survey, and their relationships with rock art, ceramics and worked stone.

Affinities with the central Sahara

Many of the stone features recorded during the extensive survey are typically 'Saharan', and reflect forms that are also common to the central Sahara. Tumuli are ubiquitous across much of the Sahara, and many of the forms described by BANI (1994) and Paris (1996) for Niger are found in the Free Zone. These include conical tumuli, tumuli with a more spherical form (*'tumuli en calotte de sphère'*), lower-relief 'lenticular' tumuli (*'tumuli lenticulaire'*), and 'truncated' tumuli with flat tops (*'tumuli à plate-forme'*). However, tumuli constructed with a crater-like interior (*'tumuli à cratère'*) or a more hollow, 'well-like' interior (*'tumuli à puits'*) appear to be absent. Bazinas are present, although they take a diversity of forms, some of which appear to be more specific to the northwestern Sahara (see below). Some crescents are similar to the *'tumuli en croissant'* recorded in Niger (BANI 1994; Paris 1996). Corbeilles are found in the central Sahara, where they have been demonstrated to house the remains of cattle and other animals in the Libyan Fezzan (di Lernia 2006; di Lernia and Gallinaro 2010; di Lernia *et al.* 2013). Stone platforms have been described in the central Sahara by BANI (1994) and Paris (1996).

Gauthier (2015) presents distribution maps of 11 types of stone monuments throughout the Sahara, based on a combination of field survey, literature review, and the examination of high-resolution satellite imagery. Based on these maps, regular crescents, or monuments resembling them, are widespread in the central Sahara and the wider western Saharan region, extending from the northern Mauritanian coast in the west to the far southwest of Libya (Fezzan) and northwest of Niger in the east, and from southern Morocco in the north to the northern latitudes of Mauritania, Mali and Niger in the south. Gauthier (2015) identifies monuments with straight, parallel arms and a central platform and/or tumulus as existing in an area restricted to the central Sahara, extending across southeastern Algeria and into southwestern Libya, northwestern Niger, and northeastern Mali. At least one such 'V-type' or 'V-shaped' monument (IR3-3) has been identified in the Northern Sector of the Free Zone, and Saenz de Buruaga (2010, 122) presents what appears to be a V-type monument near Azaig Bedrag in the northern part of the Southern Sector. Crescent antennae monuments, also recorded in the Northern Sector, are similar in form to these monuments, sharing their characteristic straight, low-relief antennae with parallel sides, often defined by kerb stones. Monuments with auxilliary towers ('monuments à alignement' or MAA) are distributed across the Sahara from the central regions around the Tassili n'Ajjer, Ahaggar and Aïr mountains all the way to the coastal areas of southern Morocco, Western Sahara and northern Mauritania, although only two such monuments (one of which is a large stepped bazina) were recorded on the ground in the course of extensive survey work.

Further evidence of connections with the central Sahara is provided by the alignments of crescent and antenna-type monuments. Overwhelmingly, these are oriented in

an easterly direction compatible with deliberate luni-solar alignments, with a very small proportion having westerly orientations, reflecting the orientation of these types of monuments in the Sahara at large (Gauthier 2015). Many other monuments are associated with deliberate alignments defined by their form or through the incorporation of features such as annexes and standing stones, indicating a wider concern with orientation.

The above results suggest that the Free Zone of Western Sahara was part of a wider Saharan cultural complex, or at least in the interaction sphere of the central Saharan cultures that constructed tumuli, crescents and other 'antenna-type' monuments, corbeilles, stone platforms, bazinas and monuments with auxilliary towers. While some of the similarities between the stone features of Western Sahara and the central Sahara might be coincidental, the number of forms in common and the very particular constructions of some of these forms suggest that these regions were linked.

That the parts of Western Sahara studied during the extensive survey work were connected to the wider Holocene Saharan cultural context is also evident from rock art, ceramics and worked stone. Lithic technologies include those typical of the Holocene (and indeed Pleistocene) Sahara at large, and this situation is also reflected in the ceramics, which include pottery typical of the Mid to Late Holocene pastoral cultures of the central Sahara, as well as the wider western Saharan region. Rock art themes include those typical of the central Sahara, including large humid-climate fauna, cattle, and anthropomorphic figures, depicted in the form of both paintings and engravings. The presence of Libyco-Berber script (*e.g.* at LD0-9, described above), and depictions of chariots in Western Sahara (Pellicer Catalan 1973–74), mean that the possibility of links with the late Holocene Garamantian culture of the central Sahara, suggested by the similarity between monuments with short lines of orthostats and Garamantian burials with 'proto-stele', should be taken seriously.

Cultural links between the central Sahara and what is now Western Sahara also fit with what we know about Saharan prehistory. Monumental funerary architecture, including all the types of stone features listed above, appears to have spread throughout the Sahara with cattle pastoralism, in what appears to be a generally east-to-west direction (di Lernia 2006; Jousse 2004; Kuper and Kröpelin 2005). As described above, cattle are a common theme in the rock art of both the Northern and Southern Sectors of the Free Zone, which often occurs in close proximity to concentrations of monumental stone features.

Regional innovation

While the Free Zone of Western Sahara exhibits many affinities with the central Sahara, it also appears to be part of a more regionally specific western Saharan cultural complex. These two observations are not incompatible: it is possible that the importation of monument styles and other cultural elements from the central Sahara was blended with existing regional traditions, or was followed by a period of innovation in which distinct regional western Saharan styles were developed. Currently there is no evidence of a pre-existing monument building tradition in Western Sahara, but this cannot be ruled out.

Regional innovation in monument building is suggested by the restricted range of certain types of monument. For example, Type 1 goulets occur in a limited area encompassing southern Morocco south of the latitute of Agadir (in the vicinity of the Wadi Draa and Wadi Chbika), the northern sector of the Free Zone of Western Sahara, the adjacent region of northwestern Mauritania to the south, and the area around Tindouf (Gauthier 2015), with a single example (GF2-6) being recorded in the Southern Sector of the Free Zone during the extensive survey work (Plate 7d). Gauthier (2015) refers to these as 'western goulets', to distinguish them from the 'eastern goulets' that occur in the central Sahara around Immidir and Tassili n-Ajjer. Whereas western goulets include a paved area with or without a tumulus, eastern goulets are characterised by a 'true' tumulus at their western end (Gauthier 2015). The wider distribution of Type 2 (western) goulets, recorded in the Northern Sector of the Free Zone during the extensive survey, is unknown. Goulets resemble keyhole monuments, and eastern goulets and keyhole monuments have a similar distribution, with the former likely predating the latter (Gauthier 2015). No goulets have been reliably dated (Milburn 2012), but nine keyhole monuments in the northern Ténéré of Niger have been dated to the middle to late 5th millennium BP (Paris and Saliège 2010). Western goulets bear a closer resemblance to their eastern counterparts than to keyhole monuments. It is therefore possible that western goulets represent a stylistic divergence from eastern goulets that predates the development of keyhole monuments, suggesting that western goulets may have evolved in the western Sahara from central Saharan traditions, prior to around 4500 BP.

The extensive survey has recorded complex monuments in the Northern Sector of the Free Zone. One of us (Gauthier) has observed some dozens of similar constructions in the Moroccan-controlled areas of Western Sahara north of Smara, South of Abteh, and along the Wadi Chbika in Morocco. Along the latter water course, Gandini (2002) and Searight (2003) each report one such feature. In addition to those recorded in the field, complex monuments with well-marked paved areas, sometimes subdivided by stone lines, can be identified on satellite images north of Tifariti and in the Mheres region. A handful of further examples are suggested by satellite imagery in the south of Western Sahara, in the Adrar region of Mauritania, and around Tindouf in Algeria (Gauthier 2015). Like goulets, these

monuments appear to be a western Saharan innovation. Unlike goulets, they have no obvious counterparts in the central Sahara.

Ridge monuments also appear to be a western Saharan phenomenon, and may be related to complex monuments, given the prominence of long lines of orthostats in both monument types. Ridge monuments have been recorded in Mauritania by Milburn and Kobel-Wettlauffer (1975), and one of us (Gauthier) has observed similar structures south of Akka, in the Anti Atlas of Morocco. The central Saharan forms most closely resembling ridge monuments are the Garamantian burials with proto-stele (Mattingly with Edwards 2003), although the numbers of orthostats are much greater in the former monuments, with the Garamantian proto-stele burials being much closer in form to the monuments with short lines of orthostats in Western Sahara.

The very large tumuli observed in isolation in the Northern Sector also appear to be unusual in central Saharan contexts. At least some of these appear to be degraded, possibly stepped, bazinas that are much larger and complex in their construction than those described in the central Sahara (BANI 1994; di Lernia *et al.* 2002; Mattingly 2007; Paris 1994). Indeed, the bazinas of Western Sahara seem to represent a wider diversity of forms than those of the central Sahara, that fits more with the traditions of the Maghreb. They include stepped bazinas, bazinas with mounds, bazinas with flat tops, bazinas with annexes or false entrances such as those associated with chapel monuments, and square and round bazinas. They range in height from about 1m to some 5m. Some of them (for example ER1-4 and TR2-1) are similar to monuments described elsewhere in the western Saharan region, for example at Djorf Torba, where the presence of metal in excavated monuments indicates an age no older than the 3rd millennium BP (Lihoreau 1993). Camps (1986) identifies chapel tumuli with the nomadic Guteles, and concludes that they date from the latter half of the 3rd millennium BP and the first half of the 2nd millennium BP.

The exceptionally large tumuli that make up the three funerary complexes identified in the Erg Azefal in the far southeast of Western Sahara may be unique in the Sahara, and (together with other very large monuments such as those at Aij) are likely to indicate cultural trajectories towards considerable social complexity, as recognised by Sáenz de Buruaga (2013).

The use of quartz and the extensive use of standing stones, both as free-standing monuments and incorporated into tumuli, both suggest a distinct western Saharan tradition, and indeed are reminiscent of practices associated with the 'megalithic' cultures of the Atlantic seaboard of Europe and Morocco, as discussed further in Chapter 8. The depiction of halberds in rock art further suggests links with Atlantic Europe, and has been used to develop a relative dating framework for the rock paintings of the Northern Sector as discussed above.

Relative dating of monumental stone features

Given the origins of pastoralism thousands of kilometres to the east, we might expect monuments associated with pastoralists to be more recent in Western Sahara than in the central Sahara. Nonetheless, it is worth considering the date ranges of central Saharan monumental stone features comparable to those in Western Sahara. While we cannot simply transplant chronologies from other Saharan regions to Western Sahara, comparisons with these regions can help us develop a tentative, relative chronological framework in which to interpret the stone features of the Free Zone. For example, we might infer that the types of monumental stone features common to Western Sahara and the central Sahara predate types that are found only in the former region, on the grounds that they are likely to represent regional innovations, perhaps derived from the earlier 'pan-Saharan' forms. The presence of central Saharan forms in certain parts of the Free Zone and their apparent absence from others might imply that the former areas were occupied earlier, as a result of the westward spread of pastoralism and associated funerary practices and architecture, prior to the development of local traditions that resulted in a divergence of western and central Saharan monument styles.

The oldest monuments in the Sahara are simple conical tumuli, which date back to the early to mid-7th millennium BP in the central Sahara (BANI 1994; Sivili 2002). The earliest tumuli contain animal burials (Sivli 2002; di Lernia *et al.* 2013), with the earliest human interments dating from the mid-6th millennium BP. However, these tumuli span a very long time period, extending into the late 2nd millennium BP. Stone platforms have been dated to around 6200 BP in Niger, but the youngest date to around 3500 BP (Paris 1996).

After simple tumuli and the oldest stone platforms, the monuments with the oldest confirmed dates in the central Sahara are corbeilles, V-type monuments and crescents. Corbeilles, associated with cattle and other aninmal burials, have been dated to the mid- to late-6th millennium BP in the Libyan Fezzan (di Lernia *et al.* 2013). The oldest V-type monuments have been dated to around 5400 BP, although the date range for these monuments extends to around 3000 BP (Sivili 2002). The BANI (1994) inventory gives a date range for 'crescents' from the mid-6th millennium BP to the end of the 5th millennium BP (of 3500–2000 BC). However, these, and the 'croissants' of Paris (1996) seem to have more in common with mounded crescents than with 'true' or regular crescents as recorded in Western Sahara.

The earliest rounded tumuli have been dated to the early to mid-4th millennium BP (Paris 1996). The BANI (1994) inventory cites a date of around 2200 BC for truncated tumuli, while Paris (1996) presents a range of 3350–3200 BP. BANI (1994) gives a date range for monuments with

auxilliary towers of 2200 BC to AD 800; however, Paris (1996) indicates a more restricted range from 3485–1055 BP for these monuments. Bazinas, or bazina-like monuments, have been dated to the late 5th millennium BP in Niger and Nubia (Paris 1996), and to the 2nd and 3rd millennia BP in the Fezzan (Castelli *et al.* 2005; di Lernia *et al.* 2002; Mattingly *et al.* 2007). The bazinas of the Fezzan may be distinct from those of Nubia and Niger, and some authors include 'drum' monuments under this classification; however di Lernia (2013) classifies 'drum-shaped tombs' separately from bazinas.

Of the monumental stone features recorded during the intensive survey that have been described and dated in the central Sahara, conical tumuli, stone platforms, corbeilles, V-type monuments and crescents therefore appear to be the oldest, dating back as far as the 6th (or, in the case of the earliest tumuli), 7th millennium BP in the central Sahara.

Other tumuli and monuments with auxilliary towers are more recent, dating from the late 5th millennium BP onwards. Bazinas appear to include different types of monuments with different age ranges, and the bazinas recorded in Western Sahara appear to be quite different from those of the central Saharan typologies, exhibiting a diverse range of forms that might represent a more localised tradition, as disussed below. Garamantian burials incorporating 'proto-stele', which may be related to monuments with short lines of orthostats, as discussed above, date from the latter half of the 3rd millennium BP (Mattingly with Edwards 2003).

The identificaiton of a complex monument built on top of, and using material from, a crescent antenna monument (TF6-4) supports the hypothesis that complex monuments are more recent than crescent and antenna-type monuments, perhaps evolving through regional innovation after the latter monuments had been 'imported' from the central Sahara. The apparent construction of a corbeille on top of a mounded crescent (SL4-1) suggests that the latter do not predate the former, which might indicate considerable antiquity for mounded crescents.

Differences between the Northern and Southern Sectors

The Northern and Southern Sectors of the Free Zone exhibit significant differences in terms of both their physical environments (Chapter 2) and their archaeological records. For example, certain types of monumental stone features appear to be concentrated in one sector or the other. Indeed, the different landscapes probably contributed to the cultural differences that are manifest in the material culture of the two Sectors, and this is reflected in the physical contexts of the stone features recorded in the detailed survey areas in the two sectors (Table 4.2).

Key characteristics of the Northern Sector

The Northern Sector is characterised by hills, plateaux and plains housing dense drainage networks and numerous large wadis (Chapter 2). In this sector, detailed survey areas MH1, TF6 and TR2 are all adjacent to water courses. MH1 runs along the west bank of the Wadi Ratina, and TR2 is located on the north bank of the Wadi Ternit where the wadi changes direction. TF6 straddles a series of ridges immediately south of the TF1 Study Area (Chapter 5) that run from east to west on the east bank of the Wadi Tifariti. These contexts echo those of southern Morocco, for example along the Draa and the Noun, where monuments are concentrated along water courses, and where wadis converge or change direction (Bokbot 2003, 35; Bokbot *et al.* 2011, 306). Detailed survey area MS1 is focused around a flat-topped hill, but houses a relatively low density of monuments. These contexts appear to be representative of the stone features of the Northern Sector, based on individual features and groups of features recorded outside these areas.

Complex monuments have not been recorded in the field south of Irghraywa (Fig. 4.3) and only a handful of possible such features have been identified outside of the Northern Sector, using satellite imagery (Gauthier 2015). The isolated Type 1 goulet GF2-6 is the only goulet recorded to date in the Southern Sector, and is over 300km south of those at Bir Lemuesat in Mauritania, previously the most southerly known goulets (Brooks *et al.* 2006; Milburn 2012). Paved crescents, crescent antennae, and axle-shaped monuments have only been recorded in the Northern Sector in the field to date. A single V-Type monument (IR3-3) has been recorded in the Northern Sector, and Sáenz de Buruaga (2010, 122) shows what appears to be a V-type monument in the north of the Southern Sector. Only one mounded crescent (LD1-51) has been recorded in the Southern Sector to date, and this classification is somewhat insecure. The results of the extensive survey therefore suggest that goulets, paved crescents, crescent antenne, axle-shaped monuments, mounded crescents and complex monuments represent one or more 'northern' traditions of monument building that were focused on the Northern Sector and the immediately adjacent regions. The standing stone monuments in the northern sector, consisting of multiple orthostats that do not exceed about 1m in height (and are often much smaller), and that do not incorporate cairns, are also quite distinct from anything observed in the Southern Sector.

While bazinas and large tumuli are found in both sectors, domed bazinas and stepped bazinas have been recorded only in the Northern Sector, as have the large, solitary tumuli that have been interpreted as degraded stepped bazinas. These findings suggest that, while bazinas are found across the Free Zone, the Northern Sector is more intimately connected with the cultures responsible for constructing large stepped and domed bazina type monuments, often alongside more 'regular' tumuli, that were responsible for sites such as the relatively nearby Djorf Torba (Lihoreau 1993).

The rock art of the Northern Sector is also quite distinct from that of the Southern Sector, being considerably

more diverse and incorporating many highly naturalistic representations of people and wild and domestic fauna. Open air sites such as Sluguilla Lawaj consist of assemblages of engravings of large humid climate fauna (Soler Masferer *et al.* 2001c), while rock shelter sites such as Rekeiz Lemgassem (Soler i Subils 2005a; Soler i Subils *et al.* 2006a and b), Wadi Kenta (Soler i Subils *et al.* 2006c) and Bou Dheir (Brooks *et al.* 2002 and above) house paintings representing a mixture of cattle, human figures, and desert-adapted species, with rarer representations of humid climate fauna. These representations suggest a greater abundance and diversity of large, humid-climate fauna than is represented in the rock art of the Southern Sector.

The abundance of large humid-climate fauna in the rock art of the Northern Sector indicates that at least some of this rock art was created during a humid period. Soler i Subils *et al.* (2006b) suggests that the oldest paintings in the Northern Sector, represented by the so-called dancers style, date to around 3800 BP, and that they are contemporaneous with the engravings of wild fauna at Sluguilla Lawaj. However, it is possible that the engravings at Sluguilla Lawaj represent a distinct tradition, perhaps dating from an earlier, more humid period.

Despite its rich and diverse stone features and rock art, the lithics and ceramics recorded in the Northern Sector indicate a highly transient use of the landscape from the Middle Holocene onwards (Chapters 6–8), and do not provide any evidence of long-term occupation or settlement during this period. Of course, it is possible that the key occupation sites in the Northern Sector have not been identified. Local informants have indicated that evidence of prehistoric settlement is present in the area of Akchache, some 10km northeast of the intensively surveyed TF1 Study Area (Chapter 5), although the dates of any such occupation are not known. This area was visited during the extensive survey seasons in 2002 and 2005, although access was restricted due to military activities. A number of individual monumental stone features were identified (but not recorded), and a site was visited where a shelter had been excavated, leaving a pile of sediment that contained some non-diagnostic lithics. While no conclusive evidence of human settlement or long-term occupation was acquired, it is possible that this represented a 'residential' area in relatively close proximity to the burial grounds around the TF1 Study Area.

Key characteristics of the Southern Sector
The Southern Sector exhibits very different topography from the Northern Sector, being characterised mainly by flat plains peppered with isolated hills and groups of hills. Extant water courses are rare, although many are likely to be filled with fluvial and aeolian sediment and thus difficult to detect on the ground. In this sector, stone features are most frequently concentrated along ridges and dykes, with lower densities around the bases of hills. In the far southeast, monumental stone features are also present in the Erg Azefal sand sea. Detailed survey area AZ1 runs along a low-relief dyke in an expansive plain, area LD1 runs along a dyke immediately south of the main group of rounded granite hills at Lajuad, and area ZG1 runs approximately in an north–south direction a few hundred metres to the west of the similarly oriented range of low mountains at Zoug. Detailed survey area GF1 is located in an area of outcropping bedrock in a plain near the distinctive rounded granite hill of Tin Gufuf, and area LD2 extends from the pediment on the north side of one of the main Lajuad hills onto a flat area with outcropping bedrock. Again, these contexts are typical of the sector as a whole.

Regular crescents appear to be much less abundant in the Northern Sector than in the Southern Sector. Only seven examples have been recorded during extensive survey in the Northern Sector, and three in the intensively surveyd TF1 Study Area. Of those recorded during the extensive survey, BD1-6 and TF4-3 have very shallow curvatures, approaching the form of axle monuments, and SL6-4 has a form that might be described as halfway between that of the regular crescents typical of the Southern Sector and mounded crescents. No 'true' regular crescents (*i.e.* typical of those recorded in the Southern Sector) were recorded in the field north of Tifariti. Gauthier (2015) identifies crescent-like monuments across the western Saharan region, from the Adrar in north-central Mauritania to the area around the Draa Valley in southern Morocco, but these identifications are based on satellite imagery and include paved crescents and crescent antenna monuments (even so, there is a notable gap in the Northern Sector of the Free Zone north of Tifariti). While regular crescents do not appear to be as obviously restricted to one Sector as some of the monuments discussed above, it does appear that they are more typical of the Southern Sector.

To date, ridge monuments have been recorded only in the Southern Sector of the Free Zone during the extensive survey, albeit in very small numbers. Similar structures have been recorded in Mauritania by Milburn and Kobel-Wettlauffer (1975). However, Gauthier has observed similar structures south of Akka, in the Anti Atlas of Morocco, indicating that ridge monuments are not an exclusively 'southern' phenomenon. Nonetheless, the monument that forms part of funerary complex LD0-3 Lajuad, whose dominant feature is a sinuous ridge with a corbeille-type appearance as it curves around the central cairn, appears to be unique to the Southern Sector.

The large, solitary standing stones that have been recorded in the central regions of the Southern Sector north of Lajuad contrast with the groups of smaller standing stones recorded in the Northern Sector. At Azaig Bedrag, the presence of monuments with short lines of orthostats alongside very large standing stone features (associated with very low

and poorly defined cairns) suggests a possible relationship between these features. These very large standing stones may have served as way markers in landscapes dominated by flat plains, in which distinctive topographic features are lacking, their nature being influenced by a function necessitated by the landscape.

Another striking feature of the Southern Sector is the fields of very large tumuli in the Erg Azefal in the far southeast of Western Sahara, which may be unique in the Sahara, and indicate a high level of social organisation (Sáenz Buruaga 2013), suggesting the development of a distinct, complex society in the Southern Sector that possibly extended into neighbouring Mauritania.

The Southern Sector also provides us with the only firm evidence of extended human occupation in the Middle to Late Holocene, in the form of a number of locations at which stone monuments are associated with concentrations of ceramic fragments, worked stone and/or rock art, namely Jebel Basfuf (BS1), Tin Gufuf (areas GF1, GF 2 and environs), Lajuad (areas LD1 to LD6), and Zoug (areas ZG0, ZG1 and environs).

The rock art of the Southern Sector is associated with less extensive assemblages of paintings and engravings than that in the Northern Sector, with an emphasis on cattle and desert-adapted species of wild fauna (domestic cattle are depicted in the rock art of both sectors). Large humid-climate fauna are rare or absent in the rock art of the Southern Sector, and representations of both people and animals tend to be less naturalistic than in the Northern Sector. The linear style defined by Soler i Subils *et al.* (2006c) is more prominent in the Southern Sector, as are highly stylised engraved representations of cattle (for example at Zoug and north of Mijek) that occur in isolation or in small groups at open air sites. In the ZG1 detailed survey area and its immediate vicinity, these are accompanied by assemblages and individual examples of spirals and concentric circles, as well as a 'ram's head' form, all of which appear to be absent from the Northern Sector.

The lack of large humid-climate fauna from the rock art of the Southern Sector strongly suggests that it was created under significantly drier conditions than that of the Northern Sector. It might have been created later than the rock art depicting large wild fauna in the Northern Sector, after the region as a whole had experienced a transition to aridity. Alternatively, a 'wet' north might have been contemporaneous with a 'dry' south. Such a model is plausible given the very different topography in the two sectors, and their proximity to two different rainfall systems: winter rains associated with the Atlantic westerlies in the north, and summer monsoonal rains in the south. Winter rainfall in the north may have resulted in better moisture penetration and retention in soils, as well as greater surface runoff, as a result of lower seasonal or diurnal temperatures, as argued for the Middle Holocene Gilf Kebir in the eastern Sahara (Riemer *et al.* 2017). In addition, the denser drainage networks of the Northern Sector would have channeled runoff into major wadis, lakes and gueltas, providing ample available surface water, as well as pasture. It is possible that the Northern Sector experienced both winter and summer rainfall, due to a stronger African monsoon system in the Early and Middle Holocene.

Conclusions

The extensive survey indicates that Western Sahara was part of the wider Holocene Saharan cultural complex, with its prehistoric material culture record echoing that of the wider western Sahara region and the central Sahara, but also southern Morocco and the Atlantic Saharan region. Many of the monumental stone features recorded during the extensive survey are similar in form and construction to those found thousands of kilometres to the east, and rock art, ceramics and worked stone are also dominated by themes, styles and forms found across the Sahara. In particular, the archaeological record of the Free Zone indicates its occupation by pastoralists who most likely either migrated from, or adopted the practices of, regions to the east. Links with the central Sahara appear to span a considerable time period, with the Free Zone housing stone features comparable with the oldest funerary monuments from the central Sahara, dated to the 7th and 6th millennia BP, as well as features resembling much more recent central Saharan monuments dating from the 3rd and 2nd millennia BP.

Nonetheless, the Free Zone also houses stone features that are not found in the central Sahara, indicating distinct regional traditions. The limited evidence we have suggests that these are later constructions that are likely to have developed as a result of regional innovation, perhaps after the western Sahara region became isolated from more easterly regions by hyper-aridity in what is now western Algeria. Some of these features (*e.g.* goulets) are part of a wider regional tradition that extends outside Western Sahara, while others seem to be more localised (*e.g.* complex monuments). Superpositions of monuments suggest that complex monuments post-date crescent antennae, which would be expected under the above interpretation.

The archaeological records of the Northern and Southern Sectors of the Free Zone are quite distinct in many respects, indicating divergent cultural trajectories during the Middle to Late Holocene. This may be a result of their having been occupied by different pastoral groups initially, of divergent cultural evolution after pastoralism arrived in the region, or a combination of these factors. The presence of paved crescents and crescent antennae in the Northern Sector, their apparent absence from the Southern Sector, and their considerable antiquity in other Saharan contexts, may indicate early links between the Northern Sector and

the central Sahara, as these monuments are both highly distinctive and typical of the latter region. The presence of 'western' goulets in the Northern Sector may be further evidence of such early links. Western goulets may represent one evolution of the architecture of eastern goulets, the other being keyhole monuments (Gauthier 2015). Eastern goulets and keyhole monuments are absent from the western Saharan region, but have similar distributions to each other in the central Sahara, where the latter may have derived from the former. This raises the possibility that the architecture of western and eastern goulets diverged before the latter gave rise to Keyhole monuments, dated by Paris and Saliège (2010) to the mid-late 5th millennium BP in Niger. This interpretation would suggest that goulets may be among the oldest monuments in Western Sahara, and place the arrival of the (presumed) pastoralist monument builders around the first half of the 5th millennium BP. This is earlier than the more constrained range of rock art dates, based on the presence of halberds (Soler i Subils *et al.* 2006c), but within the wider possible date range proposed by Soler i Subils (2010). The distribution of goulets across the western Saharan region, their density around Tifariti, and the fact that WS006 (Chapter 5, Plate 7c) is the largest goulet recorded in the Sahara, suggests that this form of monument may originally have developed in the Northern Sector of the Free Zone. This view has been expressed by Milburn (2012, 168), based on his observation that goulets far to the north or west of Tifariti 'are often inexpertly built and can look very untidy.'

The concentration of paved crescents, crescent antennae, mounded crescents and goulets in the Northern Sector may be an indication that central Saharan influence arrived earlier here than in the Southern Sector. Given the dates of these monuments in the central Sahara, an absolute upper limit for the date of their arrival, presumably alongside pastoralism, in the Northern Sector would be the latter part of the 6th millennium BP. There is well-dated evidence from freshwater molluscs for a humid period between 5000 and 4000 BP in Mali (Petit-Maire *et al.* 1983), which is consistent with the dating of *Bulinus truncatus* from one of the palaeolakes in the Northern Sector (site N4, Chapter 2) to 4495 ± 47 cal. BP. These results indicate the existence of humid conditions in parts of the wider western Saharan region, and in the Northern Sector in particular, following the onset of severe aridity in most of the central Sahara around 5000 BP (Brooks 2010; Clarke *et al.* 2016; di Lernia 2006). This provides a highly plausible context for the migration of pastoralists into the Northern Sector sometime in the 5th millennium BP. The representation of large, humid-climate fauna alongside depictions of cattle (*e.g.* at Bou Dheir and Rekeiz Lemgassem) suggests that at least some of the earliest rock art in the Northern Sector was produced by pastoralists, perhaps during the 5th millennium BP when we have evidence of humid conditions, although this is likely to represent a *terminus post quem*.

The lack of large humid-climate fauna in the rock art of the Southern Sector may indicate a later occupation of this area, after a regional transition to aridity that affected both sectors. It is possible that both sectors were occupied simultaneously, with the Southern Sector experiencing more arid conditions because of a combination of climatic and topographic factors. However, the greater affinity of the Northern Sector to the central Sahara, in terms of its monumental stone features and rock art, suggests that pastoralism arrived here first, and subsequently spread into the Southern Sector either from the Northern Sector or elsewhere, where it was associated with the development of distinct monumental traditions. These may have developed alongside the northern traditions associated with goulets and complex monuments, as the distinct cultures of the Northern and Southern Sectors underwent a process of divergent cultural evolution mediated by their different environmental contexts. Nonetheless, the presence of monuments representing both southern and northern traditions in the southern part of the Northern Sector (*e.g.* around Tifariti), and the very rich archaeological record of this area, suggests that it may have been a zone of interaction and exchange between north and south.

Chapter 5

Intensive Survey

Salvatore Garfi and Joanne Clarke

Introduction

Archaeological field survey was first carried out in the TF1 Study Area in 2005. This was very limited in scope and opportunistic in nature (Brooks *et al.* 2006). Sixty-four built stone features were recorded and seven artefact scatter sites. The positions of these monuments and sites were recorded with hand held GPS units, which were plotted on Google Earth and a basic database was compiled. This area was chosen because the density and diversity of stone features appeared to be greater here than in adjacent regions, perhaps due to the rockier terrain which provides readily available raw material, and because of its location on the Wadi Tifariti, whose channels, tributaries and watersheds would have acted as routeways, as well as providing ample pasturage for grazing, for both wild and domestic animals on which prehistoric populations would have depended. The logistical benefits afforded by the proximity of the TF1 Study Area to the modern settlement of Tifariti were also a factor in the decision to carry out detailed study work in this area.

Methods

In spring 2007 a more targeted, intensive approach to survey was undertaken. An area that included most of the 64 sites previously recorded was bounded off and the ground was systematically walked, filling in the gaps and aiming to create an inventory of all features and artefact scatter sites (most built stone features were photographed and many were sketch planned). The aim was to recognise and document different topographic features of the landscape (*e.g.* hill slopes, pediments, terraces) and use these to isolate practicable sized search areas. Each contiguous, confined area was then intensively searched, usually by following contours along slopes, or zigzagging at acute angles, across areas of flatter terrain. A new sequential numbering system was initiated with the prefix WS,[1] and new features added to the database. The results were plotted in a geographical information system (GIS) and selected distribution maps were created. In all, the original 64 sites increased to 150, including group (or 'parent') sites and their feature subdivisions. The vast majority of monuments, stone features and artefact scatter sites in the TF1 Study Area were recorded individually, and given a unique WS identifying number. However, in some cases closely situated features were recorded as a group, and these have been given a single WS number. Where there was an apparent relationship between individual features comprising a complex group, the whole group was given an overall, 'parent' number, and the constituent, associated features, were recorded individually and given their own unique 'WS'('child') numbers.

The same survey approach was adopted during the April 2008 field season and an improved survey *pro forma* was used in the field. The survey area was increased to approximately 2.80km east–west by 3.40km north–south; an area of 9.50sq. km, and the coordinate system used in the field was changed to Universal Trans Mercator (all coordinates for the Project's work in the Tifariti Area are in UTM Zone 29R – also referred to as 29N). The southwest coordinate of the area has been rounded to 337600E/2907400N, and the northeast corner has similarly been rounded to 340400E/2910800N. In some instances, sites and monuments immediately outside of the survey area have been recorded. A total of 411 built stone features and seven artefact scatter sites have now been recorded in the TF1 Study Area (see Fig. 5.1).

It was also a priority during the 2008 season to attempt a topographic characterisation, or 'zoning' of the TF1 Study

5. Intensive Survey

Fig. 5.1. The TF1 Study Area showing the distribution of all built stone features and artefact scatter sites (all noted as 'sites' in the map key) recorded during the 2005, 2007 and 2008 field seasons.

Area and to create a map reflecting the area's topography. The latter was carried out by initially tracing the outline of the main landform features from Google Earth and then producing contours based on all of the hand held GPS coordinates and elevations derived from all of the sites and features and spot heights recorded during the three seasons of work in the TF1 Study Area. However, since hand held GPS elevation readings can be unreliable, the map should be treated as a 'form line' map only. No contemporary Digital Terrain Models exist for Western Sahara therefore the project has had to rely on publicly available Google Earth satellite imagery, remote sensing and land survey in order to create a Geographical Information System for the TF1 Study Area.

Topography of the TF1 Study Area

The TF1 Study Area (Fig. 5.2) is centred on a portion of the Wadi Tifariti running diagonally from the southeast to the northwest. It is about 200m to 400m wide (at an elevation of *c*. 430m) and it dissects the four topographic zones that cross the Study Area. A number of tributaries to the wadi also dissect the Study Area. Initial impressions are that the most salient features, after the wadi and its tributaries, are an east–west ridge on the west side of Wadi Tifariti, and a southeast–northwest ridge on the east side of the wadi. However, the topography and geomorphology is much more complex than these initial impressions suggest. Thus, the TF1 Study Area can be divided into four east-to-west morphological zones, all dissected by the Wadi Tifariti and its tributaries.

Zone I: inselberg and pediment (central south)

This zone is the most striking geomorphological feature in the Study Area. It is one of a series of prominent ridges between the village of Tifariti and the TF1 area. Its east-to-west inselberg ridges are made up of a brown-red igneous rock, which has been cut through by the wadi. The upper reaches of the flanking pediments are boulder strewn in places, otherwise they gently slope down to the wadis. They are dissected by natural drainage. The maximum elevation of the ridge west of Wadi Tifariti is *c*. 460m, while east of the wadi it is *c*. 445m.

Zone II: dissected plain with tors (south)

This zone is to the south of the inselberg and pediment noted above. It mainly consists of a stony plain – fluvial in places – with occasional igneous tors (small inselbergs). The ground undulates slightly and its dissection by wadis makes it terrace-like in places. The elevation of this zone varies from *c*. 430m to a maximum *c*. 450m in the southwest.

Zone III: rising and undulating ground (central north)

The centre of this area (at a maximum elevation of *c*. 445m) is quite distinctive, especially since it juts north-northwestwards from Zone I, creating a continuous ridge. However, understanding its true relationship with Zone I requires further geomorphological fieldwork. Suffice it to say, this is an area of rising and undulating ground, made up of igneous rocks, and characterised by east-to-west igneous intrusions that have created a series of very obvious ridges in its central portion.

Zone IV: dissected plain (north)

This is a low lying stony plain, fluvial and terrace-like in places, and dissected by wadis and natural drainage, with an approximate elevation of 426m. It undulates slightly, with a modest east-to-west ridge near the northern limit of the TF1 Study Area. This zone then rises to the northeast.

Overview of archaeology
Differing landscapes

With a lack of reliable dates (see Chapter 3), it is very difficult to discuss the distribution of monuments in the TF1 Study Area in a truly sequential way; *i.e.* to isolate monument types and surmise that they populated the landscape at a given time in relation to other monument types which could be later or earlier. But just as the different monument groupings already described (Chapters 3 and 4) have structural characteristics specific to them, there seem to be preferred topographic settings that are particular to each group and their types. In a way, we can characterise feature or monument distribution in terms of 'landscapes' specific to each monument type. By so doing, we may get an ever so slight insight into the funerary and ritual preferences of the people who inhabited the wider landscape of which the TF1 Study Area is a part.

A landscape of cairns (1)

It is appropriate to begin by looking at the terrain in the TF1 Study Area as initially, a 'landscape' of cairns or, as more often used in Saharan literature, tumuli (Fig. 5.3). These are the most ubiquitous monument type in funerary landscapes across the Sahara, and in many parts of the world. In the following paragraphs, all types of tumuli from rounded (basic) to conical, disc and platform (with or without tumulus), and for the sake of this discussion, the *falcate*, paved crescents, are included (see Chapter 3 for a discussion of these types).

Paved crescents are illustrative of the potential fluidity between the three main morphological groups of monuments already described (and in this instance, between *cairns* and *falcates*). Though large and distinctive, and by their very nature arcing or embowing, it could be argued that they are simply crescent shaped platform tumuli with cairns, between *c*. 2m to 7m in diameter (*c*. 3.1sq. m to 38.5sq. m in area) on boomerang shaped platforms ranging in length from *c*. 25m to *c*. 170m. Most importantly, however, these monuments

Fig. 5.2. Topography of the TFI Study Area. Showing the lie of the land through form lines, the disposition of igneous rock intrusions and rocky/boulder outcrops, and the Area's four topographic zones.

Fig. 5.3. Distribution map of all tumulus (cairn) types and complex monuments, paved crescents, mounded crescents and stone alignments. The two tumuli excavated in 2005 (WS023 and WS024) are also shown.

also share the same type of terrain as the majority of *cairns*, which can also be found in close proximity to them, and for this reason their disposition in the landscape is being discussed here.

The relative density of monuments was calculated by the GIS, which bracketed features by groups per 200m quadrat. These figures were rounded to 1, 2, 3–4 and 5–12 per quadrat. All types of tumuli were found to be at their densest (*i.e.* in numbers greater than five per grid square (Fig. 5.4) on the higher, rockier ground of Topographic Zones I and III. They follow the watersheds on both sides of the Wadi Tifariti, agglomerating amidst the inselbergs and the broken ground where igneous intrusions are present. Small concentrations also occur around two tors in Zone II. Paved crescents are close to, or on top of the watershed east of Wadi Tifariti, aligned east or south eastward. Though one paved crescent is also located west of the wadi, on lower ground, it is still situated on the highest knoll in its immediate locality and faces southeast.

Seven out of the 11 tumuli with false entrances, offering niches or annexes (see Mattingly *et al.* 2018) are situated on or near the high ground of the two watershed ridges (Fig. 5.5). Six of the seven are on or close to the eastern watershed and they face eastwards, and it is possible that one of these, WS206, might be a chapel tumulus. The tumulus situated at the far west of the inselberg west of Wadi Tifariti faces south – at a right angle to the watershed ridge. The four remaining tumuli with niches/annexes face east, south and west, and they are all on lower ground. It is also notable that WS039 situated on the eastern watershed, facing east, includes a quern stone as part of its funerary furniture. This could be a type of offering table described by Mattingly *et al.* as characteristically 'Saharan' (2003, 212 and 2018). It is a 'so-called stone bowl', which in its simplest form could be a stone slab with a depression ground into it – similar to a quern stone – wherein offerings could be placed. A similar stone was found associated with excavated tumulus WS024 (Brooks *et al.* 2006, 88). In the region of southwest Libya these features are dated to the 1st millennium BP (Mattingly *et al.* 2018).

Twelve tumuli have some kind of standing stone, or stones, associated with them (Fig. 5.6). These may not be large and some can be found on top of tumuli. Six such tumuli are situated on or close to the watershed east of the Wadi Tifariti with one close to one of the tors in Zone II, another is on the rocky outcrop adjacent to and on the west side of the wadi, while the rest are distributed away from the main concentrations of tumuli.

The high ground of the watersheds, and the other areas of higher rocky ground were evidently important for the siting of the majority of tumuli and paved crescents in the TF1 Study Area (discussed below). Since tumuli were probably the most constant monument type, extending over the greatest date range, their very presence would have had a bearing on the disposition of other monument types in the landscape. In other words, they created an expanding configuration in the landscape around which other funerary monuments were situated.

A landscape of cairns (2) – corbeilles and bazinas
Corbeille monuments are present in both the Northern and Southern Sectors of Western Sahara. In the TF1 Study Area, eight of the ten examples recorded are along the eastern side of the Wadi Tifariti, on the undulating slopes rising to the watershed. Like tumuli, they appear to be associated mainly with rockier ground (Fig. 5.7).

Bazina type monuments are present throughout central and western Sahara. Depending on where they occur in the Sahara the dating of these features can range from *c.* 4300–3180 BP in Niger (Paris 1996, 270–271, tab. 42) to as late as 2500–1300 BP in the Fezzan (Castelli *et al.* 2005, 91; Mattingly *et al.* 2007, 6, 11 tab. 0.1). They should be distinguished from drum tombs or drum monuments of the Garamantian period (di Lernia *et al.* 2002a; Castelli *et al.* 2005; Mattingly *et al.* 2007, 6). There are only two bazinas in the TF1 Study Area (Fig. 5.5), a square type with a mounded top and an annex, WS043, and a large, round type, WS063, on a rise of higher ground between the two tors in Topographic Zone II. Both monuments have niches facing east, and the latter has a quern stone, a 'so-called stone bowl' also for offerings, and an aligned standing stone (*c.* 1.80m high), now fallen. It is possible that both of these bazinas are chapel tumuli, especially WS043.

A landscape of falcates (1)
Paved crescents have already been discussed as part of a landscape of *cairns*, covering the high ground on either side of the Wadi Tifariti in the TF1 Study Area. On the other hand, crescent antenna monuments are found away from the highest density of tumuli and are situated on relatively low ground, though the examples in the TF1 Study Area are situated near to higher ground. Three crescent antennae were recorded in the TF1 Study Area, mainly consisting of a north–south aligned elliptical or long tumulus with asymmetrical curving arms extending to the northeast and southeast. But what is most striking is the fact that the northern, longer arms of two of the three monuments recorded, WS251 and WS352, extend uphill to the ridge of their nearby watershed, and in the former instance, over the ridge and down the other side. Even the southernmost crescent antenna, and the smallest recorded, WS387, has an antenna that rises uphill away from it. There is one 'semi' antenna monument in the TF1 Study Area. It is the 'composite monument' WS082, located on the western margin of the Wadi Tifariti, virtually in line with the east-to-west watershed in Topographic Zone I (see description of monuments, below).

Fig. 5.4. Density plot of all tumuli in 200m quadrats.

5. Intensive Survey

Fig. 5.5. Distribution of bazinas and tumuli with offering niches/annexes. Also showing all other tumuli.

Fig. 5.6. Distribution of tumuli with associated standing stones. Also showing all other tumuli.

5. *Intensive Survey* 115

Fig. 5.7. Distribution of corbeille monuments.

A landscape of falcates (2) – complex monuments and mounded crescents

The designation 'complex monument' appears to apply to a monument type only present in the Atlantic Sahara (Vernet 2014), since no similar monument types appear in the publications of other Saharan fieldworkers. The only monuments with a hint of similarity have been recorded in the north-central Fezzan (Germa and Wadi al-Ajal) by the Italian, Pace, Caputo and Sergi Mission in the second quarter of the 20th century (Baistrochi 1987, 87) and the more recent Fezzan Project (Mattingly 2003; Mattingly *et al.* 2007). But the similarity is extremely tenuous, based only on the presence of a handful of orthostats, or stele, along one side of certain funerary monuments.

Orthostats or stele became quite elaborate in the Fezzan, and Mattingly with Edwards (2003, 206–10) has devised a typology for them. Our stele match their earliest types, which were unworked or slightly worked, and sometimes pointed and referred to as 'proto stele', possibly dated between 2500 to 2000 BP (Mattingly with Edwards 2003, 218). While cairns with small frontages of stele are found in the Free Zone (Chapter 4), in the TF1 Study Area, where orthostates occur, these are incorporated into complex monuments, characterised by frontages of multiple orthostats that extend well beyond the bounds of the cairns or tumuli of which they are an integral part. A description of this monument type is in Chapter 3.

Fifteen complex monuments are present in the southern half of the TF1 Study Area (Fig. 5.3). They are mainly clear of the areas where tumuli are located, with ten situated south of the watersheds in Topographic Zone I, along the lower reaches of the east-to-west pediment (examples of these include WS015, WS016 and WS353). Three further monuments are located in Topographic Zone II with one of these close to a tor (WS376), while two are near the eastern limit of the TF1 Study Area in Topographic Zone III.

It would not be out of the question to treat the mounded crescents found in the TF1 Study Area as a type of complex monument (see Chapter 3). It would be gratifying to equate them with the crescent tumuli recorded by Paris (1996), but their similarities are superficial. Two of the three recorded in the TF1 Study Area (WS326 and WS378) have attached platforms or paved areas very much like those attached to complex monuments, and they all have obvious kerbs outlining at least the inner curve of the monument's crescent shape. It can also be argued that what makes them look crescent like are mere wings that mimic the configuration of the concave alignment of orthostats fronting some complex monuments. One of these features is on high ground in Topographic Zone I while the other two are in Zones II and III (Fig. 5.3).

The people who built these two types of monuments deliberately placed them close to high ground, but not on the highest reaches (save for one mounded crescent). This could have been because the highest reaches were already cluttered with other types of monuments, and if Mattingly's late date range for the use of stelae with funerary monuments could reliably be applied to Western Sahara, then this could have been the case. But if not, then there might have been a real preference for siting complex monuments on lower ground. Perhaps we are looking at funerary practices that relied on low-lying topography – as opposed to higher ground or uphill slopes as was the case with tumuli and paved crescents – with crescent antenna monuments, as already described, literally bridging the gap between lower and higher ground.

A landscape of petroforms (1) – inscriptions on the land

It can be said that people inscribe the land with the evidence of their activities and in the TF1 Study Area there are monuments that have truly left visible inscriptions across relatively large areas of ground. Arguably the most impressive are goulets with their associated stone rings (Figs 5.8 and 5.9).

Goulets occupy relatively low-lying ground. Their large overall area more-or-less requires them to do so. The TF1 Study Area includes the largest goulet recorded in the

Fig. 5.8. The corridor of Goulet WS006 showing alignment with flat-topped hill.

Fig. 5.9. Stone circles associated with Goulet WS006.

Sahara, WS006, which has already been succinctly described by Brooks *et al*. (2006, 83), who also cite Milburn (2005). However, in the TF1 Study Area, we have now recorded a total of 18 goulets (all of which are Type 1 goulets, save for one possible Type 2, see Chapter 3). Twelve are situated south of the watersheds in Topographic Zone I and into Zone II, while one is in Zone III with the rest in the lower lying Zone IV. Eleven goulets have stone rings associated with them and nine of these are in the southern half of the Study Area (Fig. 5.10).

The greatest concentration of goulets is at the interface of Topographic Zones I and II, where the pediments east and west of Wadi Tifariti blend into dissected plains. Three goulets, including two half goulets, are to the west, close to crescent antenna monument WS352, while four other goulets are close to the densest concentration of complex monuments, east of Wadi Tifariti. This latter group is most striking in that it is made up of very poorly preserved goulets, features that were not identified on the ground in the 2005 and 2007 seasons. The area in question is characterised by spreads of stones and remnants of stone rings, some of which preserved a thickening on one side which could be considered a tell-tale sign of a ring associated with a goulet. The extensive stone spreads in the area (see parent sites WS155 and WS156) might be the same as those associated with other goulets, as can be found at WS006, and WS356 (with WS357 to the east), but they have probably been disturbed by extensive foot traffic from people and animals, and maybe even vehicles from the hostilities prior to the 1990s. Only further work on well-preserved goulets will allow us to understand this disturbed area.

Stone rings, however, can occur on their own, for example, WS164, *c*. 200m west of goulet WS134, though this might be an indicator of a very poorly preserved goulet, not easily identifiable on the ground, or one that has been totally razed. But there is a circular group of rings in the northwest quadrant of the TF1 Study Area, WS170 (a parent site), comprising ten well-made stone rings. The circles vary in diameter from *c*. 4.25m to 6.50m. They are made up of an inner and outer edging of stone differentially infilled with further stones and are up to *c*. 0.50m thick. Their maximum height is *c*. 0.2m. Not all of the rings are fully preserved, but where they are, they have no apparent entranceways. Also, some have a stony infill, which could be interpreted as a kind of paving. All of the rings extend over an area *c*. 29m by 26m and, as a group they may represent a type of funerary or ritual site hitherto unknown in the region.

A landscape of petroforms (2)

One of the most interesting site types discovered during the 2008 field season was that represented by the 11 sites made up of very low lying arcs of stones referred to as 'stone half rings'. When best preserved, they are usually only half, or five-eighths, of a circle in plan, *c*. 2m to *c*. 4m in diameter, and made up of an outer and inner margin of stones, differentially filled in and up to *c*. 0.20m high by up to *c*. 0.50m thick. They were first encountered in Topographic Zone III on the east side of Wadi Tifariti amidst a number of tumuli. Seven partial circles were visible (WS226, WS228 and WS229) and they were all open sided to the approximate south (Fig. 5.11).

At the very northern limit of the TF1 Study Area a similar, easterly facing, arc of 14 half rings stretching over *c*. 71m was recorded (WS299), while *c*. 1.50km to the southeast, a further easterly facing arc of 13 comparable stone half rings (WS307) near goulets WS050 and WS051 was also recorded. West of Wadi Tifariti, in Topographic Zone II, six further sites made up of half or five-eighths stone circles were recorded. Site WS386 was made up of five open-sided circles facing south, while WS359 consisted of at least 80 such features.

Fig. 5.10. The distribution of crescent antenna monuments (also showing the extent of their antennae) and goulet sites. The alignments of the larger goulets are also shown, as are the stone rings associated with them. Site WS170 is the only stone ring site not associated with a goulet.

The latter site, WS359, stretches as a sinuous half ellipse within an area *c.* 460m east to west by *c.* 240m north to south. This irregular arc faces the south with all of the *c.* 80 open sided stone half rings similarly facing eastwards, southwards and westwards. Also, the topography is such that a sizable portion of the entire array of half circles appears to overlook a slight natural hollow caused by a tributary of the Wadi Tifariti.

As has already been pointed out, these structures might be a type of 'U' structure (see above), and from the excavated evidence of di Lernia (2013) and di Lernia *et al.* (1935, 2002b), and the ethnographic evidence of Thesiger these features might be simple cenotaphs. However, like so many other feature types in Western Sahara, further detailed investigation is needed to understand and date them.

A landscape of petroforms (3) – standing stone sites and stone alignments

One of the most distinctive sites in the TF1 Study Area is WS001 (Fig. 5.12, Plate 8c), a site of approximately 65 standing stones laid out in right angled lines and with a later kerbed burial that might be very early Islamic in date (see below for a full description; Brooks *et al.* 2003, 2006 have already described this site in summary). Nevertheless, four other standing stone sites have been discovered. One (WS302) appears to consist of up to 10 stones, half of which have fallen in an area measuring *c.* 4m × *c.* 6m (Fig. 5.13). Another is made up of a single line of five stones (WS327), while a site on a slight rise in the Wadi Tifariti consists of one fallen, broken stone (WS336). The fourth site (WS361) is a single stump-like stone that might be a natural boulder, but that is uncertain.

All of these sites are on lower ground save for WS327. It is striking that WS001 is located at a junction in the Wadi Tifariti with two western tributaries. This is similar to a standing stone circle, located 8.50km southwest of the TF1 Study Area, TF0-38 (see Chapter 4 and front cover), which is probably the next largest agglomeration of standing stones in the Northern Sector. It too, is on a confluence of wadis but unlike WS001 it does not appear to be the focus of an area of high monument density. This would be a particularly interesting monument for further study in the future. Although at a confluence of wadi systems, nevertheless WS001 is sited on a slight island *c.* 1m above the wadi bed, and it would have probably stayed dry if the wadi flooded. WS001 and WS302 are also easily visible from the watersheds on the east and west of Wadi Tifariti (see Fig. 5.12 and Fig. 5.13).

Other monument types

Kerb burials

Thirty-three sites containing kerb burials have been recorded, mainly as single features, but 11 have been recorded as groups of two to five features. In all probability, kerb burials are Islamic in date, although they are often found in relationship to earlier monuments (Fig. 5.14). For example, kerb burials arc found in and around the standing stones of WS001 and were placed to take advantage of the stones.

Parent sites WS004 and WS069 include three and six kerb burials respectively, both associated with tumuli. Kerb burial sites WS141 and WS200, both made up of two burials each, are situated amidst tumuli along the watershed east of Wadi Tifariti. Similarly, kerb burial WS325 is quite close to a tumulus, a mounded crescent, and standing stones site WS327, on high ground at the east most limit of the Study Area. Bazina WS043 has a large site of multiple kerb burials to its immediate east, WS086, covering an area of *c.* 470sq. m., and like parent site WS004, these features arc situated amidst the broken and rocky ground west of Wadi Tifariti where tumuli are concentrated. Most strikingly, standing stones site WS001 has at least eight kerb burials associated with it, and one of the burials has been placed amidst the earlier standing stones, incorporating some of the *in situ* stele in its perimeter. This is repeated at another site well outside the Study Area, to the southwest by *c.* 8km where obvious kerb burials on approximate north–south alignments have impinged on a salient standing stones monument. The general sense that one gets is that kerb burials were deliberately placed in relationship to the more ancient monuments in the TF1 Study Area, sometimes utilising existing features associated with the earlier monuments but also often simply adjacent to them and in relationship with them.

Late burials and other features

Some kerb burials may be very late indeed as indicated by the disturbance of the 'desert varnish'. Some may be associated with nomad groups who would have frequented the area over the centuries, while others could be associated with the war with Morocco (Garfi 2014). There are a small number of stone outlines that might be related to temporary campsites associated with nomad activity, or recent military occupation of the wadi. There are also many military 'bunkers' and other associated structures on the east side of Wadi Tifariti in Topographic Zone III (given the single designation WS255) and occasional remains of shelters and 'look outs' along the high ground to the west of the wadi in Zone I and near the western tor in Zone II. The remains of ordnance, exploded and unexploded, can frequently be found in these areas as well.

Discussion

Relationship of monuments to the landscape

A significant proportion of monuments cluster on the high ground east and west of the Wadi Tifariti and north/south along its side tributaries. Monuments that do not cluster on high ground but are situated on lower ground and often in relative isolation are those that have a large

Fig. 5.11. Distribution of stone half ring sites.

Fig. 5.12. Standing stone monument WS001.

Fig. 5.13. Standing stone monument WS302.

footprint, such as goulets and antenna monuments. Even in circumstances where goulets and antenna monuments are located on lower ground, an arm of the former or the corridor of a goulet can extend up the side of the wadi to higher ground. Part of the reason for situating such features on higher ground appears to be to provide a clear line of site to the standing stone monuments, WS001 and WS302. A significant proportion of tumuli and other cairn-type monuments 'reference' these standing stone sites. A view shed from WS001 (Fig. 5.15) demonstrates that approximately 75% of monuments can 'see' WS001. A large proportion of the remaining 25% that can't reference WS001 can reference WS302 (Fig. 5.16). In theory then, tumuli were by-and-large positioned in order that they could see a standing stone site. This summation gives us a loose chronology, that is, that standing stone monuments WS001 and WS302 must be earlier than other monuments otherwise they would not be able to be visually referenced by so many. Tumuli that are unable to reference standing stone sites may be later, erected at a time when the TF1 landscape was already full. All this suggests that the standing stone sites were important in some way to the people who built the funerary monuments. Other kinds of monuments that cannot directly reference standing stone sites reference prominent natural features in the landscape. The corridor of goulet WS006 (described below) is aligned along an east–west axis and sights onto a prominent flat-topped hill directly to the west; this mesa occupies a break in the approximately north–south oriented plateau of Rekeiz Lemgassem, one of the Northern Sector's major rock art sites. The position and orientation of monuments was therefore usually pre-planned in order that they were situated in the landscape in a meaningful way.

Patterns in monument types – spatially and to do with associated features

Cluster analysis for monuments in the TF1 Study Area shows that the only monument types that cluster with any statistical significance are tumuli, with a Z-Score of -15.07. However, the likelihood is that this is because they are also the most numerous monument type in the TF1 Study Area (n = 266). Complex monuments, for all their relative scarcity (n = 15) also cluster to some extent (Z-Score -3.69). All other monument types show no particular tendency to cluster (Table 5.2). The results of cluster analysis therefore, suggests that monuments in the TF1 Study Area were not placed to be close to one another, or indeed close to particular landscape features, however, the results of the view shed analysis do suggest that site lines onto other monuments and landscape features were important.

Relationships with monuments farther afield

Tumuli, bazinas and certain types of antenna monuments occur throughout the central and western Sahara, and many of these forms are found in association with the Libyco-Berber script (Gauthier 2009), connecting the Free Zone of Western Sahara with regions further east. This link is reinforced by the presence of the Libyco-Berber script in the wider western Saharan region and as reported by literature from the colonial period relating to Western Sahara (Pellicer Catalán *et al.* 1973–1974). In contrast, goulets and complex monuments are restricted to parts of Morocco, Mauritania and Western Sahara, and appear to belong to a western tradition of monument building.

Evidence for connections with north-western and western Morocco is also demonstrated in the large and complex standing stone arrangements documented in the Northern Sector of the Free Zone. While standing stones occur elsewhere in the Sahara, the Northern Sector appears distinctive (in a Saharan context) in that it contains groups of dozens of standing stones arranged so that they form particular geographical alignments, including sub-rectangular and circular features. Standing stone arrangements are features of the Moroccan Atlantic region and are often associated with large tumuli. A well-known example is the Cromlech de Mzora, a stone circle

122 *Salvatore Garfi and Joanne Clarke*

Fig. 5.14. Distribution of 'other' monument/feature types including – hearth sites, kerb burials, stone outlines, a stone emplacement site, and an open-air mosque. Features associated with the 1975–1991 conflict are also shown.

Fig. 5.15. View shed from WS001 showing monuments that can 'see' from the standing stone site.

Fig. 5.16. View shed from WS302 showing monuments that can 'see' and 'be seen' from the standing stone site.

and tumulus measuring *c*. 56m in diameter (Bokbot 2008; Salisbury 2011) with 167 standing stones forming a circle around the mound and averaging 1.5m in height (Bokbot 2008, 26). Peripheral to this were several megaliths forming a smaller circle and containing a 3m long single standing stone. Other stone circles and single standing stones have been recorded throughout Atlantic Morocco (Belmonte 1999). The Cromlech de Mzora has a west orientation which suggests an Atlantic influence and is at odds with most western Saharan tumuli that tend to have an east or south-east orientation (Bokbot 2008, 27 and see Chapter 3).

Thus, in some ways the monuments recorded in the TF1 Study Area represent a mixture of east and west. While on the one hand its pre-Islamic funerary architecture sits comfortably within the Saharan pastoral tradition with many of its monuments identical, or similar to, those found in Algeria and Libya, on the other hand it is distinctive for its apparent links with the Atlantic zone of northwest Morocco. What that actually means in terms of cultural interaction and connectivity is not as so many monuments are so poorly dated, but what seems to be clear is that this interconnectedness was complex and was undertaken over vast geographical distances, most probably via water courses that link the Atlantic coast with the Saharan interior.

Although kerb burials have also been recorded in the TF1 Study Area there is no obvious association of these features with earlier tumuli, or other types of monuments.

However, the fact that some have been placed in close proximity to non-Islamic monuments reinforces what is already known about the spread of Islam in the west of the Sahara. The Berber, Sanhaja tribes converted gradually, though superficially to Islam by the mid-8th century, but their attachment 'to Islam prior to the Almoravid period [from the mid-11th century] was superficial, and animist notions retained much of their hold' (Pazzanita and Hodges 1994, 39, 400). As with other parts of the Sahara, Sahel and Sudan (Insoll 2003), their conversion was partial and their practices were obviously mixed with earlier, traditional African religious practices. With this in mind, it is possible that some funerary monuments, for example the tumuli, could have been constructed after the 8th century, and/ or, early Islamic graves could have been placed amidst the funerary landscape of the TF1 Study Area, and close to earlier monuments, since such locations may have had continued religious importance.

Description of monuments and artefact scatter sites from the TF1 Study Area noted in the text

The following is a descriptive listing only of the features and monuments referred to in this chapter. A simple, tabulated listing of all of the sites recorded in the TF1 Study Area is presented in Table 5.1.

NB: All goulets described below are Type 1 (see Chapter 3).

WS001 Standing Stones Site with associated, later kerb burials (Fig. 5.12)

This site is situated on a slight rise of compacted (fluvial) sand and gravel on the western flank of Wadi Tifariti. There is a tributary to the wadi to the immediate west. The site is on ground, about 1m higher than the main wadi to the east, and it was probably an island of dry land whenever Wadi Tifariti flooded in the past.

This conspicuous, standing stones site, made up of 65 orthostats, is on an approximate north–south alignment. It covers an area *c.* 15m east–west × 30m north–south. Its constituent stones are preserved to varying heights ranging from stumps in the ground to orthostats *c.* 0.60m to 0.80m high, and up to *c.* 1.10m high for upright stones in salient positions such as corners. The ground between the stones is littered with quartz fragments; they are also present around the bases of the individual uprights. The stones are laid out in two near rectangular enclosures. The northern one is aligned north–south while the southern one is at *c.* 168°N. The gap between the enclosures varies from 10m in the west to 7m in the east. There are no preserved standing orthostats outlining the east side of the two enclosures. There are at least eight kerb burials encroaching on this site. They are on the west side of the monument and some have incorporated stones from the southern enclosure, *in situ*. The stones making up this monument appear to be local and igneous, but some might be sedimentary. This monument has a clear aspect all around.

WS004 Tumulus with kerb burials (Fig. 5.17)

This is a 'parent' site designation, consisting of five separate features. It is located on a relatively smooth but rocky slope dissected by natural drainage gullies, on the southern side of the high east–west ridge on the western side of Wadi Tifariti and with an aspect to the south and southeast. The main monument is a tumulus (WS074), sub circular in area, measuring *c.* 5m × 3.50m × 1m high, and with an area of *c.* 13.70sq. m. It has been dug into from the top and a cyst stone has been disturbed. There is a scatter of small quartz fragments immediately to the southeast. To the immediate northeast *c.* 2.50m, is a smaller tumulus (WS075), measuring *c.* 3.75m in diameter × 0.30m high, and with an area of *c.* 11sq. m. This feature has been constructed of pebble to cobble-sized stones, and part of a stone outline is visible. There are also small quartz fragments scattered over it. Three satellite kerb burials are close to the main tumulus, WS074. The first is WS076, just *c.* 1.50m north of WS074. This is a small rectangular feature on a near north–south alignment, measuring *c.* 1.25m long × 0.75m wide × 0.05m high. It includes short orthostats at its northern and southern ends. These measure up to 0.25m high. There are quartz fragments on the ground to the northeast. The second kerb burial (WS077) is to the west by *c.* 1.25m. It is rectangular and low lying with no orthostats and it is on a northeast–southwest alignment, measuring *c.* 1.60m long × 1m wide × 0.05m high. It has obviously been disturbed. The third kerb burial (WS078) is *c.* 5.50m further to the southwest, and *c.* 3.50m west of WS074. This feature is aligned northwest–southeast. It is rectangular and low lying and outlined by cobble sized kerb stones. It measures *c.* 1.70m long × 0.75m wide × 0.10m high, with orthostats up to 0.20m high at its ends.

WS006 Goulet (Fig. 5.8)

This monument has been described by Brooks *et al.* (2005, 83) and it is quoted here. This goulet 'is the largest monument of its kind recorded to date in the Sahara… The monument is oriented east–west, aligned with an isolated flat-topped hill to the west, with the tumulus at the western end in an area of ground covered by stones to form a symbolic platform. To the east of the [two] enclosures [separated by a central gully] forming the main part of the monument are two large stone rings, slightly offset from the central, east–west oriented gully or corridor. Beyond these are a large number of features consisting of approximately round or oval concentrations of stones, in some of which are set crude, low relief mounds [possibly representing burials]. A single angular rock is set in the ground some distance beyond these, aligned with the central corridor of the goulet. The total length of this "goulet complex" is 630m'.

WS015 Complex Monument (Fig. 5.18)

This complex monument is situated on the stony, dissected plain between the Wadi Tifariti and its watershed to the northeast. It comprises a long cairn of variably sized stones and small boulders on a bearing of 30°N. The eastern side of the monument was delineated by orthostats of which only a few survive. The cairn is *c.* 3m wide × 7.50m long (north–south). On its west side, there is an attached rectangular area, *c.* 5.50m long × 3.5m wide. It is outlined by small boulders and partly infilled with tumble from the cairn. There are small boulders spread about at some 12m from the cairn at a bearing of 150°N. Some of the stones appear to make an oval with some placed as orthostats. This monument has a clear aspect east, south and west.

WS016 Complex Monument (Fig. 5.19)

This complex monument is to the northeast of WS015, situated on the stony, dissected plain between Wadi Tifariti and its watershed to the northeast. It comprises a cairn outlined on its south side by a line of orthostats (with a tall central stela) on a bearing of 70°N. The cairn is an approximate half circle, *c.* 5m long × 3.50m wide. At its eastern end, the orthostats extend for *c.* 2m, while at its western end the extension of orthostats has apparently been re-modelled to accommodate a small stone circle *c.* 1.75m in diameter. Also, on the north side of the cairn, there is

Fig. 5.17. Sketch plan of WS004 showing tumulus surrounded by satellite features. Features WS076, WS077 and WS078 are kerb burials.

an associated, partially preserved stone circle, *c.* 1.50m in diameter and filled with tumble. This monument has a clear aspect east, south and west.

WS023 Tumulus
The larger (with an area of *c.* 33.2sq. m) of the two tumuli excavated in November 2005 (see Chapter 6).

WS024 Tumulus
The smaller (with an area of *c.* 23.8sq. m) of the two tumuli excavated in November 2005 (see Chapter 6).

WS032 Paved crescent (Fig. 5.20)
This feature is situated just below the watershed on the high ground east of Wadi Tifariti, and at a break in slope, downwards to the north, along an east-to-west igneous rock intrusion. The ground is rocky and dissected by gullies. This monument comprises a very large crescent shaped expanse of stones of variable sizes extending up slope, and apparently of one layer, lying directly on the desert surface. The feature's orientation is 45°N with one end pointing to the south and the other pointing east-northeast. The distance between these ends is *c.* 86m, and the broadest, central part

Fig. 5.18. WS015 view looking northeast. The rectangular outlined area at the rear, western side of this complex monument, is clearly visible.

Fig. 5.19. WS016 view looking north-northwest, clearly showing the orthostats making up the front of this complex monument.

Fig. 5.20. Partial view of paved crescent WS032 looking south-southwest towards the Wadi Tifariti.

Fig. 5.21. WS039 view looking west at tumulus, showing standing stones. A false entrance or offering niche is just visible at the base of the monument, off centre.

of the crescent is *c*. 14m wide. At the centre, there is an integral cairn of stones, *c*. 7m in diameter × 1m high. This feature has an aspect to the south, west and north.

WS039 Tumulus (Fig. 5.21)

Situated in a slight hollow surrounded by rocky outcrops and boulders, this feature is a prominent cairn made up of cobble-sized stones up to small boulders (*c*. 6.5m in diameter × 1m high). Though apparently disturbed, there is still a short standing stone in position at its top. There is a niche, on its east side, on a bearing of 84°N. In front of the niche there is a quern stone *c*. 0.45sq. m, which probably acted as a type of offering receptacle. The offering table consists of two upright slabs and measures in plan, *c*. 1m long × 0.70m wide. Further to the east, by *c*. 7m, there are further standing stones. These might represent contemporary, or later, satellite burials. This feature has an area of *c*. 33.20sq. m with an aspect to the southwest, west, north and east-southeast.

WS043 Bazina (Fig. 5.22)

This rectangular, bazina-like monument could possibly be interpreted as a 'chapel tumulus' (see Chapter 3). It is situated on broken rocky ground surrounded by higher boulder outcrops on the west side of Wadi Tifariti. It is well constructed with near upright sides made up of long rectangular boulders. The top consists of mounded stones and it has obviously been disturbed with the northeast corner partially collapsed. Its measurements are, *c*. 7m long × 5.50m wide × 2m high and it is aligned east to west. There is a niche on the east side, *c*. 0.9m wide with a single stone lintel on stone posts. In front of this, by *c*. 1.8m, there is an annex, apparently a small square cairn measuring *c*. 2m long (north–south) × 1.50m wide × 0.40m high. As with many other features in the TF1 Study Area, there are numerous small quartz fragments on the ground nearby, especially to the west. This monument has an area of *c*. 38.50sq. m, and its only aspect is to the east.

Fig. 5.22. WS043 view of square bazina, looking southwest. A false entrance or offering niche? is visible while standing stones making up part of WS086 are also visible. This is a composite image.

WS050 Goulet

This is a large, poorly preserved goulet constructed of local rock up to small boulders in size, and oriented to 145°N. It is situated on a sand and gravel area that slightly rises eastwards between two east-to-west wadis to the west of Wadi Tifariti. There is a paved area of cobble-sized stones, and a small circle of stones at its north-northwest end. Both the wings and central gully show evidence of vehicle damage. Overall dimensions are c. 60m long × 33m wide. An 8m wide double ring of stones (stone ring WS306) is associated with this monument at its southern end. This goulet has a clear aspect for 360°.

WS051 Goulet

A poorly preserved goulet located c. 100m to the northeast of goulet WS050, with straight edged, rather than curved, 'wings'. It measures c. 54m east to west and 21m north to south, and its orientation is c. 107°N. There are two stone rings with diameters of c. 5m (WS308 & WS309) approximately 30m to the east. This goulet has a clear aspect for 360°.

WS063 Bazina

An impressive bazina, which has experienced robbing activity, situated on a low level, rocky outcrop on a terrace dissected by natural drainage. Its burial chamber is slightly exposed and its cyst has been shifted. There is a false entry on the eastern side of the structure, where there is also a short stela and the remains of a quern stone. At c. 3.50m to the east, there is a roughly oval outline of stones, c. 1.75m long × 1.25m wide, that could be considered an annex. At c. 5m further east, there is a stela that has collapsed to the west and was at least 1.80m high when standing. The orientation of this monument is 106°N, and it is c. 7m in diameter by 0.90m high. Its area is c. 38.50sq. m.

WS069 Tumuli and kerb burials

A group of funerary monuments made up of features WS070 to WS073 – tumuli and kerb burials. Situated on flat ground, amidst a rocky east-to-west spur on the west side of Wadi Tifariti with a 360° aspect. The area around is relatively free of larger surface stones, presumably collected to construct these features. Feature WS070 is a near conical tumulus c. 4m in diameter by 1.50m high. To its southwest is tumulus WS071, oblong in shape and measuring c. 9.50m long by 3.50m wide by 1m high and on a west-southwest alignment. On the north side of WS071 is kerb burial WS072, measuring c. 1.30m long by 0.95m wide, while further to the north-northwest are the five kerb burials that make up WS073, only c. 2m west of WS070.

WS082 Composite monument (see WS083 below) (Fig. 5.23)

Situated on the western edge of Wadi Tifariti with rising, stony ground to the west, this monument is made up of a long tumulus of variably sized stones and rocks, c. 23.50m long × 8m wide × 1.80m high, on a roughly north–south alignment of 10°N. A poorly preserved, straight 'antenna' arm outlined by kerb stones (c. 1.35m wide and on a bearing of 170°N) extends south-southeast from the tumulus for c. 52m, while extending north-northeast out of the tumulus (on a bearing of 32°N), is a second, very short arm (c. 6.50m long × 1.35m wide), at the end of which is a smaller tumulus (WS083). There is no obvious evidence to suggest that the northern arm extended any further then its present limit, therefore the arm and small tumulus might be integral. If this is the case, then this type of monument is an asymmetrical antenna monument with multiple tumuli – a 'composite' monument. The area of the long tumulus is c. 147.7sq. m.

WS083 Tumulus

Situated at western edge of Wadi Tifariti where there is rising stony ground to the west is a round cairn of variably sized stones, c. 3.20m in diameter × 0.60m high, and with an area of c. 8sq. m. This feature might be integral with the c. 6.30m arm that extends north-northeast out of WS082 (described above).

WS086 Multiple kerb burials (probable)

A site of more than 20 standing stones on the broken ground to the immediate east of bazina WS043. The heights of the stones vary from c. 0.18m to 0.65m and they are spread out over an area of c. 13m north to south by 36m east to west, but the greatest concentration seems to be close to WS043. There is one orthostat that has fallen which might have stood c. 1.10m high. There are some quartz fragments spread on the ground. It is likely that this site is a large group of kerb burials. Even though it is hard to make out individual 'graves', there are at least three standing stone groups that

Fig. 5.23. Sketch plan of composite monument WS002, made up of a long central tumulus (WS082), tumulus WS083, and with a presumably later kerb burial, WS084.

appear to be on a north–south alignment at 10°N. The lie of the land in this vicinity suggests that the bedrock may have been quarried at some earlier time.

WS089 and WS090 stone alignments (Fig. 5.24)

Situated on the east side of the Wadi Tifariti, on a stony slope rising up to the watershed where there are numerous cairns, is a simple linear arrangement of stones *c*. 0.40m to 0.70m wide, consisting of large and small cobble stones. The stone alignment was arranged southwest to northeast. It meanders very slightly, and when plotted in 2005, a small,

Fig. 5.24. WS089 view of stone alignment, looking west-southwest, towards Wadi Tifariti.

possibly oval arrangement of stones was noted as integral along its path. This feature overlies paved crescent WS032 and it is roughly parallel with the linear intrusions of harder igneous rock in the immediate vicinity, which it seems to mimic. It is *c*. 90m long on a bearing of 240°N from its northeast end. It has a clear aspect from the southwest to the northwest.

To the southwest, downhill by *c*. 50.50m, and virtually in line, is another stone alignment – WS090. This is a linear arrangement of stones, mainly cobble sized with occasional small boulders, and two standing stones up to 0.50m high. This feature is *c*. 50m long, on a bearing of 240°N from its eastern end. The standing stones and boulders punctuate the arrangement of the feature, between which are irregular shaped groupings no more than 1m in diameter, of cobble-sized stones. Some of these encircle some of the smaller boulders making up the line. There is a slight bow in the alignment at its west end, and near the east end one stone grouping resembles a rectangle. This feature is *c*. 50.50m long with the same aspect as WS089.

WS092 Corbeille

This monument is made up of a double circle of orthostats situated on flat ground close to the eastern edge of Wadi Tifariti. About three quarters of the circle remains. Its external diameter is *c*. 4m, while the width of the ring of 'side-by-side' orthostats outlining the feature is *c*. 0.50m. This feature has an area of *c*. 12.60sq. m and its aspect is to the south and west.

WS095 Paved crescent

A paved crescent, *c*. 40m long, arcing along a chord on an approximate north to south alignment and situated on a slight slope up to the watershed on the high ground on the east side of Wadi Tifariti. The central, broadest part of the feature is *c*. 10.50m wide and along its west side, delineated

by a kerb, there is a cairn *c.* 4m in diameter. The cairn is low lying, with a standing stone on top, *c.* 0.50m high. This monument is simply a single layer of stones on the desert surface. Its arcing form opens up eastwards. There is an associated 'V' shaped alignment of stones adjacent, on a north to south alignment, *c.* 5m long. This feature has an aspect to the south, west and northwest.

WS134 (with WS135) Goulet (Fig. 5.25)

This monument is situated on a slightly sloping terrace-like area, east of Wadi Tifariti, dissected by natural drainage. This poorly preserved site is made up of two spreads of cobble-sized stones of irregular shape. The eastern one, WS134, is roughly 5m × 7m in area, and along its northern limit there is a curvilinear alignment of stones that gives the appearance of a kerb or outline. Very close by, and to the immediate west-southwest is another, similar stone spread, WS135, but here there is no hint of a kerb-like outline. Nevertheless, it is possible that these two stone spreads represent the poorly preserved, paved, northern end of a goulet that might have had a gully running southwards. These features have a clear aspect to east, south and west.

WS141 Kerb burials

Situated just off the ridge of the watershed, east of Wadi Tifariti, amidst many boulder outcrops and rocky, slab-like surfaces, this small site is made up of two apparent kerb burials. The first is a small outline of stones roughly oblong in shape, *c.* 1.40m long × 0.7m wide, and on a bearing of 104°N. The second burial is adjacent and to the immediate north, and represented by three standing stones. It is on a similar alignment to the first burial, with two stones at its eastern end, and a single stone at its western end where there are also some kerbstones preserved. This second burial is *c.* 1.75m long. The aspect of these two kerb burials is from the north-northeast to the south and the northwest.

WS149 Kerb burial

This kerb burial is located on the dissected plain east of Wadi Tifariti. It has a 'boat' shaped outline of large cobble-sized stones and is *c.* 2.20m long × 1.30m wide × 0.25m high. Internally, this feature is free of stones save for a small central standing stone, another at its north end (inside the stone outline), and similarly, a small boulder and three other small stones at its southeast end. The alignment of this feature is north to south.

WS155 Area of stone spreads

This is an area of *c.* 3.90 hectares (39,000sq. m) in which low-lying stone spreads are present. Some of the spreads are very irregular while others make up relatively definable features. These can include curvilinear lines, groups of small stone spreads, sub-circular features and very small features that might even be hearths. Some features have been recorded individually, *e.g.* WS134 and WS135 which might represent a goulet and are noted above, while features WS136 to WS138 and WS148 are listed in Table 5.1. Tumuli are also in this area, and they too have been recorded separately.

WS156 Area of stone spreads

This is an area measuring *c.* 2.20 hectares or 22,000sq. m well to the east of WS155, but very similar, comprising spreads of surface stones. This area is less dense, however, and the features present include stone rings and short stone alignments, as well as simple concentrations of stones, *e.g.* WS013, WS014 and WS154, which are listed in Table 5.1.

Fig. 5.25. WS134 (with WS135) view, looking south, of stone spreads that probably represent the partial remains of a goulet.

Table 5.1. Site/monument listing. This table includes all of the sites/monuments (or features) recorded in the TF1 Study Area

Topo zone	WS code	Ext. survey code	Entry type	Site/monument type	Additional information	Includes	Part of	Area – sq metres
II West	001	TF1.01	Group	Standing stones site; Kerb burial	Large rectilinear standing stones site with multiple, later period kerb burials			200.0
I West	002	TF1.02	Parent	Composite	With multiple parts	WS082; WS083; WS084		
I West	003	TF1.03		Tumulus				9.6
I West	004	TF1.04	Parent	Tumulus; Kerb burial	1 large and 1 small tumulus with 3 later kerb burials	WS074; WS075; WS076; WS077; WS078		
I West	005	TF1.05		Tumulus	With an associated mound or annex			95.0
II East	006	TF1.06		Goulet	With 2 stone rings, and stone spreads			
I West	007	TF1.07		Tumulus				12.6
II East	008	TF1.08		Tumulus (?)				
I East	009	TF1.09		Tumulus				28.3
I East	010	TF1.10		Complex				28.3
I East	011	TF1.11		Complex				16.1
I East	012	TF1.12		Tumulus				19.6
II East	013	TF1.13		Stone ring	Associated with WS332			
II East	014	TF1.14		Stone ring	Associated with WS332			
II East	015	TF1.15		Complex				35.3
I East	016	TF1.16		Complex				
I East	017	TF1.17		Complex				
I East	018	TF1.18	Group	Paved crescent	With an associated tumulus			
I East	019	TF1.19		Complex				12.3
I East	020	TF1.20		Tumulus	With a concentration of stones nearby – a possible annex			13.5
I East	021	TF1.21		Complex (?)				16.0
I East	022	TF1.22		Stone ring				9.6
III East	023	TF1.23		Tumulus				
III East	024	TF1.24		Tumulus				5.5
III East	025	TF1.25	Parent	Tumulus		WS087; WS088		
III East	026	TF1.26		Tumulus	With a flat top			70.9
III East	027	TF1.27		Tumulus				38.5
III East	028	TF1.28		Tumulus				7.1
III East	029	TF1.29		Tumulus				30.2
III East	030	TF1.30		Tumulus				14.5
III East	031	TF1.31		Tumulus				28.3
III East	032	TF1.32		Paved crescent				
III East	033	TF1.33		Tumulus				7.1
III East	035	TF1.35		Tumulus				19.6
III East	036	TF1.36		Tumulus				28.3
III East	037	TF1.37		Tumulus				37.7
III East	038	TF1.38		Corbeille				7.1
III East	039	TF1.39		Tumulus	With an associated annex, including a quern stone, and with a standing stone on top			33.2
III East	040	TF1.40		Tumulus (?)				11.0
III East	041	TF1.41		Tumulus	With an associated annex			28.3
III West	043	TF1.43		Bazina	A large square bazina with offering niche (possibly a chapel tumulus) and an annex nearby			38.5
III West	044	TF1.44		Tumulus				19.6
III West	045	TF1.45	Parent	Tumulus	2 tumuli	WS0166; WS0167		
III West	046	TF1.46		Tumulus	With a possible annex			19.6

Table 5.1. Site/monument listing. This table includes all of the sites/monuments (or features) recorded in the TF1 Study Area (Continued)

Topo zone	WS code	Ext. survey code	Entry type	Site/monument type	Additional information	Includes	Part of	Area – sq metres
III East	047	TF1.47		Tumulus	With a possible annex			12.6
III East	048	TF1.48		Tumulus				19.6
III East	049	TF1.49		Tumulus	With a small annex			7.1
IV	050	TF1.50		Goulet	Associated with WS306			
IV	051	TF1.51		Goulet	Associated with WS308 and WS309			
IV	052	TF1.52		Tumulus				9.4
IV	053	TF1.53		Tumulus				4.9
IV	054	TF1.54	Group	Tumulus	3 tumuli			3.1
IV	055	TF1.55		Kerb burial	2 kerb burials			
III East	056	TF1.56		Tumulus	With crude annexes			12.6
I East	057	TF1.57		Tumulus	With short 'wings' and an additional tumuls			12.6
I East	058	TF1.58		Tumulus				
I East	059	TF1.59		Platform tumulus (?)				22.0
I East	060	TF1.60		Tumulus				9.6
I East	061	TF1.61		Tumulus	With a possible annex			28.3
III East	062	TF1.62		Tumulus				2.1
II West	063	TF1.63		Bazina	With a offering niche, a standing stone, and a probable annex			38.5
II West	064	TF1.64		Tumulus				113.1
III West	065	TF1.66		Tumulus				6.2
III West	066	TF1.67		Tumulus				3.1
III West	067	TF1.68		Tumulus				27.5
III West	068	TF1.69		Tumulus				7.1
III West	069		Parent	Tumulus; Kerb burial		WS070; WS071; WS072; WS073		
III West	070	TF1.70		Tumulus			WS069	12.6
III West	071	TF1.71		Long tumulus			WS069	26.1
III West	072	TF1.72		Kerb burial			WS069	
III West	073	TF1.73	Group	Kerb burial	5 kerb burials		WS069	
I West	074			Tumulus			WS004	13.7
I West	075			Tumulus			WS004	11.0
I West	076			Kerb burial			WS004	
I West	077			Kerb burial			WS004	
I West	078			Kerb burial			WS004	
I West	079			Platform tumulus				19.6
I West	080			Tumulus				15.9
II West	081			Tumulus				3.1
I West	082			Long tumulus	Main part of WS002		WS002	147.7
I West	083			Tumulus			WS002	8.0
I West	084			Tumulus			WS002	2.5
I West	085			Tumulus				0.8
III West	086		Group	Kerb burial	Multiple kerb burials with stelae and adjacent to WS043			
III East	087			Tumulus	With standing stones		WS025	163.4
III East	088			Tumulus	With offering niche and partly overlying WS087		WS025	16.6
III East	089			Stone alignment				
III East	090			Stone alignment				
I East	091			Corbeille				4.2
I East	092			Corbeille (?)				12.6
I West	093			Tumulus				7.1
III West	094			Corbeille (?)			WS108	6.2

(Continued on next page)

Table 5.1. Site/monument listing. This table includes all of the sites/monuments (or features) recorded in the TF1 Study Area (Continued)

Topo zone	WS code	Ext. survey code	Entry type	Site/monument type	Additional information	Includes	Part of	Area – sq metres
I East	095			Paved crescent				
I East	096			Tumulus				8.8
I East	097			Paved crescent				0.0
I East	098			Tumulus				9.4
I East	099			Tumulus				19.6
I East	100		Parent	Lithics site		WS101; WS102		
I East	101			Lithics site			WS100	
I East	102			Lithics site			WS100	
I West	103			Lithics site				
III West	104		Parent	Lithics site		WS105; WS106; WS108		
III West	105			Lithics site			WS104	
III West	106			Lithics site			WS104	
IV	107		Group	Lithics site; hearth; tumulus; kerb burial	Artefact scatter site with hearths, possible stone alignments, kerb burials and a small tumulus			
III West	108		Group	Tumulus; Corbeille (?)	Possible multiple tumuli and corbeille (?) WS094, also possible stone alignments, hearth and quarry activity	WS094	WS104	
I East	115			Corbeille (?)				11.5
I East	116			Tumulus	With 2 standing stones on top			13.9
I East	117			Platform tumulus				10.8
I East	118			Platform tumulus (?)				6.2
I East	119			Stone spread; stone outline	Multiple stone spreads and outlines			
I East	120			Tumulus	With associated boulders			1.8
I East	121			Tumulus				6.2
I East	122			Tumulus				19.6
I East	123			Tumulus				0.9
I East	124			Platform tumulus (?)				9.4
I East	125			Tumulus				10.6
I East	126			Tumulus				6.2
I East	127			Platform tumulus (?)				6.2
I East	128			Long tumulus				24.2
I East	129			Tumulus				33.2
I East	130			Tumulus				19.6
I East	131			Long tumulus (?)				17.9
I East	132			Tumulus				18.9
I East	133			Tumulus				13.9
I East	134			Goulet (?)				27.5
I East	135			Stone spread				
I East	136			Stone ring (?)	Including a stone spread			20.1
I East	137			Stone ring (?)				
I East	138			Tumulus (?)				33.2
I East	139			Tumulus				6.6
I East	140			Tumulus				1.2
I East	141		Group	Kerb burial	2 kerb burials			
I East	142			Stone outline/ oval	Possibly a shelter			6.7
I East	143			Tumulus				18.9

5. Intensive Survey

Table 5.1. Site/monument listing. This table includes all of the sites/monuments (or features) recorded in the TF1 Study Area (Continued)

Topo zone	WS code	Ext. survey code	Entry type	Site/monument type	Additional information	Includes	Part of	Area – sq metres
I East	144			Tumulus				18.9
I East	145			Tumulus				5.9
I East	146			Tumulus				6.9
I East	147			Tumulus				9.6
II East	148			Stone ring	Associated with WS333			33.2
II East	149			Kerb burial				
II East	150			Corbeille (?)				3.1
I East	151			Tumulus				10.8
I East	152			Tumulus				23.8
I East	153			Tumulus				22.0
I East	154			Stone spread (?)	Or possible platform monument			11.0
I East	155		Parent	Stone spread	Area of multiple stone spreads	WS134; WS135; WS136; WS137; WS138; WS148		
II East	156		Parent	Stone spread	Area of multiple stone spreads	WS013; WS014; WS154; WS399		
I East	157			Tumulus				4.7
I East	158			Tumulus				9.6
I East	159			Tumulus				3.1
I East	160			Tumulus (?)	Or possible platform monument			14.2
III East	161			Disc Tumulus (?)				7.1
I East	162			Tumulus				44.2
I East	163			Tumulus	With possible niche			9.6
I East	164			Stone ring				38.5
III West	165			Tumulus				17.3
III West	166			Tumulus	With possible standing stones on top		WS045	9.4
III West	167			Tumulus			WS045	9.6
I West	168			Tumulus				11.0
I West	169			Tumulus				32.2
III West	170		Parent	Stone ring	10 associated stone rings and 1 possible kerb burial	WS171; WS172; WS173; WS174; WS189; WS190; WS191; WS192; WS193; WS194; WS195		
III West	171			Stone ring			WS170	32.2
III West	172			Stone ring			WS170	25.5
III West	173			Stone ring			WS170	19.6
III West	174			Stone ring	Possibly paved internally		WS170	19.6
I West	175			Tumulus				16.5
I West	176			Tumulus				11.8
I West	177			Tumulus				20.4
I West	178			Tumulus	With a central hollow			9.0
I West	179			Tumulus				9.6
I West	180			Tumulus				12.6
I West	181			Tumulus				8.0

(*Continued on next page*)

Table 5.1. Site/monument listing. This table includes all of the sites/monuments (or features) recorded in the TF1 Study Area (Continued)

Topo zone	WS code	Ext. survey code	Entry type	Site/monument type	Additional information	Includes	Part of	Area – sq metres
I West	182			Tumulus				38.5
III West	183			Tumulus				14.2
III West	184			Mounded crescent (?)				
III West	185			Tumulus	Apparently compartmentalised and possibly associated with WS184			9.6
III West	186			Tumulus				4.9
III West	187			Paved crescent	Associated with WS188			0.0
III West	188			Tumulus	Associated with WS187			4.0
III West	189			Stone ring	Possibly paved internally		WS170	32.2
III West	190			Stone ring	Possibly paved internally		WS170	22.1
III West	191			Stone ring	Possibly paved internally		WS170	25.5
III West	192			Stone ring			WS170	19.6
III West	193			Stone ring			WS170	14.2
III West	194			Stone ring			WS170	14.2
III West	195			Kerb burial (?)			WS170	
III West	196			Tumulus				1.8
III West	197			Tumulus				2.4
I West	198			Tumulus				21.2
I West	199			Tumulus				2.9
III East	200		Group	Kerb burial	2 kerb burials			
III East	201			Tumulus				28.3
III East	202			Tumulus				38.5
III East	203			Tumulus	With standing stone on top			12.6
III East	204			Tumulus				12.6
I East	205			Disc Tumulus (?)				44.2
I East	206			Tumulus	With offering space			19.6
I East	207			Tumulus				19.6
III East	208			Tumulus	With flat top			28.3
III East	209			Tumulus				3.1
III East	210			Tumulus				3.1
III East	211			Tumulus				12.6
III East	212			Tumulus				7.1
III East	213		Group	Kerb burial	3 kerb burials			
III East	214			Tumulus				12.6
III East	215			Paved crescent				
III East	216			Goulet	With associated tumulus			
III East	217			Tumulus	With possible offering space and a flat top			28.3
III East	218			Tumulus				35.3
III East	219			Tumulus				3.1
III East	220			Tumulus				4.9
III East	221			Tumulus				1.8
III East	222			Tumulus				0.8
III East	223			Tumulus	Oblong in shape			3.0
III East	224			Tumulus				12.6
III East	225			Tumulus				3.1
III East	226		Group	Stone half ring	2 stone half rings			
III East	227			Kerb burial				
III East	228		Group	Stone half ring	3 stone half rings			
III East	229		Group	Stone half ring	2 Stone half ring			
III East	230		Group	Tumulus	4 tumuli			3.1
III East	231			Tumulus				7.1
III East	232			Tumulus				3.1
III East	233			Corbeille	Apparently square with a possible entrance way			6.3

Table 5.1. Site/monument listing. This table includes all of the sites/monuments (or features) recorded in the TF1 Study Area (Continued)

Topo zone	WS code	Ext. survey code	Entry type	Site/monument type	Additional information	Includes	Part of	Area – sq metres
III East	234			Tumulus	With small annex			38.5
III East	235			Tumulus				28.3
III East	236			Tumulus				1.1
III East	237			Tumulus				38.5
III East	238			Tumulus	With possible tail			3.1
III East	239			Tumulus	With offering space and a standing stone on top, plus a secondary burial			19.6
III East	240			Tumulus				19.6
III East	241			Tumulus				12.6
III East	242			Corbeille (?)				3.1
III East	243			Tumulus				7.9
III East	244			Paved crescent				
III East	245			Tumulus				7.1
III East	246			Tumulus				38.5
III East	247			Tumulus				19.6
III East	248			Tumulus	Oblong and with a flat top			35.0
III East	249			Corbeille				1.8
III East	250			Tumulus	With standing stone on perimeter			78.5
III East	251			Crescent Antenna				
III East	252			Tumulus				12.6
III East	253			Tumulus				3.1
III East	254			Tumulus	With standing stone on top			12.6
III East	255			Military field structures	Numerous field remains associated with the 1975–91 war in Western Sahara			
III East	256			Tumulus				7.1
III East	257			Paved crescent				0.0
III East	258			Tumulus	With flat top			38.5
III East	259			Tumulus				7.1
III East	260			Tumulus (?)				12.6
III East	261		Group	Kerb burial	2 kerb burials and an associated *qibla* wall			
III East	262			Tumulus				0.8
III East	263			Kerb burial				
III East	264			Tumulus				4.9
III East	265			Open-air mosque				
III East	266			Tumulus				12.6
III East	267			Tumulus				38.5
III East	268			Tumulus				7.1
III East	269			Tumulus				
III East	270			Kerb burial	Lithics present			
III East	271			Kerb burial				
III East	272			Tumulus				1.8
III East	273			Tumulus				19.6
III East	274			Tumulus				1.6
III East	275			Tumulus				0.8
III East	276			Tumulus				28.3
III East	277			Tumulus				7.1
III East	278			Tumulus				9.6
III East	279			Tumulus				
IV	280			Tumulus				12.6
IV	281			Tumulus				19.6
IV	282			Tumulus				12.6
IV	283			Corbeille	with possible tail			28.3
IV	284			Tumulus				38.5
IV	285			Kerb burial (?)	2 possible kerb burials			

(Continued on next page)

Table 5.1. Site/monument listing. This table includes all of the sites/monuments (or features) recorded in the TF1 Study Area (Continued)

Topo zone	WS code	Ext. survey code	Entry type	Site/monument type	Additional information	Includes	Part of	Area – sq metres
IV	286			Kerb burial	2 kerb burials			
IV	287			Kerb burial (?)				
IV	288			Kerb burial (?)				
IV	289			Tumulus				12.6
IV	290			Tumulus				4.9
IV	291			Tumulus				19.2
IV	292			Tumulus				3.1
IV	293			Tumulus				7.1
IV	294			Long tumulus				39.3
IV	295			Tumulus				3.1
IV	296			Tumulus				4.9
IV	297			Goulet	With associated stone ring			
IV	298			Tumulus				12.6
IV	299		Group	Stone half ring	14 stone half rings			
IV	300			Kerb burial	Possibly 2 kerb burials			
IV	301			Hearth				
IV	302			Standing stones	Small standing stones site			24.0
IV	303			Goulet	With no avenue within its outline			
IV	304			Tumulus				18.8
IV	305			Tumulus				1.8
IV	306			Stone ring	With inner concentric ring, and associated with goulet WS050			50.3
IV	307			Stone half ring	13 stone half rings			
IV	308			Stone ring	Associated with goulet WS051			19.6
IV	309			Stone ring	With paved surface and associated with goulet WS051			19.6
IV	310			Stone outline	Possible remains of rectilinear shelter			12.0
IV	311			Tumulus	With possible tail			9.8
IV	312			Tumulus				1.8
IV	313			Tumulus				1.8
IV	314			Kerb burial (?)				
IV	315			Tumulus				3.1
III East	316			Complex (?)				19.6
III East	317			Complex (?)	With possible offering space and a stone alignment nearby			19.6
III East	318			Tumulus				4.9
III East	319			Tumulus	With possible offering space			15.9
III East	320			Stone outline	Outline of possible circular shelter			7.1
III East	321			Stone outline	Outline of possible rectilinear shelter			6.0
III East	322			Tumulus	With offering niche; and possible enclosing arms			19.6
I East	323			Tumulus				28.3
I East	324			Tumulus	With offering niche			12.6
I East	325			Kerb burial				
I East	326			Mounded crescent	With paved area in front			
I East	327			Standing stone	Line of 5, short, standing stones			
II East	328			Tumulus				7.1
II East	329			Goulet	With a possible stone ring			0.0
II East	330			Tumulus	With ring of stones on top			28.3
II East	331			Goulet (?)				
II East	332			Goulet	Associated with stone rings WS013 and WS014			
II East	333			Goulet	Associated with stone ring WS148			
II East	334		Group	Hearth	2 hearths			
II East	335			Kerb burial (?)				
II East	336			Standing stone	Fallen stela, in pieces			
II East	337		Group	Stone spread	5 curvilinear stone spreads, associated with WS006			

Table 5.1. Site/monument listing. This table includes all of the sites/monuments (or features) recorded in the TF1 Study Area (Continued)

Topo zone	WS code	Ext. survey code	Entry type	Site/monument type	Additional information	Includes	Part of	Area – sq metres
II East	338			Goulet	With associated stone ring			
II East	339			Stone spread	Oblong in shape, possibly a platform			8.0
II East	340			Stone spread	Oblong in shape, possibly a platform			8.0
II East	341			Tumulus				19.6
II East	342			Tumulus				50.3
II East	343			Tumulus				38.5
II East	344			Tumulus				7.1
II East	345		Group	Stone spread	4 oblong shaped stone spreads, 2 with edging			
II East	346			Burial	Possible modern burial with coins on ground			
II East	347			Tumulus				12.6
II East	348			Tumulus	Or possible platform tumulus			12.6
II East	349			Goulet (?)	Almost circular in plan and incorporating a tumulus. Probably a Type 2 Goulet			
I West	350			Tumulus				57.7
I West	351			Tumulus				19.6
I West	352			Crescent				
I West	353			Antenna Complex				
I West	354			Goulet	With a tumulus and 2 stone rings			
I West	355			Goulet	A half goulet and with 1 stone ring			
I West	356			Goulet	Half goulet matching WS355			
I West	357		Group	Stone spread	Approximately 10 stone spreads associated with goulets WS356 and WS357			
II West	358			Tumulus				19.6
II West	359		Group	Stone half rings	Atleast 80 stone half rings outlining a large enclosing arc			
II West	360			Tumulus				1.8
III West	361			Standing stone	An erratic orthostat			
IV	362			Tumulus	With 2 standing stones			3.1
IV	363			Tumulus	With 4 standing stones and a very small tumulus nearby			67.2
IV	364			Tumulus				14.2
IV	365			Tumulus				9.6
IV	366			Tumulus	With offering niche and an alignment stone			7.1
IV	367			Tumulus				3.1
II West	368			Kerb burial				
II West	369			Tumulus				9.6
II West	370			Tumulus				19.6
II West	371			Tumulus	With a possible standing stone on top			9.6
II West	372			Tumulus				3.1
II West	373			Tumulus				14.2
II West	374			Tumulus	With flat top			9.6
II West	375			Tumulus				9.6
II West	376			Complex				
II West	377			Tumulus				7.1
II West	378			Mounded crescent	With paved area behind, similar to a complex monument			
II West	379			Long tumulus (?)				13.7
II West	380			Tumulus	With possible wing			7.1
II West	381			Tumulus	With possible offering space			8.3
II West	382			Stone emplacement	Multiple stone emplacements			50.4

(*Continued on next page*)

Table 5.1. Site/monument listing. This table includes all of the sites/monuments (or features) recorded in the TF1 Study Area (Continued)

Topo zone	WS code	Ext. survey code	Entry type	Site/monument type	Additional information	Includes	Part of	Area – sq metres
II West	383			Stone half ring				
II West	384			Stone half ring				
II West	385		Group	Stone half ring (?)	Possibly 2			
II West	386		Group	Stone half ring	5 stone half rings			
II West	387			Crescent Antenna				
II West	388			Tumulus				13.9
II West	389		Group	Stone outline	2 possible shelter outlines			
II West	390			Kerb burial				
II West	391			Tumulus				7.1
II West	392			Tumulus				4.9
II West	393			Stone outline	Possible shelter outline			
II West	394			Tumulus	With a possible offering niche			9.6
II West	395			Complex				
II West	396			Tumulus	Oblong in shape and with wings			6.3
II West	397			Stone half ring (?)				
II West	398			Complex				
I East	399			Stone spread			WS156	13.9
II East	401			Tumulus				4.9
II West	402			Kerb burial				
II West	403			Goulet	Associated with stone ring WS404			
II West	404			Stone ring	Associated with goulet WS403			50.3
II West	405			Tumulus				1.3
II West	406			Tumulus				4.9
II West	407			Goulet	Associated with stone ring WS408			
II West	408			Stone ring	Associated with goulet WS407			
II West	409			Tumulus				7.1
II West	410			Kerb burial (?)	Possibly 4 kerb burials with associated standing stones			
II West	411			Tumulus				3.1
II West	412			Platform tumulus	Without cairn			9.6
II West	413			Platform tumulus; Kerb burial	A kerb burial overlying a later platform tumulus			12.6
II West	414			Kerb burial	2 kerb burials			
I West	415			Tumulus	With offering space and an annex nearby			16.6
I West	416			Tumulus				12.6
II West	417			Complex				
II West	418			Complex				
I West	419			Tumulus				3.5

Key:
TOPO ZONE: This is the topographic zone in which a site/monument is located. If it is noted as 'East' then the site is located to the east of Wadi Tifariti, and if it is noted as 'West', then the site is on the western side of Wadi Tifariti. Zone IV is not divided east or west. WS CODE: The sites/monuments in the TF1 Study Area have been given unique, numerical identifiers, prefixed with 'WS'. EXT. SURVEY CODE: Prior to being given a WS Code some of the monuments were recorded as part of the Extensive Survey (Chapter 4). Their TF1 numbers are given for concordance. ENTRY TYPE: Every monument or feature has usually been recorded and numbered individually, but some closely situated features have been given a single 'WS' number and recorded as a 'Group'. When features making up a group are relatively complex, then the whole group can be given an overall, 'parent' number, and the constituent features can each be given a unique 'WS' number (ie, 'child' numbers). This column only notes those sites/monuments which are 'Groups' of features and 'Parent' sites. Where there is no entry type, then the monument described is a single site or feature. SITE/MONUMENT TYPE: This column is self explanatory, it includes site/feature types found in Western Sahara. Re: Goulets, unless otherwise noted, all goulets are Type 1 (see Chapter 3). ADDITIONAL INFOMATION: This column includes further, descriptive or qualifying information. INCLUDES: This column lists those constituent ('child') features that make up, or are part of a 'Parent' site/monument. PART OF: 'Parent' sites/monuments are listed in this column. AREA – SQ METRES: Gives approximate measurements in square metres for monuments where size could be estimated.

During the 2008 season it became apparent that features in this stone spread area, and WS155, might be associated with goulets, such as WS134, described above, and WS331, WS332 and WS333 listed in Table 5.1.

WS164 Stone ring

A very low-lying circle of cobble sized stones nearly flush with the ground and *c*. 7m in diameter. Situated on the terrace on the east side of Wadi Tifariti. There is a slight concentration of stones within the ring and occasional quartz fragments are present. This feature has an area of *c*. 38.50sq. m, with a southerly aspect.

WS170 Stone ring complex

This complex of features comprises a rough circle of ten stone rings made up of large cobbles and small boulders. Some of the rings are well preserved while others are only partly preserved. The area has suffered from, presumed, foot traffic of animals and people in a roughly east–west direction. Where the rings are in good condition, they are *c*. 0.20m high, and are obviously made up of a double-faced (and differentially infilled) outline of stones up to 0.50m thick. Where rings are adjacent, their outlines often merge. The internal diameters of the rings vary from *c*. 4.25m to 6.40m, and some have a stony infill that can possibly be interpreted as paving. The two smallest rings are on the eastern side of the group, where there is also a kerb burial. Where the rings are wholly preserved, there are no entrances present. The rings making up this site extend over an area *c*. 29m × 26m. They may represent a type of funerary or ritual monument, and their apparent lack of entrances suggests that they are not habitation structures. The constituent features making up this site are WS171, WS172, WS173, WS174, WS189, WS190, WS191, WS192, WS193, WS194 and WS195, and they are listed in Table 5.1. This site is situated on a low, relatively flat area of stony ground, partly dissected by drainage, and with a tributary to the Wadi Tifariti to the north. It has a northerly to easterly aspect.

WS200 Kerb burials

Two kerb burials situated in an area of flat, high ground, with exposed weathered bedrock, overlooking Wadi Tifariti to the west. The western burial is aligned east-northeast by west-southwest and measures *c*. 0.90m × 1.40m with kerb stones more prominent on its west side. The eastern burial is oriented north-northeast by south-southwest and measures *c*. 0.90m × 1.20m. Its kerbstones are well defined. These features have a 360° aspect.

WS206 Tumulus

This small circular tumulus is situated on bedrock, on a north-facing slope of higher ground. It measures *c*. 5m in diameter × 1.50m in height, and it has a southeast facing offering niche. It is made up of local rocks up to small boulders in size. It appears to have been damaged, perhaps during the past conflict. This feature has an area of *c*. 19.6sq. m with an aspect to the north and northeast.

WS226 Stone half rings

These two features are located on low, flat ground, near the eastern edge of Wadi Tifariti. The western of the two features is a stone half circle open to the south and measuring *c*. 5m wide × 3m deep. Its stone outline is *c*. 0.50m thick. The second feature, only about 1m to the east, is a smaller arc of stones, also opened to the south and *c*. 3m wide. Its stone outline is also *c*. 0.50m thick. Some chipped stone is present on the ground. These features have a westerly aspect.

WS228 Stone half rings

Three adjacent, stone half rings located on low ground close to the east edge of Wadi Tifariti. All of the outlines are *c*. 0.50m thick and up to 0.15m high. The western half ring is *c*. 3m wide × 3m deep, the central half ring is *c*. 4m wide × 3m deep while the eastern half ring is *c*. 2m × 2m deep. All features are open to the south. It is probably contemporary with WS226 and WS229. Some chipped stone is present on the ground. These features have a westerly aspect.

WS229 Stone half rings

Two stone half rings situated on the low ground close to the eastern edge of Wadi Tifariti. The south-western half ring is *c*. 4m wide × 3m deep × 0.15m high. Touching it, and to the northeast, there is a similar feature of similar dimensions. The outlines of both features are *c*. 0.50m thick. Some chipped stone is present on the ground. These features have a south and westerly aspect.

WS251 Crescent antenna

This is a large crescent antenna monument measuring *c*. 240m in overall length. It is situated on a west-facing slope on the east side of Wadi Tifariti. The monument's antennae are paved and outlined with ill preserved kerbs. They are their widest, at *c*. 10m, where they join with the central tumulus, thinning to *c*. 1m at their ends. The central tumulus is *c*. 25m long by *c*. 10m wide on an approximate north–south alignment and is outlined by small boulders. Its height is *c*. 1.40m and its top is relatively flat. The northern antenna is longer than the southern one and it rises up to, and extends over, a ridge to the east. There are three satellite tumuli, one of which is situated on the southern antenna and close to the central mound. The aspect of this monument is south to west and it has an orientation of 90°N. There has been obvious damage to this monument, presumably due to military activity in the area.

WS255 Military field fortifications

WS255 represents a relatively large area of at least 19 abandoned military field structures, comprising dugouts and

bunkers, all of which are now in poor condition, and extend over an area measuring c. 900m north–south × 300m east–west. These features are concentrated along the eastern edge of Wadi Tifariti, more or less where the eastern watershed drops down to the wadi towards the flatter terrain to the north. The bulk of the structures are square or rectangular and constructed of mud bricks and/or local stones and surrounded by embanked sand. At least one of the structures is a simple stone structure, while another is a large mud brick rectangular complex of c. 60m × 40m with the ruins of two mud brick, domed structures nearby. WS265 is an open-air mosque and is part of this site. There are also at least two possible 'lookout' positions on the higher ground on the western side of Wadi Tifariti, as well as a possible dugout along the wadi's western edge.

These structures probably represent a small Moroccan military camp dating to the earlier years of the Western Saharan conflict of 1975 to 1991.

WS261 Kerb burials and a qibla

Two Islamic burials with a semi-circular *qibla* (open-air mosque) nearby, facing east-southeast. Both burials are on a north-northeast to south-southwest alignment. The larger of the two is made up of a c. 3m × 4m outline of stones with presumed entries along the north and south sides. There are low, standing stones at the heads and feet of the graves. The *qibla* wall is c. 3m wide and 1m deep. These features are in a flat area of low lying ground.

WS265 Open-air mosque (Fig. 5.26)

An open-air mosque facing east and measuring c. 4.50m east–west by c. 4m north–south. Outlined by local grey cobble sized stones. There is a c. 1m-wide entry along the west side and a slight projection with a c. 0.3m-high standing stone along the feature's east side marking a *qibla*.

This feature is well preserved and was probably made by the soldiers occupying the bulk of the features making up WS255.

WS302 Standing stones site (Fig. 5.13)

Situated on a flat, low lying spur between two subsidiary wadis, this small site of standing stones covers an area of c. 6m north–south × c. 4m east–west. Five stones are standing, up to 0.60m in height and c. 0.25m wide. At least ten stones have fallen and it is possible that all of the stones may represent a circular ring. Further stones extend to the south for several metres. It is not clear whether these were once standing. There are no quartz fragments strewn on the ground amidst this feature, as is the case with the considerably larger standing stones site, WS001.

WS307 Stone half ring (Fig. 5.27)

A north to south-aligned series of thirteen stone half rings, all facing eastwards in an arc and situated on the northern edge of a wadi east of Wadi Tifariti and possibly related to goulets WS50 and WS51, which they are relatively close to but face away from. This arc of features covers an area c. 100m from north to south. Each half ring is very low lying and c. 3m wide by c. 1.50m deep. The walls are c. 0.50m thick. The distances between each half ring varies from c. 2m to 4m with one larger gap of c. 16m.

Fig. 5.26. WS265 view of small open-air mosque. Looking to the east.

Fig. 5.27. Sketch plan of arced arrangement of stone half rings, WS307.

WS325 Kerb burial

A possible kerb burial with a short standing stone at its north end, c. 0.25m high. Comprised of local stones no larger than cobbles. It is situated on south facing, sloping ground with a southerly aspect.

WS326 Mounded crescent (Fig. 5.28)

A mounded crescent, arcing and facing eastwards, situated on rocky and undulating, south-facing ground. It is well preserved and measures c. 8m north–south × c. 6m east–west. Constructed of locally collected varying sized small boulders and is outlined by a kerb. There is also a kerbed, paved area that extends out for c. 2m on the eastern side of the feature, almost mirroring the shape of the mound itself. Its orientation is 90°N, with a southerly aspect.

WS327 Standing stone alignment

This monument is situated on south facing sloping ground, rocky and undulating, with clear views to the south. A well-preserved alignment of five, short, standing stones, running from west-southwest to east-northeast. They range between c. 0.10m to 0.50m in height and they extend 5m from end-to-end on an orientation of 68°N.

WS352 Crescent antenna (Fig. 5.29)

Situated on the southern flank of the east to west watershed, west of the Wadi Tifariti.

This is a very large monument comprising an elliptical cairn of variably sized local stones (cobbles to small boulders). The cairn is aligned north to south and measures c. 20m long × c. 7.50m wide × c. 1.75m high. A long antenna, or arm, arcs to the northeast and smoothly emerges out of the northern end of the cairn, extending northwards,

Fig. 5.28. Sketch plan of mounded crescent WS326 with an area of pavement in front.

Fig. 5.29. Sketch plan of large crescent antenna monument WS352 with complex monument WS353.

uphill, to the ridge of the narrow rocky watershed that runs east to west. This antenna varies in width from c. 2.75m down to 1m, but at its blunt north-eastern end, it is c. 1.75m wide. The antenna is outlined by large cobbles and small boulders up to c. 0.25m in height. These kerbstones are infilled with smaller stones. Similarly, extending from the south of the cairn is another arm, or antenna, arcing to the southeast, but poorly preserved. Where visible, this arm is also made up of kerbstones (no more than 0.1m in height) infilled with a paving of smaller stones.

It is possible that this monument has been slightly altered during the war in Western Sahara. There are four depressions that might represent hollow 'dug out' positions in the western flank of the cairn, in which an individual could lie for protection. They each measure c. 2m long × 0.75m wide and there are stones piled up between them. There is also a small stone ring (c. 1m × 1.75m) nearby that might be associated with the depressions. A slight hollow at the top of the monument indicates a possible attempt at robbing the monument. The orientation of this substantial feature is 104°N, with an aspect to the east, south and west.

WS353 Complex monument

This monument is before situated c. 7.50m east of WS352 on slightly sloping ground dissected by natural drainage. This complex monument comprises a cairn c. 3.50m in diameter by c. 0.75m high with low lying wings extending north and south by c. 2.75m each. The southern wing is c. 1m wide while the northern wing is c. 0.85m wide. Both are c. 0.25m high. There appears to be a ridge through the body of the cairn joining the wings, and to the west of this, on top of the cairn, there is a single orthostat, c. 0.40m high and aligned north to south. There is a partly paved rectangle, c. 2.80m east–west × c. 3.50m north–south × c. 0.20m high, attached to the western side of the monument. The dominant stones making up this monument are small local boulders, with occasional cobbles. There are vague stone alignments around this feature. One is on the south side while another is a group of boulders to the immediate east. There are also concentrations of quartz fragments nearby. The orientation of this feature is 138°N, with an aspect to the east, south and west.

WS354 Goulet (Fig. 5.30)

Situated on a low stony terrace dissected by natural drainage, south of the east-to-west watershed on the west side of the Wadi Tifariti, this goulet is unusually oriented to the west. Its narrower, paved part is situated at its eastern end while the central gully extends westwards in a west-northwest direction. Overall, this monument is c. 47m long (east to west) × c. 31m wide (north to south). The narrower, paved end is c. 9.25m wide by c. 4.25m deep. The gully passes through the paved end and is c. 0.90m wide. It is possible that the paved area was once larger, perhaps hinting at even a different type of monument, since ill preserved, similar paving extends outside

Fig. 5.30. Sketch plan of goulet WS354 and associated features.

of the goulet outline by a further *c*. 4.25m. Also, this extended area of paving has been robbed to construct an adjacent cairn *c*. 4.25m in diameter × *c*. 0.40m high. The stones that delineate the goulet are large cobbles and very small boulders. Outside the west end of the goulet, just north of the central gully, are two low-lying stone rings (no more than 0.20m high). The closer one, only *c*. 4.25m from the goulet, is a simple circle of cobbles, *c*. 5m in diameter with no easily apparent entry. Further to the west by 2m, is a larger stone ring (*c*. 8.50m internal diameter), with an outline *c*. 0.50m thick and made up of inner and outer cobble-sized kerb stones, filled in with occasional smaller stones. There is an incurving entrance into the eastern side of the ring, *c*. 0.60m wide. At the far western end of the ring is a *c*. 5.50m long platform which is simply a progressive thickening in the width of the ring's outline, extending its thickness to *c*. 1.20m. There is a small spread of quartz fragments to the northwest of the smaller stone ring. The orientation of this goulet is 287°N, with an aspect to the east, south and southwest.

WS355 Goulet (half goulet)

Situated on a low stony terrace dissected by natural drainage, south of the east to west watershed on the west side of the Wadi Tifariti, this goulet is one of a pair of half goulets (see WS356) situated immediately to the east of goulet WS354. Both goulets are *c*. 33m apart and this large gap, in effect, acts like the typical gully that is found down the centre of goulets. The northern side of WS355, made up of small boulders and cobbles, is straight and extends eastwards for *c*. 41m from a sub-circular ring made up of piled stones, *c*. 1.90m wide × *c*. 2.30m long × *c*. 0.30m high. A line of cobbles arc from this feature to the southeast, and turn northwards to complete the monument's outline. There is also a paved area to the immediate east of the sub circular ring at the western end of the monument, extending *c*. 4.25m. The broadest part of the goulet is *c*. 11m. Beyond the eastern limit of the goulet, by *c*. 10m, is a simple stone ring outlined by cobbles. It is *c*. 5.70m in diameter. The orientation of this goulet is 98°N, with an aspect to the east, south and west.

WS356 Goulet (half goulet)

This is the half goulet, *c*. 33m north of WS355. Both WS355 and WS356 make a pair. This monument is delineated by cobbles and small boulders. Its southern side is straight and more or less in line with the straight northern side of WS355. It is *c*. 30m long. There is an irregular, cairn-like concentration of stones, *c*. 3m in diameter × *c*. 0.30m high, at the western, narrow end of this monument, where from there is a possible area of paving for *c*. 5m and an arc of stones which delineates the northern outline of the monument. The widest part of this goulet is *c*. 16m, and natural drainage has eroded the monument's eastern end. This feature's orientation is 105°N, with an aspect to the east, south and west.

WS357 Area of stone spreads

This area of stone spreads is immediately east of goulet WS356. It seems to consist of approximately ten, relatively level and variably sized spreads of stone. Some give the appearance of tending toward circular, while others are more amorphous. Some appear pavement like and quartz fragments can be present. There has also been disturbance by foot traffic. We cannot be certain as to what these spreads represent, but as in the case of goulet WS006, they might represent burials.

WS359 Stone half rings (Fig. 5.31)

This site, the largest of its kind recorded by the Western Sahara Project, is spread out southwards over slightly sloping ground, dissected by natural drainage, along an arc that measures *c*. 600m from near the southern flank of goulet WS354 to the further southwest. The site comprises a linear, arcing alignment of at least 80 half circles of low-lying stone walling. These wall segments are very similar in build to stone half rings recorded in other parts of the TF1 Study Area. The wall segments can be *c*. 0.45m to 0.5m thick, and rarely more than 0.15m high. They usually consist of cobble sized outlining stones with a variable infill of smaller stones. In some instances, all the stones are almost flush with the surrounding ground surface. The diameters of the segments average 2.80m. These features usually look within the overall arc that they delineate, facing to the southeast, south and southwest, though a very small number are positioned outside of the overall arc and are open to various aspects. The overall aspect of this site is to the east, south and southwest.

WS376 Complex monument (Fig. 5.32)

Situated north of a tor, on a wadi terrace dissected by natural drainage, this complex monument consists of a semi-circular cairn (*c*. 6m wide × *c*. 3m deep) fronted by a roughly north-northwest to south-southeast outward arcing line of orthostats (*c*. 12m long), with the central stela collapsed. There are the remains of a rectangular arrangement of

Fig. 5.31. View to east-northeast showing a small number of the approx. 80 stone half rings that make up site WS359.

Fig. 5.32. Sketch Plan of complex monument WS376.

stones behind the cairn, but this possible pavement is poorly preserved. There is a group of small boulders within 10m of the front of the monument. This feature has an orientation of 65°N, with a clear, all round aspect.

WS378 Mounded crescent (or complex monument)

This feature is situated on the lower, eastern slope of a salient tor, amidst a dissected terrace. It is a winged, crescent shaped tumulus built on a bouldery outcrop and made up of very large cobbles. The wings arc outwards to the east. Further to the east, by *c.* 5.50m, is a spread-out grouping of stones. At the rear, western side of the tumulus, there are the remains of a square paved area, or platform, with two low orthostats (*c.* 0.15m high) indicating the platform's western end. The spread of stones in front of the monument, along with the paved area at its rear, more than suggests that this type of mounded crescent is a variation of a complex monument; one without a façade of orthostats. This monument is oriented to 90°N, and it has a north, and east to southwest aspect.

WS382 Stone emplacements (Fig. 5.33)

This site is situated on a low lying plain dissected by natural drainage. It is a roughly rectangular area in which there are approximately 20 small stone emplacements, almost flush with the ground, of local red stone that could have come from a nearby outcrop. Those outlining the east and west sides of the site are aligned in straight lines. These emplacements vary in size from 0.30m to 0.50m in diameter, while some are rectangular at *c.* 0.30m × 0.50m. Some are also irregular in shape. Also, within the northern end of the site there is a larger concentration of stones with a possible arced outline, measuring *c.* 1.50m × 1.75m. The stones making up these features vary in size up to small cobbles. The overall dimensions of the site are *c.* 8m north–south × *c.* 7m east–west, and its aspect is to the northeast, south and southwest. There are further stone scatters around the

Fig. 5.33. Sketch plan of roughly rectilinear arrangement of stone emplacements WS382.

Fig. 5.34. View to northwest, showing two of the stone half rings making up site WS386.

immediate vicinity of this site, as well as four groupings of medium sized, red boulders.

WS386 Stone half rings (Fig. 5.34)

This site is situated on a dissected plain, or terrace. It consists of a south facing arc of five stone half rings, nearly flush with the ground and each, *c.* 2.50m to 2.75m in diameter. There is a gap between each half ring (up to *c.* 0.75m) and they extend over an area more than 14m in length. Though differentially preserved, each arc is made up of variably sized cobbles, and the arcs themselves are *c.* 0.50m to 0.75m thick, with their constituent stones laid in a pavement like way. About 4m to the northwest is a single stone half ring, open to the northwest and measuring only 1m in diameter by 0.1m high. Also at *c.* 4m to the west-northwest, there is a small stone emplacement, *c.* 0.60m × 0.30m in size, similar to those at WS382. This site has a 360° aspect.

WS387 Crescent antenna (Fig. 5.35)

This crescent antenna monument is situated near the bottom of a rocky slope with boulder outcrops on the western side of a tor. It is made up of a central, elliptical tumulus, *c*. 7m long × *c*. 3.50m wide, on a north–south alignment with stone kerbed, differentially preserved antennae acing outwards to the northeast and southeast. The stones making up the monument range in size from cobbles to boulders, and the tumulus itself appears to have a kerb of boulders in places. On the ground to the east are spreads of quartz fragments. The distance between the ends of the antennae is *c*. 60m. There is a small upright stone nearby, but this might be natural. The northern antenna terminates on slightly higher ground. This monument has an aspect to the south, west and north.

Note

1. All TF1 monuments recorded in the extensive survey presented in Chapter 4 have been converted to the new numbering system prefixed by WS. A concordance of the old and new numbering systems is given in Table 5.1.

Fig. 5.35. Composite image of crescent antenna monument (WS387), looking toward its central mound. View to south-southwest.

Table 5.2. Nearest Neighbour Analyses (WS) TF1 Study Area rounded to three decimal points

	Observed mean distance	Expected mean distance	Nearest neighbour index	Number of points	Z-Score
All TF1 Study Area	46.170	84.197	0.5483	400	-17.2804
Artefact Scatter Sites	243.550	167.404	1.4549	10	2.752
Standing stone sites	950.995	468.937	2.0280	5	4.397
All tumulus types	52.569	106.081	0.496	244	-15.074
Complex monuments	146.052	290.673	0.5025	15	-3.686
Paved crescents	358.393	263.129	1.3620	8	1.959
Mounded crescents	1681.273	527.103	3.190	3	7.255
Tumulus with offering niche	520.877	423.309	1.230	11	1.462
Bazinas	1283.935	256.291	5.010	2	10.848
Tumulus with standing stones	313.023	304.495	1.028	12	0.186
Corbeilles	324.578	254.529	1.275	10	1.665
Crescent antenna monuments	1114.758	418.497	2.664	3	5.513
Goulets	289.690	356.173	0.813	18	-1.515
Stone half rings	434.102	415.892	1.0438	11	0.278
Kerb burials	220.5487	238.128	0.9261	33	-0.811
Stone outlines	560.474	488.367	1.148	6	0.692

Chapter 6

The Excavations

Joanne Clarke, Vicki Winton and Alexander Wasse

Introduction

In 2005 a team of archaeologists went into the field to excavate two conical stone cairns (tumuli), the most common of the built stone features in the TF1 Study Area and known widely across the Sahara as a common form of burial monument usually associated with pastoral populations (di Lernia *et al.* 2002a, 2013; Gauthier 2009, 2015; Mattingly *et al.* 2018; Paris 1992, 1996). It was a principal objective to clarify the function of different types of features, in order to determine the types of cultural activities that took place in the Wadi Tifariti and its tributaries and whether these activities changed over time. The aims of the excavations were to (i) retrieve material for scientific dating purposes and (ii) to undertake an anthropological assessment of the individuals interred in the tumuli in order to formulate individual biological profiles and to document skeletal markers in an attempt to distinguish ante-, peri- and post-mortem modifications.

In 2007 the team returned to Tifariti to excavate a number of test pits through surface scatters of lithics and pottery that had been identified in previous seasons' field walking. Analyses of lithic material derived from the surface scatters (reported in Chapter 7) determined that at least three of these sites were of a more ancient age than the stone monuments, and dating of charcoal indicated that the Wadi Tifariti had been occupied during the early Middle Holocene, as well as the Late Holocene, as indicated by the dates from the excavated tumuli. The aims of the 2007 excavations were to (i) determine the extent of deflation and whether any cultural material had survived *in situ*, (ii) to determine the chronological span of each site using a combination of typological analyses of material finds and where possible, scientific dating, and (iii) to determine whether any of the surface scatters related in any way to the monuments. As these were the first systematic recording and excavation of stone monuments and surface scatters in the Free Zone the project saw this work as vital to 'filling in' the very considerable gap in the Saharan archaeological record.

2005 Excavations

Excavations in 2005 were undertaken in the TF1 Study Area. The Study Area lies in a region characterised by a series of escarpments between which are found ephemeral rivers and playa (wet weather) lakes. In common with other Saharan regions, Western Sahara is characterised by an arid environment containing numerous indicators of past humid conditions. In the vicinity of the TF1 Study Area, dense networks of drainage channels focus runoff into a number of occasionally active wadis, which flow northwards into the Saguia el-Hamra, a large ephemeral river to the north of Tifariti. Other wadis are filled with accumulated sediment and appear to be permanently dry. Sand and gravel plains, sandstone hills, elevated plateaux, and extensive playa surfaces are major features of the landscape.

In total, project members identified and recorded 411 built stone features and seven lithic scatters, some with pottery (see Chapter 5). Two tumuli were chosen for excavation on the basis of their prominent position on ridges overlooking the Wadi Tifariti and for their proximity to many other similar features on the ridge and slopes below (Fig. 5.3 and Fig. 6.1).

Other criteria for selection included size and preservation: both tumuli were acknowledged as being small enough to be excavated in a three-week field season and of sufficient structural integrity as to offer hopes of acquiring the sorts of data needed to address our research aims.

Fig. 6.1. WS023 and WS024 in relationship with other built stone features.

The initial phase of excavations involved the removal of surface layers of the tumuli, which consisted of small stones and wind-blown sediment, exposing the larger angular rocks of the local granite beneath. These stones on average measured 0.20m × 0.30m and were heaped in a roughly circular mound directly onto the bedrock outcrop. Each monument was divided into two halves, exposing a cross section which left the central burial chambers intact. Sediments from the monuments were sieved using a 0.50cm and 0.25cm mesh in order to aid recovery of small finds (*e.g.* bone fragments, teeth, beads *etc.*). Once both halves of each monument had been excavated to the lowest courses of the surrounding constructional material, the central burial chambers were opened to expose their contents.

The subsequent treatment of the human remains within the chambers was determined by their preservation. Well-preserved skeletal material that was likely to survive removal was uplifted from the burial chamber for analyses, while remains unlikely to survive the removal process were assessed *in situ* and reburied. All skeletal remains were subjected to detailed anthropological assessments including age at death, sex and stature to establish ante-, peri- and post-mortem modifications to the skeletal remains. Where possible an assessment of the skeletal markers characteristic of trauma and/or pathology was undertaken. Samples of long bones and teeth were taken for radiometric dating and for future isotopic studies in order to determine the dietary signature of the individuals interred in the monuments.

Human remains and grave goods recovered from the monuments were taken to Tifariti for recording, consolidation and sampling. Small finds were cleaned, photographed and stored for further analyses.

WS023

WS023 is a medium-sized dry-stone tumulus *c.* 6.50m in diameter and approximately 1.40m high (Fig. 6.2). It was constructed on a prominent outcrop of granite bedrock within easy view of other monuments in the Study Area, and with extensive views over the Wadi Tifiriti to the south. It comprised a central, megalithic, roughly oval burial chamber constructed from slightly inclined granite standing stones, over which were placed large (up to 1m) granite slabs. Circling this at a distance of approximately 2m was a perimeter retaining wall, or kerb, within which angular stones were piled up in an apparent spiral over the chamber to create the mound. On the eastern side of the perimeter wall were two rows of parallel stones, which

Fig. 6.2. The tumulus, WS023, looking southwest.

may have represented a false entrance or offering niche (Fig. 6.3).

The chamber contained the remains of a well-preserved adult female, 21–30 years old, lying in a flexed position on its right side, with the head directed towards the east and facing north (Fig. 6.4). The body lay *in situ* on the bedrock but extensive evidence of animal activity was suggested by the presence of human bone near the top of the tumulus, while animal bones within the tumulus were identified as the greater white-toothed shrew (*Crocidura russula*), the North African elephant shrew (*Elephantulus rozeti*), and the rodent species, *Gerbillus gerbillus, Pachyuromys duprasi, Meriones libycus, Psammonys obesus and Jaculus jaculus*, all of which occur today in North Africa. It is likely that animal activity is responsible for the disturbance of the burial chamber. Below is a detailed description of the excavated contexts.

Fig. 6.3. Plan of WS023, showing the burial chamber and possible false entrance/offering niche.

Fig. 6.4. Plan of the burial within the chamber of WS023.

Fig. 6.5. Cut through the burial chamber of WS023, showing large flat stones laying on top of the burial chamber, which is constructed of angled vertical uprights.

Construction

Prior to excavation, WS023 was photographed and then divided into east and west halves. Initial cleaning of wind blown dust and silt from between the rocks revealed a layer, approximately 10cm thick, of fine rubble (009) covering the large angular blocks. This was composed of mainly small, grey, granite and sandstone rocks and pebbles, considerably smaller than the stones used to build the main structure of the mound. Beneath this layer were the uppermost courses of the underlying constructional material (008 and 058). The eastern half was excavated first, leaving the western half to form a north–south section across the mound. The eastern half of the monument (008) was comprised of various sizes of granite stones. On exposure of the burial chamber, the excavation of the construction material (008) was extended to include the western half of the mound (058). The lowest course, which sits on the bedrock, appears to have been deliberately arranged in order to form a stable foundation for the mound of stones. Of these, the outer perimeter ring of stones was placed first, creating a retaining wall or kerb (056) within which subsequent circular arrangements of stones were positioned around the burial chamber. The stones lying directly against the wall of the burial chamber were randomly arranged, while the outer three rings of stones closest to the perimeter wall were more clearly defined. On the eastern side of the perimeter wall, sitting directly on the surface of the bedrock, was a rectangular stone arrangement (010) comprising two parallel lines of stones, approximately 60cm apart and extending *c.* 1.60m beyond the perimeter wall of the mound. At the most eastern end of each line of stones, were placed two larger stones which angled towards the south, effectively creating a curve in the end of the feature. The western end of this feature was incorporated into the perimeter wall establishing its contemporaneity with the construction of the mound. This feature may have represented a false entrance or offering niche for the mound.

Placed centrally within the mound of stones and rubble was an approximately oval burial chamber (012), measuring 1.90m × 1.50m × 0.85m (Fig. 6.4). The upper part of the chamber was constructed mainly of flat slabs of locally sourced granite and sandstone, which were randomly stacked one on top of the other, without any obvious coursing. The structure was wider at its base, narrowing at the top in an approximation of a corbelled 'beehive' chamber (012). The basal interior stones were set vertically but pitched slightly toward the east. Like WS024 (detailed below) there was a series of larger flat stones that had been placed horizontally over the top of the chamber. These upper stones of the chamber were some of the largest encountered in the whole mound structure, averaging 1.50m × 0.30m (Fig. 6.5). The fill of the burial chamber was comprised of soft yellowish aolian sand/silt (011) with small angular inclusions of sandstone and granite chips, rodent bones and some disarticulated human bone that had been dislodged through rodent activity. These included fragments of proximal metacarpal, right clavicle, coastal ribs, sternum, left pelvis, right scapular and left talus.

The burial

Resting on the bedrock was a single inhumation which had been placed on its right side with the head directed toward the east and facing to the north. The knees were

bent with the left knee positioned on top of the right. The arms were also flexed with the hands placed in front of the face (Fig. 6.4). The individual was lying in a flexed position and was relatively intact.

The chamber was clearly constructed first, with the mound of stones subsequently built up around it but it is unclear at what point the interment was placed inside the chamber.

Stratigraphic sequence

1. Removal of surface sand 009 from the whole mound surface.
2. Excavation of the western half of the constructional material 008 to the level of the top of the retaining wall 056.
3. Excavation of the eastern half of the constructional material 058 to the level of the top of the retaining wall 056.
4. Excavation of stone feature 010 abutting the eastern edge of the perimeter wall.
5. Exposure of burial chamber 012.
6. Excavation of fill of burial chamber 011.

Ceramics

Prior to excavation, pottery sherds and chipped stone were collected from the vicinity of the monument as part of the process of cleaning. Fifteen sherds were collected from the surface around the burial monument. Twelve of these comprised an homogenous assemblage of rim, shoulder and body sherds of one or two flared necked jars with rolled rims (Fig. 6.6 no. 1; Fig. 6.7 no. 1). These sherds were handmade and wet smoothed in a hard-fired, light red (2.5YR7/6-6/8), and completely oxidised fabric, with high concentrations of quartz pebbles and angular grits up to 1mm in diameter. There is nothing to suggest that these sherds were associated with the burial and may be a chance break that occurred after the tumulus was constructed.

Another 43 sherds, all possibly from one vessel, were found on the surface of the monument, in and around the construction material. All were body sherds, impressed with intersecting bands made with a comb, or in the case of one sherd Fig. 6.6 no. 3, probably a flexible fibre roulette (Fig. 6.6 nos 3 and 4; Fig. 6.7 nos 2 and 5). They were hand made in a gritty red to reddish brown fabric (2.5YR5/2-5/6) with an incompletely fired core. Three further sherds found on the surface of the tumulus included one that was decorated with impressed decoration and two were plain. As with the sherds found around the tumulus, there is nothing to suggest that these sherds date the construction material but may be simply a chance break, or were collected with the construction material as the tumulus was being built. This is in contrast to the view of di Lernia *et al.* (2002c, 133) where the authors take the view that the pottery incorporated in the building matrix of the burial monuments "could not be casual gathering of ceramic fragments during the building of the structres but voluntary insertion in the structures as part of the furnerary practices." Whatever the case it is clear that the comb impressed sherds, the roulette decorated example and the rim and body sherds of the amphora are unrelated to each other in time.

A number of sherds were found inside the burial chamber. Seventeen sherds in all were recovered. These included three incised sherds, all originating from the same vessel, found underneath the skeleton and a fourth, also from the same vessel, found in the top of the chamber fill (Fig. 6.6 nos 2, 5, 6 and 7). These were in a pale buff ware and included three body sherds and one rim sherd. All were incised with parallel lines, one in a herringbone pattern with a central dividing line. The rim sherd displays a slightly rolled, inward sloping lip. The positioning of the sherds beneath the skeleton suggests that these sherds belong with the burial.

Thirteen body sherds of different types were also found in the burial chamber. Twelve of these appear to be from the same vessel. All were impressed with overlapping bands, very similar to those found on the surface of the tumulus. It is likely that these were created by impressing a comb into the surface of the pot. For comparison see sherds from the Libyan Sahara (di Lernia and Manzi 2002, 237 fig. 19, 7–8) and from the site of Orub in the Saharan Niger (Grébénart 1985, 29–54).

It is interesting to note that even though the sherds found on top of the mound and within the burial chamber came from three to four different vessels, none could be more than partially reconstructed. Some sherds were included with the construction material (those with roulette decoration) and must therefore be earlier than the construction of the tumulus, while the sherds of the amphora lay around the tumulus and therefore indicate that they are later than its construction. The sherds within the burial may have been intentionally placed or may be there as a result of the considerable animal activity. The similarity between the sherds found inside the burial chamber and those mixed with the construction material may be explained this way.

Fig. 6.6. Photograph of pottery from WS023.

Fig. 6.7. Line drawing of pottery from WS023.

In terms of decorative schemes and possible age of the sherds, comb impressed decoration is the most common form of decoration used in the Atlantic Sahara and is found at Tintan and Chami in Mauritania (Petit-Maire 1979, 271ff) and can date from the Middle to the Late Holocene. Roulette decoration is associated with sub-Saharan West-African potters (Arazi and Manning 2010; Haour *et al.* 2010; Livingstone Smith 2007). By the middle of the 1st millennium AD, roulette decoration appears at Aghram Nadharif in the Fezzan (Gatto 2005, 2013) where it had

been absent previously. Although there is considerable debate about what this appearance means in terms of trans-Saharan trade, its presence in the Fezzan suggests widening exchange networks that probably extended into Western Sahara as much as they extended into sub-Saharan Africa.

Small finds

From the tumulus came four beads (two of ostrich eggshell, one of an unidentified soft stone and one of carnelian) and an iron point (Fig. 6.8).

Both ostrich eggshell beads (Fig. 6.8 nos 1, 3; Fig. 6.9 nos 1, 2) were situated outside of the burial chamber,

Fig. 6.8. Small finds from the burial chamber of WS023.

Fig. 6.9. Ostrich eggshell beads (left and centre). Stone bead (right).

amongst the construction material as it was being removed suggesting that these, like the pottery, were picked up and incorporated into the superstructure of the tumulus as it was being constructed. A carnelian bead and an iron point were discovered in the fill of the burial chamber at the level of the skeleton and the stone bead (Figs 6.8 no. 2; 6.9 no. 3) was discovered near the head, suggesting that these were part of the burial offerings. Ostrich eggshell beads are common across eastern, central and western Sahara and more examples were found in the vicinity of both excavated tumuli. Carnelian, on the other hand, may have originated from sources in central Sahara; it is found in the Garamantian tombs in the Wadi al Ajal where it has been souced close to the Fezzan (Mattingly *et al.* 2018). Whatever the source, Western Sahara has no sources of carnelian so the bead must have been the product of trade.

1. Ostrich eggshell bead (Fig. 6.8 no. 1 and Fig. 6.9 no. 1)
 Small Find No. 006
 Found in the matrix of the burial mound constructional material. 1cm diameter, roughly pecked on the outer edge, bifacially drilled. Undecorated.

2. Ostrich eggshell bead (Fig. 6.8 no. 3; Fig. 6.9 no. 2)
 Small Find No. 007
 Found in the matrix of the burial mound constructional material. 1.1cm diameter. Pecked and smoothed on the outer edge, bifacially drilled. Undecorated.

 Ostrich eggshell beads are very common in Saharan burial contexts and span quite some period of time. They have been found in numbers in tombs in central Sahara, in the Late Pastoral tumuli of the Tanezzuft Valley in southern Libya (di Lernia *et al* 2002b, 69–156), in the pastoral and Garamantian tombs of the Wadi al Ajal (Mattingly *et al.* 2018) and they are recorded by Paris (1996) in burial tumuli in Niger. Ostrich eggshell pieces originating from containers litter the suface of the TF1 Study Area so it is likely that this material was locally available and simply collected with the building material.

3. Stone bead (Fig. 6.8 no. 2; Fig. 6.9 no. 3)
 Small Find No. 008
 Found within the burial chamber in proximity to the head of the skeleton. 0.5cm diameter. Pecked and smoothed on the outer edge, bifacially drilled. Undecorated. Similar stone beads are known from excavations of Tumuli in the Wadi Tanezzuft Valley (di Lernia, *et al.* 2002c, 128 and Fig. 5.74: 9–14).

4. Carnelian bead (not illus.)
 Small Find No. 009
 Found within the general fill of the burial chamber. 0.80cm diameter. Rounded profile, roughly pecked outer surface biconically drilled. Similar carnelian beads are known from excavations of tumuli in the Wadi Tanezzuft Valley and in the Fezzan (di Lernia *et al.* 2002c, 128 and fig. 5.74: 4 and 5; Mattingly *et al.* 2018). Mattingly (*et al.* 2018) confirms that in the Fezzan they were locally sourced. Whether or not our example comes from such a distance is unknown but it was certainly imported.

5. Iron point (Fig. 6.8 no. 4)
 Small Find No. 010
 Heavily corroded 2cm in length, triangular, narrowing to a point at one end.

Vernet (2007a, 163) records iron smelting mines in the vicinity of the Wadi Draa in southern Morocco, and in Akjoujt in southwestern Mauritania and agrees with Grébénart (1988) that the earliest evidence for smelting of metals in western Sahara occurred sometime around the 1st millennium BC. Iron smelting furnaces have also been dated to the 1st millennium BC in Niger (Grébénart 1985, 203) but there is debate as to whether iron began being smelted in sub-Saharan Africa before 500 BC (Childs and Killick 1993, 321). In southwest Africa, beyond the Niger–Nigerian area, the earliest evidence of iron technology is dated from *c.* 400 BC at Nokara A and Jenne-Jeno in Mali (Holl 1997, 22). Childs and Killick note that iron appears in West Africa as early as copper but Grébénart (1985, 187) dates the presence of iron objects at Afunfun near Agadez to the *Cuivre II*, around the middle of the 1st millennium BC. Radiocarbon dating of long bones from WS023 date the death of the individual interred in the tumulus to *c.* AD 420–770 (see below for a full analysis of the dates on bone from WS023 and WS024), so the presence of an iron pin in the burial is entirely consistent with the advancement of metallurgy in the previous millennium.

WS024

WS024 is a small dry-stone tumulus *c.* 3.20m in diameter and 0.80m high. It is constructed on a prominent outcrop of granite bedrock within easy view of the other monuments

Fig. 6.10. WS024 prior to excavation.

in the Study Area, and which affords extensive views of the Wadi Tifiriti to the south (Fig. 6.10).

It is comprised of a central megalithic burial chamber lying within a rough retaining wall, or kerb. Between the central chamber and the retaining wall was a stone fill, which spiralled outwards from the chamber to the perimeter kerb wall. Prominent fallen stones were noted on the east side of the mound, which may originally have formed a false entrance or offering niche (see Fig. 6.11).

The burial chamber contained two individuals: the poorly preserved remains of a child, which lay above the remains of an adult lying in a crouched position on its right side, with its head directed west–northwest and facing approximately south. An *in situ* copper earring and pierced shell pendant were found with the adult individual. Traces of red ochre were noted around the head and feet of the adult. The positioning of the child in relation to the adult, and the absence of sediment build up between the two, would indicate that the child and adult were placed in the burial chamber at approximately the same time. Below is a detailed description of the excavated contexts.

Construction

The monument was constructed of predominantly angular rocks of the local granite, averaging 0.30m × 0.20m in size, but extending down to 0.10m × 0.05m and up to 0.65m × 0.30m. The stones appear to be heaped up in a roughly circular mound (0.80m in height) lying directly on the bedrock outcrop, which more likely than not, was cleared and prepared for the construction of the cairn. No trace of a retaining wall could be seen at the base of the mound prior to excavation, but two large flat stones were visible on its top (with a third lying out of position to the west). These were aligned approximately north–south, suggesting the presence of a disturbed burial chamber below. Prior to excavation WS024 was photographed and then divided into east and west halves. The eastern half was excavated first,

Fig. 6.11. WS024 with large, formally standing, stones to the east of the cairn.

leaving the western half to form a north–south section across the mound (Fig. 6.12).

The initial cleaning of fine windblown dust and silt (001), which had accumulated between the stones, revealed several bone fragments, suggesting that the burial had been disturbed and the mound entered from the top. The bedrock around the eastern half of the mound was also swept back during the cleaning but no artefacts were found. A compact brown silt layer 5cm thick, had accumulated around the northeast part (the upslope side) of the mound, probably through surface wash. Down slope (to the south) the bedrock was already exposed up to the base of the mound. There were a number of hollows in the bedrock immediately north of the mound approximately 0.30m diameter and filled with a soft brown silt and eroded chips of granite. This deposit seemed to be associated with the natural weathering of the rock. The constructional fill of WS024 (002) was exposed by the removal of the surface sand (001). It comprised approximately 70% angular granite cobbles, 0.30m × 0.20m in diameter, and 30% fine brown/yellow silt which had blown into the gaps between the stones post construction (Fig. 6.13). Context 002 was heaped up around a central megalithic 'beehive' type chamber (005) made from large (1m long)

Fig. 6.12. North–south section through WS024.

Fig. 6.13. Plan of WS024 showing possible 'spiraling' of stone infill.

granite blocks and was retained by a wall (003) which lay approximately 0.80m back from the perimeter of the mound as preserved. Stone fill had thus been built up over and extending beyond the retaining wall. On exposure of the burial chamber, the excavation of the construction material (002) was extended to include the western half of the mound (Fig. 6.13). The constructional material of the western half of the mound appeared identical to the eastern half, however, there was an indication that the stones had been built up by 'spiralling' around the central burial chamber (005) which was then 'filled in' around the outside to complete a roughly circular profile. Cranium fragments were discovered on the north side of the mound close to the surface. On completion of the removal of the construction material (002) it was noted that extensive rodent activity could be observed. Small bird bones were found immediately under the stones of 002 lying on the bedrock on the northern side of the mound.

The basal stones of 002 were noticeably larger than the stones found higher up the mound, suggesting that some effort had been made to provide a stable foundation, or platform, for the mound. A higher proportion of green/grey stones were noted around the central chamber (005), although it isn't clear whether or not this was significant.

A dry-stone kerb wall was constructed around the burial chamber to hold back constructional fill. The wall (003) was comprised of angular blocks and stones of the locally outcropping granite. The basal stones were larger (*c*. 0.60m × 0.30m) than those above (*c*. 0.30m × 0.20m) suggesting an attempt had been made to provide a stable foundation for the mound. Rock tumble (004) from the top of the monument lay on bedrock around the wall. A grinding

stone was found under the tumble, directly on the bedrock, up against the base of the wall.

Completion of the removal of the constructional material exposed the chamber (005). It was built of large flat slabs of the locally outcropping granite (up to 0.95m long) laid so as to create a 'corbelled' structure, approximately 0.96m high, enclosing a burial chamber on the bedrock. The burial chamber measured 0.80m north–south by 0.92m east–west and was sealed at the top by three large flat granite slabs (Fig. 6.13). One of these had slipped out of position slightly owing to the rock beneath it cracking but other than this, the chamber appeared to have remained undisturbed since the last interment. A gap between the rocks of the chamber was noted low down on the northeast side, leading up to the mound surface. This seems to have been exploited by a burrowing animal which seems to have taken up residence in the burial chamber at some time after the final interment, leading to major disturbance of the northeast half of the chamber and its occupants. This may account for the presence of a long bone and cranium fragments on the northeast side of the mound's surface.

Immediately adjacent to the retaining wall (003) were large slabs of the locally outcropping granite (006). These were located on the east side of the mound and may have represented a false entrance or offering niche to the mound, which so many other monuments in the Tifariti region possess.

The burial chamber (007) was carefully opened by removal of the large flat granite slabs. It contained a double human interment. The fill consisted of an almost pure deposit of yellow/brown soft silt/soil with a handful of granite pebbles mixed in. The chamber was excavated to bedrock in five spits, of which the fifth (lowest) represented the bulk of the *in situ* remains. Evidence of the upper burial was restricted to an unfused femur and pelvis which belonged to a child. The position of the bones suggested that it may have been laid in a crouched position on its right side. The lower burial was situated 19cm lower than the child and was much better preserved. It comprised an adult lying in a crouched position on its right side, with its head directed to the west–north-west and facing approximately south. It lay *in situ* on a 'bed' of silt, *c*. 8cm thick which covered the bedrock and which was indistinguishable from the surrounding silt (007).

A copper earring was found *in situ* by the left side of the head and pierced shells on the right side of the head. Two of the shells are *conus* while the third is *periscula cingulata*. The latter, though a different species, was probably collected for its similarity to the other two and so probably was part of the same string. Red ochre stains were observed around the head and feet. This material was sampled for analysis. Only the cranium, mandible, uppermost vertebrae and lower limbs were preserved *in situ,* the remainder of the body having been disturbed. The state of preservation of the remains was such that it was impossible to determine the gender of the body. Owing to the poor state of preservation of the bones, pressure of time and absence of facilities for conservation of grave goods, samples were taken of teeth and long bones and small finds were removed before the chamber with its human contents was backfilled and reconstructed.

Stratigraphic sequence
1. Removal of surface sand 001 across the whole mound surface.
2. Excavation of the eastern half of the collapse and tumble 004 around the kerbed wall of the cairn, exposing the megalithic burial chamber 005 and the fallen stones 006.

Fig. 6.14. Plan of WS024 burial chamber.

Fig. 6.15. Burial in the chamber of WS024.

3. Excavation of western half of constructional fill 002 to the level of the spiral retaining wall 003.
4. Excavation of the western half of the collapse and tumble 004 around the perimeter of the mound.
5. Removal of large slabs of burial chamber 005 to the level of the top of the retaining wall 003.
6. Excavation of the western half of the retaining wall 003 and remaining stones of the fill 002 on the western half of the mound to expose the bedrock around the western side of the chamber 005.
7. Excavation of the double burial and the chamber fill 007 to bedrock.
8. Reconstruction of the chamber and burial and the reconstruction of the mound.

Small finds

1. Copper earring, broken (Fig. 6.16)
 Small Find No. 002

 Circular. 1.2m diameter, pointed for insertion into the ear. Found within the burial chamber adjacent to the skull.

 Copper was smelted at Akjoujt in Mauritania during the first half of the 1st millennium BC, when it ceased around 500 BC and was resumed again in the late 1st millennium AD (Childs and Killick 1993, 320; Vernet 2012, 7). Copper items from Akjoujt have been found at sites located in western Mauritania, including Nouakchott and Dhar Tichitt-Walata (Vernet 2007a). In northwest Africa, copper deposits have been discovered on the right bank of the Wadi Draa in Morocco, which is closer to the TF1 Study Area than Akjoukt and copper objects have been found on sites along the Saguia al Hamra (Vernet 2012, 15), which is to the north of the TF1 Study Area and south of the Wadi Draa. In Algeria copper comes from the southern Oranais, and in Mali in the north-west of the Adrar des Iforas. Beyond Africa, copper production began in Spain *c.* 5000 years ago. In Morocco copper and bronze objects are first imported from Spain before being manufactured locally (Vernet 2012, 19).Other smelting sites further afield include Niger in the region west of Agadez and the Tenere-Aïr-In Gall-Tegidda-Tesemt (Grébénart 1985). Here the remains of numerous copper smelting furnaces were discovered which have been dated to the 1st millennium BC (Childs and Killick 1993, 320).

2. Worked shell (Fig. 6.17)
 Small Find No. 003

 Found within the burial chamber between the skull and vertebra. *Conus sp.* Origins West Africa, Cape Verde Islands. Very worn, with signs of wear. Apex worked. The spirals have been removed leaving a hole through which twine was threaded to form a necklace.

3. Worked shell
 Small Find No. 004

 Found within the burial chamber between the skull and vertebra. *Conus sp.* Origins West Africa, Cape Verde Islands. Very abraded, with signs of wear. Apex worked. The spirals have been removed leaving a hole through which twine was threaded to form a necklace.

4. Worked shell
 Small Find No. 005.

 Found within the burial chamber between the skull and vertebra. *Periscula sp. Cingulata.* Origins West Africa. The shape fits most closely with *p. cingulata.* The shell has been pierced (drilled) though the body of the shell to form two holes (the central fragment is missing) again through which twine may have been threaded to form a pendent.

5. Grinding stone (Figs 6.18 and 6.19)
 Small Find No. 001

 Limestone/quartzite. Pecked. Broken. 21cm diameter 3cm deep. Shallow depression on concave surface. Slightly convex base. Found on the east side of the kerbed wall of the burial mound. The concave surface is stained with a red pigment, possibly ochre.

Fig. 6.16. Copper earring.

Fig. 6.17. Worked shells.

Fig. 6.18. Illustration of the basalt grinding stone.

Fig. 6.19. Photo of the basalt grinding stone showing ochre staining.

Chipped stone from the vicinity of WS023 and WS024 (V. Winton)

The lithic artefact surface finds from WS023 and WS024 were assessed from photographic records after the end of the field season.[1] The assemblage was collected from the vicinity of the two monuments and does not represent an assemblage that is linked in any way to the monuments. The artefacts are instead likely to represent a number of successive stone tool making and/or using episodes spanning many millennia.

A range of stone tool manufacturing techniques are represented, largely indicative of the middle and end phases of the tool-making process and involving a variety of raw materials. The raw materials represented in the assemblage include fine-grained igneous rock such as basalt, also quartz, quartzite, and a variety of crypto-crystalline or fine-grained, siliceous rocks including jasper, translucent chert, and grey flint. A range of preservation is observed; while some artefacts exhibit sharply defined flake scars, others show a high degree of surface lustre across the dorsal surface which suggests prolonged exposure to wind and sand blasting. Overall the assemblage is in relatively sharp condition, though there is evidence of differential weathering due to variable degrees of exposure which may correlate to some degree with artefact age.

A variety of manufacturing techniques are represented, including:

1. examples of direct percussion (*e.g.* flakes of raw material have been detached artificially to create artefacts and subsequently to further shape flakes into tools),
2. stone grinding and polishing,
3. small, recurrent, bipolar blade core preparation,
4. small, unipolar blade core preparation

Blades, or fragments of blades, comprise at least 30% of the entire assemblage (93 artefacts) and were clearly an important component of the industry, certainly during one phase of activity at the site, if the assemblage represents a number of tool-making and use episodes. It is not immediately apparent whether the blades were struck from prismatic blade cores or Levallois blade cores since without closer examination of the artefacts it is difficult to determine the mode of flaking adopted in the production of the two cores. The artefact in Fig. 6.20 no. 14 is noteworthy as its dorsal flake pattern conforms to that of Levallois points (*i.e.* long flake scars on either margin converging at the point with a smaller flake scar struck from the centre of the platform acting to accentuate the desired morphology prior to the detachment of the final, pointed Levallois flake).

The diminutive sizes of the cores suggest that small blades/bladelets were at least acceptable products, if not the desired outcome (otherwise the cores would have been abandoned in a less reduced state).

Flakes and blades appear to have been shaped into a variety of tool forms, including endscrapers (*e.g.* Fig. 6.20 no. 9); denticulates or 'toothed edges' (*e.g.* Fig. 6.20 no. 10; Fig. 6.21 no. 7); points (*e.g.* Fig. 6.22 no. 13); and burins (Fig. 6.22 nos 17 and 18). Of particular note is a small point that appears to have a retouched, tanged base, suggesting that it might have been hafted for use as a spear point (Fig. 6.22, no. 13).

Degree of modification and raw material reduction

Only 16% of the assemblage has a maximum dimension exceeding 50mm. Approximately 22% of the assemblage appears to retain some trace of the natural, un-flaked, outer surface of the raw material units used (*e.g.* Fig. 6.21 nos 3 and 11; Fig. 6.22 no. 14). Considering the variety of raw materials represented, a higher number of flakes with

6. *The Excavations*

Fig. 6.20. Flakes, blades and cores (Top left to bottom right numbered 1–17).

Fig. 6.21. Flakes and blades (top left to bottom right numbered 1–17).

Fig. 6.22. Flakes and blades (top left to bottom right numbered 1–19). NB:the high lustre on some artefacts, notably third from left in top row.

remnants of the outer surface of nodules would be expected if the assemblage represented the entire reduction process. Moreover, as previously noted, some 30% of the assemblage comprises blades or blade fragments. The diagnostic parallel, dorsal flake scars on the blade products demonstrate that these items were detached from advanced phases of raw material reduction, rather than from the preliminary 'shaping-out' stage (which leads to more diverse dorsal flake scar orientations).

Raw materials

The raw materials represented in the assemblage appear to include fine-grained, igneous rock such as basalt, quartz (*e.g.* Fig. 6.20 no. 7); quartzite (*e.g.* Fig. 6.21 no. 1); and a variety of crypto-crystalline or fine-grained, siliceous rocks including jasper (*e.g.* Fig. 6.20 nos 16 and 17; Fig. 6.21 nos 2, 5, 6, 14, 15; Fig. 6.22 no. 13); translucent chert (*e.g.* Fig. 6.21 nos 4 and 16; Fig. 6.22 nos 2 and 15); and grey flint (Fig. 6.20 no. 14).

Comparisons and interpretation

The assemblage indicates that artefacts were brought to the site as shaped-out cores or individual flake and blade tools.The raw materials used were mostly selected for fine-grain quality and were presumably imported from diverse geological sources, or from a geologically diverse secondary deposit. It is possible that the range of raw materials attest to curation of lithics over considerable distances or exchange of these (valued) rock types between neighbouring social groups. The fact that there is no evidence that tools were 'made' *in situ* supports the prevailing view that the people utilising this region of the desert were mobile.

The apparent ground stone artefacts are not made of the crypto-crystalline cherts so common in the assemblage but coarser, harder rocks such as basalt.These artefacts appear not to be completely ground and polished since flake scars are still visible. Perhaps these arefacts were unfinished, as their asymmetry might suggest, or were re-flaked post-depositionally? Ground stone axes are described from Neolithic contexts in Mali such as the site of Dialaka, Kayes near the Senegal border (Konaté 2000, 38, fig. 15, b).

The tanged point (Fig. 6.20, no. 13) and the Levallois point (Fig. 6.20, no. 14) are reminiscent of the northwest African Aterian industry which dates to between 90,000 years ago and 20,000 years ago. Good comparative material is provided by the Aterian sites of the Zouerete region of western Mauritania, near the Western Sahara border (Naffé, Vernet and Kattar 2000, 137, fig. 2, citing Pasty 1999). However, the blade and blade fragments, which are such a common component of the assemblage, tend to be less than

50mm in length and frequently less than 30mm. Such small items, verging on 'microliths', are more characteristic of early Neolithic industries of northwest Africa. Of particular note in this regard are artefacts nos 17 and 18, Fig. 6.22, which appear to be small, obliquely retouched bladelets and, depending upon a closer examination of the shaping, may have affinities with such microlithic assemblages as that of the Neolithic site of Gobnangou in Burkino Faso (Millogo and Kote 2000, 23) and the Mékrou Valley, Niger (Idé, 2000, 199). What the Tifariti assemblage lacks, however, are any signs of the characteristic Neolithic, tanged, arrowheads shaped by invasive, parallel retouch on thin blades that are associated with tumuli sites in the Akjoujt region of nearby western Mauritania (Naffé, Vernet and Kattar 2000, 38 fig. 20). Such carefully shaped artefacts may have had very different patterns of discard to the other artefacts represented here and if not would certainly be the first of any surface assemblage to be looted.

Dating of the tumuli

Two sets of dates were run by different laboratories on the same femurs taken from the adult interments in WS023 and WS024. The dates came back from the labs internally cohesive. The determinations for the femur from WS023 were (LTL1336A) 1429 ± 80 BP, which when calibrated gave a date range of AD420–770 at 95.4% probability, and (P115/AA95065) 1539 ± 35BP, which when calibrated produced a date range of AD 430–595. As the latter date is a subset of the first it is likely that the two are accurate. The presence of an iron point in the chamber of WS023 gives the burial a *terminus post quem* of the latter part of the 1st millennium BC if using Akjoujt as a source (Vernet 2007a; Holl 1997). There are other sources, Walalde in Senegal for example, has been reliably dated to between the 8th and 3rd centuries BC (Pole 2010, 58). Thus, a date for the burial in the first half of the 1st millennium AD is not inconsistent with the general increase in iron working that happened some time from the 1st century BC onwards.

The two determinations from WS024 are more problematic. The first, (LTL1337A) 1394 ± 85BP gave a calibrated date range of AD 430–820 at 95.4% probability. The second (P116/AA95066) 1776 ± 35BP gave a calibrated date range of AD 133–345. Thus, there is no overlap in the dates even at two standard deviations. Yet, on the basis of construction and burial behaviour WS024 is very similar to WS023 and could be considered to be stylistically comparable. On a broader chronological scale, if we assume that the individuals interred in WS024 are likely to have died and been buried in the tumulus in the first half of the first millennium AD or slightly later, then the two burials could be considered within the same broad tradition of monument building in the first half to the middle of the 1st millennium AD. That said, there is no reason to assume the burials in the two tumuli were in any way contemporary.

The copper earring found within the chamber of WS024, may shed some light on the dating of the tumulus. The nearest source of copper to Western Sahara was the smelting site of Akjoujt in Mauritania, where the first evidence for smelting copper dates between the 9th and 3rd centuries BC (Childs and Killick 1993, 320) after which copper smelting ceased, not to be resumed until the late 1st millennium AD. The first of these time frames is out of sync with the placement of the copper earring in the burial but the resumption of smelting copper late in the 1st millennium AD would coincide with a date falling in the latter part of AD 430 to 820.

Discussion

WS023 and WS024 are members of a common form of simple conical cairn (tumulus) found throughout the Sahara and Sahel (details of which are discussed in Chapters 3 and 4). They are one element of a wider tradition of stone monument building associated with funerary rites found throughout the Sahara but which are not well understood due to the absence of high resolution dates for different types of monuments. Conical tumuli with human interments are the most ubiquitous of burial monuments in the Sahara and range in date from *c.* 6000 to 1200 BP depending where in the Sahara one looks; the spread of these monuments was east to west (Brooks *et al.* 2009, 929) with origins in

Table 6.1. Measured value of radiocarbon age taken on a femur from each of the adult interments in WS023 and WS024

Laboratory	Lab ID	Site	Sample	Radiocarbon age (BP)	Calibrated date (2s) cal AD
CEDAD	LTL1336A	WS023	Bone	1429 ± 80	540 (68.2%) 670
					420 (95.4%) 720
					740 (3.3%) 770
CEDAD	LTL1337A	WS024	Bone	1394 ± 85	550 (63.4%) 710
					740 (4.8%) 770
					430 (95.4%) 820
Paris/Tucson[1]	P115/AA95065	WS023	Bone	1539 ± 35	
Paris/Tucson	P116/AA95066	WS024	Bone	1776 ± 35	

[1]The lab. in Paris undertook the CO_2 extraction from the bone bioapatite, whereas Tucson did the AMS on the CO_2 obtained.

northeast Egypt around the Nabta Playa (Sivili 2002; di Lernia 2006). The burials within WS023 and WS024 are therefore at the very end of stone cairn/simple tumulus sequence.

2007 surface collection and excavation

Excavations in 2007 shifted the focus of the Project from burial monuments to seven utilisation sites that had been identified and systematically surveyed in previous seasons. These were all characterised by dense scatters of lithics and occasionally pottery. A series of 1m × 1m test trenches were excavated in each of the seven sites. These are detailed below.

WS100

WS100 is a low rocky knoll on the east bank of the Wadi Tifariti, measuring approximately 95m north–south and 105m east–west. The knoll stands c. 12m above the east bank of the wadi, immediately adjacent to its confluence with a major tributary wadi entering from the west. The area is characterised by outcrops of dark rock, partially covered with yellow windblown sand. The site commands excellent views over the drainage to the south, west and north and up to the watershed to the east, which runs along the top of a range of low hills. Much of the knoll was covered with a scattering of debitage and microlithic tools, however, two self-contained but closely-located surface scatters (WS101 and WS102), one on the summit of the knoll and the other on the lower terrace, were identified as significant due to the presence of a roughly oval stone arrangement measuring 4.20m × 3.20m. In 2005 a grab sample was collected across the whole of WS100 but no further surface collection was undertaken due to the very dense nature of the lithic scatter. Instead, it was deemed important to trial trench the area. Analyses of the chipped stone collected identified it as Early Holocene from the dominance of Ounan points in the assemblage (see Chapter 7), however a radiocarbon date on bone from Area 2 suggests a much later date for the deposit. The significance of this will be discussed below.

WS100.101

WS100.101 occupied the lower 'terrace' of WS100 immediately above the wadi bed. It was characterised by an area of flat ground c. 17m × 10m bounded by rocky outcrops, approximately 1m high on the west side. On the southeast and northeast sides the area was more open giving access to the slopes leading down to the wadi bed. The east side of the flat area rises up to the summit of the knoll where WS100.102 is located. Three 1m × 1m test trenches were laid out across the lower terrace (WS100.101) 4m apart, labelled Areas 1, 2 and 3 (Fig. 6.23).

Area 1 was a 1m × 1m surface scrape inside the oval stone arrangement. The uppermost deposit (013) extended

Fig. 6.23. Plan of WS100.101, Areas 1–3.

across the whole of the test trench and comprised small black/brown grits in a matrix of yellow windblown sand, interpreted as deflated surface gravel. This lay directly over a yellow silt wash (unexcavated). Within the surface gravel was a scattering of chipped stone artefacts. Area 2 was a 1m × 1m test trench located 4m to the southeast of Area 1 on a baseline running southwest to northeast across the terrace. This trench was the only test square on the lower terrace to be excavated to bedrock (Fig. 6.24).

The uppermost deposit (014) extended across the whole of the test pit and consisted of a thin 10cm matrix of yellow windblown sand containing small black and brown grits and a scatter of chipped stone artefacts in denser concentration that Areas 1 and 3. This deposit was interpreted as deflated surface gravel. Below this was a yellow silt wash deposit (019) which extended over the whole of the test area to a depth of 40cm. This deposit, which became redder with depth, was almost certainly compacted earlier surface gravels formed by long-term deflation. Some chipped stone was also found in this layer. Below this was a 31cm-thick deposit of silt and ash, clearly a cultural deposit (021), lying over a depression in the bedrock and which contained chipped stone artefacts, charcoal, pottery, incised ostrich eggshell and bone. It is from this deposit that the bone for radiocarbon dating was collected. The surface of this deposit was compacted to form an 8cm-thick 'crust'. This may have been a surface of some kind but the 1m × 1m exposure was too small to confirm this interpretation, nor whether the cultural layer was *in situ.*

A 1m × 1m surface scrape, designated Area 3, was situated 4m northeast of Area 2 on the same baseline as

6. The Excavations

Areas 1 and 2. The uppermost deposit (015) extended across the whole of the square metre scrape and consisted of a thin deposit of (1cm) yellow windblown sand with black and brown grits like those that characterised Areas 1 and 2. This lay over a yellow silt wash which was not excavated. There was a medium density of chipped stone artefacts in the deposit.

WS100.101 clearly has potential for further excavation. The 1m × 1m trial trench, designated Area 2 produced a third of a metre of cultural material and further exploration of this lower terrace is planned in future seasons of fieldwork.

WS100.102

The summit area of the knoll, designated WS100.102, was characterised by another dense scatter of lithics measuring approximately 20m southeast to northwest and 12m southwest to northeast. In the centre of the summit was a linear arrangement of stones averaging 40cm and extending 3.20m almost due east to west. The arrangement comprised seven *in situ* stones and one toppled stone. The whole summit area was distinguished by a very high density of chipped stone artefacts, especially immediately to the north of the linear structure. In addition to the linear arrangement of stones, there was a roughly circular stone arrangement *c*.1.40m located approximately 5m southeast of the linear stone arrangement (Fig. 6.25).

Three 1m × 1m test trenches were laid out along an southeast-northwest base line on the summit of WS100 (WS100.102). These were spaced unevenly in order to

Fig. 6.24. Plan and section of WS100.101, Area 2 following excavation.

Fig. 6.25. Plan of WS100.102, Area's 4–6.

incorporate the linear stone alignment into one of the test pits. Thus Area 5, which was located immediately adjacent to the stone alignment, was placed 5m to the east of Area 6, while Area 4 was only four metres to the east of Area 5.

Located at the southeast end of the WS100.102 baseline, Area 4 was a 1m × 1m surface scrape. The uppermost layer (016) consisted of 60% yellow windblown sand with 40% black and brown grits approximately 1cm thick. This lay over a yellow silt wash which was unexcavated. A scatter of chipped stone artefacts, some patinated were found in the surface layer.

Area 5 was situated 4m to the west of Area 4 adjacent to the stone arrangement identified during surface survey (Fig. 6.26). A 1m × 1m test trench determined the surface material to be identical to that of Area 4; a yellow layer of windblown sand (017) containing quantities of black and brown grits. This layer covered the entire 1m × 1m square and produced the largest number of chipped stone artefacts on the WS100 site as a whole. Although located adjacent to the stone arrangement no relationship to this feature was noted. Below 017 was a 5cm deposit of yellow silt wash which contained very occasional black and brown angular grits and stones, representing long-term deflation of surface gravels (020). Directly beneath this was a dark grey/brown layer of silt and ash, up to 35cm thick (022) containing chipped stone, pottery and bone. The stone arrangement, however, clearly had no relationship to these earlier deposits.

Area 6 was the most westerly of the 1m × 1m test trenches on the summit of WS100.102. Situated 5m to the northwest of Area 5 it too produced a thin layer of yellow windblown sand (018) mixed with black and brown grits over the entire area of the scrape. Below this was the same yellow silt wash present in all other test trenches on the WS100.102 site.

WS103

Four-hundred metres west-southwest of WS100 on the opposite bank of the Wadi Tifariti, was a low gravel terrace that comprised WS103. This site, situated slightly above the modern course of the Wadi Tifariti in an area covering around 175m northeast–southwest and 60m northwest–southeast, is very noticeably located on the flatter ground of the terrace and apparently forms part of a palaeo-alluvial deposit. The scatter of chipped and ground stone included a number of polished axes and a stone bracelet fragment. Artefacts were predominantly located in a thin (*c.* 40cm) layer of surface gravel overlying a silt wash, which in turn, overlay a fine grey silty deposit containing minimal artefacts. Some surface features, including an approximately linear stone arrangement *c.* 4m long and orientated northeast to southwest, and a series of three possible hearths were noted. These 'hearths' were approximately 1m in diameter and were comprised of a circular arrangement of small stones partially surrounded by two or three larger stones.

A series of six transects, orientated northeast to southwest were laid out across the site. These were given the designations, Areas 7 to 12, and each measured 50m × 0.50m wide (Fig. 6.27).

One of the 'hearths', F023, was excavated in an effort to determine the age of the feature and whether cooking took place. F023 measured approximately 1.60m north–south and 1m east–west. To the south the boundary of the feature was indicated by six sizeable red/grey granite stones 15cm to 40cm, whose interior surface was covered with small blueish-white granite chips. Within this feature was a sandy compact deposit 2cm thick (024) which was underlain by a grey gritty deposit (025), approximately 20cm thick, but nowhere were there signs of burning (Fig. 6.28) and thus, no samples for radiocarbon dating could be taken.

Site WS103 is unusual for its prevalence of ground stone. Items collected included polished stone axes (Figs 6.29, 6.30 and 6.33), a stone bracelet fragment (Fig. 6.31), a palette (Fig. 6.32), ground stone discs and expedient tools, such as

Fig. 6.26. Plan and section of WS100.102, Area 5 following excavation.

Fig. 6.27. Plan of WS103, showing layout of transects and placement of hearths.

hammerstones and burnishers. There is no doubt that the quantities of ground stone at WS103 should be considered significant in that the only other ground stone objects recovered from the Study Area were isolated finds, such as the grinding stone associated with WS024 and a chipped axe blank recovered within the vicinity of the standing stone site WS001. Stone bracelets have a long history in Saharan Africa dating back to the 5th millennium BC (MacDonald 2010) and are common on pastoral sites. However, there is some evidence that the tradition is very rare after the 1st millennium BC and almost never recorded on large settlement complexes or in their cemeteries (MacDonald 2010, 124). Polished stone axes similar to the examples illustrated in Figures 6.29 and 6.30 were recorded by Amalgro Basch (1946, 75–77) in Spanish Sahara and are dated by him to the Saharan Neolithic from approximately 5000 BC. Holdaway *et al.* (2010) examine the incidence of low-level food production in desertic environments throught the presence and composition of lithic tool kits. They say that 'low-level food production' was practised to different degrees by mobile societies who were both hunters and farmers. In the Fayum region of Egypt *c.* 6500 BP archaeological remains consist of surface scatters of stone artefacts (including polished flint axes) pottery and hearth features. The presence of polished stone axes in numbers at WS003, along with a series of ephemeral hearths may indicate low-level food production by mobile groups during humid periods or rainy seasons when wild grasses would have been abundant. WS103 is the only site of its kind in the TF1 Study Area and warrants further research and excavation in the future in order to determine the date and nature of the occupation.

WS104

A long ridge of broken ground, interspersed with flatter open areas, was identified as WS104. The area is situated approximately 450m west-northwest of WS100 on the opposite bank of the Wadi Tifariti above the confluence of the Wadi Tifariti with a tributary wadi entering from the west. The ground rises up to the west-northwest but drops off steeply to the south and more gently through a series of low terraces to the north. A low-density scatter of chipped stone artefacts covered an area of 210m east-southeast to west-northwest and 100m north-northeast to south-southwest (Fig. 6.34). The density of chipped stone was highest along the ridge top, especially in flatter, more open areas. A grab sample across the whole of the site identified two self-contained scatters, which were designated WS104.105 and WS104.106. Around the area of WS104 generally was evidence for a number of burial monuments, stone alignments, and possible hearths. A curvilinear structure approximately 5m in diameter was also identified. Some of the site appeared to be heavily deflated, while other areas less so.

WS104.105

This was an open area on the crest of the ridge. To the south the ground drops sharply away, while to the north and east there is a more gentle gradient to lower parts of the WS104 ridge. The site is located on the southern edge of the WS104 ridge and affords good views over the Wadi Tifariti drainage to the north, east and south. The site is also intervisible with WS100 to the southeast. Concentrations of chipped stone artefacts were located on the ridge top measuring approximately 40m east–west by 30m north–south. Some surface pottery, probably associated with the burial monuments was also noted. This area of the site is very heavily deflated but the clustering of artefacts suggests a degree of spatial integrity.

A 1m × 1m test trench, designated Area 13, was excavated on the flatter ground which forms the 'terrace' WS104.105. The uppermost deposit (026) comprised a thin layer of yellow windblown sand mixed with 40% black and brown grits. Beneath this deposit was 027 which was a thin compact layer of sand and grits. The two deposits together form the deflated and weathered deposits overlying the bedrock (028) beneath (Fig. 6.35).

WS104.106

This was a concentration of chipped stone, located in a small flat area south of, and immediately below, the rocky crest of the WS104 ridge (WS104.105). The flattish ground is located high on the slope of the ridge, which provides shelter from the strong, near continuous westerly wind. The ground drops away steeply to the south, affording magnificent views across the Wadi Tifariti confluence area and of the standing stones (WS001). WS104.106 is intervisible with WS100 to

Fig. 6.28. Plan and section through the hearth (F023) associated with WS103.

Fig. 6.29. Ground stone axe.

Fig. 6.30. Ground stone axe.

Fig. 6.31. Stone bracelet fragment.

Fig. 6.32. Ground stone palette.

the southeast and with WS103 to the south. The chipped stone was spread in a thin scatter covering an area of 25m northwest–southeast to 10m northeast–southwest. A grab sample was collected across the site prior to test excavations.

A 1m × 1m test trench was excavated in WS104.106, designated Area 14 (Figs 6.34 and 6.36). It was located south of a series of three stone arrangements situated adjacent to a rocky outcrop, both of which offer some shelter from the north westerly winds. The uppermost deposit consisted of yellow windblown sand mixed with gravel and small stone

fragments (029) across the whole of the test trench to a depth of 1cm. Directly beneath this was a more compact yellow sandy silt wash 2cm in depth (030), which also covered the whole of the 1m × 1m test trench and which overlay a red/brown gravelly grit deposit (031) beneath. Within the centre of this deposit there appeared to be some evidence of a silt mixed with ash, which contained chipped stone, bone and some ostrich eggshell indicating that a small area of cultural deposit has survived deflation in this area.

Area 23 was a 1m × 1m test trench, positioned 20m to the north-northeast of Area 14 on the same lower 'terrace' (WS104.106). It was surrounded by outcrops of bedrock to the northwest, west and east giving it some protection from the very strong north westerly winds (Fig. 6.37).

The uppermost deposit (046) extended across the whole of the test trench and was made up of a loose yellow windblown sand and gravel mixed with quantities of chipped stone up to 2cm thick. Beneath this and also extending across the whole of the test trench was a compacted yellow sand and gravel (047) up to 23cm in thickness and which was the

Fig. 6.33. Chipped stone axe.

Fig. 6.35. Plan and section through the test pit, Area 13 of WS104.105.

Fig. 6.34. Plan of WS104 showing WS104.105 (Areas 13, 14 and 23) and WS104.106 and WS104.108.

Fig. 6.36. Plan and section of excavations of test pit, Area 14 of WS104.106.

weathered and deflated desert gravels. Beneath this was a thick brownish grey deposit containing high concentrations of chipped stone and other artefacts (048). This context was cut by 049 and 051. Deposit 049 was a roughly circular depression situated in the northeast quadrant of Area 23 cutting 048. It had a radius of approximately 0.50m and a depth of 15cm. The shape of this cut and its higher density of charcoal and ash with clusters of chipped stone, led the excavator to deem this a hearth and give it the feature number F049 (Fig. 6.38). The fill of F049 was a mixture of

Fig. 6.37. Plan and section of excavations of test pit, Area 23 of WS104.106.

ash and charcoal with concentrations of small stones and some artefacts, including an ostrich eggshell fragment. F051 was what appeared to be a stakehole, situated to the north and east of the hearth F049. It measured 13cm in diameter and a depth of 20cm. This feature is situated below 048 but

cuts through 053. Deposit 052 was the fill of the stakehole and was comprised of a soft brown/grey silt. Below 048 was 053 a reddish brown natural deposit laying directly above bedrock.

WS104.108

At the most eastern, down slope, extent of the WS104 ridge was located WS104.108. This area was approximately 80m east–west and 50m north–south, consisting of rocky outcrops interspersed with several flat areas. At its lowest, eastern extent, it rises only 10cm above the wadi bed, while at the western end it rises to 10m above the wadi bed. Several stone alignments were observed in this area, including burial monuments and a modern hearth sitting directly on the outcropping bedrock. Slightly to the north of the stone alignments a thin scattering of chipped stone was also observed.

WS107

This site is located at the northern end of the TF1 Study Area on the northerly bank of a low gravel slope, northeast of the confluence of the Wadi Tifariti and due north of a tributary wadi. The low gravel slope is approximately 1m above the bottom of the wide shallow confluence and somewhat higher (approx. 5m) than the Wadi Tifariti drainage to the southwest (Fig. 6.39).

The southern extent of the site is sheltered by low rocky outcrops, approximately 0.4m high, where windblown sand has banked up against the southern face. To the north the site is very exposed but it has good views to the north, west and east. The site was characterised by an extensive scatter of chipped stone and pottery covering an area approximately 200m east–west and 100m north–south. In and around the lithic concentration were identified a number of stone features, many of which may have been hearths, a recent (Islamic) grave, earlier burials and a possible stone 'structure'. A series of five transects, numbered 15–19 were laid out in an east–west direction across the site. Each was 50m × 0.50m and 20m apart. A 1m × 1m test pit (Area 20) was opened up in the middle of the artefact scatter (Fig. 6.40).

The uppermost deposit (032) extended over the whole of the test trench and was comprised of a thin layer (1cm) of yellow windblown sand mixed with granite chips and small quantities of chipped stone. Beneath this layer, was a compact mix of sand and grit (033) extending across the whole of the square-metre test trench to a depth of 5cm and which appeared to be the result of long-term weathering and deflation of the surface sand. Chipped stone was found in small quantities throughout this deposit. A red-brown deposit (034), extending across the whole of the test trench directly below the deflated surface material to a depth of 0.50m. This layer was comprised of grit mixed with ash and contained relatively high quantities of chipped stone, bone, pottery sherds and ostrich eggshell. Most of the artefacts were recovered from the upper part of this layer and some even appear to by lying horizontal, suggesting that there may have existed a meagre surface, very much disturbed.

Fig. 6.38. East section through the hearth, F049.

Fig. 6.39. Plan of WS107 showing features such as hearths, stone alignments and graves, and showing the position of transects across the site.

Fig. 6.40. Plan and section of WS107, Area 20.

The lower part of this deposit had been heavily disturbed by burrowing animals.

Area 21 was a second 1m × 1m test trench, placed approximately 80m to the east and 10m further up-slope to the north of Area 20, outside of the main concentration of artefacts that characterised WS107 but directly in the centre of a second discreet artefact scatter (Fig. 6.41).

Across the whole of the test trench was a thin deposit (1cm) of yellow windblown sand mixed with sandstone and granite chips, containing medium quantities of chipped stone (035). Beneath this was a compact layer of yellow sand and gravel (036) 2cm in thickness, which contained high concentrations of chipped stone. This deposit extended across the whole of the 1m × 1m trench above a layer of reddish-brown layer of silt mixed with gravel (037) 4cm thick and which contained a very high concentration of chipped stone, including arrowheads, blades and debitage. A friable layer of what appeared to be weathered bedrock (038) extended across the whole of the test trench directly below 037. Its maximum depth was 21cm.

Area 22 was a third 1m × 1m test trench placed approximately 65m due west of Area 20 adjacent to a semi-circular stone arrangement (Fig. 6.42).

Fig. 6.41. Plan and section of WS107, Area 21.

As with Areas 20 and 21, Area 22 was comprised of a thin (1cm) surface layer of yellow windblown sand (039), mixed with granite chips and low concentrations of chipped stone artefacts, extending across the whole of the test trench. Beneath this, also extending across the whole test trench, was a thin (3cm) compact, friable deposit of weathered bedrock gravel mixed with yellowish sand (040), which contained considerably fewer artefacts. Beneath this was a layer of weathered natural bedrock (041). The quantity of artefacts recovered from Area 22 was very small.

A number of individual hearths and clusters of hearths were scattered throughout WS107. Five metres south of Area 22 was one such feature (F042), which was deemed to be of some interest as it was in an area of desert 'varnish', suggesting it was of some considerable age (Fig. 6.43).

The general plan of the hearth was a shallow circular, scooped pit which was filled with charcoal, ash and stones. The surface deposit (043) extended across the whole of the hearth and was comprised of sand mixed with gravel 2cm in thickness, interspersed with larger stones (measuring up to 2cm). Beneath this was 044 a compacted layer of weathered sand and grit, again extending across the whole extent of the hearth and which sealed 045, the hearth fill. The two

Fig. 6.42. Plan and section of WS107, Area 22.

surface deposits mirrored the surface deposits in Areas 20 and 21 and thus suggested that the hearth had been exposed to deflation and weathering for some time. The hearth fill (045) was comprised of 70% stones, some fire cracked, 20% gravel mixed into a red-brown sandy matrix and 10% ash and charcoal. The centre of the hearth was darker and ashier and this was later designated 054. The surface of the cut made for the hearth showed evidence of being baked. During excavation of the hearth fill it became clear that F042 had been cut twice. The southern extent of the hearth fill thus became 045 and the northern extent became 055.

Dating

Radiocarbon samples were collected where possible. Some sites (WS104) did not produce charcoal and WS100.101 and WS100.102 produced only burnt bone so, dating of the artefact scatter sites has been constrained by the retrieval of adequate radiocarbon samples. Even so, some comments can be made regarding the two dates from WS100.101 Area 2 and WS107, F042 (Tables 6.2).

The first date from WS100.101 Area 2 is from a deposit characterised by Ounan points and therefore one we deemed to be Early Holocene on the basis of typological comparison with other sites in the region. The radiocarbon determination was taken on burnt bone and the $\delta^{13}C$ value was very low suggesting that the sample may have been contaminated. Indeed, the determination is very young for a site that has produced large numbers of Ounan points (4577 ± 45, 3500–3100 BC at 95% probability). The whole area of WS100.101 was badly deflated and this might also have partly contributed to the young age of the radiocarbon determination. If the area was utilised for some period of time and different material has been mixed up then the bone may be a later component of a mixed deposit. Whatever the cause, the high numbers of Ounan points indicate that WS100.101 was initially utilised in the Early or early Middle Holocene (see Chapter 7).

The site WS107 is very different in nature from WS100.101 on the basis of the presence of large quantities of pottery and numerous hearths. Although pottery was collected from WS100 there were very few sherds and they were all very small, quite different from the larger, less abraded sherds from WS107. The radiocarbon determination was made on charcoal from the hearth F042 in WS107 (5605 ± 50, 4540–4340 BC at 95% probability) and the calibrated date range is much more in line with the chipped stone assemblages located nearby. Although there is as yet no chronological sequence for Western Sahara, the calibrated date 4540–4340 BC falls at the end of the Early Holocene (the end of the Early Pastoral period in central Sahara, di Lernia 2013a) and the Early to Middle Holocene in the Atlantic Sahara, that is, before the onset of the drying of the Sahara.

Ceramics from the 2007 surface collections and excavations

Ceramics from the surface collections and excavations of WS100, WS103, WS104 and WS107 displayed a number of general characteristics. Assemblages were typically

Fig. 6.43. Plan and section of F042.

Table 6.2. Measured values of radiocarbon age for charcoal from WS100.101 and WS107

Site	Site code	Lab. ID	Radiocarbon Age (BP)(*)	$\delta^{13}C$ (‰)(**)	Calibrated date (2s) cal BC
WS100.101	WS R4	LTL13444A	4577 ± 45	-9.7 ± 0.2	3500 (16.8%) 3430
					3380 (38.0%) 3260
					3250 (40.6%) 3100
WS107	WS R11	LTL13446A	5605 ± 50	-23.7 ± 0.5	4540 (95.4%) 4340

* = ?? ** = ??

prehistoric, very homogeneous and highly abraded (with most sherds not much larger than 5cm diameter). The pottery assemblage in general is typically Saharan with comb impressed decoration predominating but also some sherds with incised decoration (for comparisons, see Camps-Fabrer 1966, 469; Petit-Maire 1979; Vernet 2007a, 2014, 33 fig. 8b).

Twenty-two sherds were recovered from test pits in WS100.101 and WS100.102. Many were burnt and decorated in tightly packed zigzags of comb or shell impressed designs. Fabrics were dark with high concentrations of white grits. Comparative material comes from Uan Afuda Cave (see di Lernia 1999a: 91, Fig. 6.23) and Uan Tabu rockshelter (see Garcea 1999: 159, fig. 4) in the Libyan Sahara and further to the south where the Early Ténérian pottery of Adras Bous shows similarities in techniques of decoration (Garcea 2008, 276). Early Holocene pottery was also prevalent at WS107. In particular, the thick-walled rim of a bowl decorated with rocker stamping closely resembles examples from Uan Afuda where di Lernia comments that a feature of the Early Holocene pottery is the 'considerable thickness of the walls' (di Lernia 1999a: 88) (Fig. 6.44 no. 5). Forty-nine sherds in total were collected from WS107 of which 22 sherds were decorated. Generally sufaces were heavily abraded and the decoration was worn. Sherds are all very small (2cm to 3cm). There is homoegeneity within the fabric and surface finish. The fabric is coarse with high concentrations of grey and white rounded inclusions, including quartz. All were incompletely fired and had a dark grey core and red/orange surface indicating firing took place in an open kiln. Undecorated sherds were most likely heavily abraded decorated sherds that had lost all trace of surface treatment. Decoration consists of comb stamped and punctate impressions (Fig. 6.44) typical of the Saharan Neolithic.

Eight sherds were collected from WS104.105, 19 sherds from WS104.106 and none at all from WS104.108. Sherds from 105 and 106 were all very worn and abraded and those that could be identified showed evidence of incised decoration in a herringbone pattern.

Again the abrasion and small size of the sherds from the artefact scatter sites demonstrate the extent to which deflation has impacted the integrity of the deposits. Stylistically, in comparison with pottery from across the Sahara, the sherds compare well with pottery of an Early Holocene date, but the radiocarbon dates from WS100.101 and WS107 place the deposits much later. There are two explanations for this; the first is that pottery in Western Sahara lagged behind other regions of the Sahara but this is unlikely given that the pottery fits well with the Ounan points that are also present at both WS100 and WS107. More likely is that mixing of depostis caused by deflation and the possibility of contaminated radiocarbon samples (at least from WS100) has meant that the dates don't fit well with the material.

Discussion

The TF1 Study Area is extraordinarily rich in archaeology of different kinds; burial monuments, other funerary monuments including Islamic graves, way markers, stone emplacements, ephemeral sites characterised by open air hearths, activity areas of lithics and pottery and rock art. All these features testify to a plentiful and varied use of the Sahara over long periods of time and together amount to the material manifestations of the cultural activities of the people that lived and died in this landscape. Each archaeological feature is a puzzle piece that begins to tell the narrative of Western Sahara. Although only limited archaeological excavation has been carried out to date, the story now can begin to be told in conjunction with the field survey and specialist reports. In terms of the questions that we set ourselves at the beginning of excavations we have been able to answer most of these. The retrieval of material from the tumuli for scientific dating has confirmed that the people buried within the tumuli died somewhere during the first half of the 1st millennium AD and the archaeological evidence would tell us that it is likely that the tumuli are approximately contemporaneous and that the burial of the individuals within the tumuli was most likely to have happened at the same time or soon after the construction of the cairns. This correlates with what we understand of the chronology of simple tumuli in other regions of the Sahara, where a date anywhere between 3000 and 1000 years ago would be acceptable for tumuli of this type, and thus, the first half of the 1st millennium AD is entirely plausible for the use of TF1 as late as the Historic period. Although 3000 years seems a vast period of time for the use of the TF1 Study Area as a necropolis, it is unlikely that it was used continuously. What is clear is that the monuments would have borne testement to the importance of the location in social memory and this may well have reinforced the area's importance for later populations and aided the continuance of the place being used as a burial site. What made the TF1 Study Area a place where the dead were buried in preference to other parts of the desert will be addressed in the discussion chapter, but the natural basin-like topography appears to have leant itself to the placement of monuments in specific locations in order to achieve enhancement/reinforcement of the monument/landscape relationship (see Chapter 5). So, it is not just chance that the high ground is largely reserved for high relief monuments, while the wadi bottom and the rising banks were used for many of the low relief monuments. In these cases the landscape/monument relationship is strengthened; arms of antennae features rising up the banks of the wadi, lengthen the perspective and our perception of the arms. Tumuli built on prominent outcrops add size and height to our perspective of the tumuli.

In addition to the excavation of the burial monuments, excavation of the seven activity areas of lithics and pottery enhance our understanding of the Study Area by illustrating

Fig. 6.44. Pottery from WS107.

Table 6.3. Sequence of contexts

Site	Unit	Area	Matrix	Finds
WS 101	013	1	Surface gravel and sand	chipped stone
WS 101	014	2	Surface gravel and sand	chipped stone
WS 101	015	3	Surface gravel and sand	chipped stone
WS 102	016	4	Surface gravel and sand	chipped stone
WS 102	017	5	Surface gravel and sand	chipped stone
WS 102	018	6	Surface gravel and sand	chipped stone
WS 101	019	2	Yellow silt wash	chipped stone
WS 102	020	5	Yellow silt wash	chipped stone, bone, pottery
WS 101	021	2	Ashy brown/grey silt (below 019)	chipped stone, pottery, bone, ostrich eggshell
WS 102	022	5	Ashy brown/grey silt (below 020)	chipped stone, pottery, bone, ostrich eggshell
WS 103	F023	5	Possible hearth	none
WS 103	024	5	Fill of F023	chipped stone
WS 103	025	5	Grey deposit below 024 (natural?)	chipped stone
WS 105	026	13	Surface gravel and sand	chipped stone
WS 105	027	13	Yellow silt wash	chipped stone
WS 105	028	13	Red-brown grit/gravel	none
WS 104.106	029	14	Surface gravel and sand	chipped stone
WS 104.106	030	14	Yellow silt wash	chipped stone
S 104.106	031	14	Red-brown grit/gravel	chipped stone, ostrich eggshell, bone
WS 107	032	20	Surface gravel and sand	chipped stone
WS 107	033	20	Yellow silt wash	chipped stone, bone
WS 107	034	20	Grey-brown grit/gravel	chipped stone, bone, pottery, ostrich eggshell
WS 107	035	21	Surface gravel and sand	chipped stone
WS 107	036	21	Weathered sand, yellow silt wash	chipped stone, bone
WS 107	037	21	Reddish-brown gravel and grit	chipped stone, bone, ostrich eggshell
WS 107	038	21	Weathered grit and gravel	chipped stone, ostrich eggshell, snail shell
WS 107	039	22	Surface gravel and sand	chipped stone
WS 107	040	22	Yellow silt wash	chipped stone
WS 107	041	22	Red-brown grit/gravel	chipped stone
WS 107	F042	22	Possible hearth	none
WS 107	043	22	Fill of F042	none
WS 107	044	22	Fill of F042	chipped stone
WS 107	045	22	Fill of F042	chipped stone
WS 104.106	046	23	Surface gravel and sand	chipped stone
WS 104.106	047	23	Yellow silt wash	chipped stone, pottery, bone
WS 104.106	048	23	Brown silt	chipped stone, pottery, bone, ostrich eggshell
WS 104.106	F049	23	Possible hearth	none
WS 104.106	050	23	Fill of F049	chipped stone, ostrich eggshell
WS 104.106	F051	23	Possible stake hole	none
WS 104.106	052	23	Fill of possible post hole	none
WS 104.106	053	23	Reddish-brown gravel/grit (natural)	none

the use of the wadi prior to the Late Holocene. The earliest lithics that we collected from the excavations are Levallois technique, while WS400, which is mentioned in the analysis of the chipped stone in Chapter 7 but has not yet been test pitted, appears to be a well-preserved Palaeolithic site and well worth further investigation. Likewise, WS100 has the potential to be a very important Early Holocene site with deposits that appear to be *in situ* where deflation has not impacted. It is hoped that further work can be undertaken here in the future. WS103, WS104 and WS107 appear more mixed in terms of their chipped stone and pottery assemblages and the presence of hearths and small stone alignments suggest itinerant and expedient use of a more recent nature.

In the following chapter, the lithics analyses contributes to our understanding of how and when the desert was utilised for the day-to-day tasks of subsistence and survival through a detailed investigation of the chrono-typological and technological variety represented at each of the activity areas.

Note

1 Logistics in the field meant that the chipped stone was unavailable for full analyses.

Chapter 7

The Chipped Stone

Anne Pirie

Introduction

Chipped stone comprises a significant component of the artefact repertory from the excavations in the TF1 Study Area. This report constitutes the results of analyses of the lithics arising from the text excavations of the artefact scatters, WS100.101, WS100.102, WS103, WS104.105, WS104.106, WS104.108, WS107, WS400 and a number of other individual transects, listed below. The report does not include the lithics collected from the excavations of the conical cairns which are reported on in Chapter 6.

WS100

WS100.101 (Fig. 7.1)

An assemblage of 456 artefacts was retrieved from WS100.101 (Table 7.1). The upper test pit context, unit 013 (a deflated and compacted windblown sand and gravel) contained the most artefacts (40%) of the assemblage. The assemblage contained numerous fine flakes and a fairly high proportion of blade and bladelet products (1:3 flakes). Small amounts of microburins were also recovered. Cores and core trimming elements were rare and were found almost entirely in the upper silt wash context.

A variety of raw materials were used – half of the assemblage is quartz, which was a material of choice at sites further south and west, such as Tintan (Petit Maire 1979, 255). Significant quantities of jasper, flint and silicified sandstone are also present, and very small amounts of rock crystal and chalcedony (Table 7.2). There is also a range of more coarse, unidentified materials in various colours. While flint/chert, jasper, quartz, and silicified sandstone occur in all contexts at WS100.101, the silicified sandstone is more common in the silt wash context of the test pit, where it makes up 25% of the assemblage. The choice of material used may well reflect the ubiquity of quartz and coarse material in the area, widely outcropping in the wadi, and less heavily utilised or conserved in the assemblage. Jasper is available in the general area, although no sources to date have been located in the wadi itself; flint sources are as yet not located, and although Vernet (2007a) reports sources of poor quality flint on the Mauritanian coast, the flint used here is of a very high quality, homogenous and often dark brown or caramel coloured and so may also be imported.

There is evidence of knapping of all materials in the form of the cores and core trimming elements present, except silicified sandstone. The lack of cores in silicified sandstone is interesting, especially given the fairly large amounts of the material retrieved, all apparently brought to the site as blanks or tools. However, low core proportions generally throughout the assemblage suggests that the areas test pitted, at least, were not heavily used as knapping areas, and it is possible that silicified sandstone cores occur elsewhere in the site. Flint and jasper in both areas are the main source of the blade element of the assemblage, as is silicified sandstone to a lesser degree. Quartz, which is also present in quantity, is rarely used to make blades, and much of this material is in the form of chips or fragments.

Tools are made on all raw materials in use at the site, with a third on jasper and another third on quartz (Table 7.3). Jasper and silicified sandstone are both disproportionately chosen for tools, with, for example, jasper making up 31% of the tools and only 19% of the assemblage overall.

At WS100.101, flint and jasper receive similar treatment (approx. 24% retouched) (see Table 7.4) with silicified sandstone again being slightly less commonly retouched and quartz and other materials rarely retouched.

There are few signs of knapping in the two areas, but the limited core and core trimming elements at the site show a

178 *Anne Pirie*

Fig. 7.1. Chipped stone from WS 100.101; 1, core; 2, truncated microburin; 3, double truncation burin; 4 backed point; 5, bladelet; 6, backed bladelet; 7, denticulate; 8, burin on retouched bladelet; 9, scraper; 10, blade.

Table 7.1. Frequency of technological types from WS100.101

Reduction technique	Number	%
Flakes	270	59.2
Blades	18	3.9
Bladelets	56	12.3
Microburins	5	1.1
Spalls	1	0.2
Chips	43	9.4
Core trimming element	4	0.9
Indeterminates	52	11.4
Cores	7	1.5
Total	456	

Table 7.2. Frequency of raw material use at WS100.101

Raw material	Number	%
Flint/chert	47	10.3
Jasper	90	19.7
Other	13	2.9
Quartz	226	49.6
Rock crystal	1	0.2
Silicified sandstone	79	17.3
Total	456	

Table 7.3. Frequency of tool materials at WS100.101

Tool materials	Number	%
Flint/chert	11	15.9
Jasper	22	31.9
Other	1	1.4
Quartz	20	29.0
Rock crystal	1	1.4
Silicified sandstone	14	20.3
Total	69	

Table 7.4. Frequency of retouch at WS100.101 in different raw materials

Raw material	Total	% Tools
Flint/chert	47	23.4
Jasper	90	24.4
Other	13	7.7
Quartz	226	8.8
Rock crystal	1	100.0
Silicified sandstone	79	17.7

Table 7.5. Percentage of retouched pieces at WS100.101

Tool class	Number	%
Awls	1	1.4
Backed flakes	2	2.9
Burins	12	17.5
Denticulates	2	2.9
Fragments	6	8.7
Microliths	5	7.2
Marginally retouched flakes	12	17.4
Marginally retouched blade/lets	6	8.7
Notches	10	14.5
Pièces esquillées	–	
Points	6	8.7
Scrapers	4	5.8
Strangled pieces	–	
Tanged pieces	2	2.9
Truncations	1	1.4
Total	69	

mixed technology of small multi-directional platform cores and flat, exhausted bipolar on anvil cores. Core rejuvenation of platform cores is carried out mainly through platform edge removals. The small size of many cores contributes to an overall impression of conservation of raw materials and that material was brought with them (which would account for the high number of blanks and tools).

Fifteen percent of the assemblage is retouched (Table 7.5). Tools include small points and microliths (Fig. 7.1 nos 4, 6), with points in both areas a mixture of small symmetrical and asymmetrical pieces, showing various combinations of backing and inverse retouch, tangs, etc. The tanged tools are small Ounan points; with marginal retouch towards the tip and bilateral semi abrupt or abrupt retouch forming the tang. Sometimes there is invasive retouch on the ventral face of the tang. Other points, slightly more common, are similar to lunates, with one lateral edge backed in a curved shape, and the adjoining edge truncated using the microburin technique to form a point with the backed edge, and retouched. The opposite end is marginally retouched on the dorsal face to form a point. Microliths are varied, some are retouched with no substantial backing, and others backed in a variety of forms, often arched or lunates. These, as well as the points, are often made using the microburin technique, sometimes using double microburin technique to create pointed truncations at both ends of the tool. A number of double microburins were found on site (e.g. from WS100.102, Fig. 7.3 no. 2), as well as some possible failed pieces with notches (e.g. from WS100.102, Fig. 7.3 no. 5) and single microburin scars. It seems clear that manufacture of points and microliths was carried out on site.

Overall, the laminar aspect of the tool assemblage at WS100.101 is important, especially in surface contexts where more blade tools than bladelet tools are present, and where flake tools are relatively rare (31%) (see Fig. 7.2). In the lowest context of the test pit, however, flake tools make up 88% of the tool assemblage. Across the assemblage, a very high proportion of the blades at WS100.101 are retouched (66%), compared to 28% of the bladelets. This is reflected in smaller proportions of formal bladelet tools such as points and microliths, and greater numbers of ad hoc retouched blades, and truncation burins (Fig. 7.1 no. 3 and Fig. 7.3 no. 8).

WS100.102 (Fig. 7.3)

A total assemblage of 987 artefacts was retrieved from WS100.102. The upper context (017), which comprised deflated windblown sand and gravel, contained the most artefacts, 73% of the test pit assemblage. The assemblage was very similar to that found at WS100.101. The discussion that follows will simply point out differences in the WS100.101 assemblage and must be read in conjunction with the description of the assemblage from WS100.101.

The use of raw material is similar to that at WS100.101 with a wide range of materials present, although here there is significantly less silicified sandstone, and more of the coarse material, which, together with quartz, is most common in the lowest ashy levels (Table 7.7). The flint at WS100.102 is even more heavily blade-oriented than that at WS100.101.

As at WS100.101, tools are made on all raw materials in use at the site, but at WS100.102 flint is disproportionately chosen for retouching (see differences in proportions of the use of raw material, Table 7.7 and the frequency of tools, Table 7.8), with many fewer tools on silicified sandstone. At WS100.102, where flint makes up many of the tools and blades, much of the flint on site is retouched (43%) (see Table 7.9). A fairly high proportion of jasper is also retouched here (30%), with less of the silicified sandstone being further modified, and very little of the quartz and other materials. Core technology is similar to that at WS100.101.

Fig. 7.2. Percentage frequency of tool blanks in the upper (surface), middle (silt wash) and lower (ashy silt) layers in the three test pits excavated at WS100.101.

Fig. 7.3. Chipped stone from WS100.102; 1, burin core; 2, double microburin; 3, microburin; 4, core tablet; 5, notched bladelet; 6, retouched bladelet; 7, borer; 8, truncation burin; 9, tanged piece.

Table 7.6. Frequency of artefact types at WS100.102

Artefact type	Number	%
Flakes	569	57.6
Blades	11	1.1
Bladelets	141	14.3
Microburins	22	2.2
Spalls	3	0.3
Chips	157	15.9
Core trimming elements	9	0.9
Indeterminates	65	6.6
Cores	10	1.0
Total	987	

Table 7.7. Frequency of raw material use at WS100.102

Raw material	Number	%
Flint/chert	133	13.5
Jasper	159	16.1
Other	151	15.3
Quartz	494	50.1
Rock crystal	7	0.7
Silicified sandstone	43	4.4
Total	987	

Table 7.8. Frequency of tool materials at WS100.102

Tool materials	Number	%
Flint/chert	58	31.7
Jasper	49	26.8
Other	15	8.2
Quartz	53	29.0
Rock crystal	2	1.1
Silicified sandstone	6	3.3
Total	183	

Table 7.9. Frequency of retouch at WS100.102 in different raw materials

Raw material	Total assemblage	% Tools
Flint/chert	133	43.6
Jasper	159	30.8
Other	151	9.9
Quartz	494	10.7
Rock crystal	7	28.6
Silicified sandstone	43	14.0

Overall, 18.6% of the assemblage at WS100.102 is retouched, but there is variability across the assemblage in this figure, with the excavated contexts having significantly higher levels of retouch (20%) than the surface context (10%).

WS100.102 is dominated by non-formal, marginally retouched flakes, including notches and backed flakes, with medium proportions of microliths and points (see Table 7.10). Here tools are mainly on flakes (see Fig. 7.4), although there are numerous bladelet tools as well, especially in the two lower levels of the test pit, where microliths become more frequent than they are at WS100.101 (18% of the tool assemblage).

Table 7.10. Percentage of retouched pieces at WS100.102

Tool class	Number	%
Awls	4	2.1
Backed flakes	13	7.1
Burins	5	2.7
Denticulates	5	2.7
Fragments	9	4.9
Microliths	31	16.9
Marginally retouched flakes	56	30.6
Marginally retouched blade/lets	3	1.6
Notches	14	7.7
Pièces esquillées	1	0.5
Points	25	13.7
Scrapers	3	1.6
Strangled pieces	3	1.6
Tanged pieces	4	2.2
Truncations	7	3.8
Total	183	

Discussion

Overall, the bladelet industry associated with microliths and Ounan points suggests an Early Holocene date for both areas at WS100 (see discussion below). There are many tool classes represented, probably representing a wide range of activities. However, evidence from the limited investigations to date does not suggest that much knapping was carried out on site, although point- and microlith-making were clearly important based on the presence of microburins, half-finished microliths, the bladelet industry associated with microliths, and the point forms found.

The two areas of the site are very similar in many respects, with an emphasis on bladelet technology and many small fine artefacts, and the presence of very similar microliths and points in all contexts. However, there is clear variability between the two areas in tools.

The differences between the use of different blanks within the site is clearly illustrated in Figs 7.2 and 7.4, where we can see;

a) The importance of blades in the two upper contexts of WS100.101,
b) The overall importance of laminar tools (both blades and bladelets) in the two upper contexts at WS100.101, in contrast to the flakes of the lower context,
c) The role of bladelets at WS100.102, which increases with depth at the site.

Tool classes, not surprisingly, vary as well, with WS100.101 having more burin/truncations and fewer microliths and points, while WS100.102 contains higher proportions of both microliths and points, especially in the lower levels of the test pit (Fig. 7.5). The two areas of the site may well represent different activity areas, either during one occupation of the site or several different occupations. The similarity in points and microliths suggests occupation in the two areas occurred within the same general period.

Fig. 7.4. Percentage frequency of tool blanks in the upper (surface), middle (silt wash) and lower (ashy silt) layers in the three test pits excavated at WS100.102.

Fig. 7.5. Percentage frequency of different tool types at WS100.101 and WS100.102.

The use of raw materials on site is interesting, showing specific and variable use of materials for certain blank and tool types. At this stage, we do not know the sources of flint or silicified sandstone; the former was central to production of bladelets and tools at WS100.102, while increased use of silicified sandstone, possibly brought to site as tools/blanks, and used for, amongst other things, the distinctive truncation burins, is important at WS100.101. It is not clear what the significance of these patterns are, but further research may continue to show variable organisation of technology in the different materials, possibly associated with mobility strategies, special attitudes to certain minerals/tools, or different groups of people with their associated materials and reduction practices.

WS103 (Figs 7.6 and 7.7)

Chipped stone from Areas 8, 9, 10, and 11 was catalogued, while material from Areas 7 and 12 was scanned (a total of 205 artefacts); this latter material is not included in the tabulations below. The chipped stone will be considered as a general assemblage in the first instance, with the material excavated from the test pit (Units 24, 25 = 19 artefacts) discussed at the end.

Fig. 7.6. Chipped stone from WS103, Palaeolithic material; 1, tanged flake; 2, retouched flake; 3, biface; 4, retouched flake.

The transects contained different densities of chipped stone artefacts, possibly due in part to different levels of expertise in collectors. This is a factor that should be taken into consideration in many surveys where volunteers are used. Transects 7 and 8 contained the most chipped stone (Table 7.11), which may be an artefact of the differential collection bias mentioned above. The overall assemblage content did not differ substantially, however, and the assemblages are considered together below, with differences pointed out where they occur.

The chipped stone is dominated by flakes across the surveyed area (Table 7.12), with a blade ratio of 1:8. Almost half of the bladelets are irregular, but there is a number of regular, probably Early Holocene, bladelets present. Cores include mainly single platform, or change of orientation cores (Fig. 7.7, no. 5), alongside several bipolar cores (Fig. 7.7, nos 1, 2). A number of crested blades were found (Fig. 7.7, no. 3), as well as a plunging blade (Fig. 7.7, no. 4) and a core edge removal. These cores and core trimming elements suggest a controlled, often blade, technology probably from the early or early Middle Holocene.

Tools include numerous nondiagnostic retouched flakes (Table 7.13), but also a number of microliths including

Table 7.11. Raw counts of collected chipped stone from each of the transects (Areas) in WS103

Transect	Number
7	120
8	174
9	102
10	99
11	77
12	85
Total	657

Table 7.12. Total counts and percentage frequencies of artefact types overall from WS103

Artefact class	Number	%
Flakes	357	79.0
Blades	5	1.1
Bladelets	35	7.7
Microburins	2	0.4
Chips	6	1.3
Indeterminates	29	6.4
Core trimming elements	4	0.9
Cores	12	2.7
Total	452	

Fig. 7.7. Chipped stone from WS103, Holocene material; 1, core; 2, core; 3, crested blade; 4, retouched plunging blade; 5, core; 6, backed point; 7, denticulate; 8, point; 9, scraper.

several lunates and a triangle. Several points were found, including two Ounan points and one backed point (Fig. 7.7, no. 6) similar, like the microliths, to WS100.101/2 and suggesting an Early or early Middle Holocene date. Other tools include truncation burins, tanged flakes and denticulates (Fig. 7.7, no. 7) – all suggesting an Early or Middle Holocene date.

Middle Palaeolithic material occurs at low levels across the survey area, with a number of thick flakes with facetted platforms, some Levallois flakes and several possible tools including one possible Aterian point, a tanged flake, and a retouched Levallois flake. One Levallois core was retrieved.

Overall, the assemblages from these transects show the use of the wadi over a long timespan, in the Middle Palaeolithic, the Early Holocene, and the early Middle Holocene. The material is not clustered in any way in Areas 7–12, although some show greater density than others.

Table 7.13. Total counts and percentage frequencies of tool types from WS103

Tool class	Number	%
Aterian points	1	0.7
Awls	6	4.1
Backed flakes	12	8.1
Bifacial core tools	1	0.7
Burins	2	1.3
Denticulates	11	7.3
Endscrapers	1	0.7
Fragments	5	3.4
Microliths	7	4.7
Marginally retouched flakes	52	34.9
Marginally retouched blade/lets	4	2.7
Notches	16	10.7
Others	1	0.7
Points	8	5.4
Retouched Levallois flakes	1	0.7
Scrapers	11	7.4
Tanged pieces	6	4.0
Truncations	4	2.7
Total	149	

WS103 Test pit (F023)

The small assemblage of 19 artefacts from the test pit was dominated by flakes and included a number of jasper and flint pieces as well as quartz, and one chalcedony possible microlith/borer fragment. One bipolar quartz core was found. The assemblage is small and largely undiagnostic, although the chalcedony piece suggests an Early or early Middle Holocene date.

Discussion

This area contained a dense accumulation of artefacts from the Middle Palaeolithic, the Early Holocene and the early Middle Holocene. The earliest material was heavily worn/abraded, and had been water transported, while the Holocene material was much fresher. No particular concentrations of material were noted.

WS104 (Fig. 7.8)

WS104.105

A total of 58 artefacts were retrieved from this area, of which 48% came from the test pit, with no clear differences in chipped stone between the different contexts. This is a largely undiagnostic assemblage dominated by flakes (75%), with small numbers of bladelets and a blade, all from the surface (Table 7.14). Eight percent of the assemblage is made up of cores, largely multiple platform with flake removals. Over half (55%) of the assemblage is on quartz, although flint and jasper are also present in smaller amounts.

Tools are on all raw materials in similar proportions to their presence in the overall assemblage. A very high 38% of the assemblage is retouched, with most tools on flakes. A significant minority of tools is on bladelets (15%), but

Table 7.14. Total counts and percentage frequencies of artefact types from WS104.105

Artefact class	Number	%
Flakes	44	75.9
Blades	1	1.7
Bladelets	3	5.2
Chips	2	3.4
Core trimming elements	2	3.4
Indeterminates	1	1.7
Cores	5	8.6
Grand total	58	

Table 7.15. Total counts and percentage frequencies of tool types at WS104.105

Tool class	Number	%
Backed pieces	2	10.5
Burins	2	10.5
Microliths	1	5.3
Marginally retouched flakes	8	42.1
Marginally retouched bladelets	1	5.3
Notches	5	26.3
Total	19	

these were all found in the surface collection and may be unrelated to the rest of the assemblage.

Tools include mainly non-formal marginally retouched flakes as well as several notches (Fig. 7.8, no. 2), backed flakes and burins. The surface assemblage included one lunate and one marginally retouched bladelet.

This assemblage is fairly undiagnostic but is likely to be post-Early Holocene, although some surface elements are clearly Early Holocene.

WS104.106, Area 14

The surface collected chipped stone was scanned rather than fully catalogued (total 67 artefacts), and is not included in the tabulated assemblages below.

This assemblage is a large one of 215 artefacts (Table 7.16). Most of these were from the lowest context (031). While many fine flakes were retrieved the assemblage has a high blade:flake ratio (1:5), entirely made up of bladelets, and the assemblage from context 031 has an even higher blade ratio of 1:3. A number of microburins were also retrieved (Fig. 7.8, no. 5), all from context 031 where they make up a high 6% of the assemblage.

Only small numbers of cores and core trimming elements were found, including two quartz bipolar cores, and a flint core tablet suggestive of a more controlled reduction strategy.

The assemblage was mainly on quartz (60%) and flint, with smaller amounts of jasper and silicified sandstone. Retouched tools reflected the overall proportions of raw materials in the assemblage.

A high 19.8% of the assemblage is retouched (Table 7.17). Tool classes included large numbers of non-

Fig. 7.8. Chipped stone from WS104.105 (numbers 1–4) and WS104.106 (numbers 5–8); 1, core; 2, notched flake; 3, retouched flake; 4, tanged flake; 5, microburin; 6, backed oblique truncation; 7, truncation burin; 8, truncated denticulate.

Table 7.16. Total counts and percentage frequencies of artefact types at WS104.106, Area 14

Artefact class	Number	%
Flakes	122	61.9
Bladelets	23	11.7
Microburins	9	4.6
Chips	26	13.2
Core trimming elements	1	0.5
Indeterminates	14	7.1
Cores	2	1.0
Scanned	18	
Grand total	215	
Total catalogued	197	

Table 7.17. Total counts and percentage frequencies of tool types at WS104.106, Area 14

Tool class	Number	%
Backed pieces	4	10.3
Burins	3	7.7
Denticulates	3	7.7
Endscrapers	1	2.6
Fragments	2	5.1
Microliths	6	15.4
Marginally retouched flakes	12	30.8
Marginally retouched bladelets	1	2.6
Notches	2	5.1
Scrapers	1	2.6
Truncations	4	10.3
Total	39	

formal marginally retouched flakes (30%), with quite a few microliths (15%), including lunates and straight-backed segments. There were smaller amounts of truncations, which included an obliquely truncated bladelet (Fig. 7.8, no. 6), as well as backed flakes and burins. No points were found in this assemblage. Many tools were on flakes, but numerous bladelet tools were also present.

Overall, this assemblage is similar to those from WS100.101 and WS100.102 in a number of ways. The emphasis on a bladelet technology (although not seen in the cores), and the use of microburins to make microliths in similar forms, is reminiscent of site WS100 across the wadi. Raw materials used are also similar, although there is a greater use of quartz, especially for tools. However, the lack of any points is interesting, and may suggest a different activity area, or links to microlithic non-point bearing assemblages elsewhere (see discussion below).

WS104.106, Area 23

The surface collected chipped stone was scanned rather than fully catalogued (total 18 artefacts), and is not included in tabulated assemblages below.

The assemblage is a large one at 309 artefacts, of which 75% were from the test pit (Table 7.18). Most of these (84%) were retrieved from context 048, a deposit in the lower levels of the test pit. The assemblage is dominated by flakes, although there is still a small bladelet component (with many more irregular bladelets), as well as a slightly larger blade element. This blade element is nearly all from context 048, a deposit in the lower levels of the test pit. Overall, there is a blade ratio of 1:5 flakes. A number of microburins were retrieved, all from context 048, several of which are on blades rather than bladelets.

Only a small number of cores and core trimming elements were found, including several bipolar cores and a few simple platform cores, all quartz. One jasper core tablet suggestive of a more controlled reduction strategy was retrieved.

The assemblage is mainly on quartz (58%), with some jasper (15%) and silicified sandstone (10%) and small amounts of flint. Very small quantities of chalcedony (five artefacts) were retrieved from context 048, and are all bladelets or microburins. Tools are made on quartz and jasper in similar amounts, with some flint and silicified sandstone.

Retouched tools make up 11% of the assemblage, and include mainly non-formal marginally retouched flakes, as well as burins on blades, including several dihedral burins and one truncation burin (Fig. 7.8, no. 7) (Table 7.19). The small number of fragmentary points is made up of bifacially retouched tangs. Tools are often fragmentary, and on indeterminate fragmentary blanks (29% of the tool assemblage).

Overall, this assemblage is likely to postdate the Early Holocene assemblages of WS100.101, WS100.102 and WS104.106 Area 14. While the burins and truncations are reminiscent of WS100.102, the lessening emphasis on a bladelet technology and the point fragments, in contrast to those at WS100.102, signal a date in the Middle Holocene.

WS107 (Figs 7.9, 7.10 and 7.11)

Areas 15–19 transects

An assemblage of 500 artefacts was collected from five transects (Table 7.20). Two transects were notably dense: 16 and 18. Otherwise, little variability in types of material collected was noted, and these assemblages will be reported together below.

Table 7.19. Total counts and percentage frequencies of tool types at WS104.106, Area 23

Tool class	Number	%
Awls	2	7.4
Burins	3	11.1
Denticulates	1	3.7
Fragments	4	14.8
Microliths	1	3.7
Marginally retouched flakes	9	33.3
Marginally retouched bladelets	1	3.7
Notches	1	3.7
Others	1	3.7
Points	2	7.4
Truncations	2	7.4
Total	27	

Table 7.18. Total counts and percentage frequencies of artefact types at WS104.106, Area 23

Artefact class	Number	%
Flakes	161	66.5
Blades	14	5.8
Bladelets	11	4.5
Microburins	7	2.9
Chips	19	7.9
Core trimming elements	1	0.4
Indeterminates	25	10.3
Cores	4	1.7
Scanned	67	
Grand total	309	
Total catalogued	242	

Table 7.20. Total counts of artefact types at WS107, by transect

	Transect						
Tool class	15	16	17	18	19	Total	%
Flakes	60	82	34	161	53	390	78.0
Blades	6	6	1	11	1	25	5.0
Bladelets	1	6	–	14	1	22	4.4
Microburins	–	2	–	4	–	6	1.2
Spalls	–	1	–	–	–	1	0.2
Chips	–	–	–	2	–	2	0.4
Core trimming elements	3	2	–	6	1	12	2.4
Indeterminates	2	8	1	6	1	18	3.6
Cores	3	5	1	9	6	24	4.8
	75	112	37	213	63	500	

Fig. 7.9. Chipped stone from WS107, Palaeolithic material; 1, Levallois core; 2, Aterian point; 3, Levallois flake.

Condition of material varied across transects, with Areas 17 and especially 19 having much higher proportions of abraded artefacts. In part this may relate to the proportions of Palaeolithic artefacts in these transects, which are considerably higher than in the other transects. Transect 19, for example, contains at least 22% Palaeolithic material in the form of Levallois cores and flakes, and discoidal flakes. Transect 17, also with fairly high levels of Palaeolithic material (10%), included one tanged point, as well as several flakes and a Levallois core (Fig 7.9, no. 1). All transects as well as the general surface collection contained some Palaeolithic material, all of which was very abraded.

Overall, the assemblage was flake dominated, although numerous blade and bladelets were also collected, with a blade/flake ratio of 1:7. Some microburins were found, often on blades rather than bladelets.

Cores and core trimming elements were found in higher proportions than in some other parts of the survey area.

A number of these were Palaeolithic; other than this, the vast majority were platform cores showing various core trimming strategies – single, opposed and multiple platform (Fig. 7.10, 2). There were some blade cores, as well as many showing flake and flakelet removals. Core trimming elements included core tablets, core face removals and one crested blade (Fig. 7.10, no. 3).

Tools made up 29% of the assemblage. These included mainly marginally retouched flakes (41%) as well as numerous notches (25%) (Table 7.21). There were small numbers of microliths and points, which included two Ounan points in transect 16 as well an elongated foliate point with covering retouch (Fig. 7.10, no. 6). Transect 15 included a point with covering retouch (Fig. 7.10, no. 7) and point fragment consisting of a tang with ventral retouch.

Transects revealed multi-period use of the area, with Middle Palaeolithic, possibly Aterian (Fig. 7.9, no. 2), and Early Holocene artefacts. However, the bulk of the assemblage suggests a slightly post-Early Holocene date, with some pieces diagnostic of the Middle Holocene, such as the foliate point.

Fig. 7.10. Chipped stone from WS107, Holocene material, areas 15–19; 1, core; 2, core; 3, crested blade; 4, denticulate; 5, blade; 6, point; 7, point.

Table 7.21. Total counts of tool types at WS107, by transect

Tool class	15	16	17	18	19	Total	%
Backed flakes	1	1	–	7	–	9	6.1
Borers	–	–	–	–	2	2	1.4
Burins	–	1	–	–	–	1	0.7
Denticulates	2	1	–	3	–	6	4.1
Endscrapers	–	1	–	–	–	1	0.7
Fragments	–	–	–	8	–	8	5.4
Microliths	–	–	–	4	–	4	2.7
Marginally retouched flakes	9	14	6	26	7	62	41.9
Marginally retouched bladelets	–	3	1	2	–	–	0.0
Notches	6	13	1	16	1	37	25.0
Points	1	3	–	1	–	5	3.4
Scrapers	1	1	–	1	2	5	3.4
Tanged pieces	–	–	–	2	–	2	1.4
Truncations	1	1	1	2	1	6	4.1
Total	21	39	9	72	13	148	

Table 7.22. Total counts and percentage frequencies of artefact types at WS107, Area 20

Artefact class	Number	%
Flakes	62	55.4
Blades	10	8.9
Bladelets	12	10.7
Spalls	1	0.9
Microburins	10	8.9
Indeterminates	12	10.7
Core trimming elements	3	2.7
Cores	2	1.8
Grand total	112	

Table 7.23. Total counts and percentage frequencies of tool types for WS107, Area 20

Tool class	Number	%
Awls	1	5.3
Burins	3	15.8
Fragments	3	15.8
Marginally retouched flakes	7	36.8
Marginally retouched bladelets	1	5.3
Notches	1	5.3
Points	2	10.5
Scrapers	1	5.3
Total	19	

Table 7.24. Total counts and percentage frequencies of tool blanks for WS107, Area 20

Artefact class	Number	%
Flakes	6	31.6
Blades	1	5.3
Bladelets	7	36.8
Indeterminates	4	21.1
Core trimming elements	1	5.3
Total	19	

Table 7.25. Total counts and percentage frequencies of artefact types at WS107, Area 21

	Number	%
Flakes	181	47.5
Blades	42	11.0
Bladelets	45	11.8
Spalls	5	1.3
Microburins	2	0.5
Chips	23	6.0
Indeterminates	62	16.3
Core trimming elements	2	0.5
Cores	19	5.0
Scanned	52	
Grand total	433	
Total catalogued	381	

WS107, Area 20

In this area, a total assemblage of 112 artefacts was retrieved. Many flakes were retrieved, but this is a strongly blade/let oriented assemblage with a very high blade/flake ratio of 1:2 (Table 7.22). Numerous microburins are present, making up nearly 9% of the assemblage. Small numbers of cores are present, both bipolar and change of orientation, with a few core trimming elements showing an organised core rejuvenation technique.

Raw materials include large numbers of quartz (40%) with smaller numbers of jasper and silicified sandstone artefacts. However, bladelets and microburins are overwhelmingly made on either jasper or silicified sandstone. The lower levels of the test pit contained higher proportions of silicified sandstone (17%).

Tools make up 16% of the assemblage, and are mainly marginally retouched flakes, as well as smaller numbers of burins and points, these last being an Ounan Point and an asymmetrical backed point similar to those in WS100.101 (Table 7.23). Tools are mainly on flakes (31%) and bladelets (36%) (Table 7.24). Over half of all tools are on jasper, with 26% on quartz.

Overall, this heavily bladelet oriented assemblage shows signs of being Early Holocene, similar to WS100.101. The bladelet industry and use of microburins, point typology and focus on high quality materials for tools and especially formal tools all point to a similar date. The extremely high proportion of bladelets and microburins and low proportions of cores may suggest that while the area was used for manufacturing e.g. points or other tools on bladelets, knapping was not a major activity.

WS107, Area 21

In this area, a total assemblage of 381 (plus 52 from general surface collection) artefacts was retrieved, of which 58% were from the brown silt layer (unit 037) within the test pit. In common with Area 20, numerous flakes were retrieved but blades and bladelets form a very significant part of the assemblage, with a high blade:flake ratio (1:2) (Table 7.25).

Microburins are present but form a small proportion of the whole (Table 7.25) and cores make up a larger proportion, at 5%. These are both bipolar, on quartz and

jasper, and platform cores on jasper only, showing core turning strategies in the mainly change of orientation and opposed cores.

Quartz makes up half of the assemblage, with smaller amounts of jasper, and very small amounts of silicified sandstone and flint. Many of the blade/lets and microburins are on these last three materials, rather than quartz. There are few cores core trimming elements or chips in these materials, which suggests that a substantial part of the blade/let industry was knapped elsewhere, although possibly only beyond the limits of the test pit. However, a high proportion of mainly quartz chips are present (given the methods of retrieval) suggesting quartz knapping did take place here.

Tools are made in almost equal proportions on blades, bladelets or flakes (Table 7.27). Flake tools are mainly on quartz, while blade/let tools are very largely on either jasper or silicified sandstone. Points make up a significant proportion of the tool assemblages, made on bladelets with tangs formed by covering retouch on the dorsal and often on the ventral (Fig. 7.11, no. 2). In the brown silt deposit,

Fig. 7.11. Chipped stone from WS107, Holocene material, areas 21 (numbers 2–7) and 22 (number 1); 1, core; 2, point; 3, backed microlith; 4, backed flake; 5, retouched blade; 6, dihedral burin; 7, retouched flake.

Table 7.26. Total counts and percentage frequencies of tool types at WS107, Area 21

	Number	%
Awl	3	4.3
Backed pieces	5	7.1
Burins	4	5.7
Denticulates	1	1.4
Endscrapers	1	1.4
Fragments	7	10.0
Knifes	1	1.4
Microliths	2	2.9
Marginally retouched flakes	18	25.7
Marginally retouched bladelets	14	20.0
Notches	2	2.9
Pièces esquillées	1	1.4
Points	9	12.9
Truncations	2	2.9
	70	

Table 7.27. Total counts and percentage frequencies of blades/flakes at WS107, Area 21

Artefact class	Number	%
Flakes	19	27.1
Blades	18	25.7
Bladelets	21	30.0
Spalls	3	4.3
Indeterminates	8	11.4
Core trimming elements	–	
Cores	1	1.4
Total	70	100.0

Table 7.28. Total counts and percentage frequencies of artefact types at WS107, Area 22

Artefact class	Number	%
Flakes	19	57.6
Blades	1	3.0
Bladelets	1	3.0
Microburins	1	3.0
Indeterminates	8	24.2
Cores	3	9.1
Scanned	65	
Grand total	98	
Total catalogued	33	

Table 7.29. Total counts and percentage frequencies of tool types from WS107, Area 22

Tool class	Number	%
Fragments	1	16.7
Marginally retouched flakes	2	33.3
Notches	1	16.7
Scrapers	1	16.7
Truncations	1	16.7
	6	

Table 7.30. Percentage frequencies of tools made on flakes or blades from WS107, Area 22

Tool type	Number	%
Flakes	3	50.0
Blades	1	16.7
Bladelets	1	16.7
Indeterminates	1	16.7
Total	6	

they form an especially high 17.5% of the tool assemblage. There are also a number of backed bladelets. In fact, if one considers the rare more formal backed microliths (Fig. 7.11, no. 3), the backed bladelets and marginally retouched bladelets together, these form the largest tool class at 30% of the assemblage (Table 7.26). This is particularly the case in the brown silt deposit, where tools on bladelets make up 44% of the tool assemblage.

There are rare burins on flakes, blades (Fig. 7.11, no. 6) and bladelets, as well as awls and small numbers of other tool classes. Overall, the tool assemblage contains a wide range of tool classes, with a focus on blade and bladelet tools, and these, together with the flake tools, are often informal (although a number of points and microliths are present).

The assemblage has some similarities to other assemblages in the survey area, with post-Early Holocene point types and a somewhat greater emphasis on blades rather than bladelets in a highly blade-oriented assemblage. Tools present suggest a fairly wide range of activities, alongside knapping of quartz as shown in the core and chip proportions in the assemblage. However, silicified sandstone and jasper do not seem to have been intensively knapped in this sample, although the manufacture of tools using the microburin technique in flint and jasper is present.

WS107, Area 22

In this area, a total assemblage of 33 artefacts were excavated, of which 13 were from within the excavated neighbouring hearth, and a further 65 artefacts were surface collected (Table 7.28). This smaller assemblage revealed a higher proportion of flakes than the other test pits at 107, although some blade/lets were also present, with a blade ratio of 1:6 (Table 7.28). Three cores were retrieved, including two quartz cores, one bipolar and one a change of orientation platform core. One core was a small change of orientation bladelet core on rock crystal (Fig. 7.11, no. 1). Most of the assemblage is on quartz, with smaller numbers on flint and jasper.

Tools were non-diagnostic and included various flake tools as well as a truncated silicified sandstone blade (Tables 7.29 and 7.30)

The small size of the assemblage, as well as the non-diagnostic nature of its tools, make certain period attribution impossible but there are some differences between the test pit assemblage and the excavated hearth. The assemblage from the test pit (units 40, 41) is mainly made up of quartz with a few pieces of flint, and is non-diagnostic. The assemblage from the excavated neighbouring hearth (units

42–45) was the source for that part of the assemblage that is possibly suggestive of an Early Holocene date – the jasper artefacts, as well as the rock crystal core, truncated blade and microburin.

The small assemblages
WS226, WS228, WS229
A general surface collection was made of this area, and the material was scanned. The assemblage includes some very worn Palaeolithic material, including Levallois flakes. Fairly fresh Holocene material is also present and often of a regular appearance. Cores and flakes have previous parallel-sided removals. Raw materials are mixed and include flint, jasper and silicified sandstone, as well as irregular quartz pieces. One rock crystal blade is present, and a core/tool on a cortical rock crystal nodule. The material is fairly non-diagnostic.

WS400
An extensive scatter of Palaeolithic material was located at this site. Material was not collected pending geomorphological study of the site. Material on the surface included bifaces, Levallois cores and flakes, and possible Aterian material. This assemblage is the first Palaeolithic material found by the project that appears to be above the level of the wadi, with in some cases less abraded or damaged artefacts, suggesting that further investigation of the formation of this site is necessary to determine if it may be *in situ* rather than deposited by water movement through the wadi, as is likely to be the case with Palaeolithic material from WS107, for example.

Discussion
Palaeolithic occupation
Following Vernet (1998, 2007a) we use here the same cultural periodisations that are used for Atlantic Sahara and Mauritania. All the surface collections within the lower levels of the wadi or close to it retrieved some very worn Palaeolithic material in the form of discoidal flakes, Levallois cores and flakes, and some tanged flakes/points. All of the material in these situations appears to be water transported, and occurs in small amounts, although there are areas of concentration at WS107. The material from WS400, in contrast, appears fresher and is part of an extensive scatter with concentrations of material located above the wadi bed. Although not yet collected or studied, this material suggests a possible Lower Palaeolithic presence in the form of large bifaces, as well as a Middle Palaeolithic/possibly Aterian presence in the Levallois technology and tanged pieces. Found widely throughout North Africa and the Sahara, there are also some examples from other western Saharan regions, for example, northern Mauritania (Pasty 1999). Further work may well enable more detailed comparisons with this material.

Early Holocene occupation
A number of sites in the survey area are likely to date to the Early and early Middle Holocene (Table 7.31), including several test-pitted areas as well as material from surface transects.

Most of these assemblages contain microliths (except WS107 Area 20). The importance of microliths in the lithic assemblages of the Early Holocene has been attested to across the Sahara from Egypt to Libya, Algeria and Mauritania, as well as south into the Sahel. These often take lunate or triangle forms as at Wadi Tifariti, and as seen for example in the Acacus (di Lernia 1999) or in the Capsian (Lubell 2001) but also earlier in Iberomaurusian sites. However, the presence of a form in the TF1 Study Area may clarify to some extent the period involved, and also links Wadi Tifariti with far flung Early Holocene sites. First described by Breuil (1930) as typical of the Epipalaeolithic of the region on the basis of his work in northern Mali, the point has been found in the Dakhleh Oasis in Egypt's Western Desert (MacDonald 1997), at several sites in the

Table 7.31. Breakdown of sites into chronological periods using presence/absence of material types

Site	Middle Palaeolithic	Early Holocene	Early/Middle Holocene	Non-diagnostic
WS100.101		✓		
WS100.102		✓		
WS103 (surface)	✓	✓	✓	✓
WS104.105				✓
WS104.106, 14		✓ ?no points		
WS104.106, 23			✓	
WS107, 15-19 (surface)	✓	✓	✓	✓
WS107, 20		✓ no microliths		
WS107, 21			✓	
WS107, 22		✓? (units 42–45)		✓ (units 39–41)
WS400 (surface)	✓			
WS226 *et al.* (surface)	✓		✓	✓

Basin d'Azawagh, Niger (Paris 1992), at Foum el Alba, Mali (Raimbault 1983), around Mauritania (Vernet 2007a) and the coast to the north west of Wadi Tifariti, at for example Smeil el Leben, conchero 1 (Almagro Basch 1946).

However, the type seems to encompass some variability (Riemer *et al.* 2004) of shape and manufacture. Indeed, comparisons between those reported in Vernet (2007a) and those from Wadi Tifariti show significant size differences, with the Mauritanian ones 29–74mm long, and the Western Saharan ones rarely longer than 30mm. In fact, the points from Wadi Tifariti include some variability of form and manufacture, including very asymmetric points with retouch along one, convex side, as well as somewhat more symmetric pieces with naturally pointed distal ends and no lateral retouch.

The backed points present in the assemblages are similar to ones collected by Almagro Basch at a number of coastal sites to the north west of Wadi Tifariti north of Cape Juby, such as Smeil el Leben (1945–46, 107–108) described as notched points and found with microliths including lunates, but also later Neolithic points. They were also found by Vernet at Foum Arguin 10 (2007a, 77–78) alongside more classic Ounan points and some few microliths.

Chronological placement
The chronological placement of this tool type is problematic. It has been pointed out by Reimer *et al.* (2004) that they are often in poorly dated assemblages, and certainly their reported chronological spread is rather great – from 9500 BP in Aïr, Niger (Roset 1987), to around 7300 BP. They are most commonly reported in 9th millennium sites (*e.g.* the Dakhleh Oasis, McDonald 1990; several sites in the Basin d'Azawagh, Paris 1992; Foum el Alba, Raimbault 1983). Several Ounan points have also been found in neighbouring Wadi Kenta (Soler i Subils 2005a, 689).

Their manufacture with the microburin technique, may suggest an early date within the Holocene. Riemer *et al.* (2004) describe Ounan Points made using the microburin technique in the early part of the Dakhleh Holocene sequence, later replaced by similar points made without the microburin technique. Vernet suggests (2007a) that the lack of microburin technique at Foum Arguin supports a date slightly later in the Early Holocene. Overall, these assemblages show a number of differences from the Wadi Tifariti ones – in their lack of microburin technique, the use of mediocre local flint (and lack of quartz and jasper as well as good quality flint, all seen at Wadi Tifariti), the absence of truncations and burins and the scarcity of microliths. It is difficult to know if this suggests that the Wadi Tifariti sites are earlier, based on the presence of microburins, and/or represent different activities from those seen at Vernet's coastal sites.

To the south of the Sahara, Ounan points are not present. At 8th and 9th millennium BP Ounjougou in southern Mali, assemblages are more flake based, with microliths on quartz, and in some cases points with rectilinear bases, or with bifacial retouch for example at Ravin du Hibou dating to the 8th and 9th millennium BP (Huysecom *et al.* 2001). A sub-Saharan origin is suggested (from *e.g.* Shum Laka in Cameroun (Lavachery 1996)), followed by the spread northwards of a bipolar quartz microlithic industry. A general microlithic Sub-Saharan West African industry has been identified by MacDonald (1997), with blanks that are less standardised, fewer blades, and an emphasis on microliths.

The distribution of the Ounan Point, whatever its chronological, typological and technological lack of clarity, alongside a strongly laminar industry, suggests that Wadi Tifariti's links were Saharan rather than Sub-Saharan. Equally, it is interesting to note that it is the Sub-Saharan assemblages like Ounjougou, for example, that show a heavy use of quartz and a bipolar on anvil technology – both seen at Wadi Tifariti and seldom reported in assemblages throughout the Sahara.

The large numbers of truncation burins at some of the Wadi Tifariti sites is also interesting. This is seen as characteristic of the Maghrebi Upper Capsian of *e.g.* eastern Algeria, and also the Adrar Bous of Niger (Clark *et al.* 1973). These tools have also been collected by Almagro Basch (1946) and have been found in other recent archaeological work in Western Sahara at, for example, in neighbouring Wadi Kenta (Soler i Subils 2005a). Here they have been found in association with a bladelet assemblage, microburins and opposed blade cores at Abric del Nius, the cores in some cases very similar to Capsian core reduction techniques as outlined in Rahmani (2004).

Overall, the assemblages seem likely to date to sometime in the 8th or more likely 9th millennium BP, showing various features in common with other assemblages of this period throughout the Sahara. Regional differences may include backed points made with microburin technique, and some technological characteristics such as the use of bipolar technique may suggest links to sub-Saharan areas.

Organisation of technology
The wide range of raw materials found in the assemblages may relate to high levels of mobility. We can certainly see different treatment of the various raw materials, not just in choice of artefacts made on different raw materials (*e.g.* points and microliths on jasper and flint), but also in different stages of the reduction process present in Wadi Tifariti, with an overall low proportion of cores and core trimming elements present suggesting a lack of knapping here (in contrast to clear signs of point and microlith manufacture, presumably from blanks brought to the area ready-made). This is especially seen in the silicified sandstone artefacts, with no cores in this material found. Locations of other

activities remain speculative, but the presence of similar tools and blanks, alongside cores with blade removals in nearby Wadi Kenta, is of a general absence of knapping elements across the region. However, raw materials may also be brought some distance in the form of blanks in a highly mobile system, and the widespread nature of, for example, the Ounan point may well support long distance links across the Sahara at this time.

Tool class variability

The variability between the assemblages in the types of tool classes present mirrors the variability observed across sites in the Sahara more widely. The presence of points without microliths, microliths without points, or points and microlithis together is a common theme further south for example. The significance of the presence of these tool forms is unclear; with few radiocarbon dates, considerable deflation of sites and little stratigraphy, it is not possible to get a clear chronological picture of the lithic variability. Haour summarises the situation in Niger (2003), where alternative theories about the chronological significance of these tool forms (and other artefacts such as pottery) have continued for decades. Within this small section of Wadi Tifariti, we have sites containing points but no microliths (WS107, Area 20), microliths but no points (WS104.106, Area 14) and points alongside microliths (WS100.101 and WS102; WS107, Area 20). We cannot resolve these issues on the basis of our work carried out to date, but can add to the debate by noting:

1. The extreme similarity of point forms, and of microlith types, across all our sites, whether found together or not, as well as,
2. A similarity of technology, especially seen in approaches to raw material use and blade production, as well as the widespread use of the microburin technique, across all our sites.

While this does not preclude a chronological explanation for the tool class variability, it may suggest that at least in some cases there are other causes.

The Wadi Tifariti excavations show some of this tool class variability within site, suggesting that the presence of points and microliths is influenced by activity areas and disposal patterns, and/or by post depositional factors, to the extent that in some areas there are few or none of one tool class or another that are seen in other areas. For example, site WS100 shows variability in tool classes between areas WS101 and WS102, with truncation burins and non-formal tools more common at WS101, while in one context at WS102, microliths and points are common. At WS104.106 there are no points, despite its similarity to the other assemblages in the wadi. At WS107 Area 21, points and microliths show great variability in density across the different contexts, being most concentrated in a brown silt deposit.

Many other Early Holocene sites across the Sahara share the challenge of small exposures and lack of radiocarbon dates and this may be masking within-site variability and contributing to the confusion surrounding the chronological relationships of these tool classes. Di Lernia (1999) has pointed out the great variability of assemblage make-up and lithic typology in the Early Holocene, and Wadi Tifariti and its surrounding wadis may furnish us with a range of sites to compare with the Early Holocene record further east in e.g. Niger and Libya, and coastal occupation to the west and northwest of Wadi Tifariti. Further investigation in Wadi Tifariti with its suite of neighbouring sites may help us to understand how some of the different expressions of Early Holocene assemblages fit together helping us to understand how some of the different expressions of Early Holocene settlement and technology relate to each other.

Early Middle Holocene occupation

Two areas have slightly later Holocene occupation – (Table 7.31) WS107, both in the surface transects (15–19) and in the test pit in Area 21, and WS104.106, in the test pit in Area 23. This is largely seen in both areas in a greater emphasis on large blades over bladelets, a more flake-based toolkit, and the use of more elaborately retouched points. These last are the most diagnostic, but are rare in the survey area, and often fragmentary. Those that have been found tend to be around 3cm long with either fairly rectilinear edges or a somewhat more foliate shape, with covering retouch. Many published sites across the Sahara show a range of point types present, as at Temet (Raimbault 1983), Et-Teyyedché and Tintan (Vernet 2007a), Taruma (Almagro Basch 1945–46), and Uan Telocat (Garcea and Sebastiani 1998) where transverse, foliate and tanged points all exist. These date to the 5th–6th millennium BP, and include points similar to those few found in Wadi Tifariti.

It is interesting to note that both of the areas with more Middle Holocene assemblages are on flat, low ground next to the wadi in contrast to the Early Holocene sites, which are on rocky bluffs above the wadi bed.

The lack of substantial Middle Holocene assemblages in the Study Area is particularly noticeable in comparison to the rich Early Holocene presence. This may represent a decrease in occupation of the wadi. However, the recognition of the Middle Holocene through surface lithic assemblages in the survey area may well be considerably hampered by previous collecting. This has been noted as a problem in many parts of the Sahara and Sub-Sahara (e.g. Bedaux and Rowlands 2001, Niang *et al.* 2001) with Neolithic points at particular risk because of their visibility, transportability

and commercial value. Vernet (2007a) recounts how local residents in Mauritania have collected certain types of lithics for sale to private collectors, some of whose collections number in the thousands. The size of the collections and extent of collecting in Mauritania has had significantly adverse effects on the study of the Neolithic there. It is known that local nomads in the Western Sahara have collected worked flint to use as strike-a-lights until recent decades (Ahmed *pers. comm.* 2007), and more recently, visitors to the area have collected lithics as well as fossils (*pers. ob*. 2007). Western Saharan Neolithic points are widely available for sale on the internet (*e.g.* http://www.neolithique.eu/neolithique-pointes_de_fleches.html). So it may be that, while Martín Almagro Basch collected numerous Middle Holocene points in what was then the Spanish Sahara in the earlier part of the last century (1946), the visibility of the Middle Holocene in survey assemblages may today be seriously compromised.

Chapter 8

Western Sahara in a Local and Regional Context

Joanne Clarke and Nick Brooks

Introduction

Despite ongoing work and a growing body of literature, modern archaeological research in Western Sahara is in its infancy. In comparison with the countries that surround it (Morocco, Mauritania, Mali and Algeria), very little is known of Western Sahara because the conflict with Morocco effectively stopped all research in the territory until the 1990s. It has only been in the last decade or so that archaeological and environmental study has resumed under the auspices of the University of East Anglia and the University of Girona. What is perhaps most significant is that although there is a pre-conflict history of research in Western Sahara, this work was all undertaken in the Atlantic Saharan region to the west of the berm (now under Moroccan control); the territory to the east of the berm, where our current research is focused was, until very recently, effectively unknown. Yet the desert region inland from the Atlantic zone is a relatively humid region in comparison with the rest of the Saharan interior and the Atlantic coast. This fact on its own makes research in this region enormously important for understanding the ways in which people adapted to, and exploited, different environments, and how they responded to diverging climatic trajectories within a broad context of progressive aridification in different parts of the Sahara. This volume represents the first integrated research on the crucial relationship between Holocene climatic changes and human adaptation in this region of western Sahara, and as such adds to what is known of the wider Sahara, complementing recent linked environmental and archaeological work in Mauritania (Vernet 2007), Mali (Huysecom *et al.* 2001), the central Sahara (Cremaschi 2002; Cremaschi and di Lernia 1999; Cremaschi and Zerboni 2009) and Morocco (Zapata *et al.* 2013).

The work of the Western Sahara Project between 2002 and 2009 combined extensive and intensive survey, with limited excavation and recording of material finds (rock art, lithics, pottery, metal and other small finds), however, most of what we know about the cultural development of Western Sahara derives ultimately from the intensive survey and excavations in the Northern Sector. That said, Chapter 4 presents a comprehensive review of the results of the extensive survey across both Sectors, including how these results inform our understanding of the wider region. Where relevant, these results will be referred to here.

Our earliest dated evidence of human activity comes from excavations in the TF1 Study Area and indicates that the region encompassing the Wadi Tifariti was occupied during the early Middle Holocene (*c.* 6500 BP) on the basis of a radiocarbon date from F042 – a hearth in the vicinity of WS107 – and quantities of chipped stone indicative of the Early and early Middle Holocene from four artefact scatter sites. Subsistence economies at this time were most likely based around low-intensity, mobile, or semi-mobile plant processing – as evidenced by the high number of blades and bladelets in the lithic assemblages and ground stone implements found at WS104 – combined with opportunistic hunting. Chipped stone production sites, hearths, post holes and ephemeral surfaces suggest that people were not simply moving through the region but were establishing ephemeral or temporary camps where water and food resources would presumably have been relatively plentiful. Although we have not been able to establish a chronological sequence for Western Sahara, evidence from Morocco (Zapata *et al.* 2013) and the central Sahara (Barich 2014, 23) demonstrates that a deteriorating climate around 6400–6200 BP contributed to new life ways which we see

archaeologically as abandonments of regions, aggregation in other regions, and changing subsistence practices. In the TF1 Study Area, we found no evidence of human activity between the early Middle Holocene temporary camps and the built stone features, the oldest of which are unlikely to predate the middle to late 6th millennium BP, and may well be considerably younger (see Chapter 4).

By the time people began constructing funerary and other monuments they were no longer occupying or living in the TF1 Study Area. Evidence of permanent or semi-permanent occupation is replaced in selected locales by densely packed monuments, funerary and other stone structures, presumably constructed by people practising a pastoral way of life, who used the major north–south and east–west drainage systems as both routeways and as catchments for the exploitation of resources. The built stone monuments of the Northern and Southern Sectors of Western Sahara have affinities with the central Sahara, the Atlantic Sahara and Morocco, but the extent to which these affinities is evident is not homogeneous across the Free Zone as a whole. Indeed, not only do different parts of Western Sahara show greater or lesser affinity with funerary landscapes to the north, east or west; there is also variation on a local scale. Considerable local variation in the built stone tradition of Saharan Morocco has been observed along the Wadi al-Noun and the Wadi Draa (Bokbot 2003, 2011) and is therefore not unexpected, however, it is not clear what this variation signifies (as discussed in detail in Chapter 4). What is often forgotten when material evidence of trade and exchange is largely absent is that people did not necessarily need to participate in formal exchange networks to have benefitted from, or have been influenced by broader cultural interaction. Cultural interaction often manifests materially as regional variation, as is well attested within archaeological contexts around the globe. Indeed, recent research by Mattingly and Gatto (2018) suggests that exchange networks across the Sahara during the Late Pastoral period were extensive, stretching from the Atlantic coast of Mauritania to northern Morocco in the west, and as far as Niger in the south and to Egypt in the east. The pastoral groups that inhabited the Sahara were thus highly mobile, and in their travels they would have interacted with other cultural groups with whom they would have shared worldviews, knowledge and ideas, all of which manifested in subtle ways across the Saharan material culture record.

As mentioned in Chapter 5, there appear to have been connections between the Northern Sector of Western Sahara and Morocco, particularly via the east–west drainages of the Saguia al-Hamra to the north of the TF1 Study Area, and further north via the Wadi Draa and the Wadi al-Noun. The Wadi Draa flows south along the eastern edge of the anti-Atlas Mountains, before turning west toward the Atlantic coast. It is entirely plausible that mobile populations living in the better-watered regions of Morocco utilised these large drainage systems for movement, and as places to bury their dead. The cultural interactions that would have been afforded via these routeways would have linked the Northern Sector with the 'Atlantic zone' of Morocco and indeed the Maghreb, and helps to explain the affinities between these regions. Ridge monuments, for example, are found in the Anti-Atlas around Akka, and also in the Free Zone, but not elsewhere in the Sahara, and Type 2 goulets are a particular feature of the Northern Sector of Western Sahara and Morocco (see Chapter 4).

The changing face of the TF1 Study Area

One of the aims of our work in the TF1 Study Area was to explore the ways in which the monuments related to the surface scatters of worked stone and pottery. It was reported in Chapter 4 that chipped or ground stone artefacts were identified at 52 locations throughout the Northern and Southern Sectors. Ten of these were lithic scatters only. Eleven locations contained both lithics and pottery. At five locations lithics were identified alongside rock art, and lithics occurred alongside (but not necessarily in relation to) 29 built stone features, that is, just over half of the locations. Analyses of assemblages from the TF1 Study Area demonstrated that the locations that were comprised entirely of lithics, or lithics and pottery, dated from the Pleistocene (WS400), the Early Holocene on typological grounds (WS100) and the early Middle Holocene (WS100, WS103 and WS107). At these locales, the complete knapping process was represented (debitage, blanks and tools). The chipped stone evidence for the Late Holocene was somewhat thinner, and although chipped stone comparable to that of the Late Pastoral period in the central Sahara was found throughout the study region, only the middle and end of the tool making process was represented, indicating that people were not manufacturing tools in the TF1 Study Area in the Late Holocene as they had been in the Early and early Middle Holocene. This is compelling evidence for a change in the way in which the TF1 Study Area was used over time. Although we have no direct evidence that the built stone features were associated with mobile pastoralists, all circumstantial and comparative evidence points to this fact. Moreover, the quantities of pottery and chipped stone associated with the funerary monuments are generally small, unlike in the Southern Sector where pottery and chipped stone is found in abundance in association with the built stone features. It seems most likely, therefore, that the pottery and lithics found in association with the stone monuments in the Northern Sector represent the personal items that people brought with them and discarded around the monuments (although see Gatto 2013, 87 for a different

perspective on pottery incorporated into funerary mound material at Fewet).

A landscape of meaning

The results of the intensive and extensive surveys, complemented by the identification of monuments on satellite imagery (Chapter 4) indicate quite clearly that monument building, the clearest evidence we have for patterns of utilisation and exploitation of the desert in what we may refer to as the pastoral period, was to a very large extent concentrated along drainage systems, throughways, and ridges elevated above the surrounding landscape (particularly in the south). This quite simply means that the activities of people are most obvious, and probably more intensive, in areas where resources (water, pasture, food resources and raw materials) were most plentiful, and along routes people travelled. Having said this, there is subtle evidence that the desert landscape held significance beyond simply being a place of livelihood. Monument building in the Northern Sector is most dense along the wadi courses, but unusual or significant topography and geology may have been preferentially selected for clusters of monuments, and this is particularly documented in the Southern Sector (see Chapter 4). The TF1 Study Area is a natural basin, and the monuments were positioned on the ridges above the basin (a pattern noted in other Saharan regions, see Belmonte *et al.* 1999; S24), affording views both inward toward the centre of the wadi basin but also outward toward the wider Saharan landscape. Elsewhere in the Northern Sector, monuments are often situated near the edges of plateaux, where they are visible from the adjacent lowlands. In the Southern Sector, where drainage systems are far less dense than in the north, monuments are concentrated along granite ridges and basalt dykes. In both sectors, ridges and dykes provide raw materials for the construction of monuments and also enable certain monuments to be placed in highly visible locations on these raised features. However, a great many monuments are constructed not on top of ridges or dykes, but on their flanks or the adjacent lower elevation areas.

Much has been written about the ways in which ancient monuments reference astronomical alignments (*e.g.* Belmonte *et al.* 1999), and our study is no exception, with strong evidence for luni-solar alignments of crescent and antenna monuments (see Chapter 4). These kinds of interpretations are invaluable for understanding how people engaged with the intangible but also practical elements of their environment[1] and how they referenced the significance of these alignments through the building activities tied into their ideologies. However, if we are to understand what the monuments of the Sahara meant in their ancient contexts, we must also think beyond such functional interpretations of monuments as astronomical markers (Hoskin and Aparicio 1999), or as identity or territory markers (di Lernia 2006).

Some exploration of the application of landscape phenomenology to monument building has been undertaken by Bradley (1998) and Tilley (2004) in the context of the European Neolithic and Bronze Age. Both argue that although monuments may reference astronomical alignments, this always occurs in relation to the local topography. As Bradley points out, 'many monuments command a view of natural features that might have framed the movements of the sun and moon; but they were often in places with an equally extensive view in other directions as well' (Bradley 1998, 122). This appears to be the case in the western and central Sahara, where work by Gauthier (2015) has demonstrated that monument orientation is predicated on a number of factors, including both lunar and solar alignment, and positioning with respect to prominent topographical and geological features. The range of alignments recorded for stone monuments in the course of the extensive survey (Chapter 4) echoes this finding. Therefore, in Western Sahara too, the relationships of monuments to astronomical features, to the natural topography, and to each other were in delicate balance and dependent on multiple factors largely missing from the archaeological record.

In both the Northern and Southern Sectors, monuments often reference other (earlier?) monuments, while also referencing natural features and luni-solar alignments. The positioning of monuments therefore was planned. This is most evident in the construction of cairns on prominent rocky outcrops, or antennae monuments where the longer 'arm' extends upslope, or goulets where the central corridor references features on the horizon. The silhouettes of many monuments are enhanced by the natural topography, but the monuments also merge with and become the topography. This phenomenon is aptly illustrated by the goulet WS006 in the TF1 Study Area, constructed on an area of raised ground between drainage systems. The corridor of this goulet points directly east to an isolated flat-topped hill in a gap in the otherwise continuous range of Rekeiz Lemgassem, suggesting that local topography, distant landscape features, and orientation with respect to more global frames of reference all appear to have been taken into account in the location and construction of this monument. The referencing of other monuments is aptly illustrated by Figures 5.15 and 5.16, where the view sheds for WS001 and WS302, two standing stone monuments in the TF1 Study Area, incorporate approximately 80% of the surrounding monuments.

It should not be forgotten that funerary monuments are the end result of a process that may have taken hours, days or even years to perform, may have involved several (or even many) people, and which in some cases included symbolic behaviour. Equally, it should not be ignored that monuments have a longevity that can be measured in millennia, and undoubtedly played a role in reinforcing and legitimising perceived rights of land ownership and

use (di Lernia 2006). These rights may have become vital during periods of enhanced aridity when resources were scarce and competition was increased. In this context, it is significant that monument building spread and intensified at a time when the Sahara at large was experiencing a dramatic intensification of a multi-millennial trend towards aridity (Brooks 2006, 2010; di Lernia 2006). Monuments as indicators of both territoriality and incipient social stratification (Chapter 1) are consistent with a more difficult social environment of increased competition and perhaps conflict, resulting from climatic and environmental deterioration (Brooks 2006 and 2010; di Lernia 2006).

Bradley (1998, 88) writes that public monuments provide evidence of ritual rather than of subsistence, and that ritual may involve a rather different conception of time than do more prosaic everyday activities. The burial monuments of Western Sahara are a case in point. The monuments require interpretation at two different time scales; the relatively brief timescale of the individual monument building event and the millennial timescales over which groups of monuments exist as part of constructed landscapes. Linking interpretations that require two different timescales is problematic, because the evidence on which archaeologists draw is often not of the required resolution. For example, the monuments of the TF1 Study Area were reproduced in a similar 'format' for what may have been thousands of years, and yet the actual building of a monument will have taken only hours or days in most instances. How we understand the relationship between these vastly different timescales is not straightforward. Did the monument builders have a concept of the antiquity of the practice of monument building, and did the cultural significance of monument types and burial events remain unchanged over millennia? Ultimately, how was it that these burial rites endured largely unchanged over hundreds or thousands of years? These questions will be addressed below.

Burial monuments and social complexity

Some of the monuments in Western Sahara are very large, for example the tumuli that make up the three large burial grounds in the Erg Azefal in the far southeast of the Southern Sector (Saenz de Buruaga 2013). The largest of these are some 5m in height and 20m in diameter, and represent key elements in what are evidently carefully planned funerary complexes consisting of dozens of very large tumuli and perhaps hundreds of smaller tumuli. In the Northern Sector, bazinas can reach 5m and involve complicated construction methods that suggest a significant degree of cooperation. WS006, the Type 2 goulet in the TF1 Study Area is over 100m long; it may be low to the ground but the collection and placement of stones, and organisation of labour, must have taken some considerable planning. All this suggests that a degree of social complexity was required to organise a work force capable of constructing larger monuments. It also suggests that some individuals were ascribed higher status, manifested in the size and complexity of the monuments in which they were buried, while other individuals acquiesced to a hierarchical structure that involved them in the construction of burial monuments for other members of the group. There has been a good deal written on the rise of social complexity in the Sahara (Brass 2007), in the arid sub-tropics more widely (Brooks 2006) and as a cultural construction (Honeychurch 2014) but identifying it materially in the archaeological record and understanding its roots and how it was practiced amongst mobile groups is challenging. Materially, one can observe funerary monuments of greater or lesser scale, but this does not necessarily denote social complexity within the societies that constructed these monuments. More difficult still is how social complexity amongst pastoral communities may have been politically and economically structured. For the populations of Western Sahara, it remains to be seen whether the different scales and complexity of monument building were associated with higher ranked individuals; it may be that investment of energy in larger monuments had more to do with availability of raw material or with other social factors not known to us. That said, Bokbot (2008) has interpreted the Cromlech de Mzora as an example of the display of power and wealth amongst local chiefs who had contacts with Europe during the latter half of the 1st millennium BC. Mattingly *et al.* (2018) have demonstrated how high status Garamantian burial structures were the preserve of elites who had access to exchange systems with Roman north Africa.

An 'Atlantic' connection?

A principal argument explored in this book is that western Saharan peoples may have had knowledge of, or interaction with, 'Atlantic Europe' via Morocco. The extent of this relationship is unknown but connections between the Maghreb and southern Europe via the Mediterranean, at least from the Early Bronze Age, are well documented. It is now well known that southern Iberia was part of a wider 'Atlantic Interaction Sphere' (see Cunliffe 2001, 192) and that this 'common cultural tradition' (Cunliffe 2001, 193) stretched as far as northern Morocco (Belmonte *et al.* 1999; Balbin Behrmann 1977; Bokbot and Ben-Nçer 2006). Although there are vast distances between the European Atlantic zone and Western Sahara, it is not inconceivable that knowledge and ideas spread, perhaps in diluted form between Iberia, Morocco and the Atlantic Sahara via routeways into the desert associated with large drainages, such as the Wadi Draa and the Saguia al Hamra. These transmissions of knowledge and ideas would have been re-interpreted within local Saharan traditions and thus would be manifested in very different ways from Atlantic European traditions. Even so, these adjacencies appear to be more than just mirages, and warrant some detailed consideration.

Archaeological and genetic evidence in support of interaction between Europe and North Africa from at least 11,000 years ago has been presented by a number of authors. Genetic evidence for migration from Europe to North Africa as early as 9000 BC has been described by Macaulay *et al.* (2005) and Ottoni *et al.* (2010). Behar *et al.* (2008), Gonçalves *et al.* (2005, 448) and Botigué *et al.* (2013) present genetic evidence for prehistoric migration in the other direction, from North Africa to Europe, via coastal routes and/or across North Africa to the Mediterranean. There is now a growing body of evidence to indicate seafaring along the Atlantic coast as well. Early Bronze Age (EBA) Bell Beaker burials have been recorded at Khemisset in Morocco and Bell Beaker pottery is known from a number of locations in western Morocco (Bokbot 2007, 2008). These occurrences of cultural elements traditionally associated with the European EBA close to the Moroccan Atlantic coast support the premise that interaction occurred via the Mediterranean Sea and perhaps also via an Atlantic coastal route. Schumacher *et al.* (2009, 993) argue for trade in ivory from the African savannah elephant to Portugal and south-western Atlantic Spain during the European Chalcolithic, and with south-eastern Spain in the EBA, and infer an Atlantic route for this trade, based on the above chronological differences and on comparisons between ivory artefacts from Iberia and modern-day Morocco. Recently, a complete, unworked African Savannah elephant tusk was found in an elite Chalcolithic burial at the site of Valenica de la Concepción, near Seville in southern Spain (García Sanjuán *et al.* 2013). Indeed, as long ago as 1957, Jodin argued that an Atlantic trade route between Iberia and northwest Africa existed by the Neolithic (Jodin 1957, 356) and Schumacher and Cardoso (2007, 113 fig. 11) record tens of objects made of African ivory found on Bell Beaker sites in southern Iberia. How far south into the Sahara these connections reached is uncertain due to a dearth of evidence, but again we can refer back to the presence of routeways like the Wadi Draa, which may have provided a gateway between northern Morocco and Saharan Morocco, and thus further into the Saharan interior.

There are other aspects of the western Saharan cultural complex that we would argue bear striking adjacencies with an Atlantic cultural milieu; these are:

1. A particular emphasis on quartz as a material, for the construction of a monument, for the 'carpeting' of standing stone sites and funerary monuments in quartz chips, or simply as naturally occurring outcrops that become foci of cultural interest/behaviour.
2. The use of contrasting materials in the construction of funerary monuments.
3. The deliberate and specific 'referencing' of both landscape features and other monuments including standing stone sites.

Use of quartz and contrasting materials in funerary contexts

A very small percentage of monuments recorded in the Free Zone of Western Sahara are associated with scatters of quartz chips on and around the monuments. In the TF1 Study Area, eight out of a total of 400 monuments are associated with quartz scatters. This situation appears to be reflected throughout the areas examined by the extensive survey, in which quartz scatters in association with monuments were present but extremely rare. Nonetheless, the extensive survey revealed some striking examples of the use of quartz, including:

1. An east-oriented crescent monument (AZ3-1, Plate 10d) constructed entirely of quartz and situated within a large quartz outcrop.
2. A small funerary complex (LD0-3, Plate 10c) with very dense concentrations of quartz pebbles inside and outside a well-defined perimeter, housing a large hollow boulder that had been filled with quartz pebbles (Chapter 4, Fig. 4.36b).
3. Concentrations of quartz chippings inside and outside the enclosures of goulets (e.g. Plate 7b).
4. Quartz chippings scattered on and around tumuli and other monuments in varying densities (Plate 10a).

The monuments associated with confirmed, deliberate concentrations of quartz include six simple tumuli, one platform tumulus, five goulets, two crescent antennae monuments and one crescent, two standing stone sites, one bazina and a low stone circle. Many of these represent classic 'Saharan' forms (including crescent and antennae monuments, that fall under the broader category of 'V-type' monuments) but also forms restricted to the northwestern Sahara (goulets), and other forms that occur both within and outside North Africa (tumuli, platform tumuli and standing stone sites). The morphological diversity of these forms is striking and indicates that the scattering of quartz was not systematically associated with selection criteria based on monument type. Furthermore, the infrequency of the practice suggests that it was not common in Saharan funerary traditions. Di Lernia and Manzi (2002) do not record any deliberate placing or use of quartz in the monuments of Wadi Tannezzuft in central Libya even though quartz is common in the area, nor do Baistrochi *et al.* (1987) record the deliberate use of quartz in the Tadrut Acacus. In contrast, Vernet (2007) records very similar types of funerary monuments to those found in Western Sahara, and the deliberate placement and use of quartz on a small number of these, in Atlantic Mauritania. Further east, Mattingly (pers. comm.) has noted the very rare use of quartz in the Wadi Barjuj, south of Jarma in central Libya, which may suggest that the practice was more geographically widespread than simply western Sahara. Evidence from Niger supports this; in a spatially restricted area of the Aïr Mountains, Paris (1996) recorded six monuments (approximately 3% of a

total of 190 monuments with built superstructures) that were characterised by quartz scatters. One was a crescent monument, two were simple tumuli, one was a circular platform disc with an outside wall of three layers of stones, and one a platform tumulus.

The relative rarity of quartz scatters in Saharan funerary contexts, and the diverse range of monument types with which this low-frequency use of quartz is associated, raises the possibility that this was an imported practice that was incorporated into existing funerary traditions at certain times, in certain places, and by certain groups that were not representative of the wider Saharan or western Saharan cultural complex. Where such an importation might have originated is a matter for debate but one possibility is that the practice was the result of contact with Atlantic Europe. In the region of Zag in southern Morocco, and to the northeast of Tifariti, Milburn (1974, 105) recorded a low tumulus comprised of starkly contrasting colours and materials that was 'composed of a border of whitish stones forming an enclosure, standing mostly on end, about 0.40m high; they enclose a roughly circular area ... There is a flat-packed top made with the same whitish stone.' Milburn noted nothing similar to this monument anywhere else in the region. In the region of l'Azawagh, Paris (1996, 230) recorded a crescent tumulus that used two different types of stone to achieve a difference in colour, texture and appearance; limestone slabs for the base and small quartz blocks to build up the tumulus. Sivilli (2002, 22) notes that Paris considered these to be related to groups from outside Africa introducing new cultural elements, which were then assimilated into the northeastern Niger traditions.

The use of contrasting construction materials is evident at a number of locations in the Free Zone. Typically, this takes the form of a tumulus being constructed principally from one material (usually dark fine-grained granite or basalt), with a contrasting material (typically lighter, coarse-grained granite) used to construct a 'cap' to the monument. Examples of such monuments have been recorded at Lajuad, and contrasting materials are also used in the TF1 Study Area, for example in corbeille WS038, in which they appear to define a north–south orientation.

The significance of quartz in funerary practices has a long lineage in Neolithic and Bronze Age Europe. Quartz begins to be recognised as a significant material in the construction of religious monuments in the British Isles from the Neolithic period, where it occurs in various associations with long barrows, passage graves and stone circles (Bradley 1998; Tilley 2004). Later, in the Early Bronze Age, quartz is found in association with funerary cairns. Almost all of these quartz/monument associations belong to a western 'Atlantic tradition of monument building. Indeed, it is well documented that "white materials" were preferentially selected in the British Isles ... and the role of white stones as a deliberately selected natural material, deposited and used in formal and structured ways, suggests that [it] was imbued with symbolic meaning' (Darvill 2002, 73). In this context, it is interesting to note the use of white carbonate rocks in the construction of one monument (RT3-2) in the Northern Sector of Western Sahara, and the scattering of carbonate inside a corbeille, also in the Northern Sector (LS1-3), as detailed in Chapter 4.

Darvill notes that the use of quartz has time depth. It begins in the Early Neolithic but intensifies in the later Neolithic and into the Early Bronze Age (Darvill 2002, 85). This equates to a chronological span of some 3000 years from *c.* 5000 BC to 2200 BC. It is not clear whether the meaning of use remains the same, but the context of use in ceremonial centres is largely unchanged. Indeed, the engagement of people in religious activities associated with monument building or use (burials, associated funerary rites and other religious rituals) are performances, and the funerary monuments of the Bronze Age and the performances associated with them, and also with quartz, reference the much earlier ritual and funerary monuments of the Neolithic period. This fact is extraordinary because, put simply, it means that people were aware of, and referenced in their ceremonies, the monuments and ceremonies of a much earlier age, some 2000 years distant. Quartz may have played a similar role in Western Sahara, ensuring traditions remained unchanged over centuries and millennia.

Monument locations and alignments

As mentioned in Chapters 4 and 5, many of the monuments (with and without quartz scatters) reference other monuments and/or natural features, such as prominent hills, lines of sight with the horizon, and wadi confluences. This is most evident in the construction of tumuli on prominent rocky outcrops, or antennae monuments where the longer 'arm' extends upslope, or goulets where the central corridor references features on the horizon. The most striking example of this last characteristic is the very large goulet near Tifariti (WS006) whose corridor is aligned with a prominent flat-topped hill. The silhouettes of many monuments have been enhanced by the natural topography, but the monuments also merge with and become the topography in a way that echoes the monument building of Europe in the Neolithic and Bronze Age (Bradley 1998, 122). Most strikingly, WS001, a standing stone site situated on a slight rise of compacted (fluvial) sand and gravel on the western flank of Wadi Tifariti was probably an island of dry land whenever Wadi Tifariti flooded in the past. This site also features a dense scatter of quartz chips around the bases of upright stones and amongst the stones more generally, and is in direct site line of a *c.* 75% of the tumuli and other funerary monuments situated on the ridges above it. This consideration of visibility is often combined with a choice of location at transitional points in the landscape. A second monument consisting of an assemblage of standing stones, WS0-38, is situated

west of the TF Study Area at another confluence of two wadis. Along the Wadi Ternit monuments are concentrated at a point where the wadi changes course from east–west to south–north, on both banks, where they are visible from lower elevations (an observation also made by Bokbot for monument clusters along the Wadi Draa). In the Southern Sector, where drainage systems are far less numerous than in the north, monuments are concentrated along granite ridges and basalt dykes, sometimes merging with and modifying these features (for example Aij), and in other cases situated to one side of a ridge or dyke.

Western Saharan funerary practices in regional context

The evidence provided by funerary monuments and other aspects of the archaeological record demonstrates that Western Sahara was part of the wider central and western Saharan prehistoric cultural sphere. Tumuli, bazinas and antenna-type monuments occur throughout the central and western Sahara in association with the Libyco-Berber script (Gauthier 2009), and connect the Free Zone of Western Sahara with regions further east. This link is reinforced by the (albeit limited) presence of the Libyco-Berber script in the regions examined (*e.g.* at LD0-7 and LD0-9), and as reported by literature from the colonial period (Pellicer Catalán *et al.* 1973–74). Monuments with short lines of orthostats are reminiscent of Garamantian burials in the Fezzan (Mattingly 2003); whether this indicates a cultural link or is coincidental is unknown, although the presence of chariots in the rock art of Western Sahara (Pellicer Catalán (1973–74) lends weight to this interpretation.

Goulets and complex monuments (Chapters 3, 4 and 5) appear to represent a more localised tradition restricted to the western regions of the Sahara, and there are differences between Western Sahara and the central Sahara in the construction of some types of antenna type monuments. These similarities and differences are suggestive of a funerary tradition that may have been linked with, or derived from, the central Sahara, but that later diverged from it, giving rise to specific local and regional construction traditions.

In addition to its evident links with the Saharan interior to the east, there are suggestions that Western Sahara may also have been connected with the European interaction sphere in prehistoric and later times. Until very recently, the archaeology of North Africa and the Sahara has been considered predominantly in a local context. Increasingly, however, evidence has come to light that lends support to the idea of a North African and even a Saharan outlier of a European tradition; what might be considered as the fringes of the interaction sphere. It is difficult to argue for direct connections between Western Sahara and Europe at any time in the past given their geographical remoteness from one another. However, evidence suggests that people were moving along the Atlantic littoral and sharing ideas as they travelled, for example the presence of chariot imagery in the rock art of Iberia, Morocco, Western Sahara, Mali, Mauritania, Algeria and Libya (Bradley 1998; Dupuy 2006; Mattingly 2003; Pellicer and Acosta 1972; Pellicer Catalán *et al.* 1973–1974; Ross 2010). As discussed in Chapter 4, Soler *et al.* (2006b) use the presence of halberds in the rock art of both Iberia and Western Sahara to date the rock art of the Zemmour region in the Northern Sector of the Free Zone. It is now understood that the Atlantic coast of neighbouring Morocco shared links with the European Beaker culture, for example as a result of recent finds at Khemisset near Rabat (Ballouche and Marinval 2004).

Environmental contexts and human-environment interaction

The archaeological evidence from the TF1 Study Area is consistent with our understanding of Holocene environmental change in the Sahara at large. Seasonal or semi-permanent occupation in the Early Holocene, or extended sojourns by low-level agriculturalists who also practised hunting is inferred from the evidence of worked stone and artefact scatter sites and is compatible with a humid climate that supported abundant wild fauna and flora. More transient use by pastoralists in the Middle and Late Holocene is consistent with the more arid environment that pertained throughout the Sahara in these periods.

Chapter 2 highlighted the coincidence of a date of *c.* 5800 BP for humid conditions in the south with accelerated aridity in the Sahara at large, and of a date of *c.* 4500 BP for the presence of surface freshwater in the north with the termination of humid conditions in the wider northern Saharan region. Whether or not these dates represent the termination of humid conditions in Western Sahara (Chapter 2), the date of *c.* 4500 BP indicates that surface freshwater resources were available in parts of the Northern Sector centuries after the widespread collapse of rainfall and human occupation throughout much of the Sahara *c.* 5000 BP. This part of the desert therefore may have acted as a refuge for both wild fauna and human populations after the establishment of arid conditions in many parts of the Sahara. Indeed, the arrival in a still-humid Western Sahara of pastoralists fleeing aridity in regions further east in the late 6th or early 5th millennia BP is a highly plausible scenario that is compatible with the data available to us.

In the Northern Sector, rock paintings and engravings depict species spanning the usual range of large humid climate fauna found in the Saharan rock art record, as well as some desert adapted species (Chapters 2 and 4). In the Southern Sector, the emphasis is much more on species adapted to arid and semi-arid environments, including addax, oryx and Barbary sheep. Giraffes are represented in the rock art of the Southern Sector, but in a much more

stylised fashion than in the north. Cattle are common in the rock art of both sectors, and the representations of cattle provide abundant indications of domestication.

It is possible that the representations of humid climate fauna (in the Northern Sector) may date from an earlier, wetter period than those of cattle and desert adapted species (in both sectors). Alternatively, these differences in the rock art may reflect different environmental conditions during the same period(s) in the Northern and Southern Sectors (Chapter 4). It is noted that humid climate fauna are present alongside desert adapted species and domestic cattle at northern rock art sites, meaning that the former interpretation should be treated with caution, although rock art may have been created over long periods of time at the same sites. Differences in the rock art of the Northern and Southern Sectors suggest that either (i) rock art depicting different fauna in north and south was produced by different groups, perhaps at different times, or (ii) people were mostly depicting animals that they encountered locally, and were not drawing on memories of animals they had encountered at different locations and times. The highly naturalistic way in which some species are depicted in the north also suggests direct observation.

The lithics finds in the TF1 Study Area indicate that people were carrying with them either finished tools or blanks to be shaped into tools (Chapter 7) suggesting that the human presence in this area was transient rather than permanent. Whether this applied to the entire Northern Sector is currently unclear, but it does lend some weight to the 'sojourning' scenario.

While nothing conclusive can be said about the longevity of the Holocene Humid Period in either sector on the basis of the three available dates, there are reasons to suppose that conditions may have been wetter in the north. Over the twentieth century, the highest rainfall in Western Sahara has occurred in the Zemmour region, which extends from the most northerly parts of the Southern Sector to the north and east, over the uplands in the most southerly parts of the Northern Sector. These uplands include the watersheds that house the heads of the wadis that feed the major water courses of the Northern Sector. In addition, the drainage networks of the Northern Sector are much denser than those of the south, and the more variable topography and higher relief of the north represents a more effective system for channelling and capturing runoff.

The evidence for wetter conditions in the Northern Sector provides a context for the interpretation of the stone monuments of the Free Zone. The presence of monuments similar to those in the central Sahara (crescent antennae, paved crescents and mounded crescents) in the Northern Sector, and their apparent absence or at least rarity in the Southern Sector, suggests that central Saharan influences may have arrived first in the Northern Sector. The existence of different 'western Saharan' monument styles in the Northern and Southern Sectors (*e.g.* goulets and complex monuments in the north, and ridge monuments and regular crescents in the south), including some that evidently post-date the more 'central Saharan' styles (*e.g.* complex monuments, one of which has been constricted on top of a paved crescent), indicates a process of divergent cultural evolution in the Northern and Southern Sectors that post-dates the arrival of monument building with pastoralism from or after the 5th millennium BP. Nonetheless, the meeting of these styles in the southern part of the Northern Sector suggests a zone of interaction between the cultures of the Northern and Southern Sectors.

Wetter conditions may have persisted for longer in the Northern Sector, as suggested by the depiction of large humid-climate fauna in the rock art of the Northern Sector, and the absence of these species in the rock art of the Southern Sector. Certainly, the area around Tifariti was used for monumental burials well into the historical period, as attested by the dating of two monuments in the TF1 Study Area to the early to mid-1st millennium AD. This was long after the establishment of today's arid climate throughout the Sahara, supporting the idea that Western Sahara, or at least the Northern Sector, acted as a refuge after the widespread Saharan desiccation of the Middle Holocene.

Conclusions

The work of the Western Sahara Project has demonstrated that this remote region of the Sahara Desert has been occupied and exploited for many thousands of years and that people adapted to the changing environmental conditions throughout the Pleistocene and Holocene. The importance of research in this region cannot be understated, and the fact that virtually all periods are represented in some form is crucial for filling gaps in our understanding of Saharan archaeology. The Early Holocene record is rich and varied and further work on WS100 and WS107 may offer clues to how changes in environment impacted human populations in the Early to Middle Holocene. The funerary landscapes of the Later Neolithic provide a significant body of data to add to what is already known about funerary monuments in the Central Sahara and the Sahel. The density and variety of stone monuments and the way in which the 'landscape' has been 'created' is interesting for thematic approaches to landscape studies. Further work is required however if we are to fully understand the cultural and regional development of this area of the Sahara Desert.

Note

1 Some of this may also have been practical, for example for predicting the onset of seasons, planning migrations in search of seasonal resources, and navigation.

Bibliography

Almagro Basch, M. (1945-46) Un yacimiento del Neolítico de tradición capsiense del Sahara español. *Las Sebjas de Taruma (Seguía el Hamra) Ampurias* 7–8, 69–81.

Almagro Basch, M. (1946) *Prehistoria del Norte de Africa y del Sahara Español. Consejo Superior de investigaciones científicas*, instituto de Estudios Africanos. Barcelona, Institute of Environmental Assessment and Water Research, Spanish Council for Scientific Research.

Almagro Basch, M. (1966) *Las Estelas decoradas del suroeste peninsular.* Madrid, Bibliotheca Praehistorica Hispana 8.

Amara, I. and Yass, C. (2010) Notes sur quelques structures funéraires de la région de Tindouf (Sud-sud-ouest, Algérie). *Monumental Questions: Prehistoric Megaliths, Mounds, and Enclosures*, in D. Calado, M. Baldia and M. Boulanger (eds) *Actes du 15e congrès UISPP* Vol. 8 (Lisbon, September 2006). Oxford, BAR S2123.

Arazi, N. and Manning, K. (2010) Twisted cord roulette/Roulette de cordelette torsadée, in A. Haour, K. Manning, N. Arazi, O. Gosselain, N. S. Guèye, D. Keita, A. Livingstone Smith, K. MacDonald, A. Mayor, S. McIntosh and R. Vernet (eds) *African Pottery Roulettes Past and Present: Techniques, Identification and Distribution.* Oxford, Oxbow Books.

Arcangioli, G. and Rossi, L. (1994) Monumenti preislamici scoperti nell'Erg Djourab (Ciad). *Sahara* 6, 104–108.

Armitage, S. J., Drake, N. A., Stokes, S., El-Hawat, A., Salem, M. J., White, K., Turner, P. and McLaren, S. J. (2007) Multiple phases of North African humidity recorded in lacustrine sediments from the Fazzan Basin, Libyan Sahara. *Quaternary Geochronology* 2, 181–186.

Baistrochi, M. (1987) Pre-Islamic megalithic monuments of the Northern Tadrat Acacus, in B. E. Barich (ed.) *Archaeology and Environment in the Libyan Sahara: The Excavations in the Tadrat Acacus 1978–1983*, 87–89. Oxford, BAR International Series 368.

Balbín Behrmann, R. (1975) *Contribución al estudio del Arte Rupestre del Sáhara español*, 37. Doctoral thesis, University of Madrid, Madrid.

Balbin Behrmann, R. (1977) Formas de origen Atlántico en el arte rupestre del Sahara Español. Pp. 525–534 in Crnica del XIV Congreso Arqueolgico Nacional de Vitoria 1975. Vitoria: Secretar a General.

Ballouche, A. and Marinval, P. (2004) At the origin of agriculture in the Maghreb. Palynological and carpological data on the early Neolithic of Northern Morocco. *Acts of the XIth Congress of the Panafrican Association, Bamako* 7, 74–82.

BANI (1994) Sépultures du Niger : Archives et bases de donnée. Banques de ressources scientifiques. Available at : https://www.ird.fr/bani/ (accessed 12/03/2017).

Barich, B. E. (1987) *Archaeology and Environment in the Libyan Sahara. The Excavations in the Tadrart Acacus, 1978–1983.* Cambridge Monographs in African Archaeology 23. Oxford, BAR International Series 368.

Barich, B.E. (2014) Northwest Libya from the early to late Holocene: New data on environment and subsistence from the Jebel Gharbi. *Quaternary International* 320, 15–27.

Bedaux, R. M. A. and Rowlands, M. (2001) The future of Mali's past. *Antiquity* 75, 872–876.

Behar, D. M., Villems, R., Soodyall, H., Blue-Smith, J., Pereira, L., Metspalu, E., Rosaria Scozzari, R., *et al.* (2008) The dawn of human matrilineal diversity. *The American Journal of Human Genetics* 82/5, 1130–1140.

Belmonte, J. A., Esteban, C., Cuesta, L. Perera Betancort, M. A. and Jiménez González, J. J. (1999) Pre-Islamic burial monuments in northern and Saharan Morocco. *Archaeoastronomy* 24 (supplement), S22–S34.

Bokbot, Y., 2003. Tumuli protohistoriques du Présahara Marocain: indices des minorités religieuses?. In *Actes du VIIIe Colloque International sur l'histoire et archéologie de l'Afrique du Nord* (pp. 35–45).

Bokbot, Y. (2008) Le cromlech de Mzora, témoin du mégalithisme ou symbole de gigantisme de pouvoir? *Le Jardin de Hespérides. Revue de la Société Marocaine d'Archaéologie et du Patrimone* 4, 25–29.

Bokbot, Y., and Ben-Nçer, A. (2006) Découvertes campaniformes récentes dans les plateaux de Zemmour (Maroc), in *Bell Beaker in everyday life, Proceedings of the 10th Meeting Archéologie et Gobelets,* 327–330. Florence–Siena–Villanuova sul Clisi.

Bokbot, Y., Onrubla-Pintado, J., and Salih, A. (2011) Néolithique et protohistoire dans le bassin de l'Oued Noun (Maroc Présaharien), in *Actes du Premier Colloque de Préhistoire Maghrebine. Tamanrasset le 5, 6, et 7 novembre 2007, Tome II,* 306–321. Tamanrasset' Ministère de la Culture. Centre National de Recherches Préhistoriques Anthropologiques et Historiques.

Bond, G., Showers, W., Cheseby, M., Lotti, R., Almasi, P., deMenocal, P., Priore, P., Cullen, H., Hajdas, I. and Bonani, G. (1997) A pervasive millennial-scale cycle in North Atlantic Holocene and glacial cycles. *Science* 278, 1257–1266.

Botigué, L. R., Henn, B. M., Gravel, S., Maples, B. K., Gignoux, C. R., Corona, E., Atzmon, G., *et al.* (2013) Gene flow from North Africa contributes to differential human genetic diversity in southern Europe. *Proceedings of the National Academy of Sciences* 110/29, 11791–11796.

Bouimetarhan, I., Dupont, L., Schefuß, E., Mollenhauer, G., Mulitza, S. and Zonneveld, K. (2009) Palynological evidence for climatic and oceanic variability off NW Africa during the late Holocene. *Quaternary Research* 72, 188–197.

Braconnot, P., Joussaume, S., Noblet, N. D. and Ramstein, G. (2000) Mid-Holocene and Last Glacial Maximum African monsoon changes as simulated within the Paleoclimate Modelling Intercomparison Project. *Global and Planetary Change* 26, 51–66.

Bradley, R. (1998a) *The Significance of Monuments: On the Shaping of Human Experience in Neolithic and Bronze Age Europe.* London, Routledge.

Bradley, R. (1998b) Daggers drawn: depictions of Bronze Age weapons in atlantic Europe, in P. S. C. Taçon and C. Chippindale (eds) *The Archaeology of Rock Art*, 103–145. Cambridge, Cambridge University Press.

Bradley, R. (2007) *The Prehistory of Britain and Ireland.* Cambridge World Archaeology series. Cambridge, Cambridge University Press.

Brass, M. (2007) Reconsidering the emergence of social complexity in early Saharan pastoral societies, 5000–2500 BC. *Sahara* 18, 7–22.

Breuil, H. (1930) Premières impressions de voyage sur la préhistoire sud-africaine. *L'Anthropologie.* Paris, t. XL, 209–223.

Brooks, N. (2005) Cultural heritage and conflict: The threatened archaeology of Western Sahara. *The Journal of North African Studies* 304, 413–439.

Brooks, N. (2006) Cultural responses to aridity and increased social complexity in the Middle Holocene. *Quaternary International* 151, 29–49.

Brooks, N. (2010) Human responses to climatically-driven landscape change and resource scarcity: Learning from the past and planning for the future, in I. P. Martini and W. Chesworth (eds) *Landscapes and Societies: Selected Cases*, 43–66. London, Springer.

Brooks, N., Clarke, J., Crisp, J., Crivellaro, F., Jousse, H., Markiewicz, E., Nichol, M., Raffin, M., Robinson, R., Wasse, A. and Winton, V. (2006) Funerary sites in the 'Free Zone': Report on the second and third seasons of fieldwork of the Western Sahara Project. *Sahara* 17, 73–94.

Brooks, N., Clarke, J., Garfi, S. and Pirie, A. (2009) The archaeology of Western Sahara. Results of environmental and archaeological reconnaissance. *Antiquity* 83, 918–934.

Brooks, N., di Lernia, S. Drake, N. Raffin, M. and Savage, T. (2003) The geoarchaeology of Western Sahara. Preliminary results of the first Anglo-Italian expedition in the 'Free Zone'. *Sahara* 14, 63–79.

Brooks, N., di Lernia, S., Drake, N., Chiapello, I., Legrand, M., Moulin, C. and Prospero, J. (2005) The environment-society nexus in the Sahara from prehistoric times to the present day. *The Journal of North African Studies* 304, 253–292.

Camps, G. (1986) Funerary monuments with attached chapels from the northern Sahara. *The African Archaeological Review* 4, 151–164.

Camps-Fabrer, T. (1966) *Mahére et Art Mobilier dans la Préhistoire nord-Africaine.* Paris, Arts and Méhers Graphiques.

Castelli, R., Cremaschi, M. Gatto, M. C., Liverani, M. and Mori, L. (2005) A preliminary report of excavations in Fewet, Libyan Sahara. *Journal of African Archaeology* 3/1, 69–102.

Cèsar Carreras, C. and Morais, R. (2012) The Atlantic Roman Trade during the Principate: New Evidence from the Western Façade. *Oxford Journal of Archaeology* 31, 419–441.

Chaix J. (1989) Le monde animal à Kerma, *Sahara* 1, 77–84.

Childs, S. T. and Killick, D. (1993) Indigenous African metallurgy: nature and culture. *Annual Reviews of Anthropology* 22, 317–337.

Clark, J., Williams, M. and Smith, A. (1973) The geomorphology and archaeology of Adrar Bous, Central Sahara: a preliminary report. *Quaternaria* 17, 245–297.

Clarke, J. and Brooks, N. (forthcoming) The burial monuments, in D. Mattingly and M.C. Gatto (eds) *Trans-Saharans: Human Mobility and Identity, Trade, State Formation and Mobile Technologies across the Sahara (1000 BC–AD 1500),* Volume 1. Cambridge, Cambridge University Press.

Cooke, I. M. (1996) Journey to the Stones, Mermaid to Merrymaid: Nine Walks to Ancient Sites in the Land's End Peninsula, Cornwall. Creed Books.

Cremaschi, M. (2002) Late Pleistocene and Holocene climatic changes in the central Sahara. The case study of the southwestern Fezzan, Libya, in F. A. Hassan (ed.) *Droughts, Food and Culture: Ecological Change and Food Security in Africa's Later Prehistory*, 65–-81. New York, Kluwer.

Cremaschi, M., and di Lernia, S. D (1998) *Wadi Teshuinat Palaeoenvironment and Prehistory in South-Western Fezzan (Libyan Sahara): Survey and Excavations in the Tadrart Acacus, Erg Uan Kasa, Messak Settafet and Edeyen of Murzuq, 1990–1995.* Insegna del Giglio, C.N.R.

Cremaschi, M, and di Lernia, S. D. (1999) Holocene Climatic Changes and Cultural Dynamics in the Libyan Sahara. *Journal of African Archaeology* 16/4, 211–238.

Cremaschi, M., Pelfini, M and Santilli, M. (2006) Dendroclimatology of *Cypressus dupreziana*: Late Holocene climatic changes in the central Sahara, in D. Mattingly, S. Mclaren, E. Savage, Y. al-Fasatwi and K. Gadgood, K. (eds) *Environment, Climate and Resources of the Libyan Sahara.* London, Society of Libyan Studies, 145–156.

Cremaschi, M. and Zerboni, A. (2009) Early to Middle Holocene landscape exploitation in a drying environment: Two case studies compared from the central Sahara (SW Fezzan, Libya). *Comptes Rendus Geoscience* 341/8–9, 689–702.

Damnati, B. (2000). Holocene lake records in the Northern Hemisphere of Africa. *Journal of African Earth Sciences* 31/2, 253–62.

Darvill, T. (2000) *Billown Neolithic Landscape Project, Isle of Man. Fifth Report, 1999.* School of Conservation Science, Research Report 7, Bournemouth and Douglas, Bournemouth University and Manx National Heritage.

Darvill, T. (2002) White on blonde: quartz pebbles and the use of quartz at Neolithic monuments in the Isle of Man and beyond, in Andrew Jones and Gavin MacGregor (eds) *Colouring the Past: The Significance of Colour in Archaeological Research* 73–93. London, Berg.

Delibrias, G., Ortlieb, L. and Petit-Maire, N. (1976) New C 14 data for the Atlantic Sahara (Holocene): tentative interpretations. *Journal of Human Evolution* 5, 535–546.

deMenocal, P., Ortiz, J., Guilderson, T., Sarnthein, M. (2000a) Coherent high- and low-latitude climate variability during the Holocene Warm Period. *Science* 288/5474, 2198–2202.

deMenocal, P., J. Ortiz, T. Guilderson, J. Adkins, M. Sarnthein, L. Baker and Yarusinsky, M. (2000b) Abrupt onset and termination of the African Humid Period: rapid climate responses to gradual insolation forcing. *Quaternary Science Reviews* 19, 347–61.

di Lernia, S. (1999a) *The Uan Afuda Cave Hunter-Gatherer Societies of Central Sahara.* Arid Zone Archaeology Monographs 1. Firenze, Edizioni All'Insegna del Giglio.

di Lernia, S. (1999b) The cultural sequence, in S. di Lernia (ed.) *The Uan Afuda Cave: Hunter-Gatherer Societies of Central Sahara*, 57–130. Arid Zone Archaeology Monographs 1. Firenze, Edizioni All'Insegna del Giglio.

di Lernia, S. (2002) Dry climatic events and cultural trajectories: adjusting Middle Holocene pastoral economy of the Libyan Sahara, in. F. A. Hassan (ed.) *Droughts, Food and Culture: Ecological Change and Food Security in Africa's Later Prehistory*, 225–250. New York, Kluwer.

di Lernia, S. (2006) Building monuments, creating identity: Cattle cult as a social response to rapid environmental changes in the Holocene Sahara. *Quaternary International* 151, 50–62.

di Lernia, S. (2013a) Places, monuments and landscapes: evidence from the Holocene central Sahara. *Azania: Archaeological Research in Africa* 48/2, 173–192.

di Lernia, S. (2013b) The emergence and spread of herding in Northern Africa: A critical reappraisal, in P. Mitchell and P. J. Lane (eds) *The Oxford Handbook of African Archaeology* (online). DOI: 10.1093/oxfordhb/9780199569885.013.0036.

di Lernia, S. and Gallinaro, M. (2010) The date and context of Neolithic rock art in the Sahara: engravings and ceremonial monuments from Messak Settafet (south-west Libya). *Antiquity* 85, 954–975.

di Lernia, S. and Manzi, G. eds., 2002. *Sand, Stones, and Bones. The Archaeology of Death in The Wadi Tanezzuft Valley (5000–2000 bp), The Archaeology of Libyan Sahara Volume I* (Vol. 3). All'Insegna del Giglio. Centro Interuniversitario di Ricerca per le Civilta` e l'Ambiente del Sahara Antico e Delle Zone Aride, Universita` Degli Studi di Roma and Department of Antiquities, Libya.

di Lernia, S., Bertolani, G. B., Castelli, R., Merighi, F. and Palombini, A. (2002a) A regional perspective: the surveys, in S. di Lernia, S. and G. Manzi (eds) *Sand, Stones and Bones: The Archaeology of Death in the Wadi Tannezuft Valley (5000–2000 BP)*, 25–68. Arid Zone Archaeology Monographs 3. Firenze, All'Insegna del Giglio.

di Lernia, S., Manzi, G. and Merighi, F. (2002b) Cultural variability and human trajectories in the later prehistory of the Wadi Tannezzuft, in S. di Lernia and G. Manzi (eds) *Sand, Stones and Bones: The Archaeology of Death in the Wadi Tannezzuft Valley (5000–2000 BP)*, 281–302. Arid Zone Archaeology Monographs 3. Firenze, All'Insegna del Giglio.

di Lernia, S., Merighi, F., Ricci, F. and Sivilli, S. (2002c) From regions to sites: the excavations, in S. di Lernia and G. Manzi (eds), *Sand, Stones and Bones: The Archaeology of Death in the Wadi Tannezuft Valley (5000–2000 BP)*, 69–156. Arid Zone Archaeology Monographs 3. Firenze, All'Insegna del Giglio.

di Lernia, S. and Tafuri, M. A. (2013) Persistent deathplaces and mobile landmarks: The Holocene mortuary and isotopic record from Wadi Takarkori (SW Libya). *Journal of Anthropological Archaeology* 32, 1–15.

di Lernia, S., Tafuri, M. A., Gallinaro, M., Alhaique, F., Balasse, M., Cavorsi, L., Fullagar, P. D., Mercuri, A. M., Monaco, A., Perego, A., Zerboni, A. (2013) Inside the 'African Cattle Complex': animal burials in the Holocene central Sahara. *PLOS one* 8, e56879.

Drake, N. A., White, K. H. and McLaren, S. (2006) Quaternary climate change in the Germa region of the Fezzan, Libya, in D. Mattingly, S. Mclaren, E. Savage, Y. al-Fasatwi and K. Gadgood (eds) *Environment, Climate and Resources of the Libyan Sahara*, 133–144. London, Society of Libyan Studies.

Dubief, J. (1953) *Essai sur l'hydrologie superficielle au Sahara.* Clairbois Birmandreis, Gouvernment général de l'Algérie, Direction du service de la colonisation et de l'hydraulique, Service des études scientifiques.

Dupuy, C. (2006) L'Adrar des Iforas (Mali) à l'époque des chars: art, religion, rapports sociaux et relations à grande distance. *Sahara* 17, 29–50.

Dykoski, C. A., Edwards, R. L., Cheng, H., Yuan, D. X., Cai, Y. J., Zhang, M. L., Lin, Y. S., Qing, J. M., An, Z. S. and Revenaugh, J. (2005) A high-resolution, absolute-dated Holocene and deglacial Asian monsoon record from Dongge Cave, China. *Earth and Planetary Science Letters* 233, 71–86.

Ehrenreich, S. and Fuchs, G. (2012) Archaeological investigation of a 'Goulet' (site no. 338) in the Wadi Tifariti, Western Sahara. Excavation report. Available at: http://milburn-stiftung.org/wp-content/uploads/2012/02/2012_04_01_Wadi_Tifariti_english.pdf (accessed 20/03/2017).

Elsheikh, A., Abdelsalam, M. G. and Mickus, K. (2011) Geology and geophysics of the West Nubian Paleolake and the Northern Darfur Megalake (WNPL–NDML): Implication for groundwater resources in Darfur, northwestern Sudan. *Journal of African Earth Sciences* 61/1, 82–93.

Escolà Pujol, J. (2003) Iconografía del Abrigo Grande de Rkeiz, Sahara Occidental. *Almogaren* XXXIV. Vienna, Institutum Canarium, 171-223.

Estes, R. D. (1991) *The Behaviour Guide to African Mammals.* California, University of California Press.

Faleschini, G. (1995) Le tombe solari, *Sahara* 7, 109–112.

Faleschini, G. (1997) Monumento preislamico nel Messak Settafet (Libia). *Sahara* 9, 148–149.

Faleschini, G. (1999) Un 'menhir' nel Sahara, *Sahara* 10, 133–134.

Farrujia de la Rosa, A. J. and Garcia Marin, S. (2008) The rock art site of Risco Blanco (Tenerife, Canary Islands) and the Saharan horsemen cycle. *Sahara* 18, 69–84.

Farrujia de la Rosa, A. J., Pichler, W., Rodrigue, A. and García Marín, S. (2010) The Libyco–Berber and Latino–Canarian Scripts and the Colonization of the Canary Islands. *African Archaeological Review* 27, 13-41.

Ferhat N., Striedter K. and Tauveron M. (1996) Un cimetière de boeufs dans le Sahara central: la nécropole de Mankhor, in *La Préhistoire de l'Afrique de l'Ouest*, 103–107. Saint Maure, Editions Sépia.

Fiddian-Qasmiyeh, E. (2009) Representing Sahrawi Refugees' 'Educational Displacement' to Cuba: Self-sufficient Agents or Manipulated Victims in Conflict? *Journal of Refugee Studies* 22/3, 323–350.

Flohn, H. (1975) Tropische Zirkulationsformen im Lichte der Satellitenaufnahmen. *Bonner Meteor. Abh.*, 21.

Foureau, F. (1903) *Documents scientifiques de la Mission Foureau-Lamy*, Paris, Masson, 2 T + Atlas, publication de la Société de Géographie.

Gandini, J. (2002) *Pistes du Maroc, tome 3: Le Sahara, de l'oued Draa à la Seguiet el Hamra, à travers l'Histoire, Extrême Sud Ed.* Serre Editeur Calvison.

Garcea, E. A. A. (1998) From early Khartoum to the Saharan Neolithic, ceramics in Comparison, in *Actes de la VIII Conférence internationale des Études nubiennes, III Études Cahiers de Recherches de l'Institut de Papyrologie de l'Éqyptologie de Lille* 17, 91–104.

Garcea, E. A. A. (1999) Aterian and 'Early' and 'Late Acacus' from the Uan Tabu rock shelter, Tadrart acacus (Libyan Sahara), in Cremaschi, M. and Di Lernia, S., 1998. *Wadi Teshuinat palaeoenvironment and prehistory in South-Western Fezzan (Libyan Sahara): survey and excavations in the Tadrart Acacus, Erg Uan Kasa, Messak Settafet and Edeyen of Murzuq, 1990–1995.* Insegna del Giglio: CNR. Quaderni de Geodinamica Alpina e Quaternaria, Milano, Edizioni All' Insegna de Giglio.

Garcea, E. A. A. (2008) The ceramics from Adrar Bous and surroundings, in J. Desmond Clark (ed.) *Adrar Bous Archaeology of a Central Saharan Granitic Ring Complex in Niger.* Belgium, Royal Museum for Central Africa, Tervuren.

Garcea, E. A. A. and Sebastiani, R. (1998) Middle and Late Pastoral Neolithic from the Uan Telocat rockshelter, Tadrart Acacus (Libyan Sahara), in M. Cremaschi and S. di Lernia (eds) *Wadi Teshuinat Palaeoenvironment and Prehistory in South-Western Fezzan (Libyan Sahara). Survey and Excavations in the Tadrart Acacus, Erg Uan Kasa, Messak Settafet and Edeyen of Murzuq 1990–1995*, 201–216. Milan, Consiglio Nazionale Delle Ricerche Quaderni de Geodinamica Alpina e Quaternaria, Milano: Edizioni All' Insegna de Giglio.

Garfi, S. (2014) An Archaeology of Colonialism, Conflict, and Exclusion: Conflict Landscapes of Western Sahara. Doctoral thesis, University of East Anglia.

Gasse, F. (2000) Hydrological changes in the African tropics since the Last Glacial Maximum. *Quaternary Science Reviews* 19, 189–211.

Gasse, F. (2002) Diatom-inferred salinity and carbonate oxygen isotopes in Holocene waterbodies of the western Sahara and Sahel (Africa). *Quaternary Science Reviews* 21, 737–767.

Gasse, F. and Van Campo, E. (1994) Abrupt post-glacial climate events in West Asia and North Africa monsoon domains. *Earth and Planetary Science Letters* 126, 435–456.

Gatto, M. (2005) The local pottery, in M. Liverani (ed.) *Aghram Nadharif – The Barkat oasis (Sha'abiya of Ghat, Libyan Sahara) in Garamantian Times*, 201–240. Arid Zone Archaeology Monographs 4. Firenze, All'insegna del giglio.

Gatto, M. C. (2010) The Garamantes of the Fazzan: imported pottery and local productions. *Bollettino di Archeologia On Line.* Direzione Generale per le Antichatà. Roma 2008 – International Congress of Classical Archaeology. Meetings between Cultures in the Ancient Mediterranean. Available at http://www.bollettinodiarcheologiaonline.beniculturali.it/documenti/generale/3_GATTO.pdf (accessed 11/03/2017).

Gatto, M. C. (2013) Ceramics from Fewet, in L. Mori (ed.) *Life and Death of a Rurual Village in Garamantian Times*, 79–92. Arid Zone Archaeology Monographs 6. Rome and Tripoli, Sapienza Università di Roma and Department of Antiquities, Tripoli, Libya.

Gatto, M. C. (2018) Identity markers in the SW Fezzan. Were the people of the Tanezuft/Acacus region Garamantes? In D. Mattingly and M.C. Gatto (eds) *Trans-Saharans: Human Mobility and Identity, Trade, State Formation and Mobile Technologies across the Sahara (1000 BC–AD 1500)*, Volume 1. Cambridge, Cambridge University Press.

Gautier, A. (1987) Prehistorique men and cattle in North Africa: a dearth of data and a surfeit of models, in A. E. Close (ed.) *Prehistory of Arid North Africa. Essays in Honor of Fred Wendorf.* 163–187. Dallas, Southern Methodist University.

Gauthier, Y. (2009) Orientation and distribution of various drystone monuments of the Sahara, in J. A. Rubiño-Martín, J. A. Belmonte, F. Prada and A. Alberdi (eds) *Cosmology Across Cultures*, 317–330. Spanish Institutes of Astrophysics of the Canaries and Andalucía, European Society for Astronomy in Culture (SEAC). ASP Conference Series 409.

Gauthier, Y. (2015) Pre-Islamic dry-stone monuments of the central and western Sahara, in C. L. N. Ruggles (ed.) *Handbook of Archaeoastronomy and Ethnoastronomy*, 1059–1077. New York, Springer.

Gauthier, Y. and Gauthier, C. (1998) Quelques monuments du Messak (Fezzân, Libye). *Sahara* 10, 134–136.

Gauthier, Y. and Gauthier, C. (2000) Orientation et distribution de divers types de monuments lithiques du Messak et des régions voisines (Fezzân, Libye), *Sahara* 11, 87–108.

Gauthier, Y. and Gauthier, C. (2002) Monuments à antenne en L ou apparentés – une originalité du Fezzân? Architecture, orientation et distribution. *Sahara* 13, 136–147.

Gauthier, Y. and Gauthier, C. (2003a) Orientation of some dry stone monuments: 'V shape' monuments and 'goulets' of the Immidir Mountains (Algeria), in *Calendars, Symbols, and Orientations: Legacies of Astronomy in Culture. Proceedings of the 9th Annual Meeting of the European Society for Astronomy in Culture (SEAC), Stockholm, 27–30 August 2001.* Uppsala Astronomical Observatory Report No. 59, Uppsala University.

Gauthier, Y. and Gauthier, C. (2003b) Chronologie relative de trois types de monuments l'Immidir: monuments à antennes en 'V', goulet et monuments en trou de serrure. *Sahara* 14, 155–161.

Gauthier, Y. and Gauthier, C. (2004) Un exemple de relation monuments - art rupestre: monuments en corbeilles et grands cercles de pierres du Messak (Libye). *Les Cahiers de l'AARS* 9, 45–62.

Gauthier, Y. and Gauthier, C. (2005) Monuments à alignement du Sahara occidental et leur place dans le contexte saharien. *Almogaren* XXXVI, 147–190.

Gauthier, Y, and Gauthier, C. (2006) Monuments en trou de serrure et art rupestre, in Y. Gauthier, J. L. Le Quellec and R. Simonis (eds) *Hic sunt leones, Mélanges sahariens en l'honneur d'Alfred Muzzolini. Les Cahiers de l'AARS* 10, 79–110.

Gauthier, Y. and Gauthier, C. (2007) Monuments funéraires sahariens et aires culturelles. *Les Cahiers de l'AARS* 11, 65–78.

Gauthier, Y. and Gauthier, C. (2008a) À propos des Monuments À Alignements du Sahara. *Almogaren* XXXIX, 27–88.

Gauthier, Y. and Gauthier, C. (2008b) Monuments en *trou de serrure*, monuments à *alignement*, monuments en 'V' et *croissants:* contribution à l'étude des populations sahariennes. *Cahiers de l'AARS* 12, 1–20.

Gauthier Y. and Gauthier, C., (2011) Note de lecture sur 'Le peuplement protohistorique du Sahara central par A. Heddouche, in Racines. Patrimoine - Gestion - Interprétation. Revue annuelle de l'Office du Parc National du Tassili. Numéro 1, décembre 2009'. *Les Cahiers de l'AARS* 15, 330–338.

Gauthier, Y., Gauthier, C., Nöther, W. and Lluch, P. (1997) Monuments de l'Immidir (Algérie). *Sahara* 9, 143–148.

Gautier E. F. (1908) *Sahara Algérien*. Paris, Armand Colin.

Gifford-Gonzalez, D. and Hanotte, O. (2011) Domesticating animals in Africa: implications of genetic and archaeological findings. *Journal of World Prehistory* 24, 1–23.

Gobin, Sgt Chef, (1937) Notes sur les vestiges des tombes du Zemmour, *Bulletin du Comité des Etudes historiques et Scientifiques de l'Afrique Occidental, Française* XX, 142–146.

Gonçalves, R., Freitas, A., Branco, M., Rosa, A., Ana T. Fernandes, A. T., Lev, A., T., Zhivotovsky, A., Underhill, P. A., Kivisild, T. and Brehm, A. (2005) Y-chromosome Lineages from Portugal, Madeira and Açores Record Elements of Sephardim and Berber Ancestry. *Annals of Human Genetics* 69/4, 443–454.

Grébénart, D. (1985) *La Région d'in Gall-Tegidda n Tesemt (Niger). Programme Archéologique d'Urgence 1977–1981. II Le Néolithique Final et les Débuts de la Métallurgie*. Niamey, Institut de Recherches en Sciences Humaines.

Grébénart, D. (1988) *Les premiers metallurgists en Afrique occidentale*. Paris, Errance NEA.

Guagnin, M. (2015) Animal engravings in the central Sahara: A proxy of a proxy. *Environmental Archaeology* 20/1, 52–65.

Guo, Z., Petit-Maire, N., and Kröpelin, S. (2000) Holocene non-orbital climatic events in present-day arid areas of northern Africa and China. *Global and Planetary Change* 26, 97–103.

Haour, A. (2003) One hundred years of archaeology in Niger. *Journal of World Prehistory* 17/2, 181–234.

Haour, A., Manning, K., Arazi, N. and Gosselain, O., 2010. *African pottery roulettes past and present: Techniques, identification and distribution*. Oxford: Oxbow Books.

Harrison, R. (2004) *Symbols and Warriors: Images of the European Bronze Age*. Bristol, Western Academic and Specialist Press Ltd.

Hassan, F. A. (2002) *Droughts, Food and Culture. Ecological Change and Food Security in Africa's Later Prehistory*. New York, Plenum Publishers.

Heiko Riemer, H., Kröpelin, S. and Zboray, A. 2017. Climate, styles and archaeology: an integral approach towards an absolute chronology of the rock art in the Libyan Desert (Eastern Sahara). *Antiquity* 91, 7–23.

Henderson, J. C. (2007) *The Atlantic Iron Age: Settlement and Identity in the First Melennium BC*. London, Routledge.

Hill, A. G. (1989) Demographic responses to food shortages in the Sahel. *Population and Development Review* 15, Supplement: Rural Development and Population: Institutions and Policy, 168–192.

Hodder, I. (2003) Archaeological reflexivity and the 'local' voice. *Anthropological Quarterly* 76/1, 55–69.

Hoffmann, M. A., Hamroush, H. A. and Allen, R. O. (1986) A model of urban development for the Hierakonpolis region from predynastic through Old Kingdon times. *Journal of the American Research Center in Egypt* 23, 175–187.

Holdaway, S., Wendrich, W. and Phillipps, R. (2010) Identifying low-level food producers: detecting mobility from lithics. *Antiquity* 84, 185–194.

Holl, A. (1988) *Économie et Société Néolithique du Dhar Tichitt (Mauritanie)*. Paris, Éditions Recherche sur les Civilisations.

Holl, A. (1997) Metallurgy, iron technology and African Late Holocene societies, in R. Klein-Arendt (ed.) *Traditionelles Eisenhandwerk in Afrika*, 13–54. Cologne, Colloquium Africanum 3.

Hooghiemstra, H., Lézine, A. M., Leroy, S. A., Dupont, L., and Marret, F. (2006) Late Quaternary palynology in marine sediments: A synthesis of the understanding of pollen distribution patterns in the NW African setting. *Quaternary International* 148/1, 29–44.

Honeychurch, W. (2014) Alternative complexities: The archaeology of pastoral nomadic states. *Journal of Archaeological Research* 22/4, 277–326.

Hoskin, M. and Aparicio, Carme Sauch, I. (1999) Studies in Iberian archaeoastronomy: orientations of megalithic tombs of Badajoz and neighbouring Portugal. *Archaeoastronomy* 23 (supplement), S35–S40.

Hugot, H. J. (1963) *Recherches Préhistoriques dans l'Ahaggar Nord-Occidental 1950–1957*. Mémoires du Centre de Recherches Anthropologiques Préhistoriques et Ethnographiques I. Paris, Arts et Métiers Graphiques.

Huysecom, E. (1987) *Die archäologische Forschung in Westafrica*. Materialen zur Allgemeinen und Vergleichenden Archäologie, 33, C. H. Beck, München, 2 vols., 851 + 307 p.

Huysecom, E., Boëda, E., Deforce, K., Doutrelepont, H., Downing, A., Fedoroff, N., Konaté, D., Mayor, A., Ozainne, S., Raeli, F., Robert, A., Soriano, S., Sow O and Stokes, S. (2001) Ounjougou (Mali): quatrième campagne de recherches dans le cadre du programme international "Paléoenvironnement et peuplement humain en Afrique de l'Ouest", in Jahresbericht SLSA 2000, 105–50. Zürich et Vaduz, Fondation Suisse Liechtenstein pour les recherches archéologiques à l'étranger.

Idé, O. A. (2000) *Prehistoire dans la vallée de la Mékrou (Niger méridonal)*. Niamey, Insitut de Recherches en Sciences humaines, CRIAA.

Jodin, A. (1957) Les problèmes de la civilisation du vase campaniforme au Maroc. *Hespéris* 44, 353–360.

Jolly, D., Prentice, I. C., Bonnefille, R., Ballouche, A., Bengo, M. (1998) Biome reconstruction from pollen and plant macrofossil data for Africa and the Arabian peninsula at 0 and 6000 years. *Journal of Biogeography* 25, 1007–1027.

Jones, A. and MacGregor, G. (2002) *Colouring the Past: The Significance of Colour in Archaeological Research*. London, Berg.

Jousse, H. (2004) A new contribution to the history of pastoralism in West Africa. *Journal of African Archaeology* 2, 187–201.

Joussaume, R. (1988) *Dolmens for the Dead: Megalith Building Throughout the World*. New York Hachette, Cornell University Press.

Jung, S. J. A., Davies, G. R., Ganssen, G. M. and Kroon, D. (2004) Stepwise Holocene aridification in NE Africa deduced from dust-borne radiogenic isotopes. *Earth and Planetary Science Letters* 221, 27–37.

Keenan, J., 2000. The theft of Saharan rock-art. *Antiquity* 74/284, 287–288.

Keenan, J. (2005) Looting the Sahara: The material, intellectual and social implications of the destruction of cultural heritage (briefing). *The Journal of North African Studies* 10, 471–489.

Kilian C. (1925) Au Hoggar. Mission de 1922. *Société d'éditions géographiques maritimes et coloniales*, Paris.

Kocurek, G. and Lancaster, N. (1999) Aeolian system sediment state: theory and Mojave Desert Kelso dune field example. *Sedimentology* 46, 505–515.

Konaté, D. (2000) *Éléments d'archéologie oust-Africaine II: Mali*. Nouakchott, CRIAA.

Kröpelin, S. (2007) Wadi Howar: Climate change and human occupation in the Sudanese desert during the past 11,000 years, in P. G. Hopkins (ed.) *Kenana Handbook of Sudan*, 17–38. London, Kegan Paul.

Kröpelin S., Verschuren, D., Lézine, A. -M., Eggermont, H., Cocquyt, C., Francus, P., Cazet, J.-P., Fagot, M., Rumes, B., Russell, J. M., Darius, F., Conley, D. J., Schuster, M., Suchodoletz, H. V., Engstrom, D. R. (2008) Climate-Driven Ecosystem Succession in the Sahara: The Past 6000 Years. *Science* 320, 765–768.

Kuhlmann, H. (2003) *Reconstruction of the sedimentary history offshore NW Africa: Application of core-logging tools*. Deutsche-digitale-bibliothek, Universität Bremen.

Kuper, R., and Kröpelin, S. (2006) Climate-Controlled Holocene Occupation in the Sahara: Motor of Africa's Evolution. *Science* 313, 803–807.

Lancaster, N., Kocurek, G., Singvi, A., Pandey, V., Meynoux, M. M., Ghienne, J. -F. and Lö, K. (2002) Late Pleistocene and Holocene dune activity and wind regimes in the western Sahara Desert of Mauritania. *Geology* 30, 991–994.

Lavachery, P. (1996) Shum Laka rock shelter late Holocene deposits: from stone to metal (north western Cameroon), in G. Pwiti and R. Soper (eds) *Aspects of African Archaeology*, 266–274. Papers from the 10th PanAfrican Association for Prehistory and Related Studies Congress, Harare, University of Zimbawe Publication.

Leblanc, M. J., Leduc, C., Stagnitti, F., *et al.* (2006) Evidence for Megalake Chad, north-central Africa, during the late Quaternary from satellite data. *Palaeogeography, Palaeoclimatology, Palaeoecology* 230, 230–242.

Le Quellec, J.-L. (1990) Deux idebnan en forme de V du Shati (Fezzan septentrional), *Sahara* 3, 105–106.

Lézine, A.-M. (2009) Timing of vegetation changes at the end of the Holocene Humid Period in desert areas at the northern edge of the Atlantic and Indian monsoon systems. *Comptes Rendus Geoscience* 341/8–9, 750–759.

Lézine, A.-M., Zheng, W., Braconnot, P., Krinner, G. (2011) Late Holocene plant and climate evolution at Lake Yoa, northern Chad: pollen data and climate simulations. *Climate of the Past* 7, 1351–1362.

Lhote, H. (1980) Quelques rites prophylactiquee et propitiatoires chez les populations du Sahara. *Notes Africaines* 165, 9–14.

Li, S., Robinson, W. A., and Peng, S. (2003) Influence of the North Atlantic SST tripole on northwest African rainfall. *Journal of Geophysical Research* 108/D19), 1–16.

Lihoreau, H. (1993) *Djorf Torba. Nécropole saharienne antéislamique*. Paris, Karthala.

Linstädter, J. and Kröpelin, S. (2004) Wadi Bakht revisited: Holocene climate change and prehistoric occupation in the Gilf Kebir region of the Eastern Sahara, SW Egypt. *Geoarchaeology* 19, 735–777.

Livingstone Smith, A. (2007) Histoire du décor à la roulette en Afrique sub-saharienne. *Journal of African Archaeology* 5/2, 189–216.

Lubell, D. (2001) Late Pleistocene-Early Holocene Maghreb, in P. N. Peregrine and M. Ember (eds) *Encyclopedia of Prehistory V1: Africa*, 129–149. New York, Kluwer Academic and Plenum Publishers.

Liu, T. and Broecker, W. (2000) How fast does rock varnish grow? *Geology* 28, 183–186.

Macaulay, Vincent, Catherine Hill, Alessandro Achilli, Chiara Rengo, Douglas Clarke, William Meehan, James Blackburn *et al.* (2005) Single, rapid coastal settlement of Asia revealed by analysis of complete mitochondrial genomes. *Science* 308/5724, 1034–1036.

MacDonald, K. C. (1997) Kourounkorokale revisited: the pays Mande and the West African microlithic technocomplex. *African Archaeological Review* 14/3, 143–160.

MacDonald, K. C. (2010) The stone arm ring and related polished stone industries of Hombori (Mali), in P. Allsworth-Jones (ed.) *West African Archaeology: New Developments, New Perspectives*, 117–126. Oxford, BAR International Series 2164.

MacGregor, G. (2002) Making monuments out of mountains: the role of colour and texture in the constitution of meaning and identity at recumbent stone circles, in A. Jones and G. MacGregor (eds) *Colouring the Past: The Significance of Colour in Archaeological Research*, 141–150. London, Berg.

Martínez Santa-Olalla, J. (1941a) Los primeros grabados rupestres del Sahara Español, in *Antlantis, Actas y Memorias de la Sociedad Española de Antropología, Etnografía y Prehistoria*, 163–167. Madrid, XVI, I–II.

Martínez Santa-Olalla, J. (1941b) Obras de arte prehistóricas en el Sahara español. *Mauritania (Tánger)* VIV 165, 233–235.

Martínez Santa-Olalla, J. (1944) *El Sáhara Español Anteislámico: algunos resultados de la primera expedición paletnológica al Sahara, julio–septiembre 1943: Laminas*. Madrid, Ministerio de Educación Nacional. Comisaria General de Excaviciónes Arqueológicas.

Matsuzaki., K. M. R.., Eynaud, F., Malaizé, B., Grousset, F. E., Tisserand, A., Rossignol, L., Charlier, K. and Jullien, E. (2011) Paleoceanography of the Mauritanian margin during the last two climatic cycles: From planktonic foraminifera to African climate dynamics. *Marine Micropaleontology* 79, 67–79.

Mattingly, D. J. ed. (2003) *The Archaeology of the Fazzān. Volume 1, Synthesis*. Tripoli, Department of Antiquities and the Sociey for Libyan Studies.

Mattingly, D. J. (ed.) (2013) Archaeology of the Fazzān, Volume 4. Survey and Excavations at Old Jarma (Ancient Garama) Carried out by C. M. Daniels (1962–69) and the Fazzān Project (1997–2001). London and Tripoli: Society for Libyan Studies.

Mattingly D. J. with Edwards D. (2003) Religious and funerary structures, in D. J. Mattingly (ed) *The Archaeology of Fazzan, Volume 1 Synthesis*, 177–234. Tripoli and London, Department of Antiquity and Society for Libyan Studies.

Mattingly, D. and Gatto, M. C. (eds) (2018) *Trans-Saharans: Human Mobility and Identity, Trade, State Formation and Mobile Technologies across the Sahara (1000 BC–AD 1500)*. Cambridge, Cambridge University Press.

Mattingly, D. J., Brooks, N., Cole, F., Dore, J., Drake, N., Leone, A., Hay, S. McLaren, S., Newson, P., Parton, H., Pelling, R., Preston, J., Reynolds, T., Srüfer-Kolb, I., Thomas, D., Tindall, A., Townsend, A., and White, K. (2001). The Fezzan Project

2001: Preliminary report on the fifth season of work, *Libyan Studies* 32, 133–153.

Mattingly, D. J., Bokbot, Y., Sterry, M., Cuénod, A., Fenwick, C. Gatto, M., Ray, N., (2017) Long-term history in a Moroccan oasis zone: the Middle Draa Project 2015. *Journal of African Archaeology* (2018).

Mattingly D. J., Dore J. N., Edwards D., Hawthorne J. (2003) Background to the archaeology of Fazzan, in Mattingly, D. J. (ed.) *The Archaeology of Fazzan, Volume 1 Synthesis*, 1–36. Tripoli and London, Department of Antiquity and Society for Libyan Studies.

Mattingly, D. J., Daniels, C. M., Dore, J. N., Edwards, D. and Hawthorne, J. (2007) *The Archaeology of Fazzan. Volume 2, Site Gazetteer, Pottery and Other Survey Finds.* Tripoli and London, Department of Antiquity and Society for Libyan Studies.

Mattingly, D. J., Daniels, C. M., Dore, J. N., Edwards, D. and Hawthorne, J. (2010) *The Archaeology of Fazzan. Volume 3, Excavations carried out by C. M. Daniels*. Tripoli and London, Department of Antiquity and Society for Libyan Studies.

Mattingly, D. J., Sterry, M and Ray, N. (2018) Dying to be Garamantian: burial and migration in the Fazzan, in D. Mattingly and M. C. Gatto (eds) *Trans-Saharans: Human Mobility and Identity, Trade, State formation and Mobile Technologies across the Sahara (1000 BC–AD 1500), Volume 1.* Cambridge, Cambridge University Press.

Mayewski, P. A., Rohling, E. E., Stager, J. C., Karlén, W., Maasch, K.A., Meeker, L.D., Meyerson, E., Gasse, F., van Kreveld, S., Holmgren, K., Lee-Thorp, J., Rosqvist, G., Rack, F., Staubwasser, M. and Schneider, R. (2004) Holocene climate variability. *Quaternary Research* 62, 243–255.

McDonald, M. M. A. (1982) Dakhleh Oasis Project third preliminary report on the lithic industries in the Dakhleh Oasis. *Journal of the Society for the Study of Egyptian Antiquities* 12, 115–138.

McDonald, M. M. A. (1990) New Evidence from the Early To Mid-Holocene in Dakhleh Oasis, South-Central Egypt, Bearing on the Evolution of Cattle Pastoralism. *Nyame Akuma* 3, 3–8.

McLaren, S. J., Al-Juaidi, F., Bateman, M. D., Millington, A. C. (2009) First evidence for episodic flooding events in the arid interior of central Saudi Arabia over the last 60 ka. *Journal of Quaternary Science* 24, 198–207.

Mercer, J. (1976) Spanish Sahara. London, George Allen & Unwin..

Merighi, S., Castelli, R. and Palombini, A. (2002) Appendix I. Description of the structures found during the intensive survey, in S. di Lernia and G. Manzi (eds) *Sand, Stones and Bones: The Archaeology of Death in the Wadi Tannezuft Valley (5000–2000 BP)*, 303–316. Arid Zone Archaeology Monographs 3. Firenze, All'Insegna del Giglio.

Merrill, S. (2011) Graffiti at heritage places: vandalism as cultural significance or conservation sacrilege? *Time and Mind: The Journal of Archaeology, Consciousness and Culture* 4, 59–76.

Meunié, J., Allain Ch. (1956) Quelques gravures et monuments funéraires de l'extrême sud-est marocain, Hespéris: Archives Berbères et Bulletin de l'Institut des Hautes-Études Marocaines.

Milburn, M. (1974a) Observaciones sobre algunos monumentos de paredes rectas del Sahara occidental. *Ampurias* 36, 199–214.

Milburn, M. (1974b) Some stone monuments of Spanish Sahara, Mauritania and the extreme south of Morocco. *Journal de la Société des Africanistes* 44, 99–111.

Milburn, M. (1978) Monuments lithiques et funéraires anciens du Sahara (premiers éléments d'une enquête). Doctoral thesis, Université de Paris I.

Milburn, M. (1981) Multi-arm stone tombs of central Sahara. *Antiquity* 55/215, 210–214.

Milburn, M. (1983) On the keyhole tombs ('monuments en trou de serrure') of Central Sahara. *Libya Antiqua* 13–14, 385–390.

Milburn, M. (1988) A typological enquiry into some dry-stone funerary and cult monuments of the Sahara. *Scientific Reviews on Arid Zone Research* 6, 1–126.

Milburn, M. (1993) Saharan stone monuments, rock picture and artefact contemporaneity: some suggestions. In G. Calegari (ed.), *L'arte e l'ambiente del Sahara preistotico: dati e interpretazioni*, 363–374. Milan, Memorie della Societa Italiana di Scienz di Milano, Vol. XXVI, Fascicule II.

Milburn, M. (1996a) Two types of enigmatic stone structures in the north-western Sahara. *Council for Independent Archaeology, Newsletter* 20, 9–10.

Milburn, M. (1996b) Some recent burial dates for central and southern Sahara, including monuments, *Sahara* 8, 99–102.

Milburn, M. (2005) More enigmatic stone structures of the north-western Sahara. *Independent Archaeology* 52, 6–8.

Milburn, M. (2012) Thoughts on 'keyhole monuments', goulets and some rock carvings. *Sahara* 23, 167–171.

Milburn, M. and Kobel-Wettlauffer, I. (1973) Contribution to the Study of some lithic monuments of Western Sahara. *Almogaren IV 1973*, Akademische Druck-u. Verlagsantalt Graz, 103–150.

Milburn, M.; Köbel-Wettlauffer, I. (1975) Reflections on two types of protohistoric monuments of West-Sahara. *Almogaren V-VI 1974–75*, Akademische Druck-u. Verlagsantalt Graz, 99–118.

Millogo, A. K. and Kote, L. (2000) Archéologie du Burkina Faso, in R. Vernet (ed.) *L'archéologie en Afrique de l'Ouest: Sahara et Sahel*, 5–70. Nouakchott, CRIAA.

Mirazón Lahr, M., Foley, R., Crivellaro, F., Okumura, M., Maher, L., Davies, T. Veldhuis, D., Wilshaw, A., and Mattingly, D. (2009) DMP VI: Preliminary results from 2009 fieldwork on the human prehistory of the Libyan Sahara, *Libyan Studies* 40, 143–162.

Monod T. (1932) *L'Adrar Ahnet. Contribution à l'étude archéologique d'un district saharien*. Paris Trav. et Mém. de l'Institut d'Ethnologie 19.

Monod T. (1948) Sur quelques monuments lithiques du Sahara occidental. *Actas y Memorias de la Soc. Española de Antropologia, Etnografia y Prehistoria XXIII, cuadernos* 1–4, 12–35.

Monod, T. (1951) Peintures rupestres du Zemmour français (Sahara occidental), *Bulletin de l'Institut Français d'Afrique Noire* XIII, 1, 198–213.

Morales, A. E. (1942) Sobre algunos gravados, dibujos e inscripiciones rupestres del Sahara español (nota descriptive). *Mauritania (Tánger)* I–XII, 373–379.

Morales, A. E. (1944) Gravados e inscripiciones rupestres de la alta Seguia El Hamra, en el Sahara español. *Atlantis, Actas y Memorias de la Sociedad Española de Antropologia Etnología y Prehistoria* XIX I–4, 137–151.

Mori, L., Gatto, M. C., Ricci, F. and Zerboni, A. (2013), Life and death at Fewet. *Arid Zone Archaeology Monographs* 6, 375–387.

Myers, A. (2010) Fieldwork in the age of digital reproduction, a review of the potentials and limitations of Google Earth for archaeologists. *The SAA Archaeological Record* (September), 7.

Naffé, M. O. Vernet, R. and Kattar, R. V. (2000) Archéologie de la Mauritanie, in R. Vernet (ed.) *L'archéologie en Afrique de l'Ouest: Sahara et Sahel*, 129–204. Nouakchott, CRIAA.

Neighbour, T. (2005) Excavation of a Bronze Age Kerbed Cairn at Olcote, Breasclete, Near Calanais, Isle of Lewis. *Scottish Archaeological Internet Reports* 13.

Nesbitt, L. M. (1930) Danakil traversed from South to North in 1928. *The Geographical Journal* 76/4, 298–315.

Niang, M., B. Nagando, S. Seidou and E. Wangari. (2001) *Le Pillage de Sites Culturels et Naturels au Niger*. Paris, Centre du Patrimoine Mondial (WHC), UNESCO.

Nicholson, S. and Flohn, H. (1980) Environmental and Climatic Changes and the General Atmospheric Circulation in Late Pleistocene and Holocene. *Climatic Change* 2, 313–348.

Nicoll, K. (2004) Recent environmental change and prehistoric human activity in Egypt and Northern Sudan. *Quaternary Science Reviews* 23, 561–580.

Nowak, H., Ortner, S., and Ortner, D. (1975) *Felsbilder der spanischen Sahara*. Graz, Akademische Druckund Verlagsanstalt.

Ottoni, C., Primativo, G., Hooshiar Kashani, B., Achilli, A., Martínez-Labarga, C., Biondi, G., Torroni, A. and Rickards, O. (2010) Mitochondrial haplogroup H1 in North Africa: an early Holocene arrival from Iberia. *PLoS One* 5/10, e13378.

Pachur H. J. and Hoelzmann P. (2000) Late Quaternary palaeoecology and palaeoclimates of the eastern Sahara. *Journal of African Earth Sciences* 30, 929–939.

Paris, F. (1992) Le Bassin de I'Azawagh: peuplements et civilisations, du néolithique à l'arrivée de l'islam, in A. Marliac (ed.) *Milieux, sociétés et archeologues*, 227–257. Paris, Éditions Karthala et Éditions de l'Orstom.

Paris, F. (1996) *Les Sépultures du Sahara Nigérien du Néolithique à l'Islamisation: 1. Coutumes Funéraires, Chronologie, Civilisations. 2. Corpus de sépultures fouillées*. Paris, Éditions de l'Orstom: Etudes et Thèses.

Paris, F. (1997) Burials and the peopling of the Adrar Bous region, in B. E. Barich, and M. C. Gatto (eds) *Dynamics of Populations, Movements and Responses to Climate Change in Africa*, 49–61. Rome, Bonsignori.

Paris, F. (2000) African livestock remains from Saharan mortuary contexts, in R. Blench and K. C. MacDonald (eds) *The Origins of African Livestock*, 111–126. London, University College.

Paris, F. and Saliège, J.-F. (2010) Chronologie des monuments funéraires sahariens: Problèms, méthode et résultats. *Les Nouvelles de l'archéologie* 120–121, 57–60.

Pasty, J.-F. (1999) *Contribution a l'etude de l'Aterien du Nord Mauritanien*. Oxford, BAR International Series 758.

Pazzanita, A. G. and Hodges, T. (1994) Morocco versus Polisario: A political interpretation. *The Journal of Modern African Studies* 32/2, 265–278.

Pellicer, M. and Acosta, P. (1972) Aportaciones al Estudio de los Grabados Rupetres del Sáhara Español. *Tabona* 1. La Laguna, Universidad de la Laguna.

Pellicer, M. and Acosta, P. (1991) Enterramientos tumulares preislámicos del Sahara occidental. *Tabona* 7. Universidad de la Laguna, 127–157.

Pellicer Catalán, M. P., Martínez, P. A., Pérez, M. S. H. and Socas, D. M. (1973–1974) Aportaciones al Estudio del Arte Rupestre del Sáhara Español (Zona Meridional). *Tabona* 2. La Laguna, Universidad de la Laguna.

Pereira, L., Nuno M Silva, N. M., Franco-Duarte, R., Fernandes, V., Pereira, J. B., Costa, M. D., Martins, H., Soares, P., Behar, D. M., Richards, M. B. and Macaulay, V. (2010) Population expansion in the North African Late Pleistocene signalled by mitochondrial DNA haplogroup U6. *BMC Evolutionary Biology* 10, 390.

Petit-Maire, N. (ed.) (1979) Le Sahara atlantique a l'Holocène, peuplement et écologie. *Mémories du C.R.A.P.E.*, XXVIII 28, 340–350. Alger, Centre de Recherches Anthropologiques, Prehistoriques et Ethnologiques.

Petit-Maire, N., Beufort, L. and Page, N. (1997) Holocene climate change and man in the present day Sahara desert, in H. Nüzhet Dalfes, G. Kukla and H. Weiss (eds) *Third Millennium BC Climate Change and Old World Collapse*, 297–308. Berlin and Heidelberg, Springer-Verlag.

Petit-Maire, N., Celles, J. C., Commelin, D., Delibrias, G. and Raimbault, M. (1983) The Sahara in Northern Mali: Man and His Environment between 10,000 and 3500 Years BP. (Preliminary Results). *The African Archaeological Review* 1, 105–125.

Pole, L. (2010) Recent developments in iron-working research in West Africa, in P. Allsworth-Jones (ed.) *West African Archaeology: New Developments, New Perspectives*, 53–65. Oxford, BAR International Series 2164.

Ponti, R., Aurisicchio, G., Damiotti, R. and Guidi, G. (1998) Pottery from the Tadrart Acacus (Libyan Sahara): decoration, distribution and manufacture, in M. Cremaschi and S. di Lernia (eds) *Wadi Teshuinat Palaeoenvironment and Prehistory in South-Western Fezzan (Libyan Sahara). Survey and Excavations in the Tadrart Acacus, Erg Uan Kasa, Messak Settafet and Edeyen of Murzuq 1990–1995*, 183–200. Milan, Consiglio Nazionale Delle Ricerche. Quaderni de Geodinamica Alpina e Quaternaria, Milano: Edizioni All' Insegna de Giglio.

Rahmani, N. (2004) Technological and cultural change among the last hunter-gatherers of the Maghreb: the Capsian (10,000–6,000 BP). *Journal of World Prehistory* 18/1, 57–105.

Raimbault, M. (1983) Industrie Lithique, in N. Petit-Maire and J. Riser (eds) *Sahara ou Sahel? Quaternaire récent du bassin de Taoudhani (Mali)*. 317–341 Marseille, Centre National Recherche Scientifique.

Reimer, P. J., Baillie, M. G. L, Bard, E. M., Bayliss, A., Beck, J. W., Bertrand, C., Blackwell, P. G., Buck, C. E., Burr, G., Cutler, K. B., Damon, P. E., Edwards, R. L., Fairbanks, R. G., Friedrich, M., Guilderson, T. P., Hughen, K. A., Kromer, B., McCormac, F. G., Manning, S., Bronk Ramsey, C., Reimer, R. W., Remmele, S., Southon, J. R., Stuiver, M., Talamo, S., Taylor, F. W., van der Plicht, J. and Weyhenmeyer, C. E. (2004) IntCal04.14c. *Radiocarbon* 46, 1029–1058.

Renssen, H., Brovkin, V., Fichefet, T. and Goosse, H. (2006) Simulation of the Holocene climate evolution in Northern Africa: the termination of the African Humid Period. *Quaternary International* 150, 95–102.

Reygasse M. (1950) *Monuments funéraires préislamiques de l'Afrique du Nord*. Paris, Arts et Métiers Graphiques.

Riemer, H, Kindermann, K and Eickelkamp, S. (2004) Dating and production technique of Ounan points in the Eastern Sahara. New archaeological evidence from Abu Tartur, Western Desert of Egypt, *Nyame Akuma* 61, 10–16.

Riemer, H., Kröpelin, S. and Zboray, A. (2017) Climate, styles and archaeology: an integral approach towards an absolute

chronology of the rock art in the Libyan Desert (Eastern Sahara). *Antiquity* 91, 7–23.

Rodrigue A. (2011) *La Seguia el Hamra. Contribution à l'étude de la Préhistoire du Sahara Occidental.* Paris, L'Harmattan.

Rohling, E. J., Pälike, H. (2005) Centennial-scale climate cooling with a sudden cold event around 8,200 years ago. *Nature* 434, 975–979.

Roset, J. P. (1974) Contribution a la connaissance des populations Néolithiques et protohistoriques du Tibesti (Nord Chad). *Cahiers ORSTOM sér. Sci. Hum.* XI, 47–84.

Roset, J. P. (1987) Paleoclimatic and cultural conditions of neolithic development in the early Holocene of Northern Niger (Air and Ténéré), in A. Close (ed.) *Prehistory of Arid North Africa: Essays in honor of Fred Wendorf*, 211–233. Dallas TX, Southern Methodist University Press.

Ross, E. (2010) A historical geography of the trans-Saharan trade, in G. Krätli and G. Lydon, (eds) *The Trans-Saharan Book Trade: Manuscript Culture, Arabic Literacy and Intellectual History in Muslim Africa*, 1–34. Leiden, Koninklijke Brill NV.

SADR Petroleum Authority (2006) SADR 2006 Onshore Oil and Gas Licence Offering. Sahrawi Arab Democratic Republic Petroleum Authority. Available at: http://www.sadroilandgas.com/geosum.htm (accessed 27/03/2017).

Sáenz de Buruaga, A. S. (2008) *Mendebaldeko Saharako Tirisen Kultura-Iragana Ezagutzeko Ekarpena: Arkeologia Ondarearen Inbentarioa, 2005–2007.* Kultura Saila, Eusko Jauriaritzaren Atgitalpen Zerbitzu Nagusia.

Sáenz de Buruaga, A S. (2010) *Sahara Occidental: Pinceladas de un Desierto Vivo desde la Region del Tiris, en las Tierra Libres del Sahara Occidental.* Gobierno Vasco, Departamento de Cultura.

Sáenz de Buruaga, A S. (2014), *Mendebaldeko Saharako Tirisen Kultura-Iragana Ezagutzeko Ekarpen Berriak: Arkeologia Ondarearen Inbentarioa, 2008–2011.* Kultura Saila, Eusko Jauriaritzaren Atgitalpen Zerbitzu Nagusia.

Saliège, J.-F., Person, A. and Paris, F. (1995) Preservation of 13C/12C original ratio and 14C dating of the mineral fraction of human bones from Saharan tombs, Niger. *Journal of Archaeological Science* 22, 301–312.

Salisbury, G. J. (2011) Locating the 'Missing' Moroccan Megaliths of Mzora. *Time and Mind* 4/3, 355–360.

Sandweiss, D. H., Maasch, K. A., Andrus, C. F. T., Reitz, E. J., Riedinger-Whitmore, M., Richardso, J. B. and Rollins, H. B. (2007) Mid-Holocene climate and culture change in coastal Peru, in D. G. Anderson, K. A. Maasch and D. H. Sandweiss (eds) *Climate Change and Cultural Dynamics: A Global Perspective on Mid Holocene Transitions*, 25–50. London, Academic Press, Elsevier.

Sanjuán, L. G., Triviño, M. L., Schuhmacher, T. X., Wheatley, D. and Banerjee, A. (2013) Ivory craftsmanship, trade and social significance in the southern Iberian Copper Age: the evidence from the PP4-Montelirio sector of Valencina de la Concepción (Seville, Spain). *European Journal of Archaeology* 16/4, 610–635.

Savary J. P. (1966) Monuments en pierres sèches du Fadnoun (Tassili n'Ajjer). *Mémories du C.R.A.P.E.*, A.M.G. Paris, VI.

Schlüter, T. and Trauth, M. H. (2008) *Geological Atlas of Africa: With Notes on Stratigraphy, Tectonics, Economic Geology, Geohazards, Geosites and Geoscientific Education of Each Country.* New York, Springer.

Schuhmacher, T. X. and Cardoso, J. L. (2007) Ivory objects from the chalcolithic fortification of Leceia (Oeiras). *Estudos Arqueologicos de Oeiras* 15, 95–118.

Schuhmacher, T. X., Cardoso, J. L. and Banerjee, A. (2009) Sourcing African ivory in Chalcolithic Portugal. *Antiquity* 83/322, 983–997.

Searight S. (2003) Rapport préliminaire sur des monuments préislamiques de l'oued Chebeika, province de Tan-Tan, Maroc, *Cahiers de l'Association des Amis de l'Art Rupestre Saharien* 8, 45–53.

Searight, S. and Martinet, G. (2002) Peintures rupestres d'un nouveau genre dans le Sud marocain. *Sahara* 13, 115–118.

Serra Salamé, C., Escolá Pujol, J., Soler Masferrer, N. and Ungé Plaja, J. (1999) Arqueología y cooperación en el Sáhara occidental, in *Comunicaciones libres. Congreso Nacional de Arqueología XXIV, Cartagena 1997* vol. 5, 113 117. Murcia, Instituto de Patrimonio Histórico, Dirección General de Cultura, Communidad Autónoma de la Región de Murcia.

Sereno, P. C., Garcea, E. A. A. Jousse, H., Stojanowski, C. M., Saliège, J. -F., Maga, A., Ide, O. A., Knudson, K. J., Mercuri, A. M., Stafford, T. W., Kaye, T. G., Giraudi, C., Massamba N'siala, I., Cocca, E., Moots, H. M., Dutheil, D. B. and Stivers, J. P. (2008) Lakeside Cemetaries in the Sahara: 5000 years of Holocene Population and Environmental Change. *PLoS ONE* 3/8: e2995. doe:10.1371/journal.pone.0002995.

Siméoni, A. & F., 1991, 'Suite à "note au sujet des trilithes sahariens"', *Le Saharien*, 118, p 48.

Sivili, S. (2002) A historical background: mortuary archaeology in the Sahara between colonialism and modern research, in S. di Lernia and G. Manzi (eds) *Sand, Stones and Bones: The Archaeology of Death in the Wadi Tannezzuft Valley (5000–2000 BP)*, 17–24. Arid Zone Archaeology Monographs 3. Firenze, All'Insegna del Giglio.

Smith, A. B. (1984) Environmental limitations of prehistoric pastoralism in Africa. *The African Archaeological Review* 2, 99–111.

Smith, A. B. (1998), intensification and transformation processes towards food production in Africa, in S. di Lernia and G. Manzi (eds) *Before Food Production in North Africa: Questions and Tools Dealing with Resource Exploitation and Population Dynamics at 12,000–7,000 BP*, 19–33. Rome, Union Internationale des Sciences Prehistoriques et Protohistoriques XIII World Congress, Forli, 1996. ABACO and Centro Interuniversitardo di Ricerca sulle Civiltà e l'Ambiente del Sahara Antico.

Soler i Subils, J. (2005a) Les pintures rupestres prehistòriques del Zemmur (Sahara Occidental). Doctoral thesis, University of Girona.

Soler i Subils, J. (2005b) Late prehistorical paintings in the Zemmur (Western Sahara). *Inora* 45, 15–23.

Soler i Subils, J. (2007a) Sub-Zone 1: Mauritania – Western Sahara, in *Rock Art of Sahara and North Africa: Thematic Study, June 2007*, 15–28. Paris, International Council on Monuments and Sites.

Soler i Subils, J. (2010) The Age and the Natural Context of the Western Saharan Rock Art, in *The Signs of Which Times? Chronological and Palaeoenvironmental Issues in the Rock Art of Northern Africa* Royal Academy for Overseas Sciences Brussels, 3–5 June, 2010, 27–45

Soler i Subils, J., Soler Masferrer, N., Serra I Salamé, C., Escolà I Pujol, J. and Ungé I Plaja, J. (2001) The painted rock shelters of wadi Kenta (Mehairis, RASD), *XIV International Congress of Prehistoric and Protohistoric Sciences. Pre-Prints. Section 15. African Prehistory.*

General Session. Liège 2–8 September 2001. Liège, Université de Liège, E. Cornelissen, I. Ribot, Coordinators, p. 345.

Soler i Subils, J., Soler Masferrer N., Escolà Pujol J. and Serra Salamé C. (2005) La Pintura rupestre del Sahara Occidental, in *Roches ornées, roches dressées. Colloque en hommage à Jean Abélanet, Perpignan 24–25 mai 2001*, 86–96. Perpignan, Association Archéologique des Pyrénées-Orientales, Presses Universitaires.

Soler i Subils, J., Soler Masferrer, N. and Serra Salamé, C. (2006a) *Las pinturas rupestres prehistóricas de Rekeiz Lemgasem (Zemmur, Sáhara Occidental)*. Girona, Universitat de Girona, institut del Patrimoni Cultural. Oficina de Cooperació.

Soler i Subils, J., Soler Masferrer, N., Serra, C., Escolà, J., Ungé, J. (2006b) The painted rock-shelters of the Wadi Kenta (Mehairis area, RASD), *Préhistoire en Afrique. African Prehistory, XIV International Congress of Prehistoric and Protohistoric Sciences, Université de Liège, 2nd–8th September 2001*, 167–173. Oxford, BAR International Series 1522.

Soler Subils, J., Soler Masferrer, N. and Serra Salamé, C. (2006c) The painted rock shelters of the Zemmur (Western Sahara). *Sahara* 17, 129–142.

Soler Masferrer, N., Serra, C. Escolà, J. and Ungé, J. (1999) *Sàhara Occidental: Pasado y Presente de un Pueblo*. Girona, Universidad de Girona.

Soler Masferrer, N., Escolà Pujol, J., Serra Salamé, C. and Ungé Plaja, J. (1999) Aportaciones al arte rupestre del Sáhara occidental. Los problemas del Paleolítico Superior en el ámbito mediterráneo peninsular, in *Congreso Nacional de Arqueología XXIV, Cartagena 1997* Volume 1, 123–128. Murcia, Instituto de Patrimonio Histórico, Dirección General de Cultura, Communidad Autónoma de la Región de Murcia.

Soler Masferrer, N., Soler i Subils, J., Escolà Pujol, J., Serra Salamé, C. and Ungé Plaja, J. (2001a) Una nova àrea amb pintures al Sáhara Occidental, in *Roches ornées, roches dresses. Colloque en hommage à Jean Abélanet*, 86–96. Perpignan, Université de Perpignan, Association Archéologique des Pyrénées-Orientales.

Soler Masferrer, N., Ungé Plaja, J., Serra Salamé, C., Escolà Pujol, J. and Soler Subils, Q. (2001b). El gravat rupestre del Sáhara Occidental, in *Roches ornées, roches dresses. Colloque en hommage à Jean Abélanet*, 79–84. Perpignan, Université de Perpignan, Association Archéologique des Pyrénées-Orientales.

Soler Masferrer, N., Ungé Plaja, J., Escolà Pujol, J. and Serre Salame, C. (2001c) Sluguilla Lwash, an open air site with rock art in the Western Sahara, in J. Zilhão, T. Aubry and A Faustino Carvalho (eds) *Les premiers hommes modernes de la Péninsule Ibérique: Actes du Colloque de la Commission VIII de l'UISPP (Vila nova de Foy Côa, 22–24 octobre 1998)*, 281–291. Portugal, Instituto Português de Arqueologia, Lisbon.

Souville, G. (1959), Principaux types de tumulus marocains. *Bulletin de la Société préhistorique de France* 56, 394–402.

Tafuri, M. A., Bentley, R. A., Manzi, G. and di Lernia, S. (2006) Mobility and kinship in the prehistoric Sahara: Strontium isotope analysis of Holocene human skeletons from the Acacus Mts. (southwestern Libya). *Journal of Anthropological Archaeology* 25, 390–402.

Talbot, M. R. (1984) Late Pleistocene rainfall and dune building in the Sahel. *Palaeoecology of Africa* 16, 203–214.

Thesiger, W. (1935) The Awash river and the Aussa sultanate. *The Geographical Journal* 85/1, 1–19.

Thomas, J. (2013) Monumental architecture in sub-Saharan Africa: a European perspective. *Azania: Archaeological Research in Africa* 48/2, 315–322.

Thompson, D. P., van Hollen, D., Osborn, G. and Ryane, C. (2006) Did neoglaciation begin as early as 6400 cal years ago? *Geological Society of America Abstracts with Programs* 38, 236.

Tilley, C. (2004) *The Materiality of Stone: Explorations in Landscape Phenomenology*. London, Berg.

Vernet, R. (1998) Le littoral du Sahara atlantique mauritanien au Néolithique. *Sahara-Segrate*, 21–30.

Vernet, R. (2007a) *L'archéologie en Afrique de l'Ouest: Sahara et Sahel*. Paris, Publié avec le concours du Ministère français des Affaires Étrangères.

Vernet, R. (2007b) *Le Golfe d'Arguin de la Préhistoire à l'Histoire: Littoral et Plaines Intérieures*. Nouakchott: Parc National du Banc d'Arguin. Available at: http://www.neolithique.eu/neolithique-pointes_de_fleches.html (accessed 21 December 2010).

Vernet, R. (2012) Le Chalcolithique de Mauritanie (3000–2500 cal. B.P.). État de la question. *Sahara* 23, 7–28.

Vernet, R. (2014) Regards sur une région préhistorique méconnue des confins du nord-ouest saharien. *ICOSIM* 3, 21–54.

Vernet, R. and Faure, H. (2000) Isotopic chronology of the Sahara and the Sahel during the late Pleistocene and the early and Mid-Holocene (15,000–6000BP). *Quaternary International* 68, 385–387.

Vernet, R., Naffé M. O. and Kattar, R. V. (2000) Éléments d'archéologie oust-Africaine III: Mauritanie. Nouakchott, CRIAA.

Warren, G. and Neighbour, T. (2004) Quality quartz: working stone a a Bronze Age kerbed cairn at Olcote near Calanais, Isle of Lewis. *Norwegian Archaeological Review* 37/1, 1–13.

Wasylikowa, K., Mitka, J., Wendorf, F. and Schild, R. (1997). Exploitation of wild plants by the early Neolithic hunter-gatherers of the Western Desert, Egypt: Nabta Playa as a case-study. *Antiquity* 71, 932–941.

Wendorf, F., Close, A., Schild, R. (1993) Megaliths in the Egyptian Sahara. *Sahara*, 5, 7–16.

White, K. H., Charlton, M., Drake, N. A. McLaren, S., Mattingly, D. and Brooks, N. (2006) Lakes of the Edeyen Ubari and the Wadi al Hayat, in D. J. Mattingly, S. Mclaren, E. Savage, Y. al-Fasatwi and K. Gadgood (eds) *Environment, Climate and Resources of the Libyan Sahara*, 123–130. London, Society of Libyan Studies.

Williams, M. A. and Balling Jr, R. C. (1996) *Interactions of desertification and Climate*. Edward Arnold, Hodder Headline, PLC.

Yan, Z. and Petit Maire, N. (1994) The last 140 ka in the Afro-Asian arid:semi-arid transitional zone. *Palaeogeography, Palaeoclimatology, Palaeoecology* 110, 217–233.

Zapata, L., López-Sáez, J. A., Ruiz-Alonso, M., Linstädter, J., Pérez-Jordà, G., Morales, J., Kehl, M., and Peña-Chocarro, L. (2013) Holocene environmental change and human impact in NE Morocco: Palaeobotanical evidence from Ifri Oudadane. *The Holocene* 23/9, 1286–1296.

Zhao, M., Mercer, J. L., Eglinton, G., Higginson, M. J., and Huang, C.-Y. (2006) Comparative molecular biomarker assessment of phytoplankton paleoproductivity for the last 160kyr off Cap Blanc, NW Africa. *Organic Geochemistry* 37/1, 72–97. doi:10.1016/j.orggeochem.2005.08.022

Index

Aayoun Basin 10
Abstract: motifs 93; forms 92, 94; paintings 64; patterns 97; symbols 97; shapes 98
Abteh 100
Acacia 15
Acacus 7, 16, 92, 193, 201
Accelerator mass spectrometry (AMS) 23
Acheulean lithics 19
Adrar 9, 85, 92, 100, 103, 157, 194
Adrar des Iforas 157
Aeolian sediments 14, 27
African Aterian industry 160
African Humid Period 16–18
Agadez 153, 157
Aghram Nadharif 151
Agouanit 97
Akjoujt 153, 157, 161
Akka 101, 103, 198
Algeria 4, 9–10, 18, 34, 45, 48, 55, 81, 89, 99–100, 104, 123, 157, 193–194, 197, 203
Almoravid period 123
Amphora 150
Ancient route way 44
Animal activity 148, 150
Animal burials 38, 101
Animal burrow (ing) 156, 171
Animal engravings 97
Annex 42, 43, 45–47, 50, 65–67, 69, 100–101, 111, 113, 126–127, 130–131, 135, 138
Anthropomorph 96–98, 100
Aolian sand/silt 149
Arabic script 97
Arc of stones 139, 143
Aridity 1–2, 7–8, 16–19, 32–33, 104–105, 200, 203
Artefact scatter, 3, 68, 106–107, 123, 132, 145, 170–171, 173–174, 177, 179, 203
Ash 54, 162, 164, 16–171, 173, 179–180, 182

Astronomical: alignments 199; structures 84
Aterian cultural complex 91
Aterian point 184–185, 188
Atlantic Sahara 1, 7, 17, 99, 104, 116, 151, 173, 193, 197–198, 200
Auxillary towers 39, 44, 50, 62, 76–77, 99–100, 102
Axle monuments 39, 42, 44, 103
Azaig Bedrag 58, 61, 64, 70, 75, 86, 99, 103

Backed bladelets 192
Backed blades 178, 192
Basalt 11–13, 64, 91, 158, 160, 199, 202–203
Bazinas 36, 38–39, 41, 46, 50, 58, 67, 97, 99, 100–102, 111, 113, 121, 145, 200, 203
Beads 147, 152–153
Bedrock 45, 63–64, 87, 89, 103, 128, 139, 147–149, 153–157, 162, 165, 168, 170–171
Bell Beaker sites 201; burials 201; pottery 201
Bifacial hand axes and scrapers 22
Bifacially drilled 153
Bipolar cores 183, 185
Bir Lahlou 12, 22, 25, 60, 81, 87, 88
Bir Lemuesat 79, 102
Bird bones 155
Blades 158–161, 171, 177–179, 181, 183, 185, 187–188, 190–192, 194–195, 197
Blanks 177, 179–182, 187, 190, 194–195, 198, 204
Blugzeimat 94, 98
Bone fragments 147, 154
Bou Dheir 6, 20, 23, 60, 78, 89, 94–96, 103, 105
Boulder burials 38, 41, 47, 62
Boulders 13, 22, 38, 45–47, 50, 62, 66–67, 75, 77–78, 80, 83, 85–90, 98, 108–109, 119, 124, 126–129, 132, 139, 141–145, 201
British Isles 54, 84, 202
Building matrix 150
Burial chambers 37–39, 46, 127, 147–150, 152–157

Burial offering 153
Burials, Adult 8, 84, 148, 154, 156, 161; male 8; female 148
Burials, child (remains of) 84, 154, 156
Burins 91, 158, 178–182, 184–187, 190–192, 194–195
Burning 54, 164

Cairns 34, 36–50, 52–53, 59, 62–65, 67, 71, 75–80, 86, 89–90, 97, 102–104, 108, 110–111, 116, 121, 124, 126–129, 138, 141–144, 146, 154, 156, 161–162, 174, 177, 199, 202
Camel and rider 97
Camels 4
Camps 35, 30, 44, 84, 85, 119, 197, 198; military 140; refugee 4–5, 59; temporary 119, 197–198
Capstone 54–55
Carbonate crust 19, 21–22, 29; mudstone mound 26; nodules 22, 24–25, 28; rocks 90, 202; rubble 24, 29
Carnelian 152–153
Caspian Sea 16
Cattle burials 8, 37, 69; engravings 69; herding 7–9, 78
Cenchrus ciliaris 29
Central dividing line 150
Ceramics 34, 56, 59–61, 63, 90–93, 99–100, 103–104, 150, 173
Chalcedony 177, 185, 187
Chami 151
Chapel monuments/tumuli 38, 41, 46, 61–62, 67, 101
Charcoal 54, 146, 162, 169, 171, 173
Chariots 100, 203
Chipped stone 34–35, 54, 56, 59–61, 63, 89–90, 139, 150, 158, 162–165, 167–171, 173, 176–178, 180, 182–189, 191, 197–198
Chronological sequence 173, 197
Circumcision rituals 85
Citrullus colocynthis 29–31
Cobbles 52–53, 139, 141–145, 154
Coits 54, 84
Complex monuments 39, 43–44, 47–50, 58, 62, 65, 67, 71–72, 74–78, 100–102, 104–105, 110, 116–117, 121, 124, 126, 137, 141–145, 203–204
Composite monuments 39, 44, 49, 62, 111, 127–128
Concentric circles 52, 67, 73, 98, 104
Cooking 54, 164
Copper 153–154, 156–157, 161; earring 154, 156–157, 161; production 157
Corbeilles 41, 46–47, 67–69, 97, 99–102, 111, 145
Corbelled 'beehived' chamber 149; structure 156
Cores 35, 158–160, 177–179, 181, 183, 185–195
Cranium 155–156
Crescent antennae 42, 44, 48–49, 59, 70–71, 73–74, 99, 102, 104–105, 111, 201, 204
Crescent monuments 48, 72
Crescents (regular) 38, 44, 46–49, 58–59, 63, 65, 70–74, 99–105, 108, 110–111, 116, 145, 204
Crescents paved 39, 42, 44, 47–49, 59, 65, 70–74, 102–105, 108, 110–111, 116, 125–126, 128, 130, 132, 134–135, 145, 204
Crescents with tails 39, 62, 70
Crested blades 183
Cromlech de Mzora 121, 123, 200
Cromlechs 54, 84
Cryptocrystalline cherts 91
Cueva del Diablo or 'Devil's Cave' 29, 94, 97

Cueva Pintada 97
Cultural activities 146, 174
Cultural deposit 162, 168
Cup marks 98
Curation of lithics 91, 160
Cyst 124, 127

Dait el-Aam Basin 12, 25
Dakhleh Oasis 193–194
Danakil 53–54
Debitage 35, 162, 171, 198
Decorated rock shelters 94
Desert grasses 29
Desert gravels 169
Desert pavement 83–84
Desert varnish 84, 119
Desert-adapted species 103–104
Dhar Tichitt-Walata 157
Digital Terrain Models 108
Disc tumuli 41, 46
Djorf Torba 101–102
Dolmens 55
Draa Valley 50, 103
Drainage systems 2, 11, 14, 198–199 203
Drum monuments 46, 102, 111
Dugej 13, 61, 91, 94
Dugout 142
Dung 29, 33
Dykes 11, 13, 64–65, 103, 199, 203

Eggshell 28, 152–153, 162, 168–170, 176
Egypt 8, 16, 162, 165, 193, 198
El Aayoun 12
Elous Lajaram 21–22, 24, 60, 67, 70
Elephant 7, 79, 201
Engraved lines 98
Engravings 1, 19, 29, 56, 60, 63–64, 68–69, 92–94, 96–100, 103–104, 203
Environmental change 5, 9, 17, 19, 22, 31–33, 203
Environmental conditions 1, 5–8, 10, 14, 17, 20–22, 204
Environmental *refugia* 8
Environmental studies 3
Erg Azefal 101, 104, 200
Erg Azefal sand sea 88, 103
Erg Ine Sakane 18
Ethnographic 119
Excavation 5–6, 8, 35, 46, 52, 56, 66–67, 86, 89, 146–147, 149–151, 153–157, 149, 161–165, 167, 169, 171, 173–174, 176–177, 195, 197
Exchange networks 152, 198

Falcate monuments ('Falcates') 44, 46–47, 58, 59
False entrances 38, 45–46, 50, 62, 67, 101, 111, 126–127, 148–149, 154, 136
Faunal remains 29, 54
Fayum region 165
Femur 156, 161
Flake and blade technologies: biface 183, 193; burins 91, 158, 179, 181–102, 184–187, 190, 192, 194–195; denticulates

91, 158, 178–179, 181, 184–187, 189–190, 192; discoidal 188, 193; endscrapers 91, 158, 185–186, 190, 192; inverse retouch; microburins 177–179, 181, 183, 185–188, 190–192, 194; Ounan points 7, 91, 162, 173–174, 179, 181, 184, 189, 194; plunging blade 183–184; points 7, 91, 158, 162, 173–174, 179, 181, 184–185, 187, 189–196
Flint 177–179, 181
Fluvial: sediments 14; gravels 24, 25
Foliate point 189
Food stores 35
Free Zone 3–6, 10–13, 15, 18–19, 25, 34–37, 45, 47–60, 69–71, 73–74, 79, 81, 83–85, 87, 89, 91–92, 94, 99–105, 116, 121, 146, 198, 201–204
Freshwater environments 27
Funerary complexes 60–61, 65, 68, 81, 87–88, 101, 200
Funerary monuments 1, 4–8, 34–35, 41, 46, 52–53, 87, 104, 111, 116, 121, 123, 127, 174, 198–204
Funerary practices 35, 101, 116, 202–203
Funerary rituals 3, 35, 89

Garaat al-Masiad 87
Garaat El-Masiaad 64
Garamantian culture 100
Garamantian proto-stele burials 101
Garat al-Khayl 98
Garat el-Masiad 47, 98
Geochemical analysis 10, 21
Geochemical crust 16, 28–29
Geochemical deposits 28–29
Geometric forms 94
Geomorphological: characteristics 57; features 108; fieldwork 108; indicators 5; study 193
Gilf Kebir 104
Gilf Kebir region 16, 17
Google Earth 20, 22, 24, 34, 57–59, 72–74, 77, 79, 106, 108
Goulet Type 1 39, 43, 50–52, 62, 76–79, 89–90, 100, 102, 117, 123, 138
Goulet Type 2 43, 51–52, 62, 76, 78, 89, 90, 100, 117, 137, 198, 200
Goulets 6, 36, 39, 44, 51–52, 55, 58–60, 62–63, 76–81, 86, 90, 100–102, 104–105, 116–118, 121, 123–124, 127, 129–132, 134, 136–140, 142–143, 145, 199, 201–204
Grab sample 162, 165, 167
Graffiti 97
Granite 11–13, 15, 22, 64, 88, 103, 147, 149, 153–156, 164, 170–171, 199, 202–203; hills 11–13, 15, 64, 103; outcrops 12–13; ridges 12–13, 199, 203; slabs 147, 156; standing stones 147
Grave goods 45, 59, 147, 156
Graves 84, 123, 127, 140, 170, 174, 202
Grazing 29–30, 57, 106
Great Western Erg 18
Grinding stone 29, 64, 157–158, 165
Ground stone 5, 90, 91, 160, 164–165, 197–198; axes 160, 167; burnishers 165; discs 164; hammerstones 165
Ground-truthing 57, 59
Gully 124, 127, 129, 142–143
Gun emplacements 87
Guteles 101
Gypsum crystals 28–29

Halberds 7, 93, 101, 105, 203
Half circles 52, 58, 62, 81–82, 119, 124, 139, 143
Hand axe 22, 90
Hand print 94–95
Hassi el-Mejnah 18
Hearths 3, 5, 23, 44, 53–55, 62, 84, 87, 122, 129, 132, 136, 164–166, 169–171, 173–174, 176, 192, 197
Holocene (The) 5, 7, 10, 16–18, 21, 24, 31, 90, 100, 104, 184–185, 189, 190, 193–194, 197, 203–204; Early, 6–8, 16–19, 33, 104, 162, 173–174, 176, 181, 183–185, 187, 189–190, 192–195, 197–198, 203–204; Middle 2–3, 6–8, 16–19, 31, 33, 99–100, 103–104, 146, 173, 183–185, 187, 189, 193, 195, 197–198, 203–204; Late 3, 7–8, 17–18, 99–100, 104, 146, 151, 198, 203
Holocene Climatic Optimum 16–17
Holocene Humid Phase 5, 7
Human bone, 148–149; disarticulated 149
Human burials 8, 35, 37, 52
Humid-climate fauna 103–105, 204
Human figures 7, 92–98, 103
Human remains 8, 147
Human Rights Watch 4
Humic deposits/material 10, 22, 26, 31
Hunting 9, 197, 203
Hydrogeological systems 33

Iberia 7, 93, 200–201, 203
Identity 3, 199
Igneous rocks 91, 108
Immidir 51, 100
Incised ostrich eggshell 162
Inhumation 149
Inselbergs 108, 111
Irghraywa 22, 26, 60, 74, 76, 102
Iron 18, 152–153, 161; point 152–153, 161
Islamic burials
Isotopes (isotopic studies) 16, 147
Ivory 201

Jabal Basfuf 61, 91–92, 98
Jasper 91, 158, 160, 177–179, 181, 185, 187, 190–194

Kerb burials 44, 53–54, 76, 79, 81–83, 119, 122–125, 127, 129–132, 134–136, 138–140, 145
Kerb stones 40, 45, 47–49, 62, 66, 99, 124, 127, 139, 143
Keyhole monument 36, 39, 44, 51–52, 100, 105
Knapping 177, 181, 190–192, 194–195, 198
Kudu 32, 98

Levallois 90, 176, 193; bade 158; core 184, 188, 193; flake 158, 184–185, 188, 193; point 158, 160
Lake Chad 16
Laminar tools 181
Landscape phenomenology 3, 199
Libyco-Berber symbols/script/text 7, 92–93, 97, 100, 121, 203
Limsharha 67, 74
Lithic tool kits 165
Little Humid Period 18
Local traditions 99, 101

Long bones 147, 153, 156
Lozenge shapes 96
Lunar alignment 72
Lithics 5, 19, 22, 90–91, 103, 132, 135, 146, 160, 162–163, 174, 176–177, 196–198, 204; lunate 179, 184–185, 187, 193–194; triangle 184, 193
Libya 7–8, 16, 37–39, 47, 52, 71, 85, 99, 111, 123, 150, 153, 174, 193, 195, 201, 203
Late Pastoral 8, 30, 153, 198
Limestone 10, 12, 22, 64, 157, 202
Libyan Fezzan 8, 17, 38, 47, 49, 69, 99, 101
Lajuad 13, 15, 18, 29, 31–33, 40, 50, 55, 59, 60–61, 64–68, 70–71, 75, 80–81, 83–85, 88–89, 91–94, 97–98, 103–104, 202
Lawaj 20, 22, 26, 60, 67, 74, 84, 92–93, 103
Landscape 1, 3–5, 7, 9–13, 15, 19, 21–22, 33–36, 43–44, 51, 57, 80, 102–104, 106, 108, 111, 116–117, 119, 121, 123, 146, 174, 198–202, 204

Maghreb 18, 101, 194, 200
Mali 5, 7, 9, 17, 18, 34, 99, 105, 153, 157, 160, 193–194, 197, 203
Mandible 156
Marine sediments 6, 10, 17–18, 32
Mauritania 4–7, 9–10, 12–15, 18, 24, 34, 48, 50–51, 71–73, 79, 84–85, 92, 94, 99–104, 121, 151, 153, 157, 160–161, 177, 193–194, 196–198, 201, 203
Mega-tumuli 89
Megalithic mounuments 35, 54–55, 84
Memory 3, 5, 174
Mheres 12–13, 21–24, 50, 59–60, 64, 67–68, 70, 78, 94, 100
Microburin 177–181, 183, 185–188, 190–195
Microliths 161, 179, 181, 183–190, 192–195
Micromorphological analysis 10, 21
Middle Pastoral 7–8, 34
Mijek 13, 18, 30, 34, 61, 79, 94, 98, 104
Military bunkers 119, 140
Military camp 140
Mobile groups 8, 165, 200
Mobile societies (hunters/farmers) 165
Mobility 8, 91, 182, 194,
Molluscs 10, 18–19, 22, 31, 105
Morocco 2, 4, 6–7, 10, 15, 17–18, 34, 46, 48, 50–51, 81, 87, 99–104, 119, 121–123, 153, 157, 197–198, 200–203
Mosque 76
Mounded crescents 39, 42–44, 46–47, 49–50, 58, 65, 67, 70–71, 73, 85–86, 101–103, 105, 110, 116, 119, 134, 136–137, 141, 144–145, 204
Mousterian lithics 19
Mud brick 140
Muslim 4, 53
Muyalhet Awaadi 19, 26–27, 61

Neolithic (The) 5, 7, 92, 161, 196, 199, 201–202, 204; arrowheads 161; context 160; industries 161; Pastoral 91–92; points 194–196; sites 9, 161
Niches 41–42, 45–46, 111, 113, 126–127, 130–131, 133, 136–139, 145, 148–149, 154, 156
Niger 37–40, 45, 48, 99–102, 105, 111, 150, 153, 157, 161, 194–195, 198, 201–202

Nomad 89, 101, 119, 196
Nouakchott 157
Nubia 16, 37–38, 102

Ochre 154, 156–158
Offering niche 111, 113, 126–127, 131, 136–139, 145, 148–149, 154, 156
Offering table 50, 53, 111, 126
Open-air mosque 54, 81–82, 122, 135, 140
Optically stimulated luminescence (OSL) dating 16, 21
Oranais 157
Orthostats 39–40, 43–44, 47–50, 62, 74–76, 88, 100–103, 116, 124, 126–128, 137, 142–144, 203
Orub 150
Ostrich 28, 94, 96, 152–153, 162, 168–170, 176
Ounjougou 194
Oval enclosures 83

Palaeochannel 24–25
Palaeoclimate records 16
Palaeoenvironmental indicators 6, 10, 19, 21
Palaeolake 16, 18–19, 22, 25,–27, 57, 90, 105
Palaeolithic 7, 22, 176, 183–185, 188–189, 193
Pale buff ware 150
Palette 164, 167
Parallel lines 52, 149–150
Pastoralism 8–9, 15, 100–101, 104–105, 204
Pathology 147
Paved extensions 39, 45, 48, 62
Pediment 21, 64, 103, 106, 108, 116–117
Pennisetum divisum 29
Petroforms 39, 43–44, 50, 52, 63, 76, 89, 116–117, 119
phenomenological approach 3
Pictograms 55, 77–79, 86, 90
Pierced shell pendant 154
Pigment 93–94, 96–97, 157
Pit 28, 141
Pit burial 37–38
Pivoting punch 92–93
Pivoting tool 92–93
Platform tumuli 36, 45–46, 58, 65–66, 108, 201
Platforms 38–39, 41, 45–48, 58, 64–68, 84, 99–102, 108, 116, 184
Playa surfaces 12, 21, 146
Pleistocene 3, 6–7, 17, 19, 21–22, 24–25, 100, 198, 204
Poaceae 29
Polished stone axes 164–165
Post holes 176, 197
Pottery (decoration on); comb 92, 150–151, 174; herringbone 92–93, 150, 174; punch; stamped design 91–93, 174
Pottery sherds 150, 170; angular grits 150, 164; body 91–93, 150; flared neck jars; handmade 91, 150; rim 91–93, 150, 174; rolled rims 150; shoulder 91–92, 150
Prehistoric necropolis 4
Prismatic blade cores 158
Proto-stele 101–102

qibla 54, 140
Quadriliths 84

Quadrupeds 97–98
Quartz 37, 67, 88–91, 101, 158, 160, 174, 177–179, 181, 185, 187, 190–194, 201–202; blocks 202; chippings 89–90, 201; clasts 22; feature 73; fragments 51, 124, 126–127, 139–140, 142–143, 145; gravel 73, 88; outcrops 89–90, 201; pebbles 88–90, 150, 201; scatters 77, 90, 201–202
Quartzite 78, 91, 157–158, 160
Quern stone 111, 126–127, 130

Radiocarbon dating 18, 47, 174, 195
Radiocarbon samples 173–174
Radiometric dating 7, 10, 20–21, 147
Rainfall, historical 17, 19, 104, 203
Rainfall, today 3–4, 7–9, 14–17, 204
Ram's head symbol 98
Raw material 91, 106, 158, 160, 177–179, 181–182, 185, 187, 190, 193–195, 199–200
Red dots 96
Reguibat Massif 10–13
Rekeiz Ajahfun 92
Rekeiz Lemgassem 15, 20, 22, 25, 59–60, 64, 79, 81, 92, 94, 103, 105, 121, 199
Retaining wall 147, 149–150, 154–157
Retouched blades 179
Ridge monuments 36, 39, 44, 47–50, 74–75, 88–89, 101, 103, 198, 204
Rising moon 65, 73
Ritual 1, 3, 35–36, 44, 47, 52, 54, 80, 85, 88–89, 108, 117, 139, 200, 202
Robbing 127, 142
Rock art 3, 5–7, 9, 19–20, 29–30, 32, 34–35, 56, 59, 60–61, 63, 90–92, 94, 97–105, 121, 174, 197–198, 203–204; addax, 30, 203; antelope 93–96, 98–99; Barbary sheep 7, 30, 203; bovids 93–94, 98; buffalo 94; camels 30, 93; crocodile 7; domestic cattle 30, 78, 96, 98, 104, 204; elephant 7; engravings 1, 2, 29, 56, 60, 63–64, 68–69, 92–94, 96, 97–99, 100, 103–104, 203; gazelle 30, 94, 97; giraffe 7, 19, 20, 30, 32, 93–94, 95–96, 98, 203; oryx, 30, 203; paintings 1–2, 29, 56, 59–60, 63–64, 92, 94–98, 100–101, 103–104, 203; Rhinoceros 93–96
Rock art sites 5, 60, 92, 94, 98, 121, 204
Rock crystal 177–179, 181, 192–193
Rock shelter 10, 20, 22, 26, 29, 31–33, 94, 96–97, 103
Rodent bones 149
Rodent species 148
Root casts 28
Route ways 44, 57, 106, 198, 200–201
Royal Tumulus 53–54

Saguia al-Hamra 4, 11–12, 34, 146, 157, 198, 200
Saharan Neolithic 165, 174
Sahel 8–9, 15–16, 18–19, 50, 94, 123, 161, 193, 204
Sahrawi; Arab Democratic Republic 4; indigenous population 2, 4, 5, 10, 15, 94; military 54; Ministry of Culture 4, 6, 59; refugee camps 4, 59
Sand and gravel plain 11–13, 15, 28, 64, 70, 79, 146
Sand sea 19, 65, 67, 88, 103
Sandstone 10, 12, 83, 146, 149, 171, 177–179, 181–182, 185, 187, 190–194

Satellite burials 126
Satellite imagery 13, 20–22, 24, 26, 28, 34, 57–59, 81, 99–100, 102–103, 108, 199; Google Earth (GE) 20, 22, 24, 34, 57–59, 72–74, 77, 79, 106, 108; Landsat Thematic Mapper (TM) 20, 23, 57
Savanna species 19–20; Reedbuck 19–20; Roan antelope 19–20; rhinoceros 19; buffalo 19; eland 19–20
Scars 158, 160, 179
Sebkha 14, 23, 31
Sedentary lifestyles 8
Sediments 6, 10–12, 14–20, 25–29, 32–33, 147
Senegal 18, 160–161
Sheep 4, 7–8, 29–30, 54, 203
Shells 10, 18–19, 22–23, 27, 31–32, 54, 92, 154, 156–157, 174, 176; *bulinus truncates* 23, 27, 32, 105; *conus* 156–157; *periscula cingulate* 156–157
Shelters 10, 20, 29, 31, 35, 44, 54–55, 63, 87, 90, 94–97, 119
Silt wash 162–164, 168, 176–177, 180, 182
Skeletal markers 146–147
Sluguilla Lawaj 20–22, 26, 60, 67, 74, 84, 92–93, 103
Small finds 153, 157
Small points 179
Smelting 153, 157, 161
Social complexity 6, 8, 101, 200
Spain 157, 201
Spiral horns 98
Spiral shape 98
Stakehole 169–170
Standing stones 35, 38, 42–45, 47, 49, 53–54, 62, 65–67, 75, 79–80, 83, 87–90, 100–101, 103–104, 114, 119, 121, 123–124, 126–132, 133, 136–138, 140–141, 145, 147, 154, 165, 202
Stone alignments 35–36, 38, 44, 50–51, 53, 60, 62–63, 66, 81–84, 87, 90, 110, 119, 128–129, 131–132, 136, 141–142, 16–165, 170
Stone bowl 111
Stone bracelet 164–165, 167
Stone concentrations 36, 40, 44–45, 51, 55, 63, 65, 77, 83, 85–87, 90
Stone emplacement 3, 40–42, 44, 53, 55, 63, 67, 86–87, 122, 137, 144, 174
Stone emplacements 3, 40–42, 44, 53–55, 63, 67, 86–87, 122, 137, 144, 174
Stone half rings 44, 52–53, 117, 119, 134, 136–140, 143–145
Stone lintel 126
Stone outlines 40, 44, 53–55, 58, 63, 66, 77, 80, 84–85, 87, 119, 122, 124, 129, 132, 136, 138–139, 145
Stone posts 126
Stone rings 42, 44, 47, 51–53, 58, 60, 77, 80, 84, 90, 116–118, 124, 127, 129–130, 133, 136–137, 139, 143
Stone slab 53, 83, 87, 111, 202
Stone spread 55, 117, 129–130, 132–133, 136–139, 143
Sudan 16–17, 123
Surface lustre 158
Surface scatters 1, 5, 90, 146, 162, 165, 198
Symbolic platform 63, 124

Tadrart Acacus 92
Tagnout-Chaggeret 18

Tamrit 89
Tanezzuft Valley 153
Tanged point 160, 188, 195
Tangs 179, 187, 191
Tannezuft Valley 17
Taoudenni Basin 18
Tassili n-Ajjer 99–100
Teeth 147, 156
Temper; vegetal 91; mineral 91
Tent pitch 84
Tents 35, 53–54, 94
Test excavations 5, 167
Test pit 21, 146, 162, 164, 168–170, 174, 176–177, 179, 182, 185, 187, 190–193, 195
Test trench 162–165, 167–168, 170–171
TF1 Study Area 8–9, 44 49, 51–57, 59, 63–64, 66, 70, 74–81, 90–91, 102–103, 106–108, 111, 116–117, 119, 121, 123, 126, 130–138, 143, 145–146, 153, 157, 165, 170, 174, 177, 197–204
Theriomorphs 94
Tifariti 5–6, 12, 23, 33, 35, 55–56, 58–61, 64, 67, 70–72, 74–75, 78–81, 86–87, 89, 100, 102–103, 105–106, 108, 111, 117, 146–147, 156, 161, 193, 202, 204
Tin Gufuf 61, 64–65, 70, 76, 81, 86, 91–92, 103–104
Tindouf 4, 54, 72, 79, 100
Tindouf Basin 10–13, 24, 25
Tintan 151, 177, 195
Tool forms 91, 158–159
Topographic zone I 111, 116–117, 138
Topographic zone II 111, 116–117, 138
Topographic zone III 116–117, 119, 138
Tors 108, 111
Trade 152–153, 198, 201
Transects 18, 164–165, 170, 177, 183–184, 187–190, 193, 195
Translucent chert 91, 158, 160
Triliths 54, 84–85
Truncations 179, 181, 185–187, 190, 192, 194
Tufa 28–29, 31–32, 92, 97
Tumuli 6, 35–37, 41, 44–55, 58–59, 64–67, 69, 71, 74, 83, 85–90, 97, 99–102, 104, 108, 110–114, 116–117, 119, 121, 123, 125, 127, 129, 131–132, 134, 139, 146–147, 153, 161, 174, 200–203; crater 36–37, 45, 99; flat topped 37, 45, 68; with a circular cap 45; with arms/wings 38, 41, 46, 65, 74; with concave tops 45

Universal Trans Mercator 87, 106
Urine 29

V-type antennae with mound 44, 74
V-type monuments 38–39, 47, 49, 58–59, 63, 70–71, 73–74, 99, 101–102, 201
Vandalism 59, 97
Vertebra 29, 31, 156, 157
Vertical lines 96

Wadi al Ajal 53, 116, 153
Wadi Barjuj 201
Wadi Ben Amera 12, 60
Wadi Chbika 100
Wadi Draa 7, 100. 153, 157, 198, 200–201, 203
Wadi Erni 21, 60, 67–68, 96–97
Wadi Ghaddar Talhu 23, 74
Wadi Jeneig Ramla 23
Wadi Kenta 26, 92, 94, 103, 194–195
Wadi Lejcheibi 12
Wadi Lemmuil-Lihien 12
Wadi Ratnia 22, 24, 50, 60, 64, 67, 76, 87
Wadi Sluguiat 12
Wadi Tanezzuft 35, 52–54, 153
Wadi Ternit 12–13, 60, 64–65, 67, 83–86, 102, 203
Wadi Teshuinat 92
Wadi Tifariti 9, 15, 64, 75, 81, 102, 106, 108, 111, 117, 119, 124–129, 138–143, 146, 162, 164–165, 170, 193–195, 197, 202
Wadi Um Hamra 12, 24
Wadi Weyn Tergit 12, 21, 23, 25, 60
Wadi Ymal 92
Walalde 161
Way markers 35, 44, 76, 104, 174
Weathering 30, 98, 154, 158, 170, 173
West Nubian Palaeolake 16
White carbonate 67, 202
Wild cereal cultivation 8
Wild fauna 16, 94, 96, 103–104, 203
Wild grasses 3, 165
Wind and water abrasion 91
Windbreaks 55, 63, 83
Winter solstice 67, 71–73
WS number 106, 138

Zag 202
Zemmour region 92, 203–204
Zoomorph 68, 77–79, 86, 94, 96–99
Zoomorphic pictograms 86
Zoug 12–13, 15, 27, 34, 59, 61, 64–65, 67, 75, 81, 83–84, 86, 88, 91, 94, 98–99, 103, 104

Plate 1. Paintings from Bou Dheir. a. water buffalo from recess no. 3; b. rhinoceros with bovid and dotted line from recess no. 5 (Northern Sector).

Plate 2. a. tumulus LD1-32 at Lajuad (Southern Sector); b. detail of 'annex' incorporated into tumulus feature TR2-5 on the northern bank of Wadi Ternit (Norther Sector); c. platform tumulus ZG1-12 at Zoug (Southern Sector); d. Tumulus with arms, TF5-4.

Plate 3. a. stone platform LD1-41; b. bazina LM2-1 at Limsharha (Northern Sector); c. stepped bazina DR1-1 adjacent to Wadi Dirt (Northern Sector); d. corbeille ER1-5 overlooking Wadi Erni (Northern Sector).

Plate 4. a. Regular crescent LD1-21 at Lajuad (Southern Sector); b. crescent with tails TF4-1 on isolated flat topped hill north of Tifariti (Northern Sector); c. paved crescent WS018 in intensively surveyed TF Study Area; d. crescent antenna TF5-4 in the vicinity of Tifariti (Northern Sector).

Plate 5. a. Detail of kerbing on paved crescent-crescent antenna hybrid monument MH1-34 on west bank of Wadi Ratmia north of Mheres (Northern Sector); b. V-type monument IR3-3 in the vicinity of Irghraywa (Northern Sector); c. axle-shaped monument TF3-1 at base on hill west of the main TF1 Study area north of Tifariti (Northern Sector); d. mounded crescent SL6-3 in the vicinity of Sluguilla Lawaj (Northern Sector).

Plate 6. a. Cairn with short line of orthostats WS034 in TF1 Study Area, north of Tifariti (Northern Sector), b. ridge monument LD0-3 near Lajuad (Southern Sector), c. complex monument LM1-4 at Limsharha (Northern Sector), d. monument with auxiliary towers MH0-1 just north of MH1 detailed survey area (Northern Sector).

Plate 7. a. Type 1 goulet TF6-34 just south of TF1 Study Area (Northern Sector). b. Type 2 goulet IR1-11 near Irghraywa (Northern Sector). c. corridor of Goulet WS006 in the TF1 Study Area, showing alignment to west on a flat-topped hill occupying a break in the linear plateau of Rekeiz Lemgassem, an area that houses abundant rock art; d. Goulet GF2-6, the only Goulet recorded to date in the Southern Sector.

Plate 8. a. Stone ring TF0-34 north of Tifariti (Northern Sector); b. stone half-rings TF0-41 norther of Tifariti (Northern Sector); c. standing stones that form focus of TF1 Study Area (Northern Sector); d. incomplete circle of stones TF0-38 west of TF1 Study Area (Northern Sector).

Plate 9. a. Possible zoomorphic arrangements of stones within enclosure of goulet IR1-12 (Northern Sector); b. additional stone arrangement within enclosure of Goulet IR1-12, in vicinity of zoomorph.

Plate 10. a. and b. Quartz chippings on top of tumulus MS1-4 at Garaat al-Masiad (Northern Sector); b. quartz scatters at TF0-38 north of Tifariti (Northern Sector); c. quartz concentrations at funerary complex LD0-3 at Lajuad (Southern Sector); d. central elongated tumulus of crescent monument AZ3-1, made entirely of quartz, with small quartz tumulus in foreground, Azaig Bedrag (Southern Sector).

Plate 11. Sample of paintings in one of the shelters at MH2, east of Mheres in the Wadi Kenta area (Northern Sector).

Plate 12. Abstract forms and linear style paintings in one of the shelters at MH2, east of Mheres in the Wadi Kenta area (Northern Sector).

Plate 13. Assemblage of paintings in the largest recess (recess no. 3) at Bou Dheir (Northern Sector).

Plate 14. Cattle and pastoralists represented in recess no. 5 at Bou Dheir (Northern Sector).

Plate 15. a. Abstract engravings at ER2, Wadi Erni (Northern Sector); b. engraving of gazelle at ER2; c. abstract engravings and Libyco-Berber script (top right), with dark linear style anthropomorphs in rock shelter at LD0-7 at Lajuad (Southern Sector); d. paining of cattle and unidentifed animal in rock shelter LD0-9, Lajuad (Southern Sector).

Plate 16. a. Heavily varnished engraving, possibly of a mask or shield, at LD6-1, Lajuad (Southern Sector); b. engraved concentric circles at Zoug (Southern Sector); c. 'ram's head' style engravings at Zoug; d. abstract engraving of a giraffe, with ram's heads and other engravings at Zoug.